The Impressionists
at Leisure

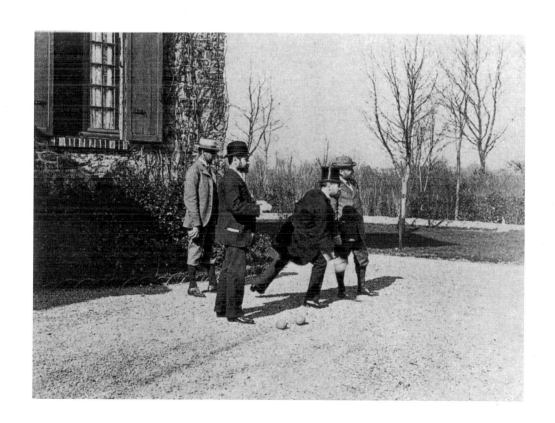

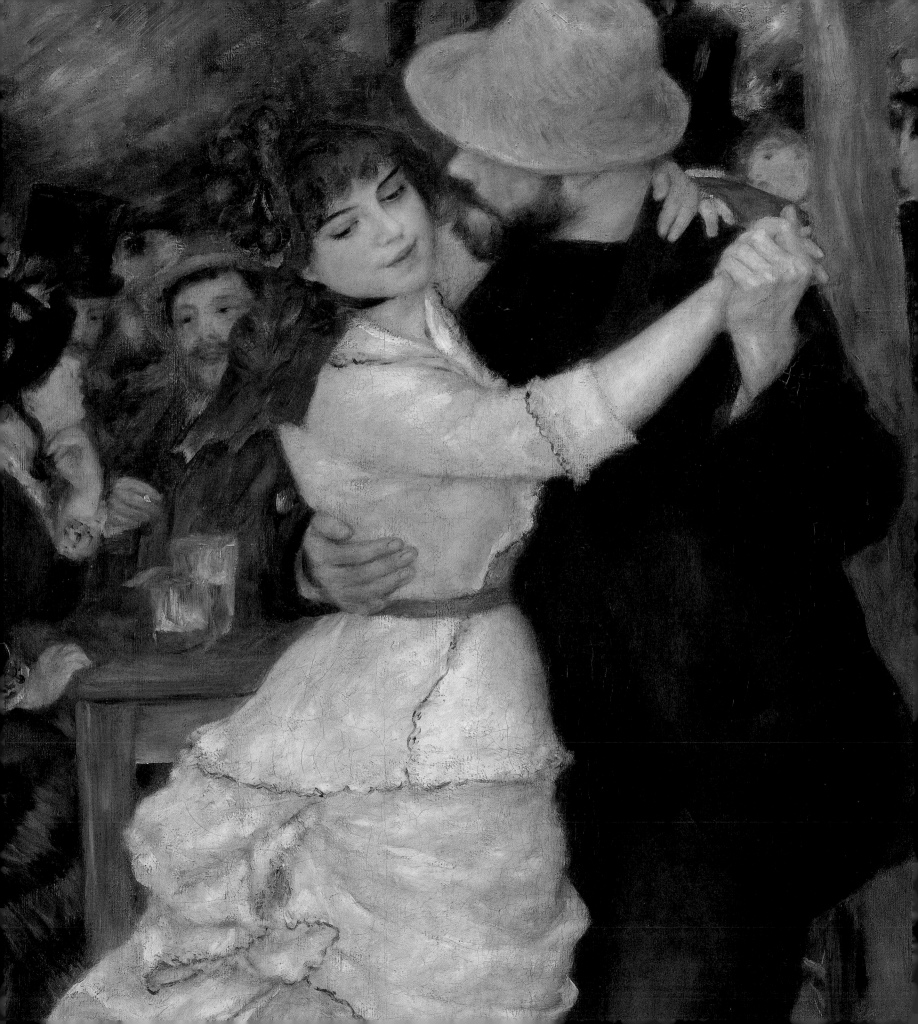

PAMELA TODD

The Impressionists at Leisure

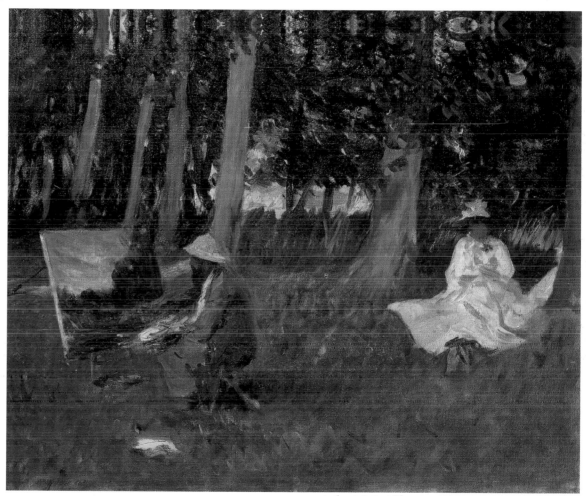

with 198 illustrations, 151 in color

Thames & Hudson

For Peter, with love

First published in 2007 in hardcover in the United
States of America by Thames & Hudson Inc.,
500 Fifth Avenue, New York, New York 10110

thamesandhudsonusa.com

Library of Congress Catalog Card Number
2006940567

ISBN 978-0-500-23839-4

Printed and bound in Singapore by C. S. Graphics

p. 1 Cassabois, Gallo, Susse and Fournier playing boules
at Petit Gennevilliers, the home of Gustave Caillebotte,
in February 1892
p. 2 Pierre-Auguste Renoir, *Dance at Bougival*, 1882–3
p. 3 John Singer Sargent, *Claude Monet Painting by the
Edge of a Wood, c.* 1887
above Edouard Manet, *Skating*, 1877

Contents

Introduction 7

CHAPTER 1 *A Time to Meet*
CAFÉ SOCIETY, BARS, RESTAURANTS AND DANCE HALLS 17

CHAPTER 2 *A Time to Enjoy*
RACING, THEATRE, OPERA, MUSIC HALLS AND BALLET 35

CHAPTER 3 *A Time to Relax*
PICNICS, PARKS AND GARDENS 59

CHAPTER 4 *A Time to Reflect*
BOATING AND BATHING 81

CHAPTER 5 *A Time to Shop*
STREETS AND THE CITY, DEPARTMENT STORES AND ARCADES 107

CHAPTER 6 *A Time to Depart*
TRAVELLING AND TRANSPORT 127

CHAPTER 7 *A Time to Escape*
FRESH AIR, RURAL LIFE, WALKING AND THE COUNTRYSIDE 147

BIOGRAPHIES 164
PLACES TO VISIT 169
FURTHER READING 170
LIST OF ILLUSTRATIONS 171
INDEX 174

Introduction

'Every picture shows a spot with which
the artist has fallen in love.'
Alfred Sisley in an undated letter c. 1880

Sunlight dances on the surface of a river, or filters through the forest canopy to play across a snow white cloth on which a tumble of fruit, a loaf of bread and a bottle of wine are laid out; people recline, or amble arm in arm through fields of waist-high poppies; there is the splash of a paddle and, beyond, the huffing approach of a small train on a branch line carrying holiday makers deeper into the countryside. The mood is serene, unruffled, deeply content.

Many Impressionist paintings communicate this irresistible love of life, a youthful, invigorating energy which grew out of common ideals, privations, celebrations and friendships. Pleasure is so often their theme that it is hard to believe that their most hedonistic paintings were often made during times of extreme privation. Monet, unable to pay his hotel bill, had to leave the canvas of his *Déjeuner sur l'herbe* behind as a pledge of future payment; Renoir worried constantly that he had

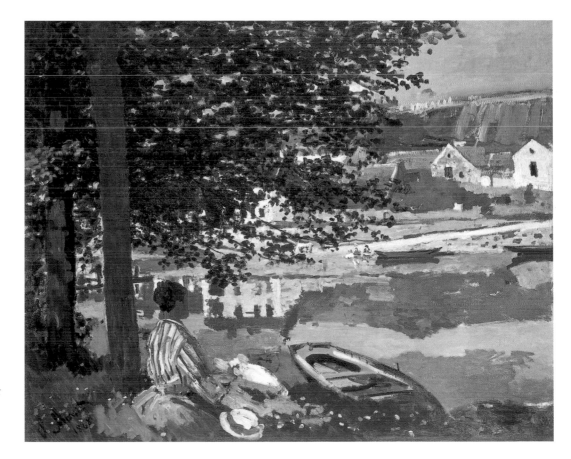

PIERRE-AUGUSTE RENOIR
At the Theatre (La Première Sortie), 1876 7
Renoir captures wonderfully well the breathless
excitement of a young girl on her first outing to
the theatre.

CLAUDE MONET
The Bank on the Seine (Bennecourt), 1868
Bennecourt is a small village on the bend of the Seine
about three miles southeast of Giverny and close to
Gloton where, in 1868, Monet took his mistress and
child because it was cheaper to live than in Paris. We
are drawn to the figure of Camille beneath the tree but
this early painting is notable for its exploration of the
theme that would become his central obsession:
reflections on calm water.

overstretched himself while painting the *Luncheon of the Boating Party*; in the summer of 1868, when the two men were painting side by side at La Grenouillère, the famous floating café on the banks of the Seine at Croissy, Renoir kept Monet, his mistress Camille Doncieux and their son from starvation by bringing them scraps filched from his parents' table. 'We might not eat every day,' Renoir wrote to Frédéric Bazille, 'but I'm content because Monet is great company for painting.'

Today the carefree conviviality of their canvases, the glowing colours, fluid brushstrokes and sunlit scenes evoke in us a feeling of well-being and a tinge of nostalgia for a time when love and light, fun and friendship were elevated above the petty commercial concerns of everyday living. In their own time their work was greeted with derision. Its immediacy, freshness and improvisation was not welcomed with open arms by the Salon – who found it disturbingly radical or provocatively anti-establishment – nor by the public who mocked and dismissed it as the daubings of lunatics. Nowadays, of course, Impressionist paintings are the jewels in national collections around the world and travelling exhibitions attract record crowds. Today we feel ourselves in tune with Impressionism and fondly imagine we would befriend rather than ridicule the young painters who worked so hard to create a new style of art, which gave light precedence over form and captured what Edouard Manet's friend Charles Baudelaire called 'the presentness of the present.'

Mostly of an age – Camille Pissarro, Edouard Manet, Edgar Degas, Frédéric Bazille, Paul Cézanne, Alfred Sisley, Claude Monet, Berthe Morisot and Pierre-Auguste Renoir were all born between 1830 and 1841; Mary Cassatt and Gustave Caillebotte, just a few years later – the Impressionists painted their own, intensely modern world and developed their own imagery of leisure pastimes. Theirs was an age of rampant prosperity and rapid social change and their paintings reveal and examine just how Paris – into the heart of which they plunged – and its environs – which they embraced with the same enthusiasm – had become places of opportunity, pleasure and excitement, for women as well as men.

The history of Impressionism is bound up in the parks, cafés, dance-halls and pleasure pots that proliferated in Paris; in the new English vogue for sea-bathing which turned Trouville and Deauville into elegant seaside resorts; and in the coming of the railway which brought the pleasant villages along the banks of the Seine within a fifteen-minute train ride from the city. Increasing industrialization meant more leisure time and new sports such as boating, bathing and bicycling became popular. The young painters were both astute observers of, and eager participants in, the new leisure activities which grew up to serve the needs of a burgeoning bourgeoisie. Instinctively in tune with the escapist urge for distraction and the new leisure-drive, they embraced the modern age, proving eager race-goers, ardent music lovers, avid consumers of the goods on offer in the new department stores, and enthusiastic samplers of new sports, as well as important responders to – and recorders of – modern life. Irresistibly drawn to the bright lights of Paris, its play of dazzling surfaces and teeming thoroughfares, they chose to paint the fashionable new brasseries and cafés, the new streets and squares of Paris, the high drama of the Gare Saint-Lazare and the brittle glamour of the Folies Bergère. Degas takes us to the racetrack and backstage at the ballet. He gives us a vertiginous view of the orchestra in the pit and an intimate glimpse of a ballerina tying her shoe. We can hear the pounding hooves of the pony in Seurat's *Cirque Fernando* and smell the absinthe in Lautrec's *Moulin Rouge*.

The Impressionists brought their acute powers of observation to bear on the shifting cultural and sexual values they found in these places of entertainment and their paintings mine male anxieties of the time about the freedom these fluid sites and spaces offered to women. Their paintings

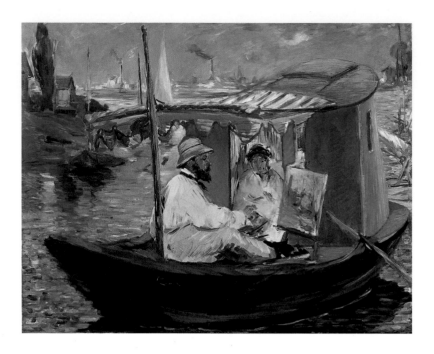

EDOUARD MANET
Monet Working on his Boat in Argenteuil, 1874
Monet recalled in 1927 how a 'lucrative sale' had enabled him to buy himself a barge and have it outfitted with a cabin made of boards. 'There was just enough room to set up my easel,' he told François Thiebault-Sisson. 'What delightful hours I spent with Manet on that little boat! He painted my portrait there…those lovely moments, with all their illusions, their enthusiasm and their fervour, should never have ended.'

PIERRE-AUGUSTE RENOIR
Picnic, c. 1893
'More than any other great modern artist,' wrote Roger
Fry in 1920, 'Renoir trusted implicitly to his own
sensibility; he imposed no barrier between his own
delight in certain things and the delight which he
communicates. He liked passionately the obviously
good things of life...sunshine, sky, trees, water, fruit.'

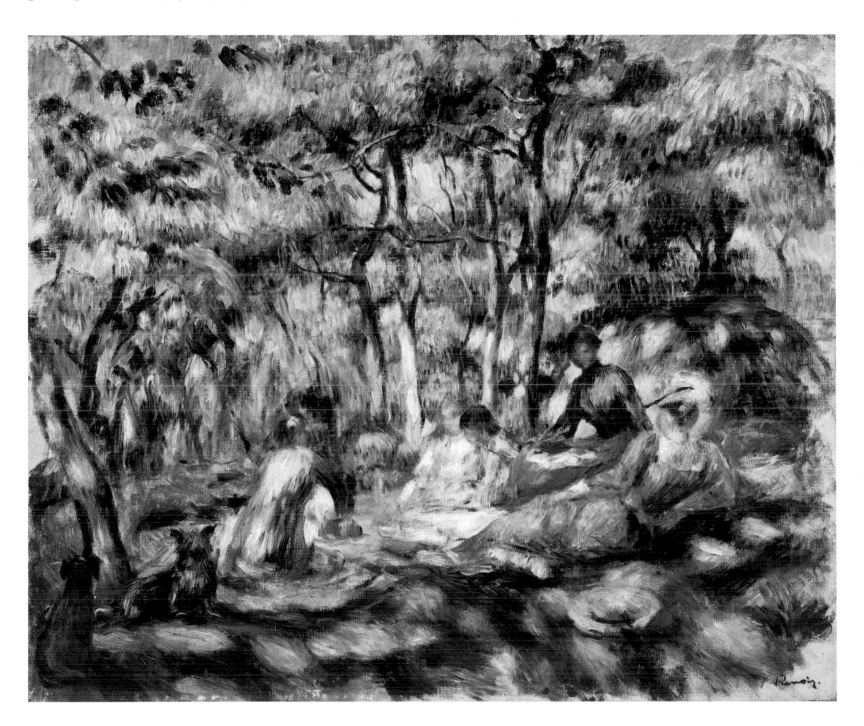

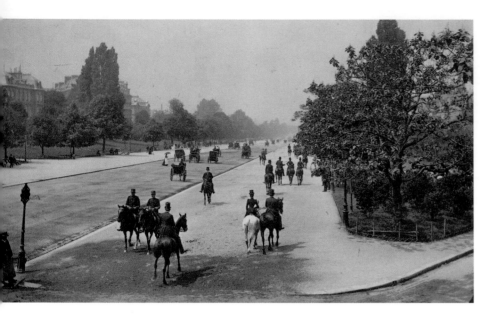

reveal evidence of the social revolution that was taking place, which allowed women into cafés, or to restaurants to dine alone, and which provided leisure to an expanding and increasingly moneyed middle class who chose to spend their Saturdays in the new department stores and their Sundays in the country.

The young painters had seen the population of Paris double in the first half of the nineteenth century and now the very face of the city was changing. Narrow streets and, in places, whole quarters were demolished to make way for Baron Haussmann's bold vision. Old areas – traditionally, economically and socially working class – were pulled down, to be replaced and repopulated by a mercantile middle class with time and money on its hands. Haussmann's strategic beautification and aestheticization of the city paid dividends. Paris prospered and kept pace with the new developments in technology which were literally making the city glow. First gas then electric lighting illuminated interiors and the street, extending the range of night-time entertainment, and causing Paris to become known internationally as the City of Light.

Haussmann's fashionable boulevards have been called 'the newly eroticized contours of city life' and the Impressionists were among those who took full advantage of the glass-fronted cafés and restaurants which lined them, providing both fresh opportunities for flagrant self display and new motifs for paintings. Paris had so many faces. It was the capital of risqué entertainment, the chic centre of good taste and high fashion, of fabulous food, fine wine and high art. The reinvention of Paris continued into the countryside and – as the arrival of the railway enabled people to travel and to consume – the landscape became another, recreational part of the urban experience. The railways kept people moving and a new kind of architectural structure – of glass and iron – was employed to build the cathedral spaces of the great stations.

Entertainment was becoming increasingly commercialized and the café-concerts were characterized by a mingling of the classes, which lent a frisson of unruliness to the spectacle and created a not unexciting air of instability. Working-class women from ballet dancers (coveted figures of sexual desire, but not the type of woman a man might expect to marry) to milliners (highly visible young women frequently seen moving about the metropolis) were often assumed to be prostitutes and there was a blurring, through fashion and the opening up, the democratization, of public spaces from parks to bars, boulevards to circuses, of the distinctions between the respectable, middle-class woman and her social climbing, working-class cousin. Impressionist paintings captured the ambivalence of

The Avenue du Bois de Bologne, Paris

CLAUDE MONET
Interior of the Gare Saint-Lazare, c. 1877
Rather than paint a landmark like the recently completed Opéra, Monet chose one of the few buildings in Paris 'having a truly original style and an appearance appropriate to its function'. Only Zola picked up on the modernity of the subject-matter; the hostile critic of *Le Figaro* complained that Monet had 'tried to give us the disagreeable impression which results when several engines whistle at the same time.'

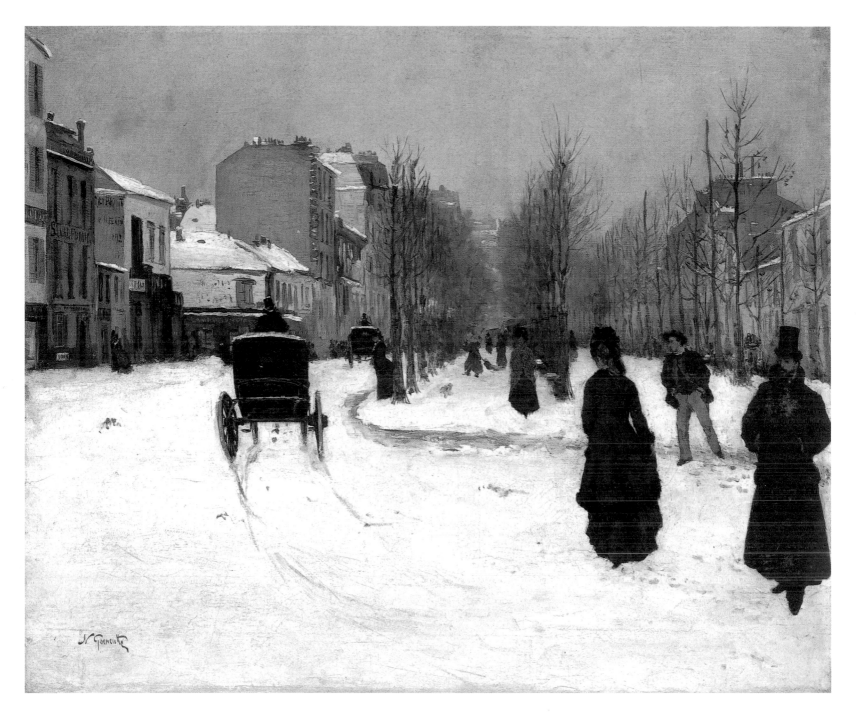

the age by concentrating on the audience more often than they did on the performer when recording urban entertainments. Looking – whether at fine art, or consumer goods, at public performances or simply at one another – had become a self-conscious spectator sport and the Impressionists were the grand masters of it. In the late nineteenth century, leisure itself had become a performance and the thing performed was class. The Impressionists understood the subtle shadings of this intensely modern moment more than most.

This book looks at leisure through the prism of the paintings, pastels and drawings of the Impressionists. The focus is on place and people, on friendship, family lives and shared experiences. It poses and seeks to answer some of the questions the paintings prompt in us: why is

NORBERT GOENEUTTE
The Boulevard de Clichy under Snow, 1876
Norbert Goeneutte was close to the several of the Impressionists, including Manet and Degas, and modelled for Renoir (see p. 15), and indeed the Boulevard de Clichy was in the heart of the artists' quarter in Paris. In this arresting painting he plays with the formal shapes of the warmly wrapped figures and carriage against the snow in a very modern way.

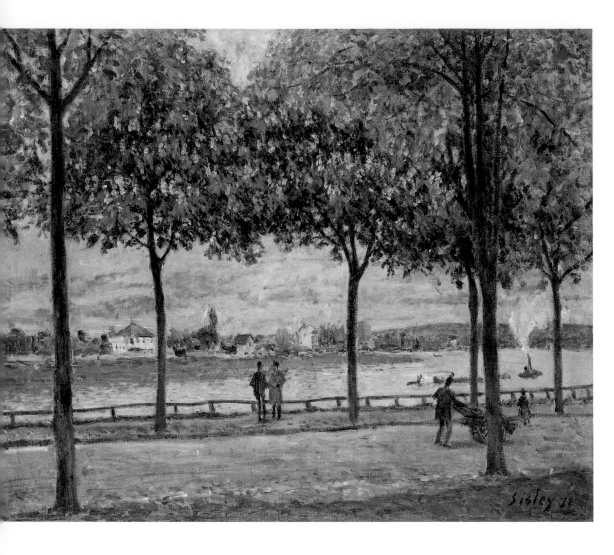

Caillebotte's rower wearing a top hat? Manet's female picnicker no clothes at all? Who brought all the paraphernalia to that bosky forest site? How novel was a picnic in a forest anyway? When did mixed bathing become the fashion?

The animating idea behind it is my own curiosity about how people, and the Impressionists in particular, enjoyed themselves and filled their leisure hours in this period. By drawing on letters, journals, first-hand accounts and the artists' own autobiographical writings, I hope to catch a glimpse of them in the crowd, to follow the French painters and their American and European colleagues into the theatres, circuses and café-concerts of Paris, to pull up a chair at the café table between Monet and Degas, or look out from the corner of a *loge* over the fragrant shoulder of Renoir's model Nini, to fall into step with Edouard Manet as he strolls down the broad boulevard, or nab that extra seat in Berthe Morisot's boat or the deckchair beside Claude Monet's family on the beach at Trouville.

In chapters devoted to different forms of recreation and amusement, this book strolls the gravel paths of their favourite parks, takes a carriage ride through the Bois de Boulogne with Mary Cassatt's sister Lydia and enjoys a day at the races with Edgar Degas. It sets off with a small rucksack filled with painting materials and a simple picnic into the shady spaces of the forest of Fontainebleau, shops in the Bon Marché, traverses the city, as the Impressionists did, by foot, cab and horse-drawn omnibus, and goes backstage at the opera and the ballet in the evening.

Recreation can be a frantic or a serene business, it can be snatched in moments or enjoyed at lingering length. The Impressionists knew how to enjoy themselves. Their zest for life is celebrated in beguiling paintings which record their own pleasures and daily distractions: theatres, dances, cafés; boating trips; picnics in the park; days at the races or in the country; seaside excursions and family holidays. Despite the struggle which characterized their early artistic beginnings, their paintings exude an air of relaxation and deep contentment with the simple pleasures of life: skating on the frozen lake in the Bois de Boulogne, boating on it in the summer, strolling beneath the shady trees in the Parc Monceau or watching the passing scene on the beach at Trouville. They were acquainted too with the fraught and darker places of pleasure. Entertainment in all its forms fascinated and inspired them and their paintings illuminate, explain and mirror the amusements and attractions of their age. They take us behind the scenes, make the audience itself the spectacle

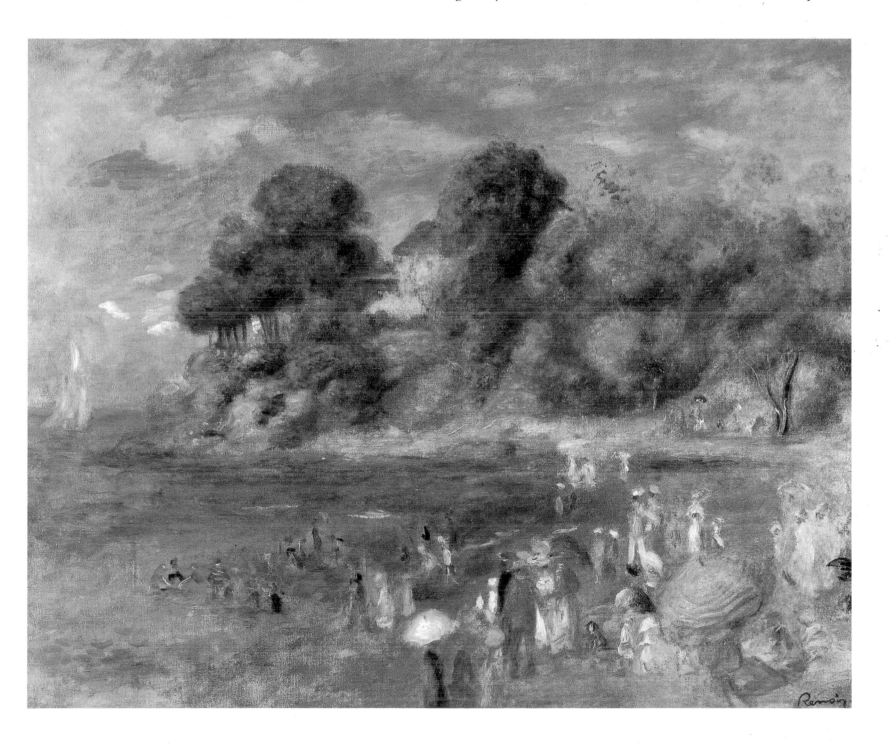

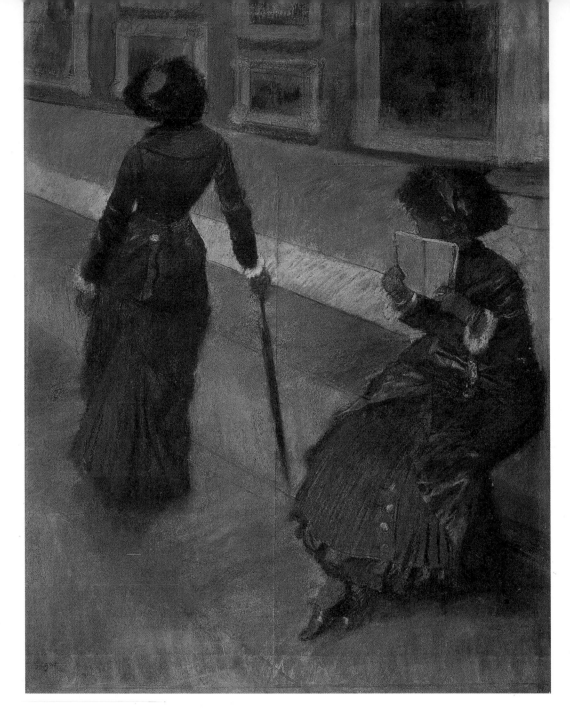

and show how, as the world speeded up, pleasure became something you could package and sell to a ready market. But we know and love them best for canvases which capture a landscape and a relaxed and leisurely style of life which is now largely vanished for ever. We prize their paintings most for their limpid play of light and dazzling happiness, though they are rich in many kinds of meanings, as I hope to show.

Let us leave the last word to Renoir, who, as has often been pointed out, did not paint unhappy pictures. He once said that there were enough burdensome things in life already without adding to them, and when his teacher at the École des Beaux-Arts accused him of painting for his own pleasure, he replied famously, 'If I didn't enjoy it, I certainly would not do it.' His enjoyment – their enjoyment – shines through these pages.

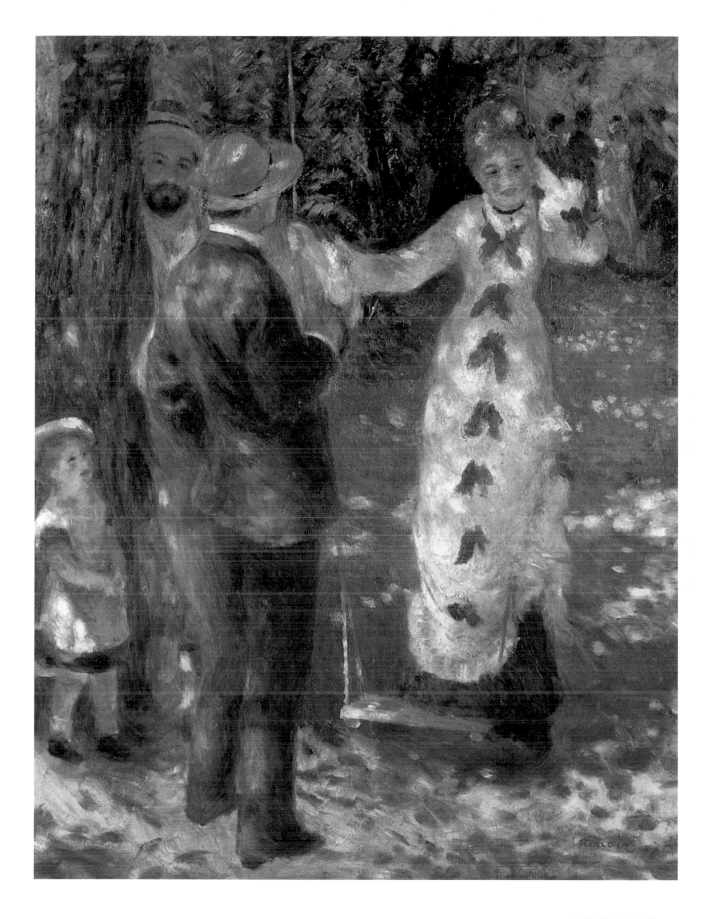

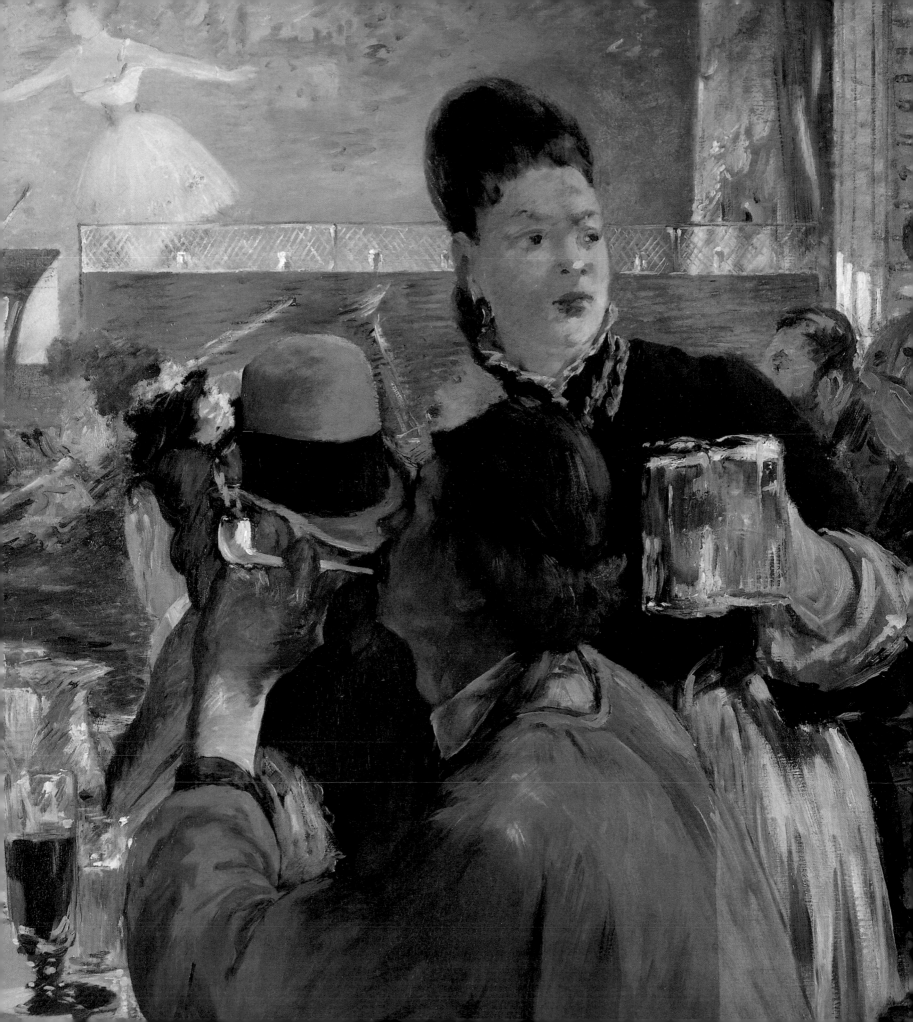

A Time to Meet

CHAPTER 1

CAFÉ SOCIETY, BARS, RESTAURANTS AND DANCE HALLS

'In 1869…Manet invited me to accompany him to a café in the Batignolles, where he and his friends met and talked every evening after leaving their studios. There I met Fantin-Latour, Cézanne and Degas, who joined the group shortly after his return from Italy, the art critic Duranty, Emile Zola, whose literary career was just beginning, and many others. I myself took along Sisley, Bazille and Renoir. Nothing could have been more stimulating that these debates, with their perpetual clash of opinion. They kept our wits sharpened, inspired us to unbiased and honest experimentation and supplied us with a store of enthusiasm which kept us going until our ideas had been finally realized.'

Claude Monet

The café Edouard Manet held court in on Thursday evenings from 1869 to 1872 was the Café Guerbois, just around the corner from the house in rue de St Petersbourg he shared with his mother, his wife Suzanne and the ten-year-old boy, Léon Koëlla, whom all three passed off as Suzanne's younger brother (though the strong likelihood is that Léon was Manet's son, born before he and Suzanne married.)

Situated at the centre of a lively triangle between the Place Clichy, the Place Pigalle and the church of Notre Dame de Lorette, the Guerbois suited Manet admirably. It was just a short step from his studio in rue de Douai and only five minutes from Renoir and Bazille's shared studio at 9 rue de la Paix (later renamed rue de la Condamine). Some have called it the birthplace of Impressionism and a small plaque above a shoe shop now marks the site of what was once the central focus for the writers and painters of Manet's circle.

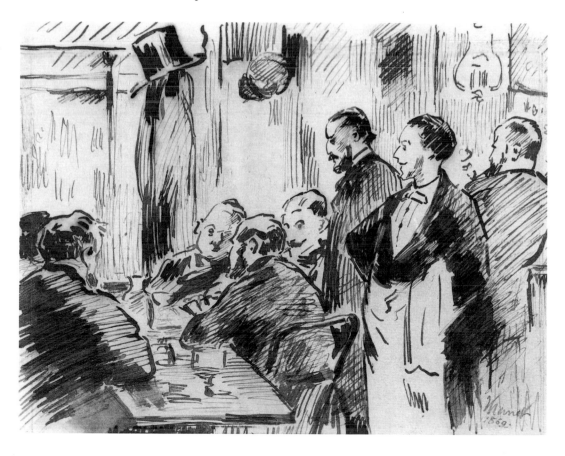

EDOUARD MANET
The Waitress (detail), c. 1878–80
The central figure of the capable waitress holding a clutch of brimming beer glasses in one hand and scanning the crowd off to her left as she sets a drink down before a customer anchors this composition. The spectacle on stage is relegated to the top corner and she becomes the true subject of the painting.

EDOUARD MANET
At the Café, 1869
A waiter looks on approvingly as the debate deepens in the Café Guerbois.

As the day ended, the lights would go off in the high studio windows in the bohemian Batignolles and Clichy districts and the painters would roll down their sleeves, pack away their brushes and make their way to the welcoming warmth of the 'spacious and comfortable' café, which was furnished in Empire style with ornate tiles and gilded mirrors in elaborately carved frames, all splendidly illuminated by the new flaring gas lamps. The patron, Auguste Guerbois, was a man of commanding presence and strong personality who had grown up in La Roche-Guyon on the banks of the Seine and often advised the young artists on perfect painting sites along the river. He always kept the first two tables at the left of the entrance reserved for the group, though often they would spill across and the waiters in their long white aprons would have to push their way between the marble-topped tables, serving drinks in an atmosphere thick with cigar-smoke and lively discussion. Against the background click of billiard balls, revolutionary new ideas about art were exchanged, advanced, argued and passionately defended. At the centre sat Manet, his elbows planted on the table, his hat pushed to the back of his head, conducting the debate, treating his followers to bursts of 'flashing wit', and making clear his determination to paint modern life free of the conventions of tradition or idealization, to evolve a new style of painting beyond the boundaries of Salon art. Already his work had caused a storm and the heady mix of scandal and notoriety made him an even more charismatic figure to the younger painters, who looked up to him for guidance and affirmation: Renoir, witty and seemingly carefree, Sisley, amiable and relaxed, Monet, broad-shouldered and handsome. Only the bantering, tart-tongued Degas could match Manet's wit and only the modest, gentle Pissarro, who came in by train from the suburb of Louveciennes where he had installed his growing family, could soothe the ruffled feathers.

Contemporary accounts tell how Manet was 'overflowing with vivacity, always bringing himself forward, but with a gaiety, an enthusiasm, a hope, a desire to throw light on what was new, which made him very attractive.' Zola described him as 'of medium size, small rather than large, with light hair, a somewhat pink complexion, a quick and intelligent eye, a mobile mouth, at moments a little mocking…a man of greatest modesty and kindness.' Others, however, saw him as 'ambitious and impetuous' and 'naturally ironical in his conversation and frequently cruel…[with] an inclination for punches, cutting and slashing with a single blow.' For his friend Theodore Duret, Manet was simply 'a Parisian of the Parisians, both in his habits and his attitude towards life. He possessed the mundane temperament, the artistic sensibility, the delight in social intercourse – all those qualities which, while they give the Parisian his distinguishing air of refinement, make for a certain artificiality in his mode of life.'

Manet was also a regular at the fashionable Tortoni's on the Boulevard des Italiens and, along with Degas, often to be seen in the elegant restaurants and smart cafés such as the Maison Doré, the cafés Riche, du Helder, Anglais and Américain, the Grand Café and the Café du Grand Hôtel. Here well-heeled cosmopolitan customers could sit for hours at outdoor tables in the pocket of privacy the high prices had secured for them watching the passing scene. These grand cafés priced their drinks to suit the purses of the middle and upper classes, but the working classes in any case preferred the congenial clamour of the hundreds of *cafés intimes* in the side streets and the small family-run *bistros* serving traditional homely dishes and wine by the carafe. They found it unnatural to choose to spend so much time dawdling on a café terrace, disconnected from the street, inhabiting a private realm, though it suited the American writer Henry James admirably. In his *Parisian Sketches*, James described the boulevards as 'a long chain of cafés, each one with its little promontory of chairs and tables projecting into the sea of asphalt.' Here an apéritif might be taken as the perfect prelude to a dinner 'in the Champs Élysées at a table spread under the trees, beside an ivied wall' where you might 'almost believe you are in the country,' – though James warned: 'This illusion, imperfect as it is, is a luxury and must be paid for accordingly; the dinner is

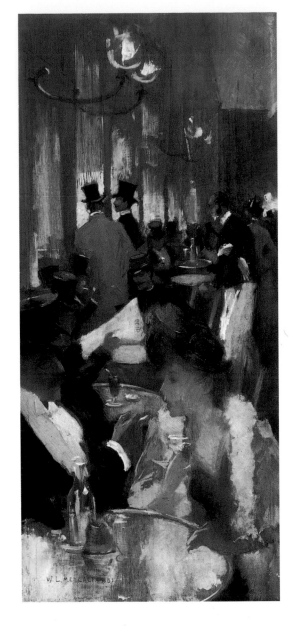

WILLARD METCALF
In the Café (Au Café), 1888
This unusual composition by American painter Metcalf was painted at the end of his five-year stay in Paris. The low viewpoint situates the artist among the other diners, on a typical streetside Parisian café. He gave the work to the proprietors of the Hôtel Baudy in Giverny, where he often stayed.

LUIGI LOIR
The Night Café, c. 1910
By the late 19th century, Paris was a twenty-four hour city, and night cafés such as this catered for shift workers, as well as those who had stayed out rather too late.

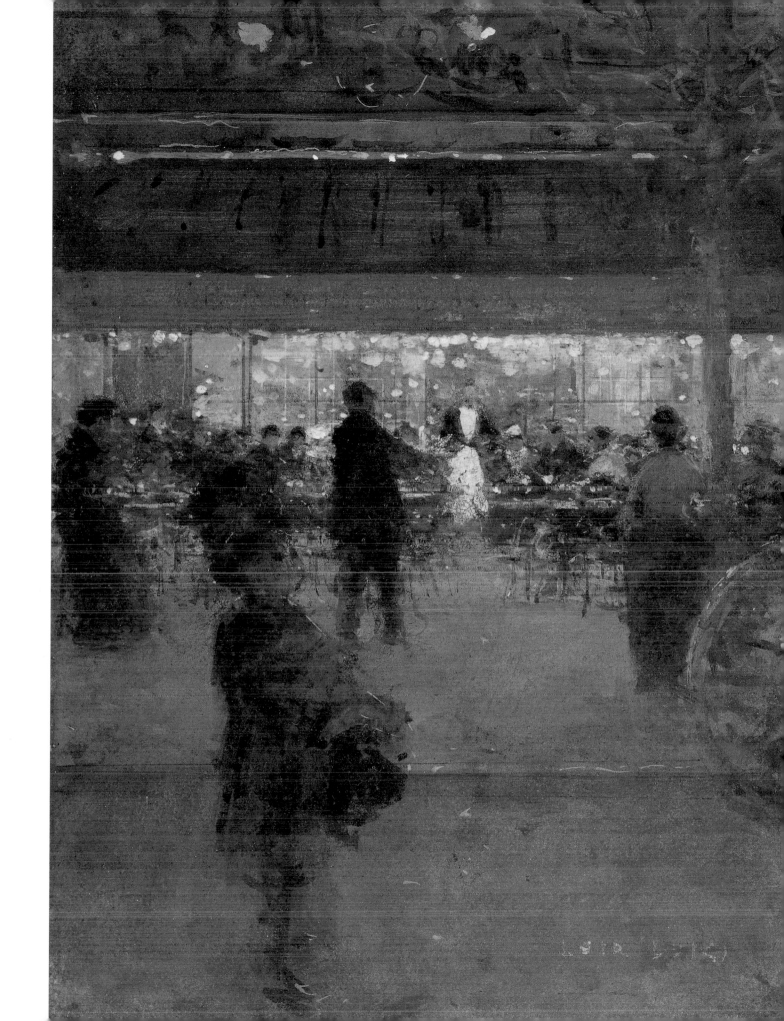

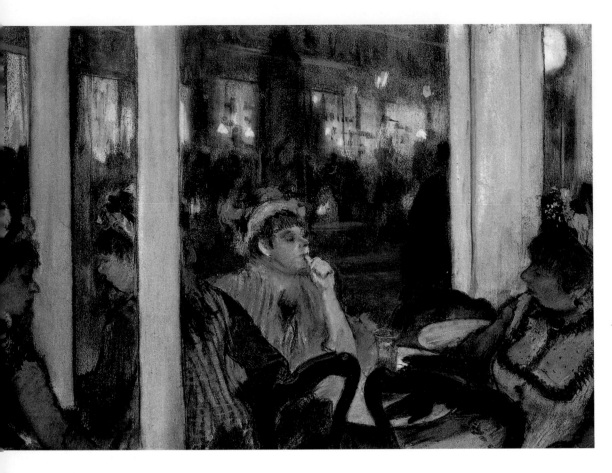

EDGAR DEGAS
Woman, on a Café Terrace,
1877
The odd, absent-minded
or preoccupied postures of
the central figures, along
with their faintly over-the-
top hats, give this work
an ambiguous feeling,
enhanced by the sense of
encroaching dusk outside.
While the central woman
looks as if she may have
spent the day shopping –
perhaps in the brightly lit
department store across
the road – her companion
across the table is dressed
for the evening to come.

not so good as at a restaurant on the boulevard, and is considerably dearer, but…the whole distraction is more idyllic.'

This delightful world was essentially masculine. For female Impressionist painters like Berthe Morisot, Marie Bracquemond or Mary Cassatt to have stepped through the door of the Café Guerbois, or to have idled away an hour at a little table on a café terrace, would have been socially unthinkable, which meant, of course, that they were denied the opportunity to participate in the artistic debates which went on in these cafés. Freedom of movement was particularly circumscribed for the unchaperoned woman. Jules Michelet, writing in 1859, commented sympathetically: 'How many irritations for the single woman! She can hardly ever go out in the evening; she would be taken for a prostitute. There are thousands of places where only men are to be seen, and if she needs to go there on business, the men are amazed and laugh like fools. For example, if she should find herself delayed at the other end of Paris and hungry, she will not dare to enter a restaurant. She would constitute an event. She would be a spectacle. All eyes would be constantly fixed on her and she would overhear uncomplimentary and bold conjectures.'

No such strictures inhibited the men, however, who in 1872 switched their allegiance to the Café de la Nouvelle-Athènes at the Place Pigalle. The roguish Irish writer, George Moore, was an habitué and captured the flavour of the place in his *Confessions of a Young Man*. For him the French café was his university: 'I did not go to either Oxford or Cambridge,' he wrote in 1886, 'but I went to the Nouvelle-Athènes. What is the Nouvelle-Athènes? He who would know anything of my life must know something of the academy of the fine arts. Not the official stupidity you read of in the daily papers, but the real French academy, the café. … Ah! The morning idlenesses and the long evenings when life was but a summer illusion, the grey

This turn of the century photograph shows the Café de la Nouvelle-Athènes – the New Athens – on the Place Pigalle, which replaced the Café Guerbois as the Impressionists' favourite meeting place in 1872.

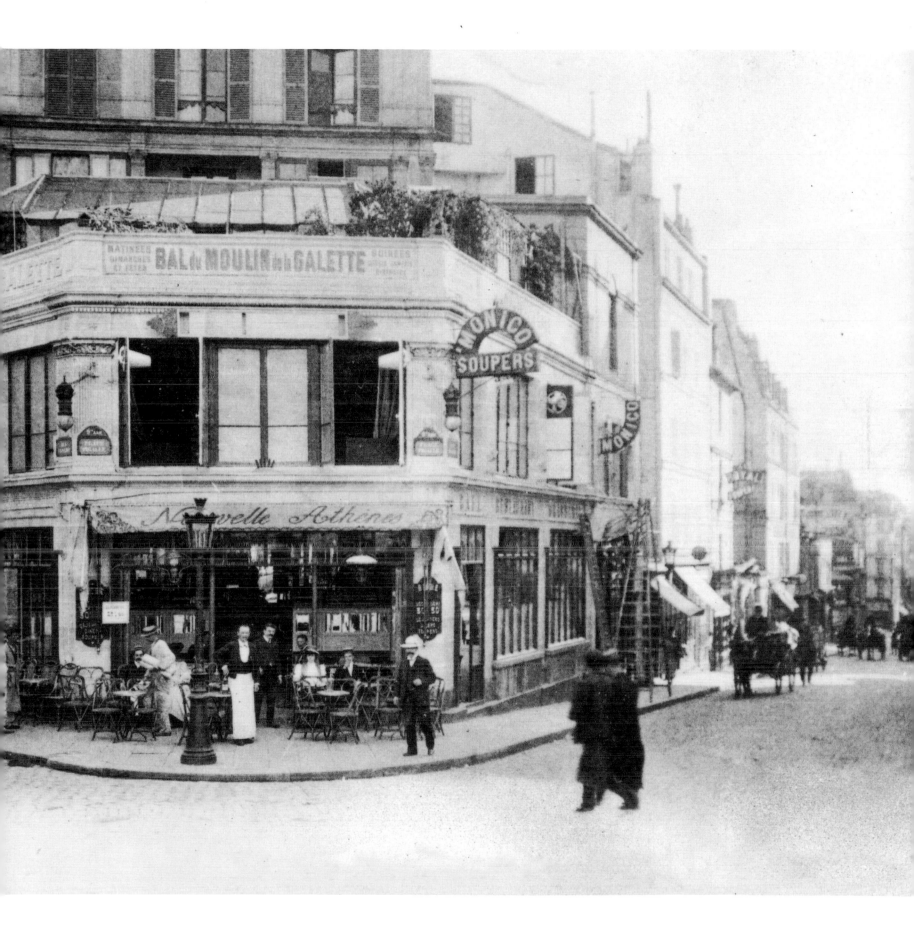

Absinthe

When Manet's former teacher Thomas Couture saw his first major painting *The Absinthe Drinker* at the Salon of 1859 he declared that the only absinthe drinker made visible by the work was Manet himself. In fact, there's no evidence that Manet had any personal acquaintance with *la fée verte* (the green fairy), but his friend Baudelaire – whose *Fleurs du Mal* supplied Manet with the title for his painting – certainly advised others to 'Be drunk always' and was not ashamed to admit that absinthe drinking was one of his vices.

Degas also produced a painting entitled *The Absinthe Drinker* in which a dazed and despondent couple sit alone in the Nouvelle-Athènes languishing over a glass of absinthe. Two friends modelled for Degas: the popular actress Ellen Andrée, who also posed for the female figure in Manet's *Chez le Père Lathuille* (p. 28), and the engraver Marcellin Desboutin. It is an image of social decline. The woman, who is often interpreted as a prostitute between clients, sits slumped before her absinthe and appears lost in a defeated dreamy fog induced by the drink. The dishevelled and disreputable figure of Desboutin drinks beer, smokes his pipe and stares off into space. The only thing the couple appear to share is their complete isolation. When the painting was exhibited at the Grafton Gallery in London in 1893, Walter Crane called it 'an illustrated tract in the temperance propaganda, a study of human degradation, male and female' and Sir William Blake Richmond called the painting a reflection on 'the deplorable side of modern life.'

Before the bitter, potent drink – made by mixing wormwood leaves with plants such as angelica root, fennel, coriander, hyssop and adding anise – became associated with artistic inspiration and *fin de siècle* decadence and excess, it was used by French soldiers to alleviate the symptoms of fever and dysentery. Known variously as 'the plague', 'the enemy' and 'the queen of poisons,' its affects were compared to that of opium or cocaine and the boast was that absinthe would cause 'euphoria without drunkenness'. The problem, however, was that, at eighty per cent proof, over-indulgence could also lead to blindness, insanity and premature death. Maupassant, Musset, Poe, Verlaine, Baudelaire and Apollinaire all drank it in dangerous quantities. So did Henri de Toulouse-Lautrec who became an alcoholic or, more accurately, an *absintheur*, since absinthe was his favourite drink. He liked to serve it mixed with cognac, a combination he called a '*tremblement de terre*' (earthquake). The Toulouse-Lautrec museum in his home town of Albi displays the hollow cane he carried with its emergency supply of absinthe secreted away in a slender glass tube.

Van Gogh's later dependence on absinthe complicated and contributed to an already tormented and tragic life. Secluded and solitary, often distraught and depressed, he is believed to have become a heavy drinker during his years in Paris, and the problem just grew worse when, on the advice of Toulouse-Lautrec, he left the capital for Arles in southern France in February 1888. Unbearably lonely at first he admitted to his

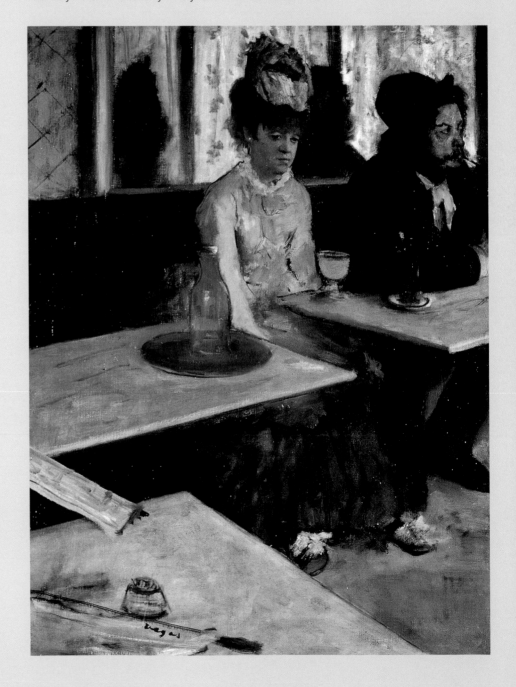

EDGAR DEGAS
The Absinthe Drinker,
1875–6

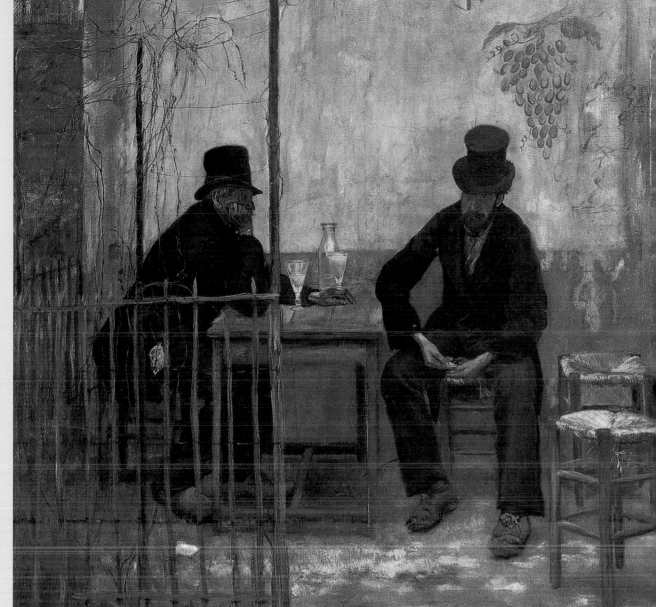

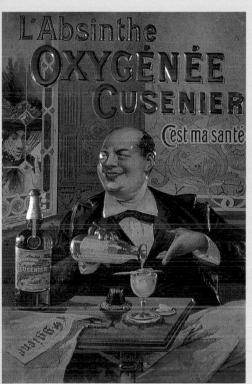

TAMAGNO
Poster advertising
'Oxygénée Cusenier
Absinthe', 19th century

JEAN-FRANÇOIS
RAFFAËLLI
The Absinthe Drinkers,
1881

brother Theo that the only way he could 'bring ease and distraction' was 'with a lot of drinking or heavy smoking.' 'If the storm within gets too loud,' he confided, 'I take a glass too much to stun myself.' For van Gogh cafés like the Café de la Gare, where he took Gauguin and which became the subject of *The Night Café*, were places 'where one can ruin oneself, go mad or commit a crime.'

Absinthe was certainly the quickest route to ruin: the *American Journal of Pharmacy* noted it 'affects the brain unlike any other stimulant; it produces neither the heavy drunkenness of beer, the furious inebriation of brandy, nor the exhilarant intoxication of wine. It is an ignoble poison, destroying life not until it has more or less brutalized its votaries, and made drivelling idiots of them.'

Despite the dangers, the drink was promoted heavily through advertisements often featuring beautiful women with blissful expressions, pouring, serving or toasting glasses of absinthe. Zola's *L'Assommoir* (The Dram Shop), published in 1877, was an attempt to raise awareness of the perils of the drink and to focus public concern through the tragedy, squalor and hopelessness of the main characters' absinthe-blighted lives. But it was another thirty years before the sale of absinthe was banned in Switzerland (1908), America (1912), Italy (1913) and finally in France (in 1915), though French producers were still free to export the drink to England which did not impose a ban until the 1930s. However, today, it is once again available in France.

moonlights on the Place where we used to stand on the pavement, the shutters clanging behind us, loath to separate, thinking of what we had left unsaid, and how much better we might have enforced our arguments…I can recall the smell of every hour. In the morning that of eggs frizzling in butter, the pungent cigarette, coffee and bad cognac; at five o'clock the fragrant odour of absinthe; and soon after the steaming soup ascends from the kitchen; and as the evening advances, the mingled smells of cigarettes, coffee and weak beer. A partition, rising a few feet or more over the hats, separates the glass front from the main body of the café. The usual marble tables are there and it is there we sat and aestheticised till two o-clock in the morning.'

A regular haunt of Renoir, Monet, Pissarro, Cézanne, Forain and the Belgian artist Alfred Stevens, it was important to Moore most of all for the presence of Manet and Degas, for their acid conversation, their ideas and their achievements as artists. 'At that moment the glass door of the café grated upon the sanded floor and Manet entered,' he recalled, going on, somewhat breathlessly, to attribute to his hero an English mien and bearing: 'Although by birth and art essentially a Parisian, there was something in his appearance and manner of speaking that often suggested an Englishman. Perhaps it was his dress – his clean-cut clothes and figure. That figure! Those square shoulders that swaggered as he went across the room, and the thin waist; and that face, the beard and nose, satyr-like shall I say? No, for I would evoke an idea of beauty of line united to that of intellectual expression – frank words, frank passions in his convictions, loyal and simple phrases, clear as well-water, sometimes a little hard, sometimes as they flowed away, bitter, but at the fountain-head sweet and full of light. He sits next to Degas, that round-shouldered man in a suit of

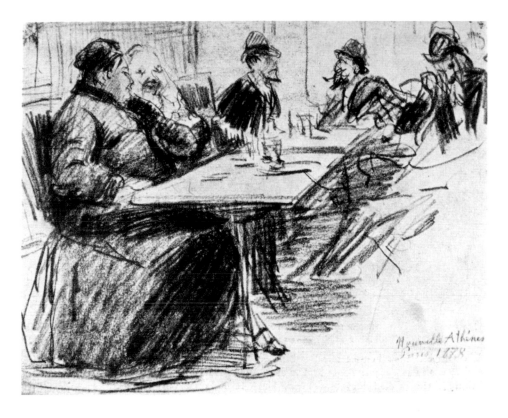

EDGAR DEGAS
The Nouvelle-Athènes, 1878
This animated sketch captures just some of the habitués of Degas's favourite café.

FRÉDÉRIC RÉGAMEY
Gervaise and Coupeau, 1878
An illustration from Emile Zola's great novel of working-class Paris, *L'Assommoir* (The Dram Shop), one of the best-known works in his novel-cycle, the 'Rougon-Macquart', each of which introduces the reader to a particular facet of life in Second Empire France. The novel appeared in installments in *La République des lettres* and was adapted for the stage by W. Busnach. Manet, who thought the novel 'brilliant!', wrote in 1879 to congratulate his friend after the triumphant first night at the Ambigu Theatre. The play ran continuously for a year and was frequently revived in Paris and the provinces.

pepper-and-salt. There is nothing very trenchantly French about him either, except the large necktie; his eyes are small and his words are sharp, ironical, cynical. These two men are the leaders of the Impressionist School. Their friendship has been jarred by inevitable rivalry.'

The critic Georges Rivière recalled Renoir in his corner, nervously twiddling a cigarette between his fingers, or 'doodling on the table with a burnt match' and Degas's habit of keeping his hands crossed behind his back when talking with someone while standing up. He dressed 'without studied elegance but also without eccentricity or negligence,' Rivière reported. 'Like all the bourgeois of his time, he wore a top hat, although his was flat-brimmed and pushed back a little on his head. On most days he protected his ailing eyes against bright light with tinted glasses or a pince-nez perched on his nose, which was a bit short. His face was almost colourless and framed by dark brown side-whiskers that were closely trimmed, as was his hair.'

Cézanne's boyhood friend Emile Zola was another regular at the Nouvelle-Athènes. He and Degas often disagreed profoundly. 'We argued about things endlessly,' Degas recalled. 'Zola's conception of art, which is to stuff everything about a subject into one volume and then go on to another subject, seems to me childish…We painters do not have synthesizing minds. And yet in a way we do, more than we seem to. In a single stroke of the brush we can say more than a literary man can in a volume. And that's why I shun phrase-making art critics.'

It was Zola's urgings that had brought Cézanne to Paris. In an early letter, dated March 1860, Zola had devised a metropolitan schedule, culminating in the promise of Sunday jaunts in the country. 'We'll take off and go somewhere outside of Paris; there are charming places, and if you care to, you can jot down on a bit of canvas the trees under which we will have had lunch.' Cézanne came, but he never liked Paris. Even Zola's friendship was not enough to compensate for the noise, the cold and the general unfriendliness he found. He rarely went to the Nouvelle-Athènes and when he did he tended to be rude, irritable and badly dressed. In 1878 Edmond Duranty wrote to tell Zola: 'Cézanne turned up a short while ago at the little café in Place Pigalle, in one of those get ups of his: blue shirt, white linen jacket covered with marks made by his brushes and other instruments, old crumpled hat. He was a hit! But such exhibitions are dangerous.' Cézanne did not seem to care – indeed he delighted in offending the bourgeois tastes of Manet and Degas by exaggerating his own vulgarity. He seemed, whether out of pride or defiance, to want to behave like a complete peasant. Monet tells how, on one occasion, Cézanne entered the café, unbuttoned his jacket, hitched up his ragged trousers with a coarse shake of the hips and then, stopping in front of Manet, greeted him in an exaggerated southern accent and told the immaculately dressed painter that he would not shake his hand because he had not washed for eight days.

Pissarro, who was always welcomed and admired by the other painters for his indomitable spirit, goodness and cheerfulness in the face of extraordinary hardships and difficulties, did his best to put Cézanne at ease whenever they met at the Nouvelle-Athènes. His modest, gentle and conciliatory manner did much to ease the tensions between members of the group and made him much sought out by the younger generation of Impressionists, particularly Paul Gauguin, Georges Seurat and Paul Signac.

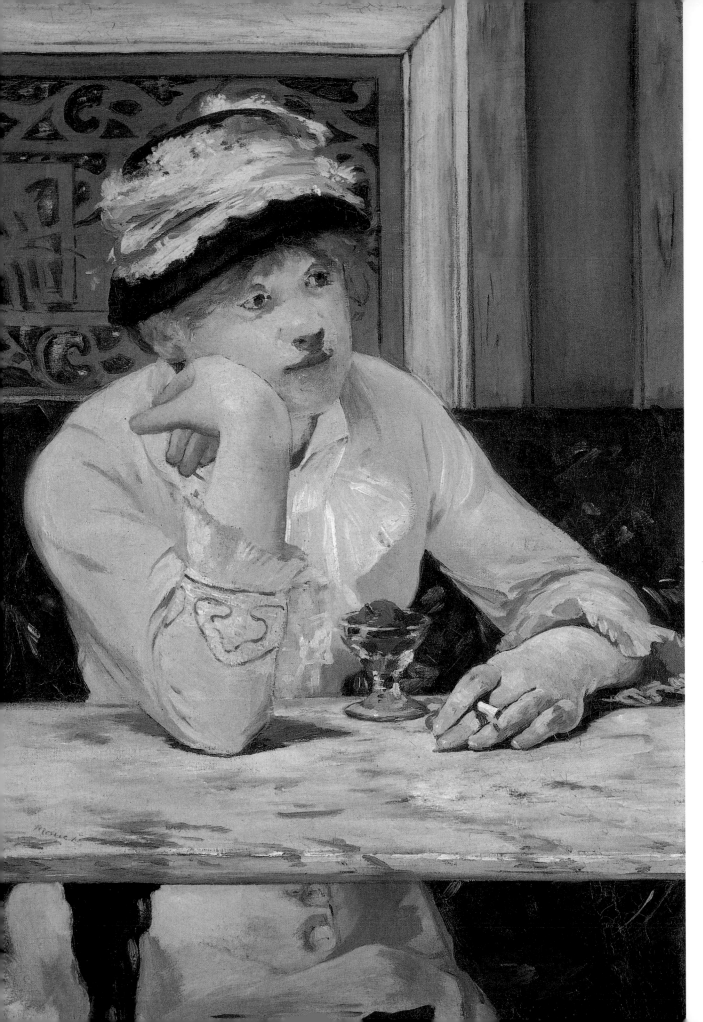

EDOUARD MANET
La Prune (The Plum Brandy), 1878

JEAN-FRANÇOIS RAFFAËLLI
Young Woman in a Café,
date unknown

The contrast between Manet's young working-class *grisette*, lost in reverie before her brandy-soaked plum with an unlit cigarette in her left hand, and the tense pose of Raffaëlli's upright young woman, clutching her umbrella and poised for flight, is marked. Respectable women ran the risk of being mistaken for prostitutes if they sat alone in cafés and Raffaëlli captures the young woman's unease.

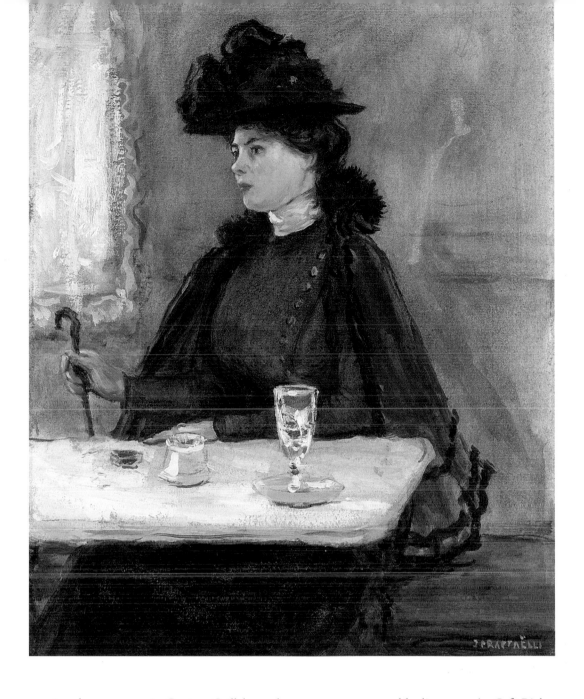

Another new recruit, Gustave Caillebotte, began to arrange monthly dinners at the Café Riche, where on the first Thursday of each month the Impressionists would gather to dine elaborately on *moules marinière* and the house speciality – fish with diplomat sauce – woodcock *à la Riche*, lamb chops on a bed of asparagus or partridge. Gustave Geffroy, critic and novelist, recalled how 'the Impressionists' table was a very lively and noisy one' and described 'these men, relaxing from the burden of work' as 'rather like children just let out of school.' Within the steamy walls of the Guerbois and the Nouvelle-Athènes they could forget the negative opinions of the outside world, confident that they were on the right path, that their shared undertaking was bold and bound – eventually – to succeed. Monet later remembered those evening discussions as an important source of reassurance and confidence at a time when most outside reactions were still hostile: 'From them we emerged with a firmer will, with our thoughts clearer and more distinct,' he wrote.

Aside from serving as places of meeting and conviviality, cafés also provided these painters of modern life with a definingly modern subject matter. At night the city came alive, sparkling with

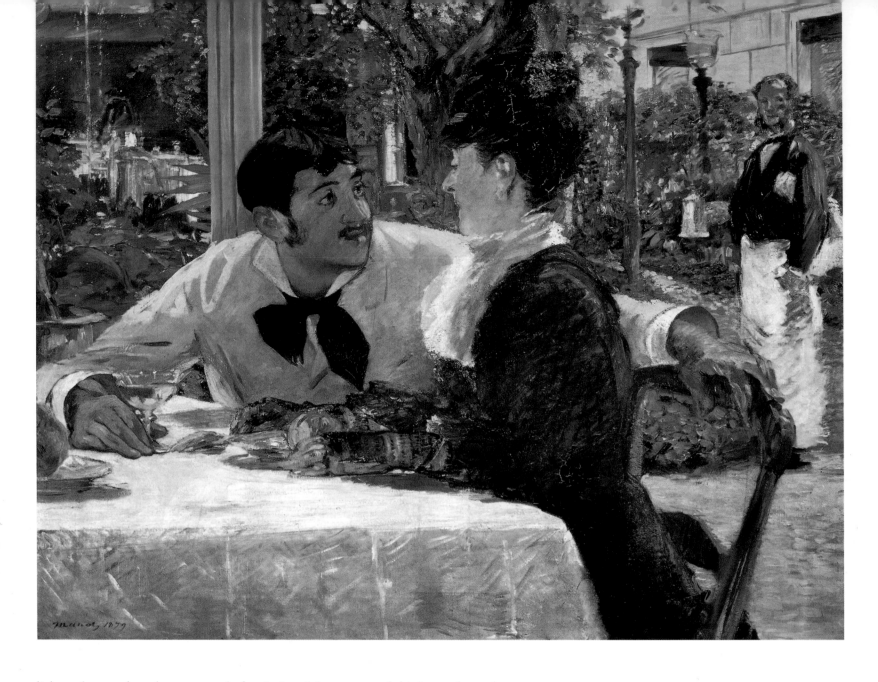

light and spectacle and a new mood of optimism. Manet captured this intensely modern moment in his series of paintings of taverns and brasseries, cafés, cabarets and café-concerts, in which he records the extremes of café life, from the quiet introspection of solitary moments – the piercingly sad woman lost in reverie before her glass of plum brandy in *La Prune (The Plum Brandy)* – to the bustle and clamour of the pleasure-seeking crowd in *The Waitress* (see p. 16), in which a solid, stern-faced waitress, severely buttoned up in black, carries tankards of frothy amber-coloured beer to rapt customers. They, in turn, look beyond her, entirely engrossed in the antics of the skimpily clad dancers with whom she makes such a stark contrast. Manet used a real waitress from the Brasserie de Reichschoffen as a model for his central figure. A little shy of the stylish, witty and flippant man, she only agreed to come to the studio to pose for him if her *protecteur* could accompany her, so Manet put him in the painting too, smoking a pipe, in the foreground.

The lively, gossipy cafés of Montmartre, both up on the hill, (the 'Butte', where many Impressionists lived cheaply), and in the more easily accessible and enveloped quarter just below, proved a magnet for Parisians. They were drawn in particular by the cheap wine (*bistros* outside

EDOUARD MANET
Chez le Père Lathuille, 1879
The son of the proprietor of the restaurant posed for the importuning male figure in Manet's modern drama, while the lone lady at the end of her late lunch was modelled first by the actress Ellen Andrée and, then, when she failed to turn up for a sitting, by Judith French, a relative of the composer Offenbach.

the official city custom walls were free of excise tax) and the exotic entertainment on offer in the *caf'concs* and popular dancing establishments like the Moulin de la Galette, Le Chat Noir and the Moulin Rouge. Despite these popular nightspots, Montmartre still retained a village atmosphere, with its leafy lanes, steep gardens descending vertiginously northwards away from the city, and carefully cultivated allotments. The beautiful white dome of the Sacré-Coeur was slowly rising, and another Paris landmark, the Eiffel Tower, was also under construction. Montmartre was full of lively *bistros* and restaurants such as Le Père Lathuille. This had started life as a farm with a herd of sixty cows providing fresh milk for Parisians and offering simple meals to travellers, but by 1879, when Manet used it as a setting for *Chez le Père Lathuille*, had become an established restaurant with a renowned chef, Prosper Montagne.

At first glance one might think that Manet's picture shows a couple of young lovers lunching contentedly together, but on closer inspection it is plain that a rather more modern drama is in progress. For a start, the young woman has been taking a late lunch alone (all the other tables are empty) and the young man, with his arm so possessively draped along the back of her chair, is not sitting at the table but kneeling beside it and making advances to her. The woman – prim, slightly uncertain – might be a tourist. The waiter has seen it all before.

VINCENT VAN GOGH
Café Terrace on the Place du Forum, 1888
This work shows a café in Arles, in the south of France. According to van Gogh he painted it on the spot, at night: '...I like to paint the thing immediately. It is true that in the darkness I can take a blue for a green, a blue lilac for a pink lilac, since it is hard to distinguish the quality of the tone. But it is the only way to get away from our conventional night with poor pale whitish light, while even a simple candle already provides us with the richest of yellows and oranges.'

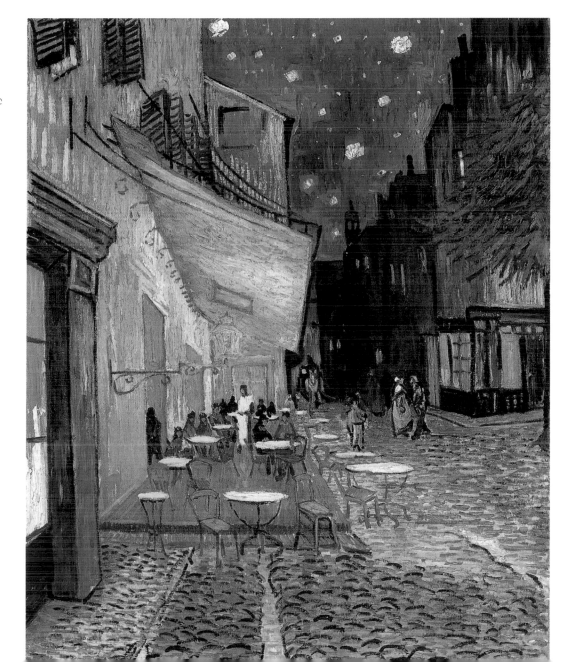

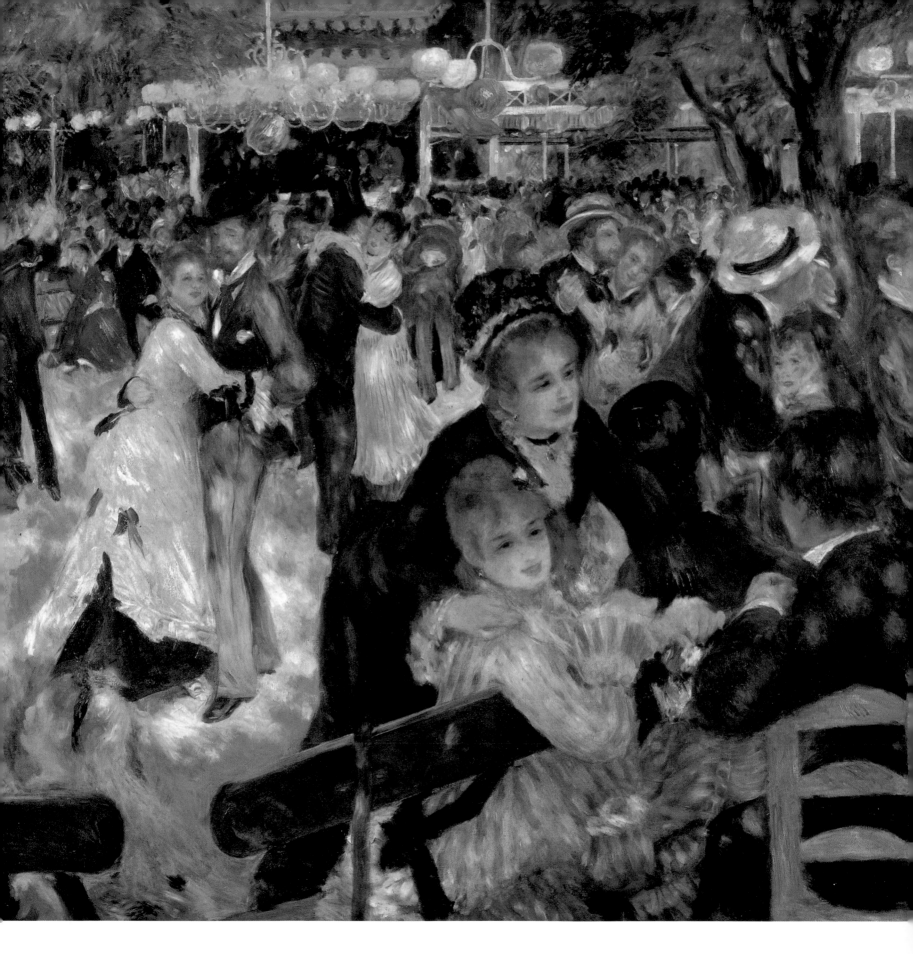

This photograph of the Moulin de la Galette taken in 1898 gives some idea of the energy and enthusiasm with which the largely working-class clientele took to the dance floor.

PIERRE-AUGUSTE RENOIR
The Ball at the Moulin de la Gallette (detail), 1876
Renoir's friend Georges Rivière identified many of the models Renoir used. They include Estelle and Jeanne on the bench, and Gervex, Cordey, Lestringuez, Lhote, and the Cuban painter Pedro Vidal de Solares y Cardenas who appear as dancers, as well as Pierre Franc-Lamy and Norbert Goeneutte. The painting was bought by Gustave Caillebotte, who included it in the background of his own *Self-Portrait at the Easel*.

Flirting, of a soft, good-natured kind is Renoir's theme, too, in *The Ball at the Moulin de la Galette.* His sunlit pink, blue and gold dancers are a far cry from the decadent-looking spectators Toulouse-Lautrec would depict in his energetic and seductive painting of the same dance-hall thirteen years later. Renoir, always lively and full of an irresistible gaiety, loved the open-air Moulin de la Galette – so called because of the thin flat cakes (*galettes*) traditionally served with drinks – with its rackety, rheumatic old windmill where every Saturday night and Sunday the shop girls, seamstresses, apprentices and clerks from the north of Paris would come to dance.

The painting was so large that Renoir rented a small house with a studio at 12 rue Cortot opposite the dance-hall and every day he and his friend Rivière carried his canvas across, a journey 'not without difficulties, when the wind blew and the big canvas threatened to shoot up like a kite over the Butte.' It was the beginning of 'many happy days'. His brother Edmond described how Renoir 'makes friends with all that little world that has its own style, which models copying their poses would not render, and in the midst of the whirl of that popular merry-go-round, he expresses wild movements with a dazzling verve.'

What Renoir presents us with in *The Ball at the Moulin de la Galette* is a vibrant and animated image of youthful hedonism. Young girls in pretty dresses take to the dance floor with their dapper partners but a closer inspection shows us that at least one young woman seems to be pulling away from an over-attentive partner and a woman in blue on the bench at the edge of the dance floor on the left of the painting has turned her back firmly on the importuning top-hatted fellow. The main group in the foreground, however, seem to reverse these roles. Here the young women, seated on the bench and therefore not part of the male party, flirt with the young men, while just beyond a blonde woman refuses to acknowledge the straw-hatted youth who seeks to engage her interest.

It is a painting about movement and transaction, about class and the nature of urban entertainment. Its overall sunniness contrasts, however, with Manet's starker view of café-concerts as places where the classes do not mingle. Where Renoir runs his figures together, Manet isolates, indeed dislocates them and they look off into the distance, their gazes, cut off by the picture frame, or distorted by mirrors, destined never to meet. Renoir, on the other hand, concentrates on the simple amusements and honest charm of a place which typified for him the 'good-natured side of the common people of Paris' and it was their careless rapture he sought to capture on canvas.

HENRI DE TOULOUSE-LAUTREC
Café-concert in Montmartre, 1888

ADOLPH MENZEL
Breakfast at the Café, 1894

Two very different depictions of cafés, in France and Germany. Toulouse-Lautrec captures the studied elegance and decadence of Montmartre, while Menzel's small gouache shows a workers' café soon after dawn, slowly getting ready for another busy day.

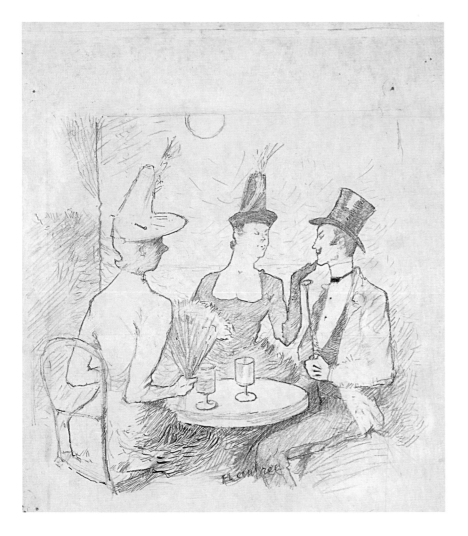

JEAN-LOUIS FORAIN
Bar at the Folies-Bergère, 1878
Pre-dating Manet's more famous painting
(see p. 40) by three years, this work by Forain
also chose to focus on the barmaid, relegating
the music-hall spectacle to the reflected image
in the mirror.

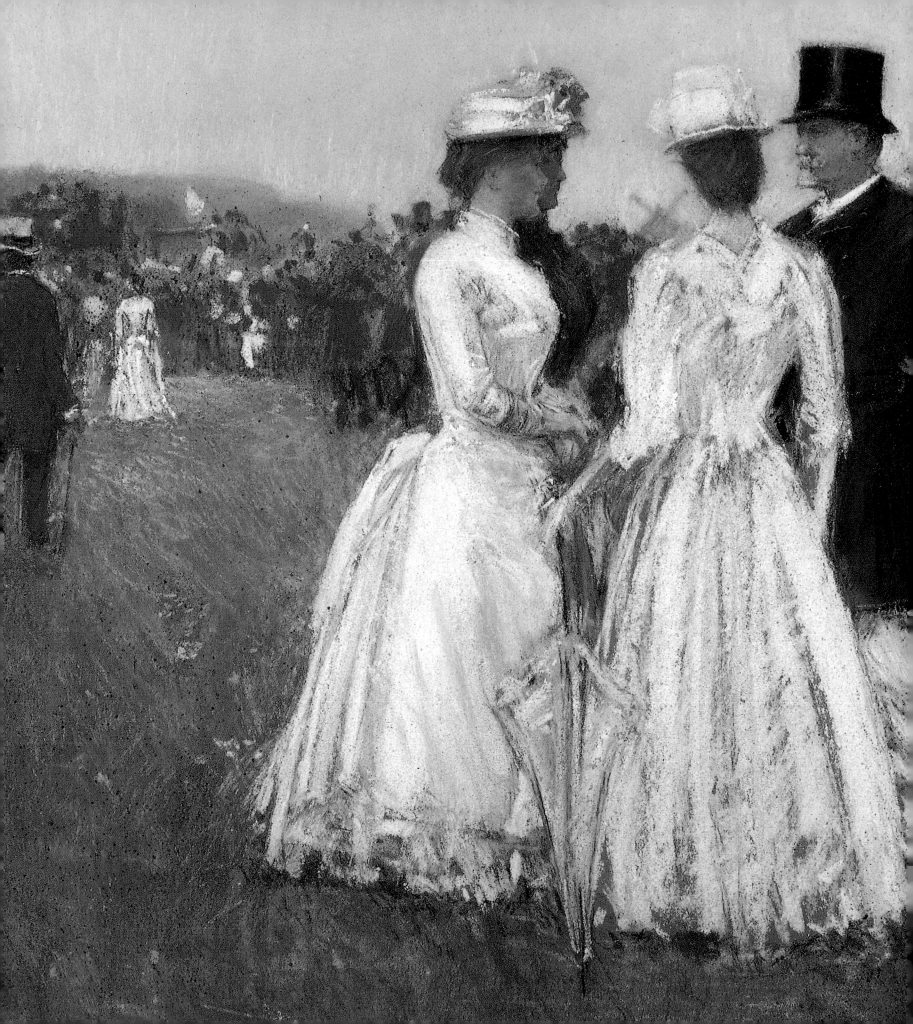

A Time to Enjoy
RACING, THEATRE, OPERA, MUSIC HALLS AND BALLET

'Yesterday I spent the afternoon in the studio of a painter named Degas. After a great many essays and experiments and trial shots in all directions, he has fallen in love with modern life, and out of all the subjects in modern life he has chosen washerwomen and ballet-dancers. When you come to think of it, it is not a bad choice.'

Edmond de Goncourt,

recording a visit to Degas in his studio in his journal of 13 February 1874

While the fortunes of the Impressionists certainly fluctuated, when things went well they were quick to take advantage of the spectacle on offer, both as participants and as documenters of modern life. Racing, in particular, offered both entertainment and artistic challenges. A swift pencil sketch by Degas of Manet at the races places the two men together at the same meet in the early 1870s. Degas captures his urbane friend in profile, viewed from behind, wearing a shiny top hat, with one hand in his pocket, the other holding a cane aloft.

Second Empire Parisians went to the races as they went to the theatre: the spectators were the show. The extravagant clothes they wore, the lavish carriages they arrived in, who accompanied whom, was all plot and scenery to the eager crowd who watched from the sidelines of the Champs-Élysées, or from the stands at the races. Drama was provided by the race itself and since the introduction in 1867 of an organized system of *pari-mutuel* betting race-goers were able to ratchet up the tension by placing a wager. This became an essential part of any day at the races, often the point and frisson of the occasion, especially for women (though a respectable one would never lay a bet herself, instead she would ask a male member of her entourage to place the money for her). *Le Figaro* (12 June 1881) observed how 'women will form a modest syndicate, worth perhaps three or four *louis*, which the youngest of the men present will go and place for them. These childish stakes are enough to concentrate the minds of the prestigious assembly which here holds court, and provoke the most intense emotions.'

Such modern activities and excitements naturally drew the Impressionists. Manet and Degas frequented the tracks at Longchamp, Auteuil, Vincennes, Chantilly and Versailles and used them

CHILDE HASSAM
At the Grand Prix in Paris (detail), 1887

EDOUARD MANET
Race Course at Longchamp, 1864

While Hassam concentrates on the fashionable race-goers, Manet captures the thrill of the event, as the jockeys gallop towards the viewer down the stretch at the Longchamp racetrack in the Bois de Boulogne. The hills of Saint-Cloud are faintly visible in the background.

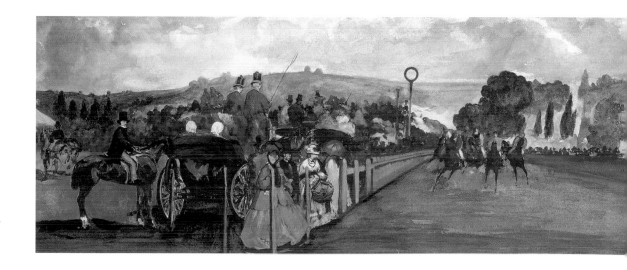

as sites for paintings, though Manet tended to depict the high excitement and speed of a race in progress, while Degas, with his novelistic eye for detail, found subtle drama in the fallen jockey, the false start or the suspense of mounted jockeys milling in front of the grandstands. Degas's remarkable modernity is very much in evidence in these paintings which give an insight into a society undergoing profound and rapid transformation.

Degas's *At the Races in the Country* depicts his friends the Valpinçons arriving at the racecourse at Argentan in Normandy. Paul Valpinçon was a boyhood friend and a great art lover. The family owned paintings by great masters, including Ingres's *La Grande Odalisque*, and Degas often stayed at their peaceful country estate at Menil-Hubert, which boasted a stud where Degas could roam for hours making sketches and detailed drawings of horses. The painting captures a moment of repose as the infant Henri tumbles into sleep in the arms of his wet nurse, whose breast is still uncovered. Beside her, beneath the parasol, Madame Valpinçon looks on, as does her husband from his elevated position in the driving seat of the tilbury. The race is relegated to the far middle distance.

Degas was Toulouse-Lautrec's senior by three decades but both men chose similar subjects to paint in jockeys, music hall singers and women at their toilette. And both enjoyed a day at the races. An aristocrat by birth, had not illness intervened Lautrec might have become a gentleman sportsman with a talent for drawing rather than the artist we now know. He learned to ride as a child but a number of riding accidents exacerbated the congenital bone disorder he suffered from, which arrested his growth. Lautrec's generous allowance meant that he did not

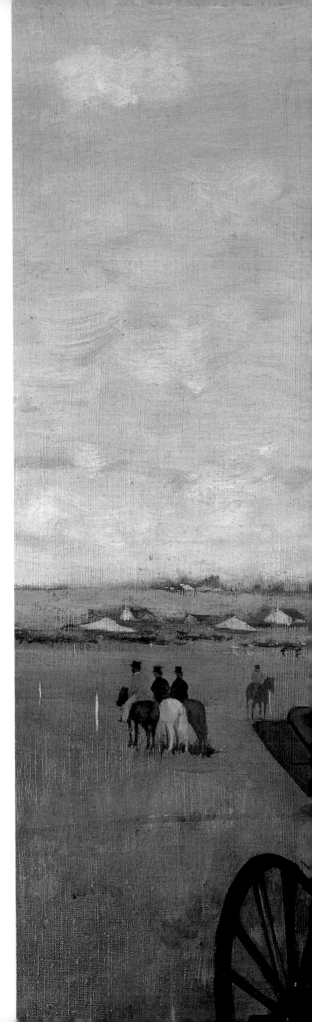

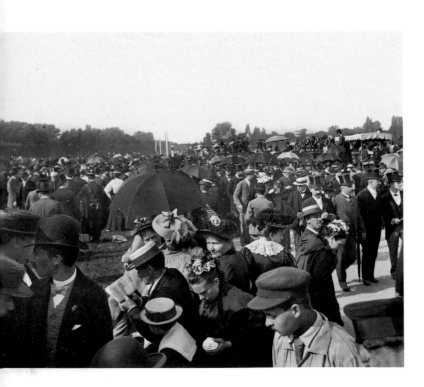

Grand Prix at the Longchamp racecourse, 1895

EDGAR DEGAS
At the Races in the Country (detail), 1869

As much as anything the races were about display – in the case of Degas's work showing his friends the Valpinçons, of the carriage that one arrived in. However, Degas clearly enjoys the formal possibilities of the broad green fields, and plays with the contrast between the sturdy carriage horses and the sleek animals bred for racing in the background. In the photo to the left we can clearly see that while the races attracted a cross-section of society, they were severely graded by dress, notably hats.

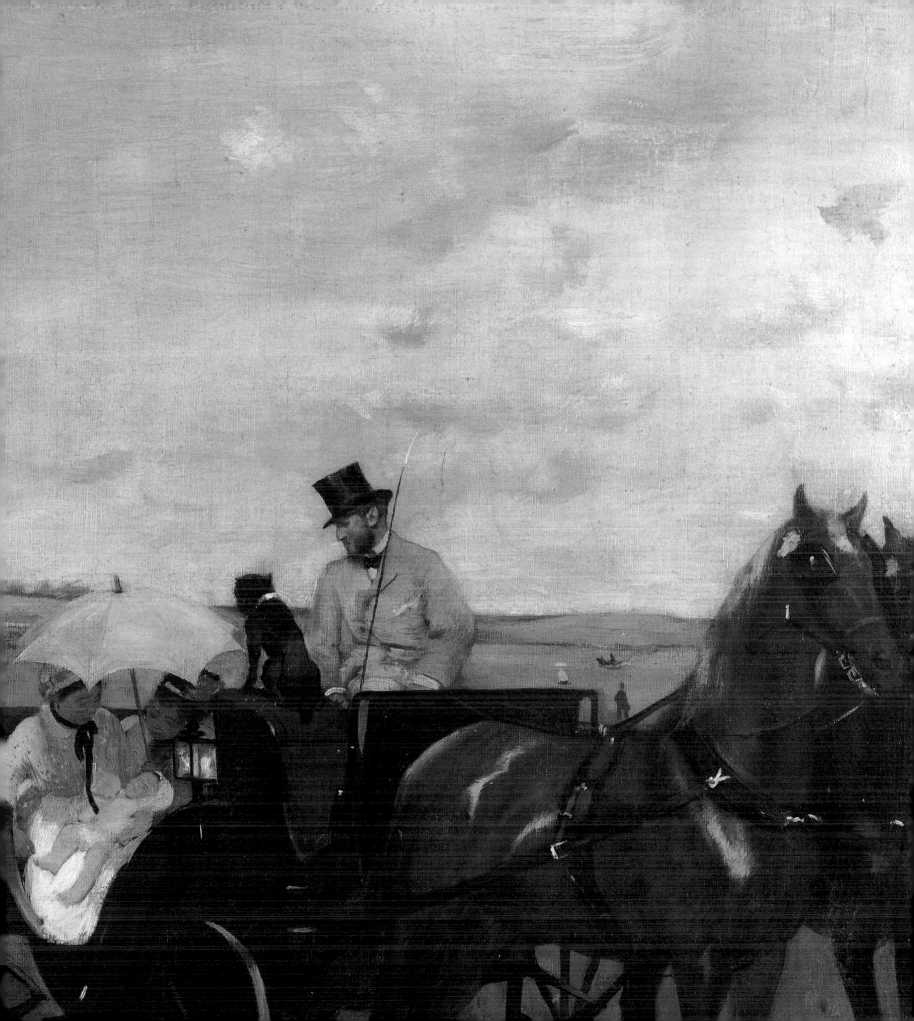

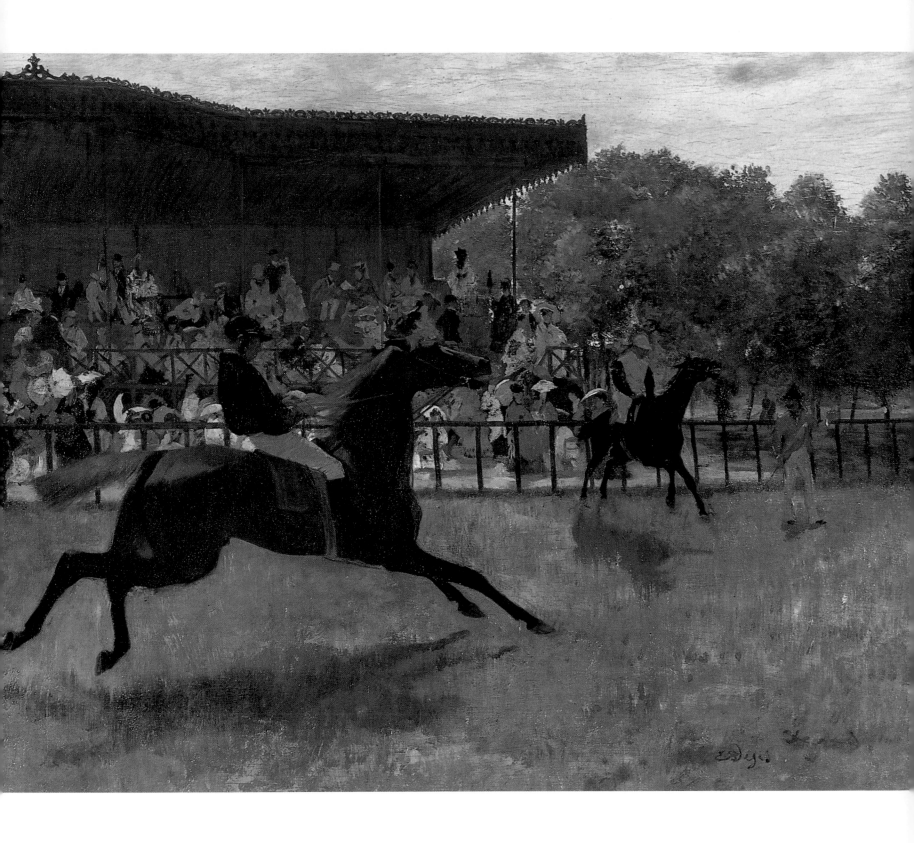

EDOUARD MANET
Les Courses, 1865–78

EDGAR DEGAS
False Start, 1869–72

Manet's strikingly modern lithograph, with its vigorously scribbled crowd and dynamically drawn oncoming horses, prefigures a cinema shot, while Degas – equally inventive – concentrates on the anticipatory tension at the start of a race which so often leads to false starts.

have to worry about supporting himself and also ensured a deep pool of acquaintances and seasoned race-goers happy to accompany him. He made a point of frequenting the more important race meetings – the grandest of which in the entire racing calendar was the Grand Prix de Paris. A great international horse race and high society event, it was run since 1863 on the first Sunday in June in the Hippodrome de Longchamp, built on the site of a twelfth-century convent in the Bois de Boulogne. The prize was usually carried off by the French or the English but in 1881 the Americans shocked the racing world by winning with a horse named Fox-Hall. Half-a-dozen years later the American Impressionist Childe Hassam produced a painting entitled *Grand Prix Day* (see p. 132) in which he concentrated not on the race, but on the urban elegance of the race-goers. He painted the spectators as they set off from the Arc de Triomphe in their stylish carriages through brilliant sunshine towards the Bois de Boulogne. The women wear light pastel dresses and shield themselves from the June sun with bright parasols. The gentlemen are in dove grey or brown.

The height of chic for Hassam's race-goers would be to round the day off at a dance-hall like the Bal Mabille. 'When you have spent a fine day failing to see the horses, admiring women and swearing at drivers, you may hope,' wrote *Le Figaro*'s correspondent, 'if you are on good terms with an Englishman, a trainer, a Lord or a jockey – to end the evening at the Bal Mabille where the dancers lift their legs high enough to knock the pince-nez off a giant.' The year after Fox-Hall's triumph brought one for Manet, who set what turned out to be his final great masterpiece in a music hall theatre: Leon Sari's Folies-Bergère. Once again he used a real barmaid – Suzon – as the central figure, positioning her on display behind the bar, as much a commodity as the bottles of champagne to her right and the inviting bowl of fruit to her left.

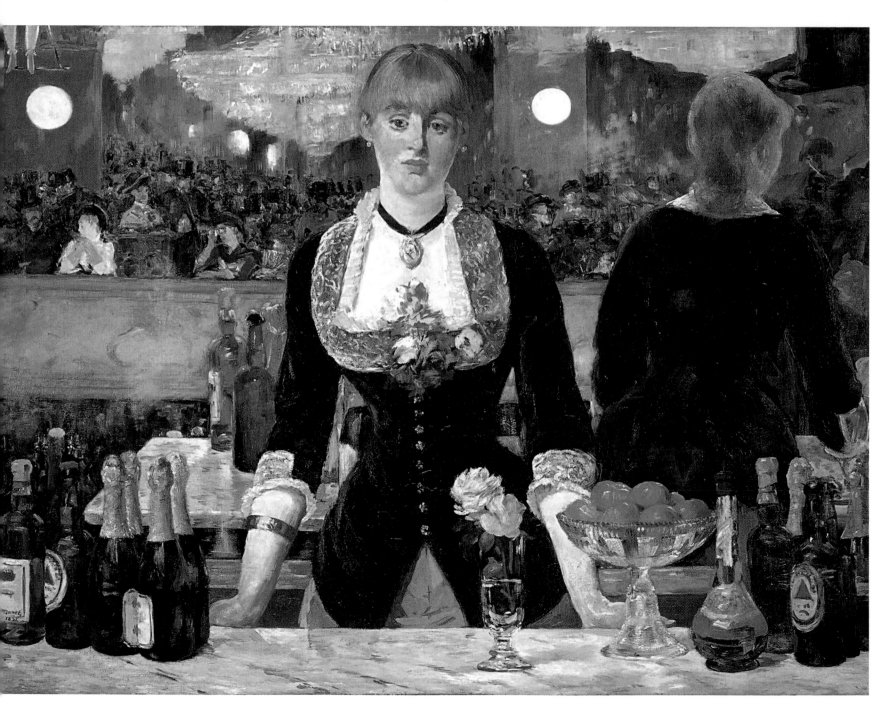

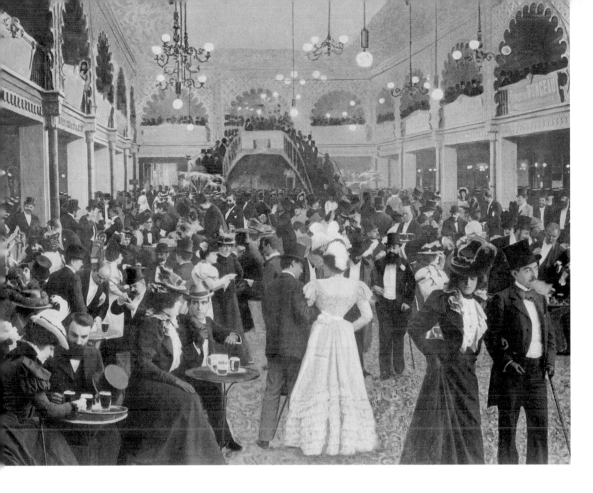

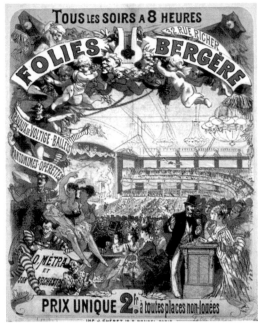

The Hall of the Folies-Bergère, 1898
The gas-lit hall at the Folies-Bergère thronged with women in extravagant hats sprouting feathers and flowers, accompanied by men in glossy black top hats, sporting canes and puffing on cigars

Poster for the Folies-Bergère, 1875
Built in 1867 as a venue for operettas, pantomimes, concerts and gymnastic dispays, the Folies-Bergère on the rue Richer was one of the most popular music-hall theatres of the period.

EDOUARD MANET
A Bar at the Folies-Bergère, c. 1882
Manet reconstructed Suzon's bar in his studio, lining up bottles, fruit and flowers on a borrowed marble-top table, and, already unwell, working in brief, intense bursts. He still welcomed visitors but they observed how 'soon, tiring, [he] would stretch out on a low couch, under the light from the window and contemplate what he had just painted'.

He unsettles the viewer by denying a clearly defined relationship between the barmaid and the top-hatted man (modelled by painter Gaston Latouche) seen in the mirror behind. Presumably she is about to serve him, but Manet refuses to offer a neat or coherent narrative. His picture prompts questions, creates uncertainties, thrives on ambivalence. There is a soft sadness about the self-contained central figure which is in sharp contrast to the icy chandeliers overhead and the festive crowd on the horseshoe-shaped far balcony. In fact the Folies-Bergère was already recognized as a haunt for prostitutes, a reputation it still held in 1889 when it was listed in a guidebook of Parisian brothels as a place '...famous for its *promenoirs* [the ground floor area beneath the balcony, cleared of theatre seats to make room for tables, chairs, several bars and space for walking about], its garden, its constantly changing attractions, and the proximity of pretty women.' It boasted a lounge, an orchestra, and the promise of a spectacle which could be seen from cheap two-franc seats or enjoyed luxuriously in the upholstered opulence of the five-franc banquettes reserved for the moneyed and fashionable. The contemporary writer Joris-Karl Huysmans in his *Parisian Sketches* provided a snapshot of a bustling, noisy place where punters had to run the gauntlet of programme-sellers and boot-blacks before 'the stage curtain finally comes into view, cut across the middle by the ceiling-like mass of the balcony.' He describes how 'A great hubbub rises from the gathering crowd...the smell of cigars and women becomes more noticeable; gas lamps, reflected from one end of the theatre to the other by mirrors, burn more dimly; it is only with difficulty that you can move about, and only with difficulty that you can make out, through the dense ranks of bodies, an acrobat on stage...'. There is a correspondence between Huysmans's vivid account of the scene, cropped and sliced by the line of the balcony, and Manet's vertiginous and unsettling glimpse of an acrobat's disembodied green-slippered feet in the top left corner of *A Bar at the Folies-Bergère*, but Huysmans is able to convey something extra: the sounds and the smell of cigar smoke and perfume; the clash of

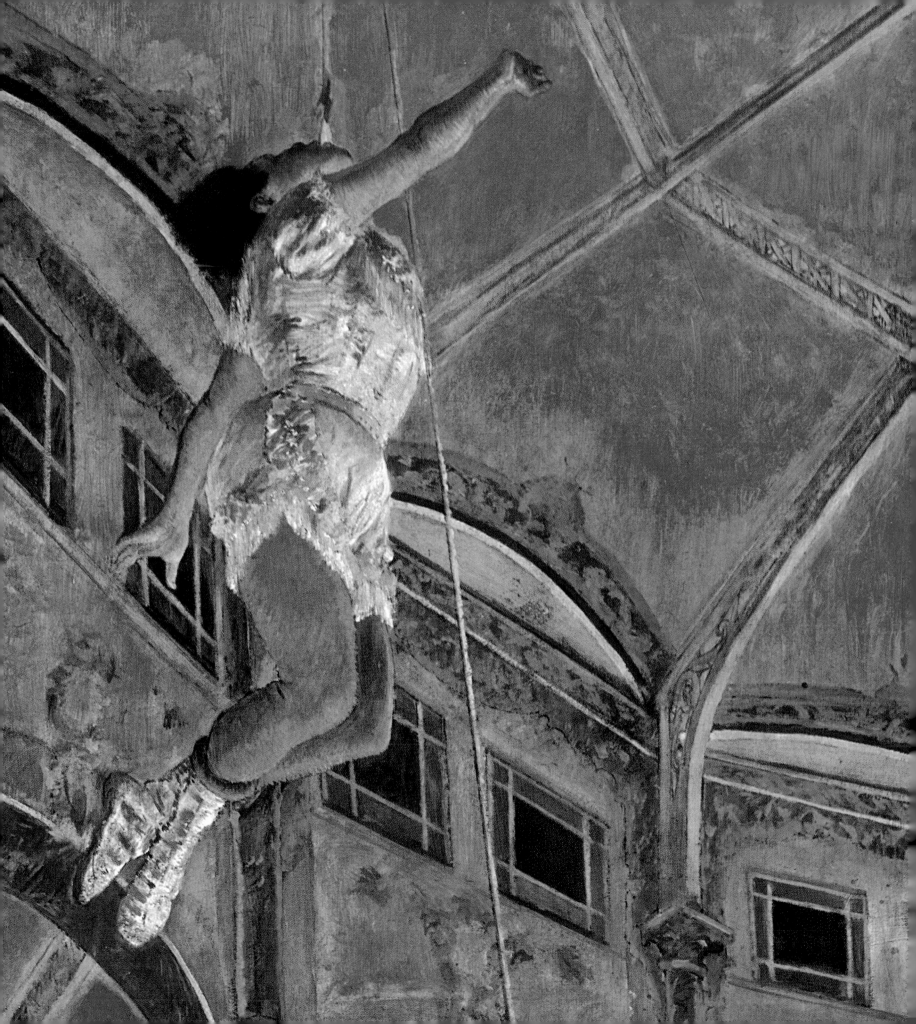

Nights at the Circus

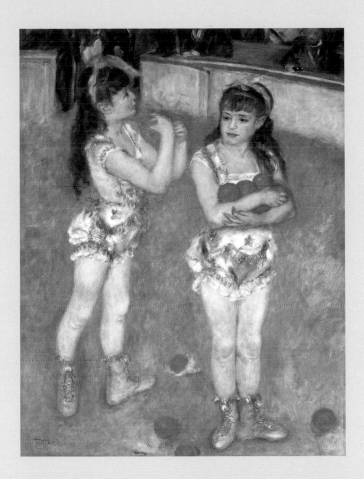

EDGAR DEGAS
Miss La-La at the Cirque Fernando (detail), 1879

PIERRE-AUGUSTE RENOIR
Acrobats at the Cirque Fernando, 1879

The Circus – an ambitious hymn to gaiety – was Seurat's last painting, shown unfinished at the seventh exhibition of the Artistes Indépendants in the spring of 1891, just a few days before his untimely death from diptheria, aged thirty-two. The setting is the Cirque Fernando, at 63 Boulevard de Rochechouart, one of the most popular places of entertainment in Paris, run by Fernando Wartenberg, whose two little acrobatic daughters, Francisca and Angelina, Renoir painted in 1879, forerunners of the many acrobats and clowns who tumble through turn of the century paintings by Toulouse-Lautrec, Bonnard, Picasso and van Dongen. Renoir adored the knockabout of the circus, from the sideshow barkers outside to the flickering glow of the gas-lights within, reflected off the performers' sparkling tutus. He called the acrobats, 'stocky girls, planted on sturdy legs' and admired the way they 'proudly arched their backs, made supple by double somersaults, and rested on their hip a little hand which was trained not to miss the trapeze bar – and to scrape carrots for their evening soup.'

The circus was also the setting for one of the most remarkable images Degas ever created, that of the acrobat Miss La-La dangling dramatically from the brilliantly lit rafters of the dome – quite literally hanging on by her teeth, high above an unseen audience, who gaze upward at her isolated, radically foreshortened, pink-clad figure, as the drum rolls and she prepares to spin in space. Also billed as 'the Black Venus' and 'the Cannon Woman', Miss La-La was a great attraction at the Cirque Fernando, famed for the astonishing strength of her teeth and jaws and for dangerous stunts like the one Degas chose to depict. From notebook pages and dated drawings it is clear that he watched her intently on four consecutive evenings in January 1879 as he puzzled out the problem of finding a pose which would convey her soaring movement.

Lautrec was another regular, fascinated since childhood by the spectacle and fantasy of the circus. His mother used to take him as a small, often sickly, boy and the associations with innocence, joy and wonder drew him back as a man. He lived nearby in Montmartre and spent many nights at the circus where he saw Monsieur Loyal and the orange-haired circus-rider who inspired him to paint his first large-scale work. In 1893 he painted the clown Medrano (known as 'Boum-Boum') who subsequently became so famous that the circus in Boulevard de Rochechouart was given his name.

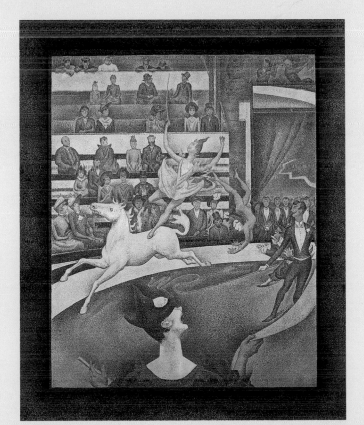

GEORGES SEURAT
The Circus, 1891

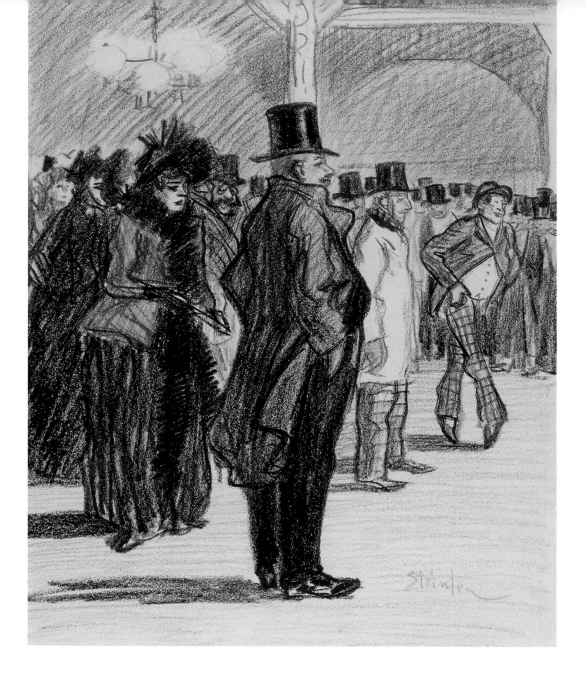

cymbals as a silver-costumed acrobat is caught by her partner; the applausive thrum 'of stamping feet, clapping hands and canes being struck on the floorboards' as the pair disappear behind a piece of scenery; and 'the shouting becomes even more tumultuous.'

In the last third of the nineteenth century Paris could boast perhaps two hundred café-concerts, ranging from seedy little *beuglants* to grand establishments like the Eldorado or Degas's favourites, the Alcazar and Les Amabassadeurs, housed in a Greek-columned pavilion in the gardens of the Champs-Élysées. In 1883 Degas wrote to the painter and musician Henri Lerolle urging him to 'go at once' to hear Theresa at the Alcazar: 'it is the right moment to go and hear this admirable artist. She opens her large mouth,' he enthused, 'and there emerges the most roughly, the most delicately, the most spiritually tender voice imaginable. And the soul, and the good taste, where could one find better?'

The café-concerts were a sort of counterpoint to the opera, in a similar register, though of course they were far more vulgar, less strict and much more lively. They attracted a broad audience drawn from the working class and the bourgeoisie. Jules Lemaitre noted that there were

THEOPHILE-ALEXANDRE STEINLEN
Aux Folies-Bergère, c. 1894
Steinlin is best known for his caricatures, and the Folie-Bergères presented plenty of opportunities for poking gentle fun at a cross-section of Parisian society. The audience is predominantly male, and here seen hovering around the *promenoirs*.

EDGAR DEGAS
The Café-Concert – Aux Ambassadeurs, 1876–7
As ever, Degas is drawn to the dramatic artificial lighting of the café-concert, and constructs receding planes, just as in a stage set. Degas had a great passion for music, and Les Ambassadeurs was one of his favourite haunts.

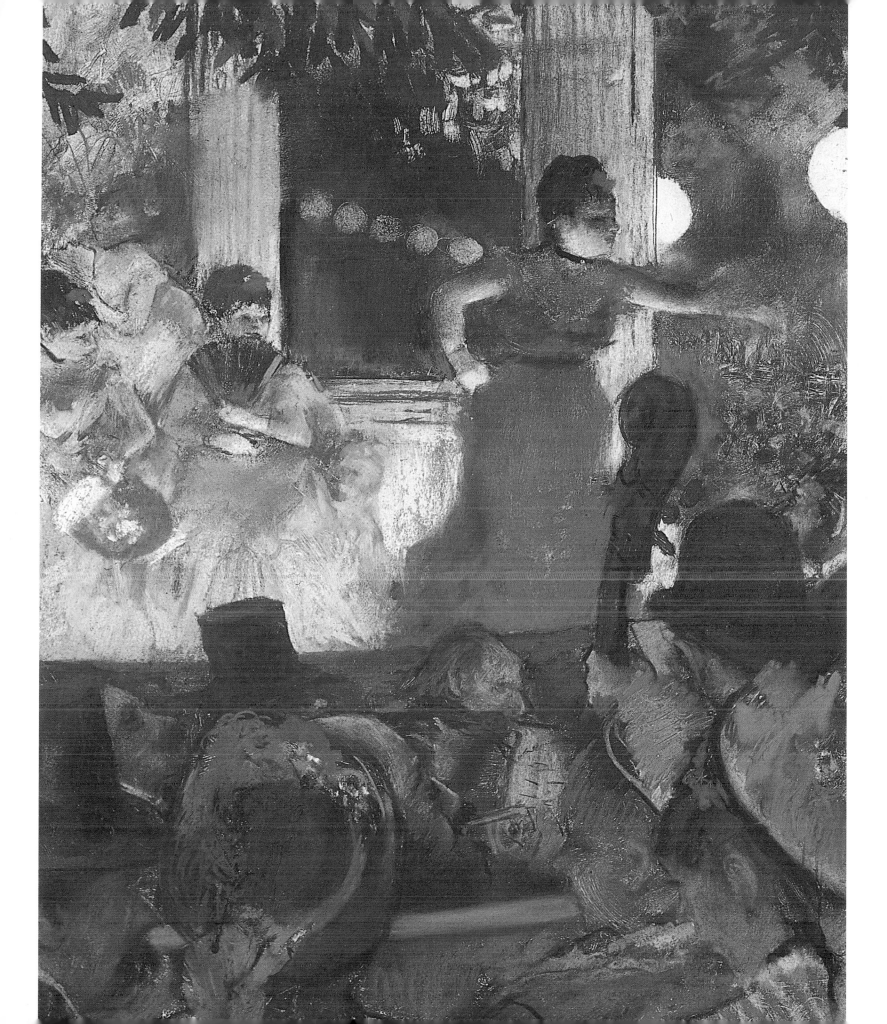

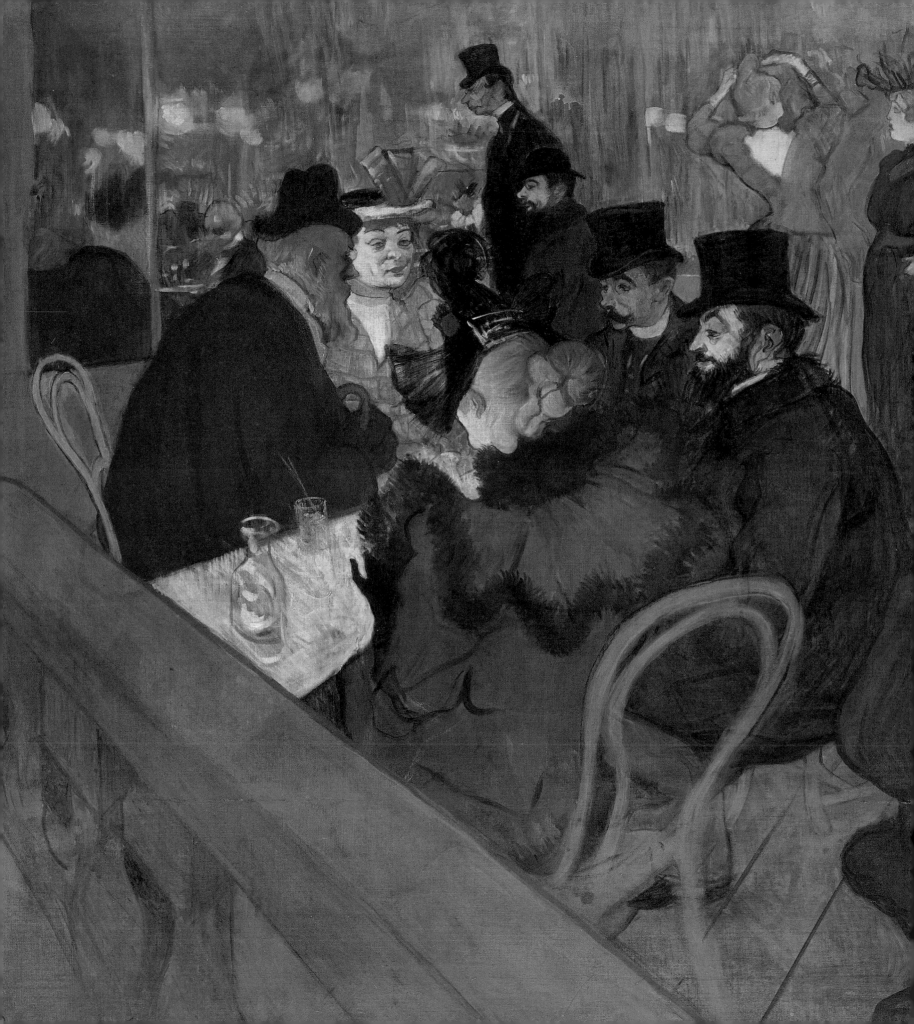

HENRI DE TOULOUSE-LAUTREC
At the Moulin Rouge, 1892
There's an almost hallucinatory quality to this peculiarly joyless painting,
conjured by the sickly colours, submarine light and ghostly faces of the women
– one of whom looms towards the viewer from the right of the frame. Lautrec
paints himself – a pallid figure in a bowler hat – walking across the rear space
beside his cousin Tapié de Céleyran. He also includes La Goulue (adjusting her
hair in the mirror) and La Macarona (seated opposite a red-haired woman who
has been identified as Jane Avril). The critic Félix Fénéon called his women
'malevolent' and his men 'maudlin puppets slipping into senile decay.'

usually some bourgeois top hats out to enjoy 'a salutary belly laugh' and a sense of 'communion in the universal stupidity.'

On the first of May 1889 the Moulin Rouge, with which Toulouse-Lautrec's name will forever be associated, opened its doors. It was one of the great Parisian 'events' of that pleasure-loving period. Situated at 82 boulevard de Clichy, it boasted an orchestra conducted by one of the Mabille brothers – and offered several different kinds of entertainment, beginning with a concert of comic and sentimental songs and ending with a display of a daring new dance – the can-can – performed by a regular troupe who became notorious for their raucous vitality and complete lack of inhibition. Soon the Moulin Rouge was known as the largest 'free market' of love in Paris with a reputation for tawdry decadence and scandal. Lautrec was in his element and, with his sharp, unforgiving eye, depicted the bawdy goings-on of the brazen, hard-bitten crowd in the intoxicating atmosphere of lasciviousness spiced with lesbianism. His Montmartre was faintly sinister, vitiated, redolent of drugs and perfumes, excess and debauchery. With abbreviated graphic daring, he painted entertainers like Jane Avril, Yvette Guilbert, the orange-haired dancer 'La Macarona' and 'La Goulue' (the Greedy One), who earned her name from drinking up the 'heel-taps' left in glasses. Lautrec was much taken by La Goulue who was famous for her whirlwind dancing – she could knock her partner's hat off with a neat kick which revealed, beneath a foam of lace, her underwear, before subsiding into the splits. He could evoke each of these fading stars with a fluid line of petticoat, a distinctive red mop of hair, or an elbow-long, disembodied black glove, and, despite the surface hilarity, he could, better than anyone, suggest the sadness at the centre of this whirling gas-lit world.

Louis Schneider, writing in *La Revue illustrée* on 1 April 1896, complained: 'People go there casually dressed, on the spur of the moment; they smoke, they drink beer, they crack jokes; the show starts an hour late and finishes at an early one, and the price is modest in the extreme... Montmartre has become the navel of Paris...'. Yet, this was the seedy world of surface glitter which Lautrec loved. Although rich, his stunted growth blighted his life and he preferred to keep to areas where he was well known, and he was a very familiar figure in Montmartre. His posters lent fame to Le Divan Japonais, Le Jardin de Paris, Le Chat Noir and Les Ambassadeurs. At the last of these Aristide Bruant, the charismatic star of the show immortalized by Lautrec in his wide-brimmed hat, dashing velvet cloak and scarf the colour of oxblood, would shout, as he entered: 'Silence, gentlemen, here comes the great painter Toulouse-Lautrec with one of his friends and a pimp I don't know.' Having stilled the crowd with a voice Jules Lemaitre described as 'for riots and barricades', Lautrec would make his way through the crowd, settle himself, graciously accept the beer that was offered to him and, in the crowded, smoke-filled room, pull out his sketch-pad and begin to draw. Le Chat Noir offered light meals of oysters, onion soup, omelettes, cold roast meats and sandwiches, but the customers came principally to drink rather than to eat. Lautrec's favoured tipple was port or absinthe. Indeed, the Symbolist painter Gustave Moreau claimed Lautrec, who died aged just thirty-seven, painted 'entirely...in absinthe.'

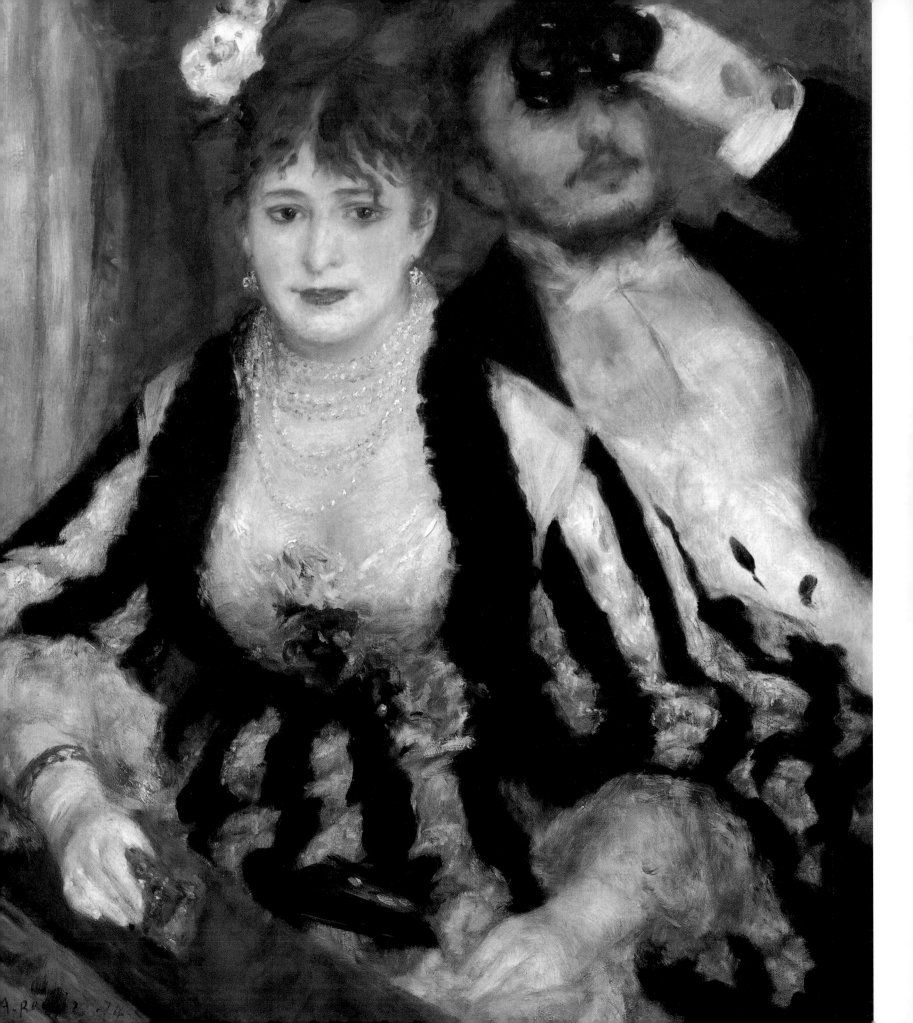

Of all the arts on offer in nineteenth-century France, theatre was the most popular. In the 1880s and 1890s half a million Parisians went to the theatre once a week, a million at least once a month. The extravagance of the setting, the lavish display of light, colour, ornament, jewels and bare shoulders made it a rich and satisfying entertainment. Monet and his second wife Alice Hoschedé were often to be seen at opening nights and tried not to miss a first performance of any play by Octave Mirbeau. They took their places in a box at the Opéra to hear Chaliapin, saw Pavlova and watched Loïe Fuller perform her *danse serpentine*.

Berthe Morisot chose three light operettas at the Theatre Français as a sixteenth-birthday treat for her daughter Julie, but – unlike Mary Cassatt, who made at least eight paintings of the opera, starting in 1878 with her series of women in *loges* – she never represented the place. Instead, Berthe chose to paint the anticipatory and reflective moment of a woman preparing to go out. Mary Cassatt also depicted her own milieu – that of an upper middle-class woman – though, as an American in Paris, she was already an outsider, which lent an edge to her work. Of course, neither Berthe Morisot nor Mary Cassatt could depict the sexually charged spaces of the wings or *coulisses*, where male painters such as Degas and Béraud ventured; instead, they painted their own world, their own marginal spaces of modernity, and by doing so they crossed the boundary between the private and public arenas.

Renoir, according to his son Jean, went to the theatre 'as others go for a Sunday walk in the country, to enjoy good air, flowers and the pleasure of being with others doing the same thing.' He loved the heightened awareness he felt the minute he passed through the doors of a theatre and in his youth never missed a single operetta by Offenbach. This pleasure he shared with Degas, who enjoyed Italian and French comic operas so much that when a niece visited Paris from America in 1892, he refused to take her anywhere other than the Batignolles, Moncey or Montmartre, small theatres which showed only comic operas of the first half of the nineteenth century and romantic melodramas.

Renoir, on the other hand, disliked melodrama intensely and, early on in his marriage to Aline Charigot, walked out of a conventionally staged play by Alexandre Dumas asking why he should 'waste an evening in an uncomfortable theatre looking at what I can see at home in my slippers and smoking a good pipe?' He wanted magic not monotony, fantasy not banality, and railed against the 'absolute tyranny' of being shut up in the dark and forced to watch the stage when 'I might want to look at a pretty woman sitting in a box'.

He was not alone. Spectacular, ostentatious display was good for box office receipts and Paris was full of elegant theatres from the opulent Opéra to the smaller horseshoe-shaped theatre houses, dramatically lit by gas chandeliers and side lights. The stage was lit by 'limelight', a calcium oxide mixture heated to incandescence, that produced a strong, white light which brilliantly illuminated the sequins, spangles, shields and shiny breastplates, the lavish liquid satins, silks and brocades, which theatre-owners knew would provide the required dazzle and glamour the paying public had come to expect. Sometimes, however, the audience witnessed a spectacle they hadn't paid to see: that of the scenery or a gauzy costume catching flame and, in 1887, the Opéra-Comique decided, despite the frequent technical difficulties associated with electricity in the early days, to install it throughout the theatre, dramatically reducing the number of accidents.

Ample proof of a lively interest in the theatre is provided by the number of *loge* – theatre-box – paintings made by both female and male Impressionists. Most of these paintings are concerned with the act of looking and viewing and often mirrors are used to explore the boundary between reality and illusion, and to comment upon social mores and class issues. The idea that men look and women are looked at is enshrined in Renoir's 1874 painting *La Loge*, though Mary Cassatt sought to seize the initiative in paintings like *Lydia Seated in a Loge, Wearing a Pearl Necklace* and *At the Français, a Sketch*. Where Renoir's lovely model Nini is passively on display (while the man behind her – modelled by the artist's brother Edmond – is shown actively looking upwards

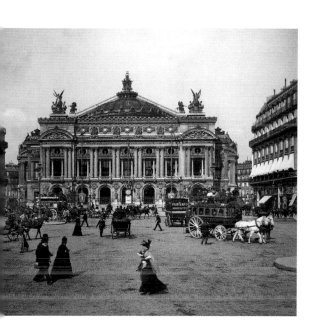

The Place de l'Opéra at the turn of the century, with the main façade of Charles Garnier's new Opéra building behind.

PIERRE-AUGUSTE RENOIR
La Loge, 1874
Renoir's younger brother Edmond modelled for the man scanning the higher reaches of the circle through his binoculars, while the lovely Nini (known rather unfairly on the evidence of this charming portrait as Gueule-de-Raie or 'fish-face') gazes out at the viewer. Renoir was an avid opera-goer with a special taste for Wagner, whose portrait he painted, although his pupil Jeanne Baudot recounts how on a visit to Bayreuth in 1896 he became restless and bored during a lengthy performance of *Parsifal* and had the audacity to strike a match so that he could look at his watch

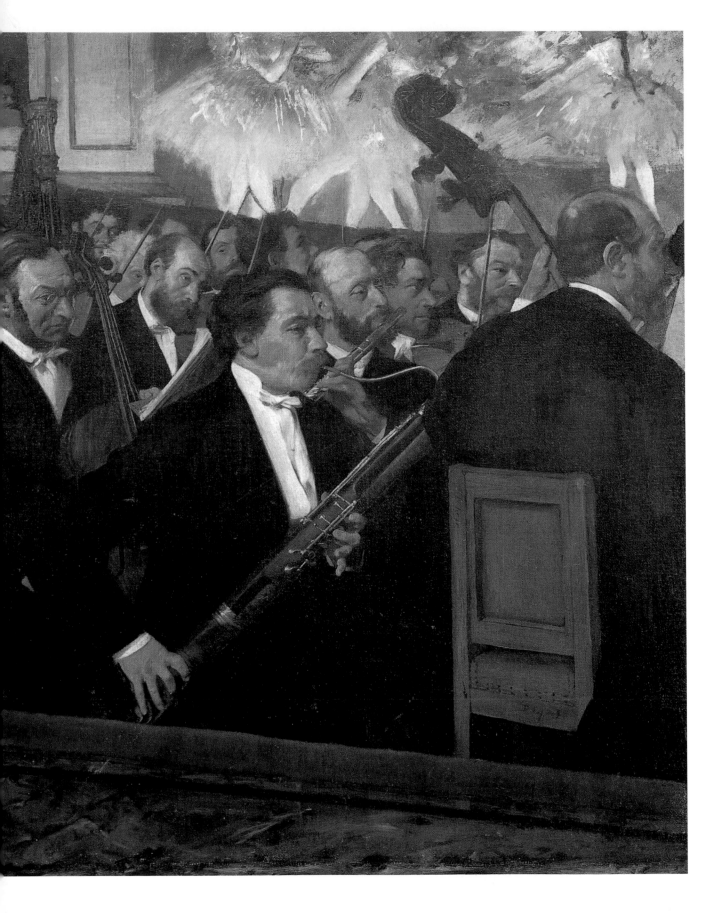

EDGAR DEGAS
The Orchestra of the Opéra,
c. 1868–9
Degas criticized himself for 'having
the time neither to live nor to
draw' and had impatient, towering
ambitions. When his close friend,
the bassoonist Désiré Dihau
introduced him to the Opéra, he
vowed to undertake a series of
paintings 'on instruments and
instrumentalists – their shape, the
contortions of the violinist's hand
arm and neck, the cheeks of the
bassoonists and oboists puffing
and blowing...' – and famously
represented Dihau at the centre of
this magnificent painting.

MARY CASSATT
At the Français, a Sketch, 1877–8
This is a picture about looking.
The main female figure is looking
intently through her binoculars,
trained not on the stage, but on
the audience across from her.
Meanwhile, she too is being
watched, both by us and the man
resting his elbow on the red velvet
of his box as he stares at her
through his own binoculars.

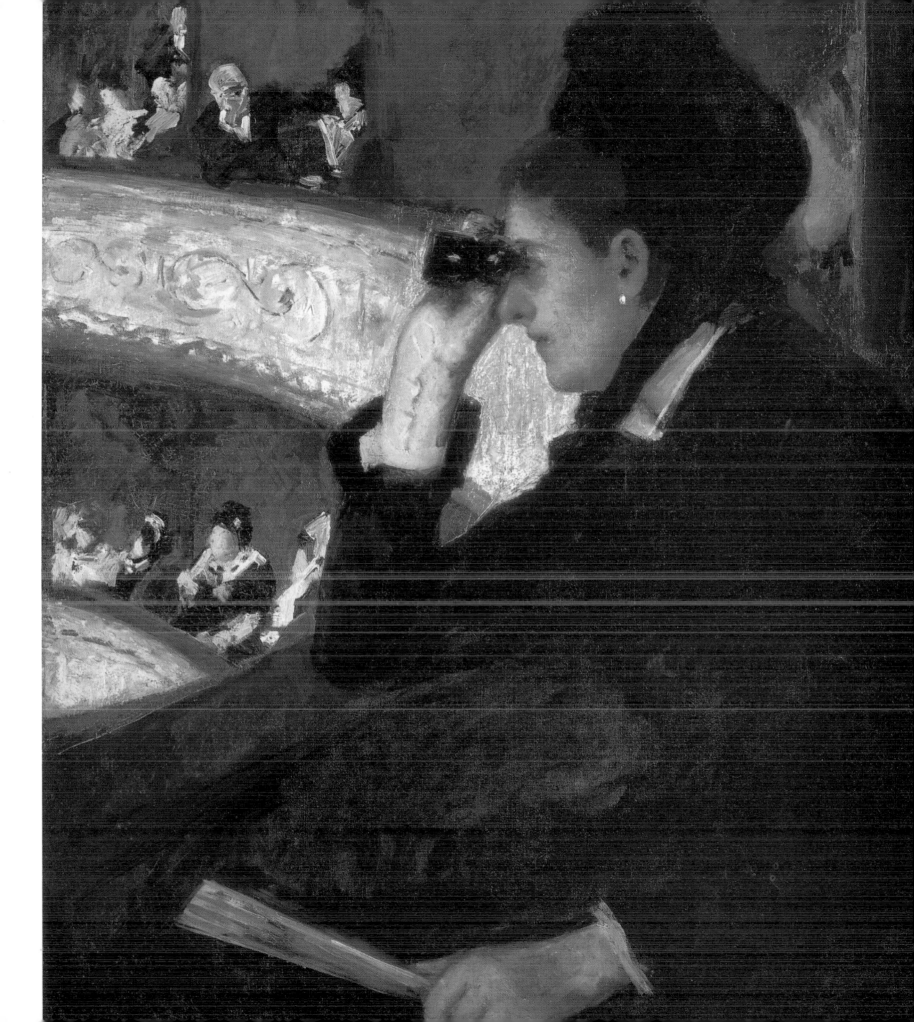

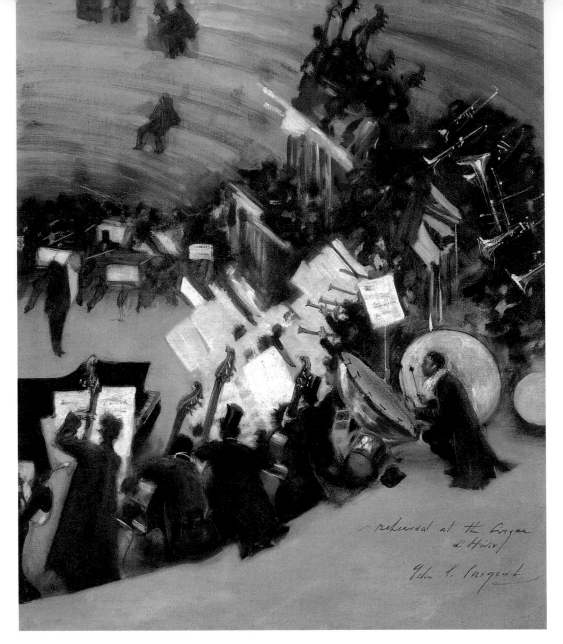

JOHN SINGER SARGENT
Rehearsal of the Pasdeloup Orchestra at the Cirque d'Hiver, c. 1879–80
Jules Etienne Pasdeloup presented 'Concerts Populaires' on Sunday afternoons in Paris from November to May between 1861 and 1887. His programme was an adventurous one and featured many of Sargent's favourite modern composers, including Fauré and Wagner. Sargent was a gifted musician himself. 'Music was John's consuming interest, after painting,' his friend Stanley Olson testified: 'It was his chief pleasure and it became the nucleus of his social life.'

through his opera glasses), Mary's sister Lydia is presented as a glowing young woman, clearly enjoying herself, in control and perfectly at ease alone in her box. More startling still is the woman in black in *At the Français, a Sketch* – a painting about looking which subverts the conventions in a number of ways. Firstly, the woman in the *loge* is alone. She is not dressed in the customary low-cut voluptuous fashion – instead her black dress discreetly trimmed with white hides the outlines of her body and is closer to the costume associated with men of the period. Far from being passively on display, Cassatt's no-nonsense subject is straining forward and training her binoculars (usually just a prop along with the fan and flowers in similar paintings by men) not at the scene on stage but upwards towards the unknown, unseen occupant of a *loge* outside the picture frame. However, she too is being watched. By us, of course, viewing the painting, and by the blade in the background who leans forward across the body of his female companion to look intently at the woman through his own binoculars. The triumph of this painting is the way in which it points up and subverts traditional gender roles. For a woman assertively looking might be seen to threaten the social and sexual order and a woman painting such an ambitious picture to challenge the patriarchy of the established art world.

Staircase in the Opéra, Paris, 1861–75
Opera reached a new height of popularity around the time of the Impressionists, even more so when the new building by Garnier was built. The interior was every bit as glamorous as the exterior, in an indeterminate style that Garnier supposedly called 'Napoleon II style'. The building inspired Gaston Leroux's novel, *The Phantom of the Opera*.

A box at the theatre, the opera or ballet could be rented by the rich for upwards of a thousand francs a year, while the working classes handed over the equivalent of a day's wages for a single ticket high up in the gallery. Strict rules meant that women could only occupy a stall seat if they were accompanied by a man, though they were free to sit together in *loges* without the prop of a male companion. These velvety private spaces cut off from, though exposed to, the view of the common herd exercised the imagination of the Impressionists and writers of the time. Charles Baudelaire observed:

> Sometimes in the diffused radiance of opera or theatre, young girls of the best society, their shoulders, eyes, and jewels catching the light, resemble gorgeous portraits as they sit in their boxes, which serve as picture-frames. Some prim and proper, others frivolous and fair. Some, with aristocratic unconcern, display a precocious bosom, others candidly reveal their boyish chests. Fans on teeth, with fixed or wandering eye, they are theatrical or solemn like the play or opera they pretend to be looking at.

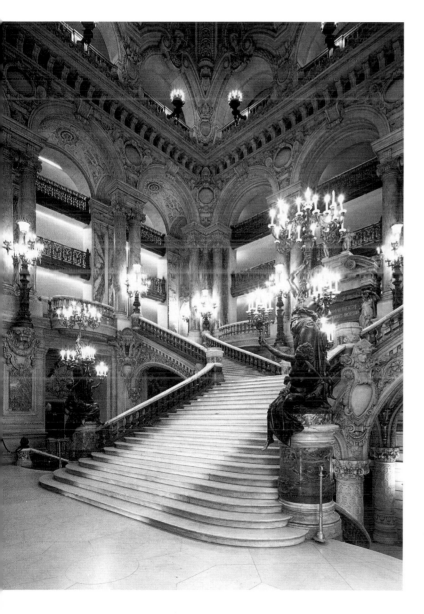

Décôlletage was considered bad taste during the day, but *de rigueur* in the evening at the opera or ballet. Diamonds – which drew the eye to a shapely bosom – were considered appropriate only for married women but even a wife, if she wore one in the middle of the day, would be branded a *parvenue* by arbiters of taste like the Comtesse de Bassanville. The rules were rigid. Young girls were barely allowed to wear pearls and turquoise, while widows were permitted only jade, black onyx or black enamel jewelry. A young girl's most versatile tool was her fan, an indispensable accessory, which made exchanges, manoeuvres and intrigues possible. Folded or open, raised or lowered, veiled or exposed, it could serve as the cleverly deployed prop of the flirt or the modesty screen of the bashful young girl.

The public desire for opera reached a peak in Paris during the Impressionists' era, fed by canny home-grown practitioners like Gluck and Berlioz, Gounod and Massenet and supplemented by Wagner and Meyerbeer, whose rambling five-act spectacles were famous for their thundering arias, swollen choruses and obligatory ballet. The old opera house in rue de Peletier had gone the way of so many Paris theatres and burned down in the autumn of 1873, temporarily depriving Degas of one of his favourite places to study, though Charles Garnier's opulent new building which opened in 1875 provided a handsome replacement. Not all were impressed. Debussy referred to Garnier's Opéra scathingly as 'le Gare' and one contemporary commentator compared the façade to 'an overloaded sideboard.' Degas, though, was a regular and through the 1880s the proud possessor of a season ticket at the Palais Garnier. Always more at home in the closed nocturnal world of the ballet and the opera than the sunlit spaces of his Impressionist contemporaries, his letters show him organizing opera evenings in the company of friends like the painter Jean-François Raffaëlli and Ludovic Halévy, a celebrated writer and librettist for opera composers like Jacques Offenbach and Georges Bizet, and a friend of Degas's since their youth. Degas attended performances of Charles Gounod's *Faust*, which was setting box-office records in Paris, and Gluck's *Orfeo and Eurydice*. He often gained access to rehearsals and examinations and, on 11 June 1885, with Ernest Reyer, Albert Boulanger-Cavé and Halévy, he was present at the

répétition générale, the final dress rehearsal, attended by critics and Opéra insiders, of Reyer's *Sigurd*, a work based on the *Nibelung* legend, which showcased the considerable talents of Degas's favourite singer, the 'divine' French soprano Rose Caron, who created the role of Brünnhilde. Reyer introduced her to Degas and he went again and again – attending over thirty performances (one as far away as Strasbourg) – to hear her voice and admire her sculptural acting style, which reminded him of the 'noble Rachel' of the Comedie Française of his youth.

Writing to Halévy in the autumn of 1885, after yet another performance of *Sigurd*, he reported: 'Madame Caron's arms are still there – those thin and divine arms, which she knows how to leave in the air for a long time, a long time, without affectation, and then lower without haste.'

The many paintings and pastels Degas made of the ballet often tended to avoid the performance itself and instead concentrate on the preparation or subsequent relaxation backstage. He painted small groups of ballerinas waiting in the wings or recovering in some bleak and austere practice room. Suzanne Mante was just nine years old when Degas painted her in her new tutu alongside her sister Blanche and their mother in *The Mante Family*. As an old woman Suzanne remembered Degas as a quiet, kind man in blue spectacles, who used to stand at the top or the bottom of one of the many staircases in the Palais Garnier, sketching the girls as they rushed up and down and sometimes asking one of them to pause for a moment. His kindness is evidenced in a letter of November 1883 in which he tried to get Halévy, who had influence in theatrical circles, to help a young *danseuse*, Josephine Chabot, with a renewal of her engagement.

Albert Boulanger-Cavé, watching Degas at an afternoon ballet rehearsal in 1891, saw that Degas excited real affection in the young *danseuses*. 'Degas found them all charming, treated them as if they were his own children, excused them everything they did, and laughed at everything they said. They in turn had for him a genuine veneration. The *petits rats* were ready to do anything to please him.'

Another first-hand account is provided by Georges Jeannoit, who, in his *Souvenirs*, recalls an afternoon spent in the printmaker vicomte Lepic's studio sketching the ballerina Rosita Mauri and a couple of Opéra rats. Degas appeared, received a warm welcome, showed the other men exactly how to draw a ballet slipper and then, humming the refrain of the song '*A table, a table,*' led them through to the buffet – cherry pie, cake, and wine – which Lepic had prepared. Apparently such interludes were not uncommon. In an undated note of 1881 Degas referred to 'lunch with some Italian and French danseuses Sunday at Boldini's place.'

Among his favourite ballerinas during the 1880s were Rosita Mauri and Alice Biot, the Harlequin Junior in *Les Jumeaux de Bergame*. In 1885 he told Halévy that Mont-Saint-Michel had made an impression on him 'second only to that made by Mademoiselle Alice Biot' and when a wealthy amateur painter persuaded a favourite ballerina to model for him, Degas accosted his rival at the Opéra and said 'Monsieur, you have no right to take our tools away from us.'

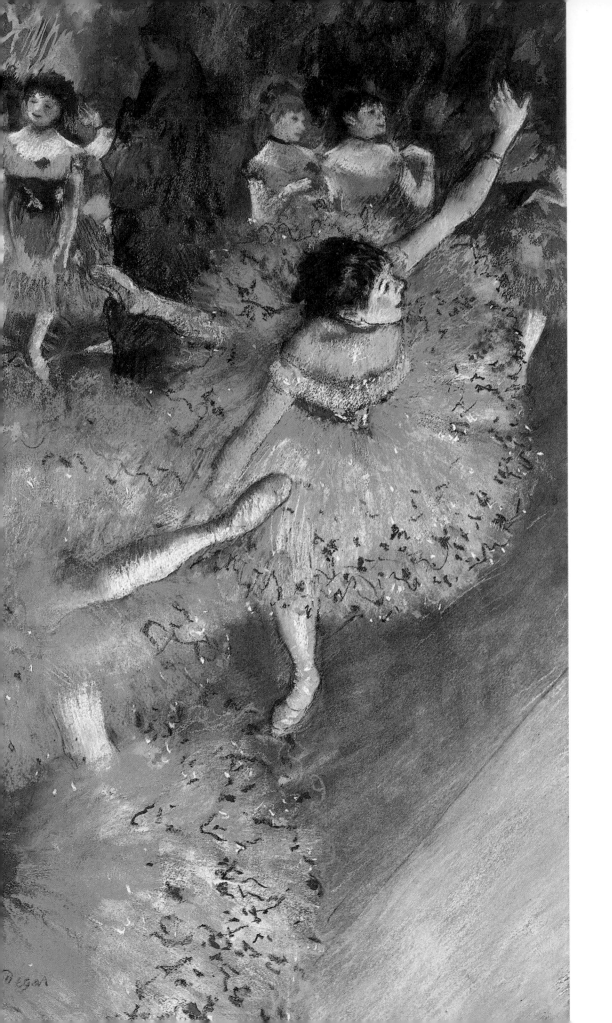

EDGAR DEGAS
Danseuses Basculant (Green Dancer), c. 1880
Degas brings his usual keen eye for perspective
and unusual composition to this dazzling work.

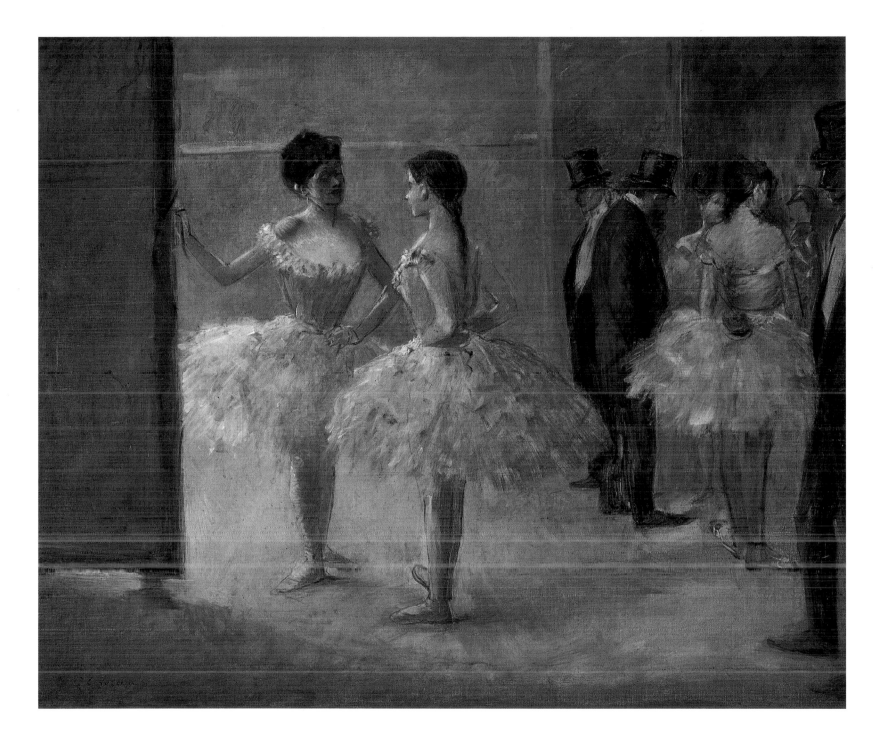

JEAN-LOUIS FORAIN
Dancers in the Wings at the Opéra, c. 1900
Forain captures the backstage activities of wealthy men, who often preyed on the young dancers, buying their way into the wings or *coulisses*, and causing a clearly exasperated Berlioz to call the Opéra 'a house of assignation'. This was a theme often explored by Degas who exposed the hypocrisy and cant of these elderly *protecteurs*.

Ballet metaphors infused Degas's letters. In one particularly poignant one written from Naples to his friend the sculptor Albert Bartholomé in January 1886, he spoke wistfully of friendship and then apologized: 'I am speaking of other times, for with the exception of the heart it seems to me that everything within me is growing old in proportion. And even this heart of mine has something artificial. The dancers have sewn it into a bag of pink satin, pink satin slightly faded, like their dancing shoes.'

CHAPTER 3

A Time to Relax
PICNICS, PARKS AND GARDENS

'…we walked through the garden of the Tuileries, which was filled with people. I stood for some time looking at a priest who was there with his school of boys; he was playing with them in a game much like the one I used to play at school which we called "prisoner's base". A large crowd of men, women and children surrounded them, those others who were not engaged in it were playing marbles, etc. It struck me as being a queer sight to see this reverend man running and shouting after the boys…'

Letter from the American Impressionist J. Alden Weir to his mother, 1 March, 1874

In 1863 a tall, bearded, twenty-two-year-old student wrote home to reassure his mother that he was combining holidaying with hard work. 'You may be surprised,' Frédéric Bazille told her, 'to find that I'm not nearly as lazy as I was last year.' He had spent a few days in the village of Chailly on the edge of the forest of Fontainebleau with his 'friend Monet from Le Havre' who was proving to be not just an excellent companion but also a useful sounding board. 'He's good at landscapes,' Bazille wrote, 'and gave me some very useful tips.'

Like Courbet, Corot, Millet and Rousseau twenty years before them, the young Impressionists were drawn to the magnificent beauty of the forest of Fontainebleau, about 55 kilometres (35 miles) to the south-east of Paris. The towering trees, wild gorges and vast, fantastically shaped boulders fired their enthusiasm and Bazille wrote home rhapsodizing about the 'magnificent' oak trees, though he found the famous rocks 'less fine' than those near his Montpellier home.

Chailly was popular with artists, and small inns – such as the Auberge du Cheval Blanc, where Monet and Bazille found lodgings for 3 francs 75 a day, and the Auberge Ganne – had sprung up to cater for them. François Ganne had started out modestly with a grocery shop, but gradually added on rooms to provide lodgings and persuaded his wife to turn chef. She provided

CLAUDE MONET
Parisians Enjoying the Parc Monceau, 1878
Mothers and nursemaids rest in the dappled shade afforded by one of the mature trees in the lovely Parc Monceau. Monet and Camille lived nearby in the rue d'Edimbourg and Camille often brought Jean to the park. In the distance one of the elegant houses which bordered the park can be glimpsed between the trees

Bois de Boulogne, illustration by Mars in *Paris Brillant*, 1890

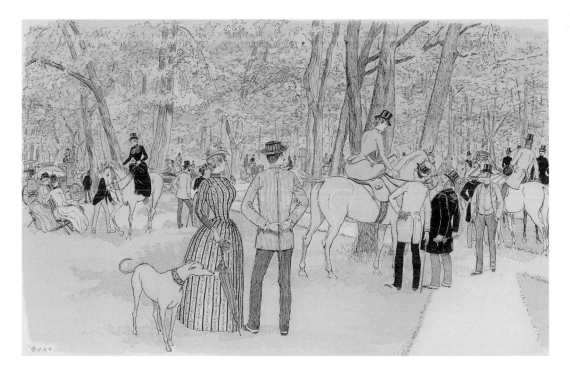

the painters with picnics to take into the forest with them, rising before dawn to stuff straw baskets with bread, chicken drumsticks, slabs of brie, fruit and bottles of wine and welcoming them back in the evenings with steaming bowls of soup and a goose roasting over a spit. Over the years, earlier artists had repaid her kindness – and occasionally the bill – by decorating the walls, sideboards and dividing panels of her dining-room with paintings of the forest.

A pattern was soon established. In the spring when Charles Gleyre closed his studio for a few weeks, the four students – Renoir, Monet, Bazille and Sisley – set out for Fontainebleau, taking the train as far as Avon or Melun and walking to Chailly or Marlotte, avoiding the overpriced and overcrowded Barbizon. They often stayed at Mère Antony's inn where the beds were excellent and the food substantial. Renoir was always at ease there in what he called 'the true village auberge' and, with his great gift for enjoying life, quickly became the favourite of the *patronne* and of her daughter Nana, 'that superb girl', who appreciated the courtesy with which he treated her.

The dense, green forest came almost to the first group of houses on the northern side of the village, while the houses to the south faced the valley of the Loing, where tall graceful trees shaded the river bank. One year Sisley brought Pissarro. Even the taciturn Cézanne turned up. The painters took long walks through the woods – meeting only poachers – and gave romantic names to forest sites. Cézanne liked 'The Valley of Hell' best, though they also christened spots 'Kosciusko's Grotto', 'The King's Table' and 'The Pond of the Fairies.' It was a golden period for them all, but especially for Sisley who, 'untroubled by money or by melancholy', was able to paint solely for his own pleasure. Later, when his father's business ran into difficulties, he would be forced to squeeze a meagre living for himself and his family through his painting, but in those heady, youthful days, alongside his friends, life was piercingly sweet.

Monet spent the summer of 1865 working on a vast painting inspired by Manet's controversial *Le Déjeuner sur l'herbe*, which the young student had seen exhibited at the Salon des Refusés two years previously. Monet wanted to paint a similar scene though not, as Manet had done, in his studio, using sketches, but out in a forest clearing. His painting was to show exactly how the light filtered through the trees and enveloped his city friends as they lounged against the trees or sat in relaxed postures on a cool cloth spread with an elegant feast, including a raised pie, a plump roast chicken, several bottles of wine and a tumble of fruit. The good-natured Bazille posed for several of the male figures in the ambitious painting. Sisley is shown seated on the left and the female models were 'Little Eugénie', whom Monet had met at Chailly-en-Bière, and a tall, graceful young woman, Camille Doncieux, who would become his first wife.

The painting's promise of peace and plenty gives no hint of the money problems that beset Monet at the time – indeed he was forced to leave the six-metre-wide canvas behind in payment for his hotel bill when he returned to Paris. Rolled up and abandoned in a corner of the house, the canvas suffered from damp during the winter of 1865–6 and when Monet went back to reclaim it he found that mildew had attacked a large strip on the outer edge. Monet cut this away and preserved the central portion with the figures, but had to give up his plans to submit it to the Salon.

Picnics, like the one Monet pictures, were greatly enjoyed by Parisians in the mid-nineteenth century and inextricably linked to their idea of landscape and the countryside, though ironically these city-dwellers tended to bring the city and its comforts along with

PIERRE-AUGUSTE RENOIR
Le Cabaret de la mère Antony, 1866
Renoir painted his friends relaxing at the end of a meal in one of his favourite restaurants. The wealthy painter Jules Le Coeur leans across the table towards Alfred Sisley, Claude Monet looks on and the admirable Madame Antony clears away. Only Le Coeur's dog, Toto, looks out at the viewer.

them. Monet's fashionably dressed women and their bowler-hatted men were typical examples of the solid, middle-class day-trippers, who would hire a cart and all the drink and the food for their feast from one of any number of excursion services at Fontainebleau, Melun or Chailly. Indeed, Monet includes the discreet – but alert – figure of a dark costumed caterer presiding over a food hamper to the right of the painting, set apart from the relaxed picnickers by the broad birch tree.

Unlike Manet's audacious painting, which set out to expose and dismantle the Salon's vision of the ideal woman, Monet's *Déjeuner* does not contain – however ironically – references to history and art of the past; instead it reflects his own class status and the simple pleasures of a burgeoning bourgeoisie keen to exercise their right to leisure.

CLAUDE MONET
Le Déjeuner sur l'herbe (study), 1865

EDOUARD MANET
Music in the Tuileries, 1862
Manet included portraits of his artistic and literary friends among the fashionable concert-goers in this great gathering: Baudelaire can be seen turning away just behind the blue bonnet of the lady on the left, but perhaps the most interesting is Manet's portrayal of himself as an elegant dandyish figure with top hat and cane standing at the extreme left of the painting.

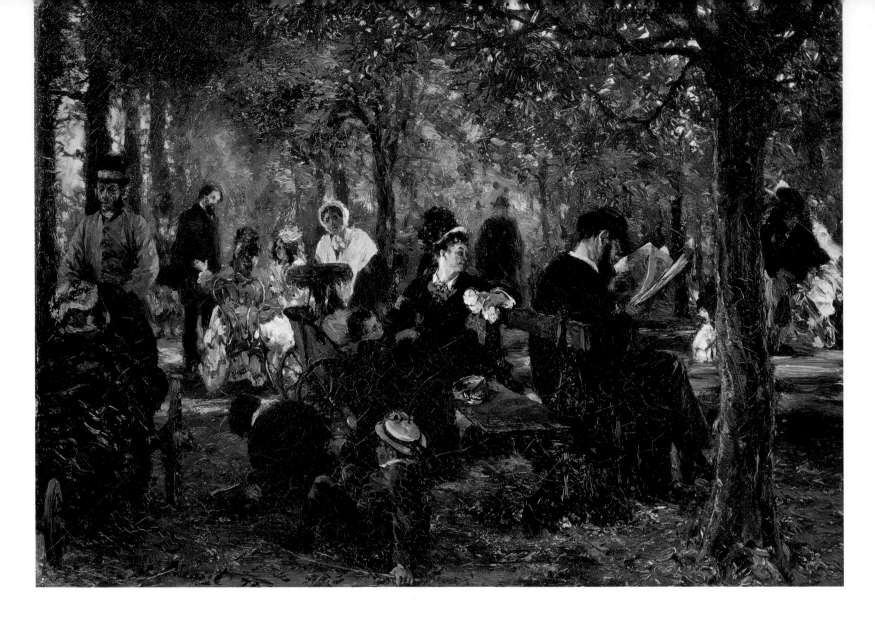

A number of Impressionists, including Manet, Renoir, Monet, Caillebotte, Childe Hassam, Mary Cassatt and Berthe Morisot, chose bucolic parks and bustling boulevards as subjects for major paintings on the theme of modern life. Manet painted the most famous of the contemporary park scenes in 1862 when he depicted a fashionable audience (in fact an assembly of artists, musicians and writers – all his friends and associates in the early years of his career) waiting to hear a concert in the Tuileries Gardens (pp. 62–3). He painted this brilliant scene from contemporary life in the studio but, according to his friend Antonin Proust (writing in the *Revue Blanche* in 1897), based it on a series of outdoor sketches and painted studies he made 'despite the curious glances' in situ. Thus he went nearly every afternoon to the Tuileries to make rapid sketches 'of the children playing and the groups of nannies who had subsided on to the chairs.' The veiled and bonnetted women – who have been identified as Madame Lejosne (with veil) and Madame Loubens – have changed out of the loose *peignoirs* they favoured as morning wear and clambered into the vast dresses, which could spread over three chairs and were worn over tightly cinched corsets, the tyranny of which doctors (and Renoir) railed against.

Very soon the mixing that went on in these new outdoor spaces became a source of concern to the authorities who, despite the evolution of a more segregated residential arrangement within the city, found policing the public spaces problematic. They were particularly concerned to maintain

ADOLPH MENZEL
In the Luxembourg Gardens, date unknown
Menzel, a German artist, spent time in Paris where he delighted in chronicling the activities and rituals of bourgeois society. Parks, those newly democratized spaces, were ideal places to capture the new elite at play.

the boundary between respectable women and those of easy virtue and the politics of street life which so fascinated Manet – the itinerant musicians and pamphleteers, the solitary women sitting on café terraces – became, as bourgeois anxiety burgeoned, a focus for considerable police activity. Beyond the teeming mask of spectacle, all kinds of middle-class insecurities and vulnerabilities lurked, though Henry James's hero Strether in *The Ambassadors* (1903) experienced no such *anomie* as he strolled through the Luxembourg Gardens: 'here at last he found his nook, and here, on a penny chair from which terraces, alleys, vistas, fountains, little green trees in green tubs, little women in white caps and shrill little girls at play all sunnily "composed" together, he passed an hour in which the cup of his impressions seemed truly to overflow.'

Baron Haussmann's radical rethink of the city had added eighteen new squares and nearly doubled the number of trees lining avenues and boulevards – some of which boasted a double row of trees on each side – contributing significantly to the 'greening' of Paris. The remodelling of the Bois de Boulogne, however, proved a mixed success. The 'rush and rattle of the race-course' at

CHARLES COURTNEY CURRAN
In the Luxembourg Gardens, 1889
'Half an hour spent on the boulevards or on one of the chairs in the Tuileries Gardens has the effect of an infinitely diverting theatrical performance,' wrote the traveller Augustus Hare in his 1887 guide to Paris.

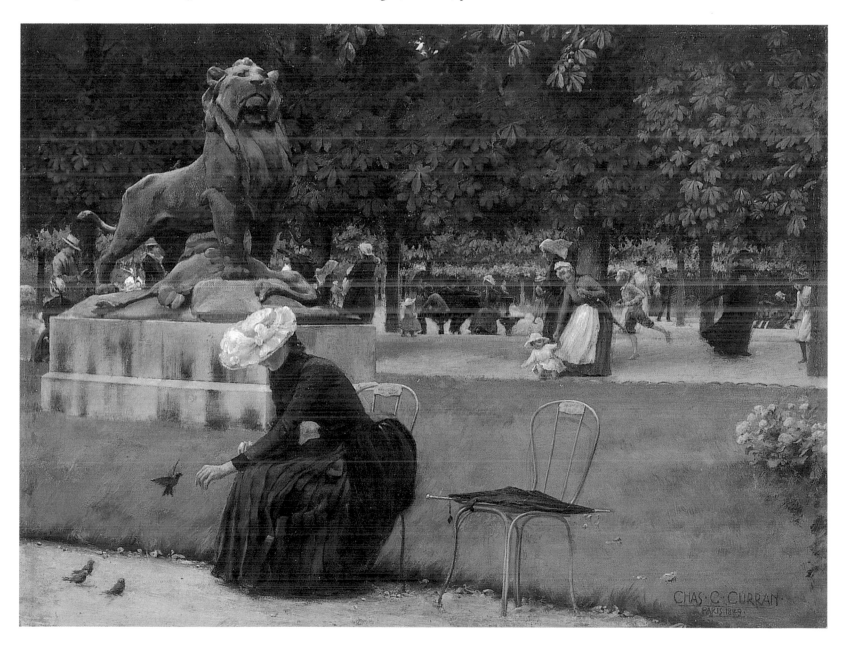

The Spread of Parks

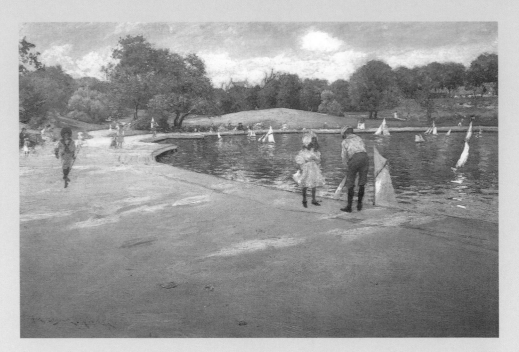

'There are charming bits,' William Merritt Chase confided to a reporter in 1891, 'in Central Park and Prospect Park, Brooklyn...when I have found the spot I like, I set up my easel, and paint the picture on the spot. I think that is the only way rightly to interpret nature.... You must be right out under the sky.' Chase's *plein air* park scenes are said to represent 'the earliest pictorial manifestation of Impressionism to take place in the United States.' Eden-like in their unruffled beauty, one might be forgiven for thinking they were intended solely for women and children. In fact, both these large, multipurpose parks were created as inclusive, democratic spaces, intended for recreational use by growing numbers of city dwellers of both sexes. They were designed in the late 1850s and early 1860s by Frederick Law Olmstead and Calvert Vaux who combined the English naturalistic tradition with the rather more rigid design of conventional French parks (for the Terrace and the Mall in Central Park, for example). The American park movement pointed up and promoted the social, moral, aesthetic, educational and health-giving properties of parks. 'In America, all pleasure grounds of large extent have from the beginning been planned for the people,' trumpeted one proud commentator, adding: 'they are a constant source to them of pleasure and pride.'

As the pressure on space in the burgeoning cities grew, supporters proclaimed the salutary effects of parks: they claimed they provided reservoirs for clean air, reduced urban mortality, and encouraged physical exercise. 'While the visitor to the park fancies himself merely resting,' wrote Mary Caroline Robbins in the January 1897 issue of *Atlantic Monthly*, 'he is in fact receiving new sensations which insensibly educate both eye and mind [and] have an artistic value which helps to make the humblest more sensitive to beauty, more intelligent as to what constitutes it.' Central Park boasted a Dairy where children could drink fresh milk and a meadow upon which sheep grazed. Ten thousand benches and chairs were scattered through its sylvan spaces and children sailed their miniature yachts on the Conservatory Water. In 1900 a writer described the special seductions of the park in winter: 'The snow attracts some who would not go there save that they wish to see again the festooned trees, and feel the cold, sweet breath of a snowy field, with which they were familiar in years and joys gone forever.' Throngs of New Yorkers – arriving on sleighs pulled

by teams of horses with jingling bridles – skated on the lake and made the scene lively.

Sargent, Whistler, Weir and Hassam also concentrated on park imagery. Whistler painted the pleasure garden of Cremorne on the banks of the Thames near his home in Chelsea half a dozen times. These six nocturnes featuring the milling crowds, points of light and shimmering fireworks are analogous to the French Impressionists' scenes of bourgeois pleasures in Parisian parks.

WILLIAM MERRITT CHASE
The Lake for Miniature Yachts, c. 1888

WILLIAM MERRITT CHASE
Park in Brooklyn, 1887

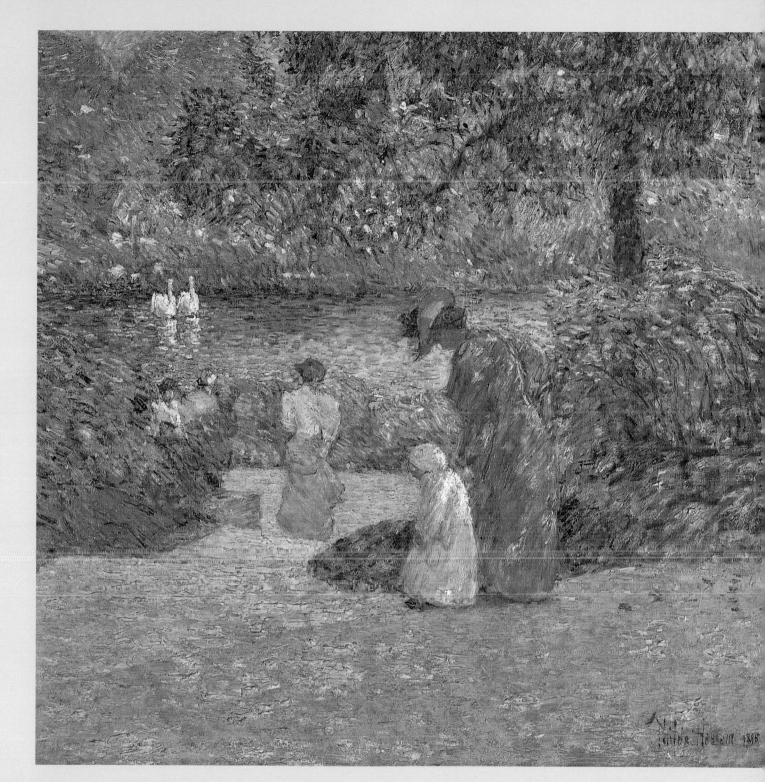

CHILDE HASSAM
*Descending the Steps,
Central Park*, 1895

The contemporary critic George William Sheldon, writing in 1888, called Hassam 'the only American who makes a practice of painting life in the cities – in the parks, in the streets, and on the house-tops...sometimes he reproduces the flower-gardens of country-houses, where the women are so charming, and, above all, so "paintable"; but it is in the cities that he chiefly finds his subjects, where the women in out-door costumes are not less charming, and where the correlated atmospheric effects appeal to the artist's pencil. Mr Hassam's pictures tell interesting stories and at the same time record the most delicate play of light and shade.'

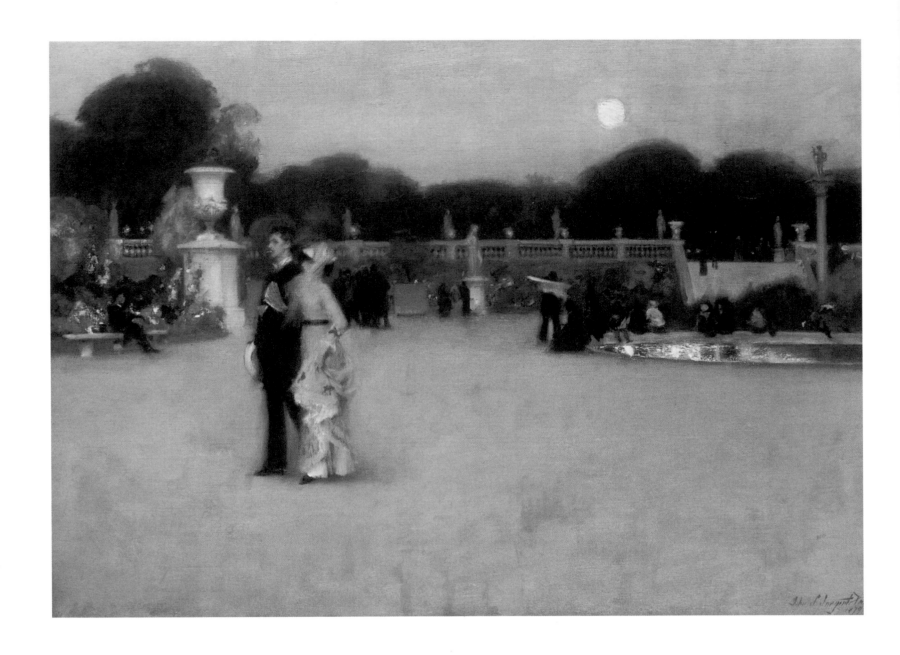

JOHN SINGER SARGENT
In the Luxembourg Gardens, 1879
Sargent depicts an elegantly dressed couple drifting
through a delicately painted, rosily diffuse scene.
Children play in their own world. A standing man reads
a newspaper, another sits, isolated on a bench, at the
edge of the sweeping parterre, against a flaming
backdrop of red flowers. The contrast between the
convivial swirl of Renoir and the fashionable crush of
Manet could not be more extreme. Sargent is closer
here to Whistler's delicate atmospheric studies.

Longchamp had become a firm fixture in the Parisian spring and autumn calendar, but the proposal to build a leisure and entertainment feature containing a café, restaurant and a 'theatre of flowers' (in which actors and ballet dancers would give performances lit by footlights whose reflectors were dissimulated among clumps of bushes and flowers to audiences of up to 1,800) proved overly ambitious and an expensive failure for the French government.

Nevertheless the leisurely parade through the Bois de Boulogne or the Tuileries, where the latest fashions could be observed, modelled and flaunted by both aristocratic women and *demi-mondaines*, soon became the high point of metropolitan life in nineteenth-century Paris. New fashions were spearheaded by women of high society and the self-advertising *grandes cocottes* who vied to out-do one another by the splendour and often sensational originality of their dress and the extravagance of their carriages.

Renoir's *The Morning Ride* and Mary Cassatt's painting of her sister Lydia driving a carriage through the Bois de Boulogne with Degas's solemn little niece Odile Fevre alongside her (see p. 129), exemplify the way in which parks offered the wealthy places to parade on horseback or in carriages. Renoir had hoped that his painting would be accepted by the Salon and find favour among the same sort of class he depicted. Sadly he was disappointed on both counts, though the picture did eventually find a buyer in Henri Rouart, Degas's boyhood friend and an amateur painter who exhibited with the Impressionists in seven of their eight exhibitions from 1876.

MAURICE BRAZIL PRENDERGAST
Sketches in Paris, c. 1892–4
These charming oil sketches on small wooden panels were made by Prendergast in Paris parks in the early nineties.

Mary Cassatt's portrait of her sister, painted four years after Lydia and her parents made their home in Paris alongside the painter, is more personal, less obviously commercial, though the backward-facing pose of the anonymous groom reveals much about the deference expected of a servant and speaks volumes about his place in society. It also indicates a certain freedom of movement, enjoyment of horses and feminine independence. This is reinforced by the painter May Alcott's account of an evening spent with Mary and mutual friends in September 1877. The four women drove to the Bois de Boulogne for ices and May (sister of the more famous Louisa) marvelled at this city that never slept: 'all the world being abroad apparently till morning. The avenues lined…with brilliant street lights… We turned into a great court-yard filled with little tables surrounded by a set of nice looking people sipping their coffee, wine or absinthe. The dense darkness of the wood surrounding it being illuminated by coloured lamps giving the whole thing a most theatrical appearance…We felt as if in a play, all was so fantastic.'

Of course few Impressionists could afford a carriage – especially in the early days – but parks and gardens offered them and humbler members of the public pleasant places in which to promenade or picnic. They could go boating on the lakes, or, when ice formed, skating on the ponds (or in the Palais de Glace which opened its doors on the Champs-Élysées in 1893), a wintry pleasure captured by Renoir in an ambitious and spirited painting, made when he was twenty-seven. He lived close to an archery club in Montmartre and ample evidence of other leisure pastimes enjoyed by Impressionists is provided by their paintings: Manet painted a croquet match (pp. 72–3) and Berthe Morisot two women floating lazily in a boat on the lake in the Bois de Boulogne. She lived on the western edge of Paris and was a frequent visitor to, and sampler of, the charms of the Bois and the Parc Monceau. She viewed public parks as an extension of her own domestic or private space and worked in them as if at home, making quiet images of nursemaids and mothers playing with their children, of her husband, her daughter and their female servants. The autumn of 1884 was particularly beautiful and Berthe, called back to Paris from holiday because of her mother-in-law's failing health, took the opportunity to set up her easel in the Bois de Boulogne and produced a number of seemingly effortless paintings, imbued with a buoyant intimacy and charm.

PIERRE-AUGUSTE RENOIR
Skaters in the Bois de Boulogne, 1868
Renoir celebrates the pleasures of the Bois in winter in this wonderfully animated image of the skating pond to the west of the park, near Longchamp. The frosty feel is enlivened by the odd splash of red in a scarf or in the trousers of the two imperial guardsmen who look on from the sidelines.

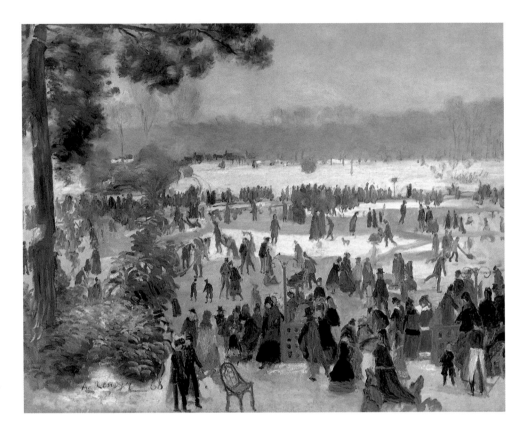

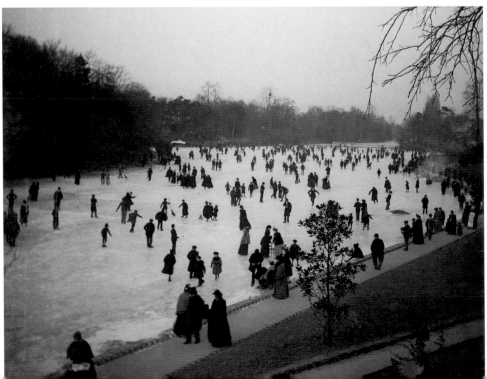

Period photograph of skaters
in the Bois de Boulogne, 1870s

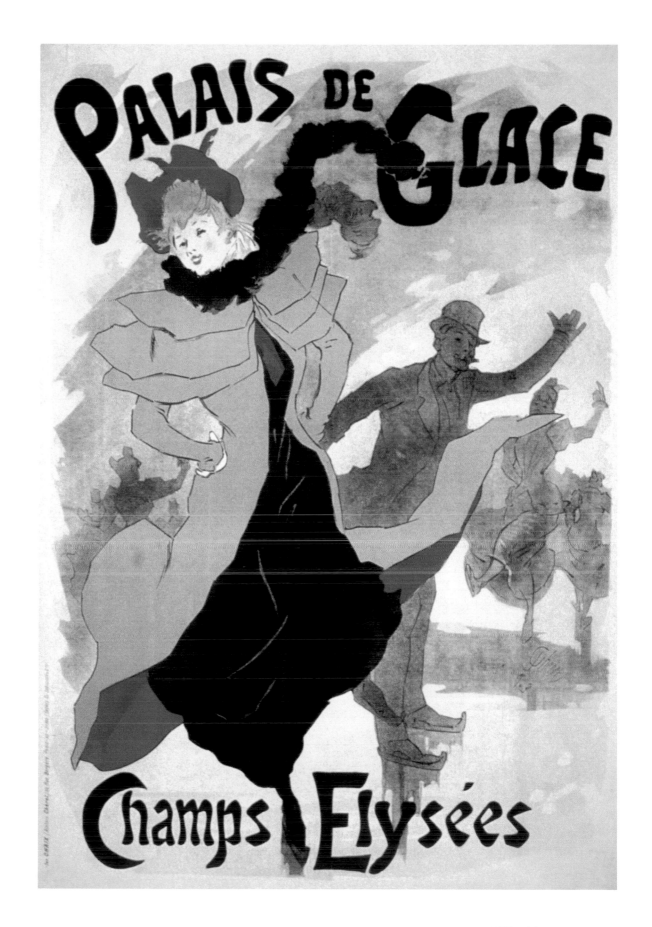

JULES CHÉRET,
Palais de Glace, 1893
A poster advertising the charms
of the Palais de Glace, which
opened its doors on the Champs-
Élysées in 1893.

EDOUARD MANET
The Game of Croquet, 1873

EDOUARD MANET
Summer at Boulogne, sketch of a game of croquet, 1868–71

WINSLOW HOMER
Croquet Scene, 1866

Croquet, which was first played by thirteenth-century French peasants who used crudely fashioned mallets to whack wooden balls through hoops made of willow branches, had become, by the time of the Impressionists, a gentle amusement for the leisured classes. It became popular in America around this time and civic leaders provided sets for public parks, which previously had not had facilities for any sport played on grass. Another novel feature of the game was that it could be played on equal terms by both men and women.

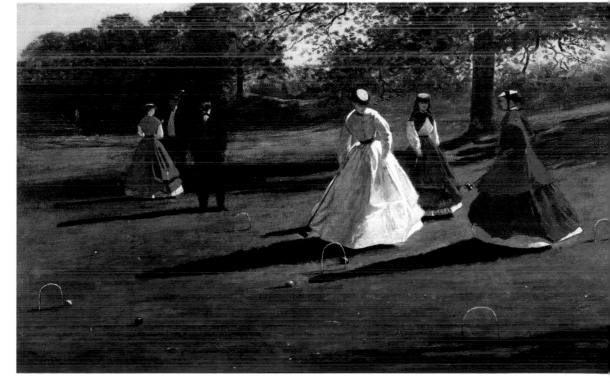

Berthe Morisot, Gustave Caillebotte, Claude Monet and the American Impressionist Childe Hassam all painted the Parc Monceau at different times. Created out of an elegant eighteenth-century garden on the edge of the eighth *arrondissement* and laid out in the English style, it had originally been designed for Philippe d'Orléans, but was now an oasis of calm open to the public and the upper-class inhabitants of the mansions which bordered it. Renoir referred to these scathingly as 'imitation castles', monstrosities with 'Gothic windows, coloured glass, no light and stairs you almost break your neck on'. Mary Cassatt, however, was a frequent visitor to the large *hôtel particulier* owned by her friend James Stillmann on the rue Rembrandt overlooking the Parc Monceau.

In October 1877 Monet – though far from rich at the time – installed his pregnant wife Camille and their little son Jean in a spacious apartment not too far from the Parc Monceau at

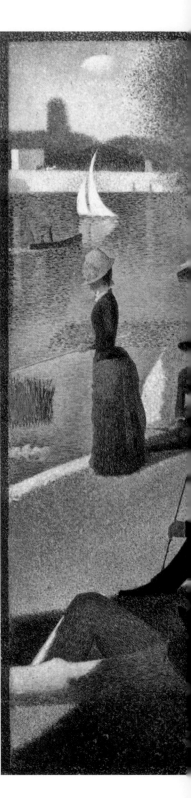

CLAUDE MONET
People in the Open Air, 1865

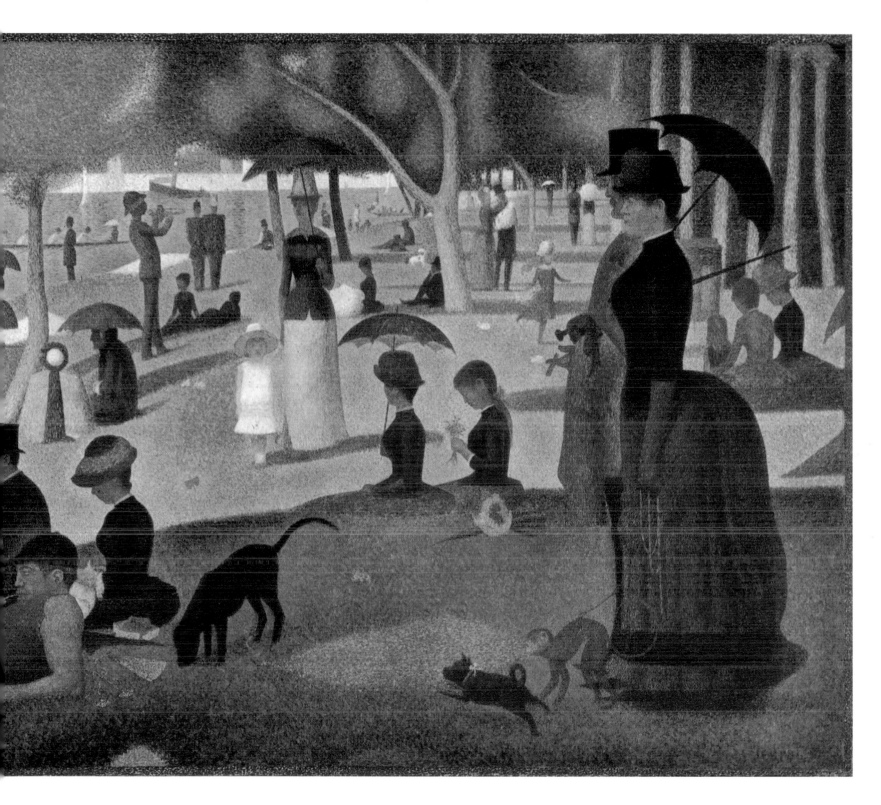

GEORGES SEURAT
A Sunday Afternoon on the Island of the Grande Jatte, 1884–6

This painting dominated the eighth and last Impressionist exhibition in May 1886, by virtue of its size, revolutionary technique and subject matter. Seurat, who sought to capture a social cosmos at the point of change as the emerging lower middle classes blurred together with the existing middle class, peopled his painting with everyone from nursemaids and soldiers to men in top hats and cloth caps, all enjoying the stillness and tranquility of a warm summer's day on the banks of the Seine.

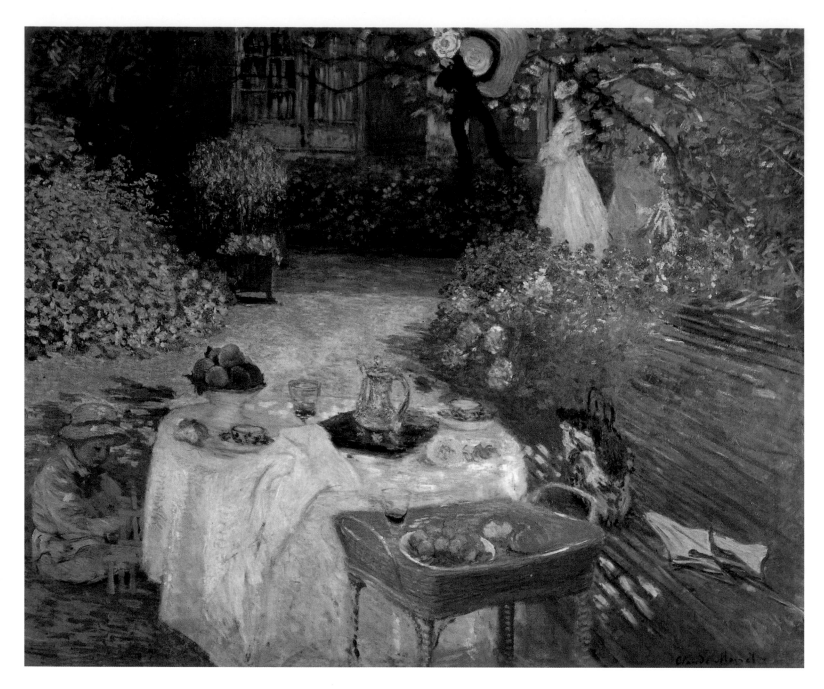

CLAUDE MONET

Le Déjeuner (The Luncheon), 1873

There is a seductive serenity to be found in the grace and beauty of the charmingly laid, untenanted table, set in a shady spot in Monet's garden at Argenteuil. Camille and another woman can be glimpsed in the background, while Monet's son Jean sits on the ground on the left absorbed in building a tower of blocks.

MARY CASSATT
Children in a Garden (detail), 1878
The motherly figure of an aproned nursemaid keeps
half an eye on her sleeping charge and the busy
figure at her feet fossicking in the flower bed, while
continuing with her knitting

Photograph of people relaxing in the Island of
the Grande Jatte
The elongated island of the Grande Jatte in the Seine,
just beyond the city limits, provided a bucolic retreat
for Parisians who flocked to the green park at the far
northwestern tip, facing the town of Courbevoie,
to picnic and play.

WILHELM BERNATZIK
Mother and Child in the Tuileries Gardens, Paris, 1883
More fashion plate than maternal figure, a stylish young
woman reclines on a chair in the Tuileries Gardens while
her little daughter is left to her own devices.

ALICE BARBER STEPHENS
A Spring Morning in the Park, 1892

26, rue d'Edimbourg. His leisurely paintings of a largely female world enjoying the charms of the park's winding paths, tidy lawns and neat flower beds are peaceful and beguiling. Young mothers and nursery nurses rest beneath large shady trees in the dappled light, chatting together, while their little charges disport themselves at their feet. Camille and Jean went there often in the months before the home birth of her second son, Michel, on 17 March 1878, but after that she became too unwell. There were complications from which Camille would never recover. Over the next year her health deteriorated and Monet's problems mounted as the price of his paintings fell following the bankruptcy of Ernest Hoschedé, a major supporter who was forced to sell his entire collection at catastrophically low prices.

Above all, the parks and gardens painted by the Impressionists give us a glimpse of the Sunday afternoon sites frequented by a working class who, thanks to hard-fought campaigns to lower the working day from twelve to ten (and eventually eight) hours, found themselves with more leisure time. Furthermore, the arrival of the railways and advances in transport meant they could now go further quicker and the suburbs and the seaside were beckoning.

A Time to Reflect
BOATING AND BATHING

'Are the sea baths beneficent for Madame Zola, and you yourself do you strike out through the salty waves?'

Cézanne from Paris, 24 August 1877, to Emile Zola who was staying with his wife at L'Estaque

'In a boat…it rocks, there is an infernal lapping of the waves; you have the sun and the wind, the boats change position every minute.'

Berthe Morisot to Claude Monet, 14 March 1888

On 3 July 1865 Renoir extended a beguiling invitation to Bazille to join Sisley, Sisley's older brother Henry and himself on 'a long sea voyage in a sailing boat' down the Seine to Le Havre where they would join Monet for the regatta:

We plan to stay there for about ten days and the whole expense will be around fifty francs. If you want to be part of it, I would be glad. There is room for one more on the boat. I am taking my paint box in order to make sketches of the places I like. I think it will be charming. There's nothing to keep you from leaving a place you don't like; nor anything to keep you from staying on in an enjoyable one. The meals will be frugal… We'll have ourselves towed as far as Rouen by the *Paris et Londres*, and from then on we're on our own. You don't have to feel embarrassed about refusing… Just answer.

CHILDE HASSAM
The White Dory, Gloucester (detail), 1895
Gloucester, a picturesque tourist town with a bustling harbour in the US, was just one hour by train from Boston and popular with artists, who put up in boarding houses and rented cottages. Hassam's sojourn there in the summer of 1895, in the company of Willard LeRoy Metcalf, proved productive for both men. *The New York Times* praised this painting for its 'brilliiancy' and 'realism of sunlight'.

PIERRE-AUGUSTE RENOIR
Oarsmen at Chatou, 1879
This is the first painting in which the young woman who would go on to marry Renoir – Aline Charigot – appears. Slender and demure, Renoir paints her about to step into a skiff, held steady by a local man. Rowing was considered a fine recreation for city dwellers, eager to escape the pressures of the metropolis. They laid claim to the river and were quick to embrace the idea of freedom and hedonistic enjoyment enshired in the simple business of boating.

They took their time, stopping off to visit the imposing cathedral at Rouen, and sharing the busy thoroughfare of the Seine down to Le Havre with steamers, tugs and schooners. Le Havre was where Monet's family lived, where he had been brought up and where, crucially, he had first met Eugène Boudin, that singular painter of limpid skies and peopled strands. 'The fact that I've become a painter,' Monet once said, 'I owe to Boudin.'

Boudin believed that painting in oils out of doors – which had only recently been made a practical possibility by the introduction of portable tubes of oil paints – was the best way of capturing a fleeting impression because 'everything that is painted on the spot has a strength, an intensity and a vividness that cannot be recreated in the studio'. The young Claude had spent his seventeenth summer painting alongside the older man on the Normandy coast. 'In his infinite kindness, Boudin undertook my instruction', he confided. 'My eyes were slowly opened and I finally understood nature. I learned at the same time to love it. I analysed its forms. I studied its colours. Six months later… I announced to my father that I wanted to become a painter and went off to Paris to study art.'

Some of Renoir's earliest paintings anticipated the holiday theme that would become an enduring Impressionist motif. His *Return of the Boating Party* – painted in 1862 when he was just twenty-one – shows barefooted young women in blue and white striped dresses, tucked up to keep them dry, descending the step ladder from a small sailing boat, which the sailors have run right up to the beach. Fashionable groups in contemporary dress or bathing costume stand about chatting amiably. A light wind catches the sail that a young boy is taking down and the ribbons on the girls' boaters flutter. Fluffy white clouds scud, children play; there is a dog. The whole scene is breezy and animated.

The summer of 1869 found Renoir staying with his parents in the village of Voisins-Louveciennes. Monet was close by in Saint-Michel with Camille and their little son Jean,

PIERRE-AUGUSTE RENOIR
Boating on the Seine (detail), 1879
An orange skiff containing two young women in light summer dresses and hats skims across the blue water, keeping close to the shore. Renoir makes a discreet nod towards Monet by including a steam train in the distance. This archetypal Impressionist image of recreation on the edges of Paris was bought by Victor Choquet.

PIERRE-AUGUSTE RENOIR
The Return of the Boating Party, 1862
An animated first attempt at a holiday theme by Renoir. Some have seen the influence of Boudin in this painting.

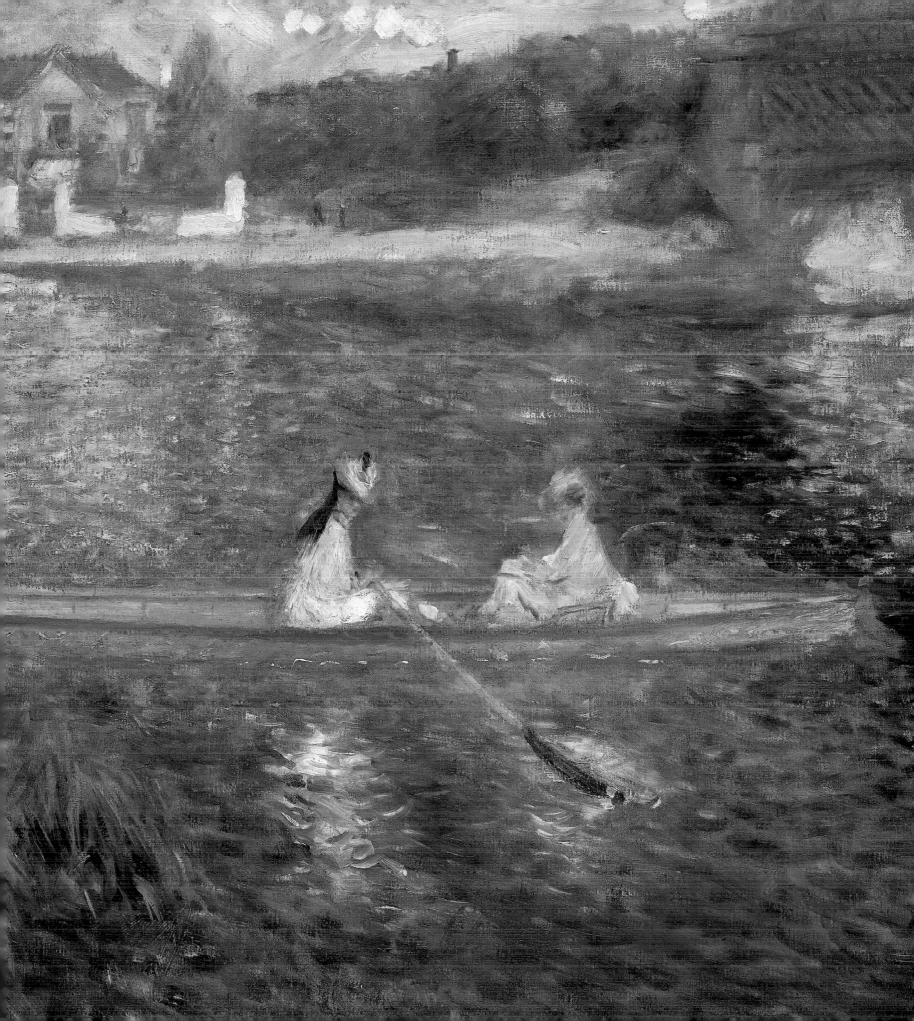

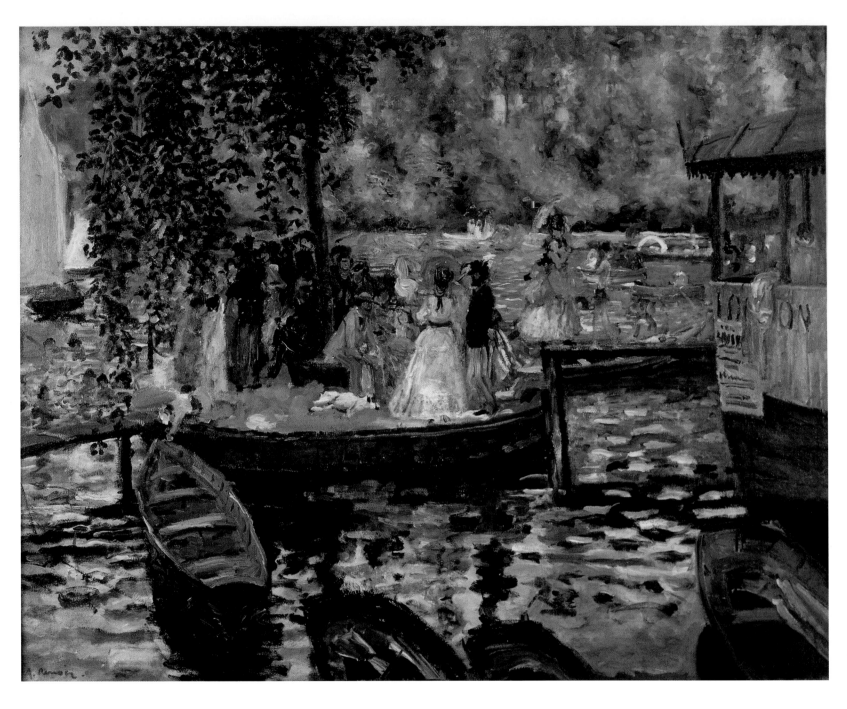

PIERRE-AUGUSTE RENOIR
La Grenouillère, 1869

D. YON
La Grenouillère, 1873

A bare-chested man holds a woman by the waist as she attempts a few strokes in the daringly mixed bathing area at La Grenouillère. Monet and Renoir made at least three paintings each of Parisians in pursuit of leisure in this Seine-side beauty spot.

CLAUDE MONET
Bathers at La Grenouillère, 1869
Two views of the floating café which Morisot's mother called 'a very rustic meeting-place for a very frivolous society.' In a letter of 1868 she observed: 'If one goes there alone, one returns in the company of at least one other person.' Monet's two women in bathing costume on the walkway being addressed by a man in a hat would seem to confirm Madame Morisot's reservations about the propriety of the place.

hatching a plan, 'a dream, a painting, the baths of La Grenouillère.' He had already done a few 'bad rough sketches,' he told Bazille, adding: 'but it is a dream. Renoir, who has just spent two months here, also wants to do this painting.' La Grenouillère (which translates literally as the Frog Pond) was a popular floating café and bathing establishment on the Île de Croissy in the Seine between Saint-Michel and Bougival, reached by crossing a small bridge. *L'Evénement Illustré* called it 'Trouville on the banks of the Seine' and it proved a powerful magnet for the noisy, well-dressed crowds of Parisian pleasure seekers who responded enthusiastically to the siren call of magazine advertisements and railway company posters. For the arrival of the railways had brought the surrounding countryside much closer. The train from the Gare Saint-Lazare

Messing about on the river

On 14 September 1891 Claude Monet wrote to Gustave Caillebotte from Giverny to let him know that: 'Your boat would be a big help to me just now. I'm painting a lot of pictures on the river Epte and am very uncomfortable in my Norwegian rowing boat. If you don't really need it, send it to me either by steamer to Vernon or Port-Ville lock, or by rail. Rail would be the most practical, I think. Drop me a line anyway.'

A keen sailor, Caillebotte was the Impressionist with the most experience when it came to boats. Wealthy enough to indulge his passion, he also explored the possibilities of designing boats for his own pleasure and for competition.

At the fourth Impressionist exhibition of 1879 he exhibited seven paintings of oarsmen on the River Yerres, in a range of boats, from traditional two-man rowing boats to the narrow, flat-bottomed single-seater *périssoires*, so called because of the precarious nature of their narrow design – their name in French derives from the verb *périr* (to perish or to sink) – which made them perfect for the shallow, tree-lined river. By far the most striking painting, however, is *Oarsman in a Top Hat*, in which a handsome young man, dressed for the city in a striped shirt, bow tie, dark suit and top hat, has stripped off his jacket and enthusiastically grabbed the oars of a wide-bodied row-

boat, which, from the angle of view, we can assume he shares with the artist.

A caricature in *Le Charivari* transformed the top hat worn by Caillebotte's blond bearded rower into a chimney stack belching steam – a pointed reference to the new wealth, created by the factories and new industries, which had lined the pockets of gentlemen rowers and provided them with the wherewithal to pursue their sport.

Rowing and boating were popular pastimes, promoted as 'useful, moral and salutary' forms of exercise. Enthusiasts extolled the virtues of filling the lungs with fresh air, developing muscles, working up an appetite (and working it off at Fournaise's), and generally promoting good health. But even boating could not escape the frictions of class – something both Caillebotte and Manet explored in their boating pictures, the former painting exclusively men in boats, showing them vigorous, active and focused on their exercise, while the latter – less interested in the physical effort such exercise entailed – concentrated more on the sexual significance of mixed couples out in boats together. There was a vast difference between the clean-limbed, high-minded sport of the bourgeoisie and the pleasure-seeking decadence of the riotous day trippers who frequented bathing spots like La Grenouillère and made use of the hired boats. This was the group Renoir and Monet had painted.

JOHN LAVERY
The Bridge at Grez, 1883

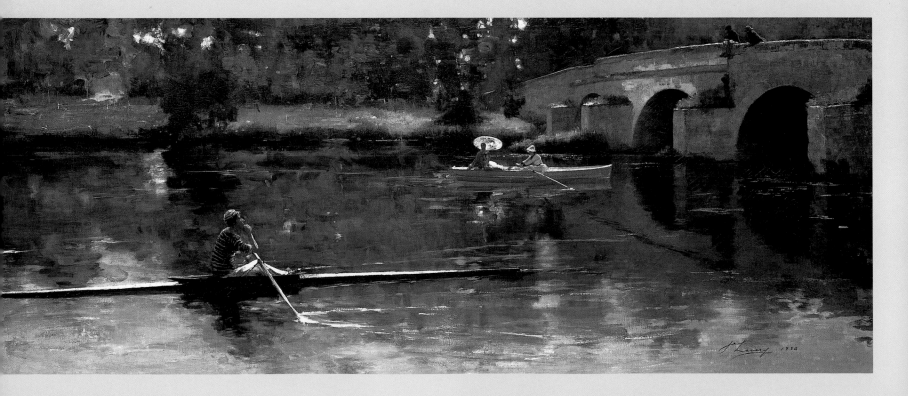

GUSTAVE CAILLEBOTTE
Oarsman in a Top Hat,
1877–8

CLAUDE MONET
*Boating on the River
Epte*, 1890

GUSTAVE CAILLEBOTTE,
Oarsmen (Canotiers),
1877

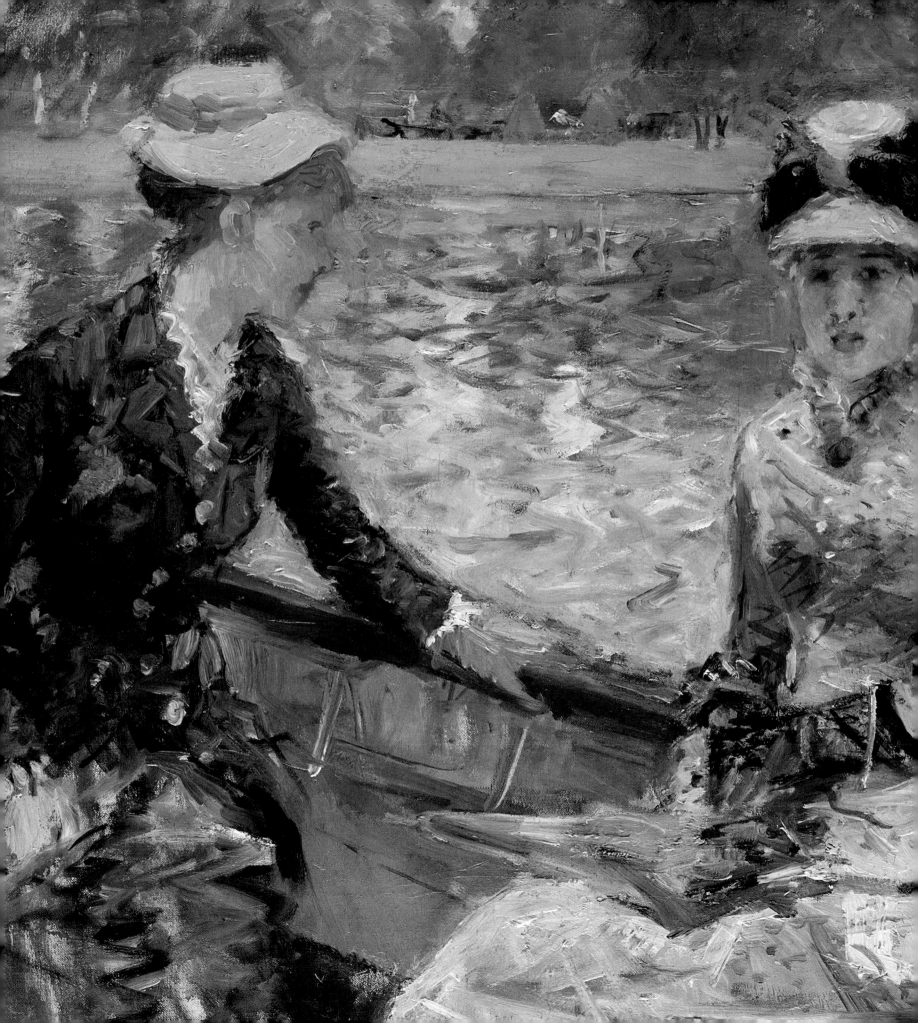

BERTHE MORISOT
Summer's Day, c. 1879
Berthe Morisot's painting depicts two young women in a boat, but neither handles an oar – instead they are on the little ferry which transported visitors to the small islands in the lake in the Bois de Boulogne.

PIERRE-AUGUSTE RENOIR
Rowers at Argenteuil, 1873

took just half an hour, cost just twelve sous and deposited them in a riverside paradise, albeit one governed by rules: 'Bathers must wear a bathing costume covering the body from knee to chest,' posted rules announced. 'Undressing, putting on costumes and dressing is forbidden except in the changing huts… Indecent or improper cries or gestures are strictly forbidden,' bleated the powers-that-be, though the rowdy crowd proved hard to control. Expectations were raised by titivating posters showing ample young women in revealing costumes moulded to curvaceous bodies, with, despite the knee to chest rule, plenty of leg on show. The canny owner of La Grenouillère made sure everything his guests would need was on offer: food, drink, bathing costumes, changing rooms, and boats and cabins to rent. 'Boats are moored all around the island,' *L'Evénement Illustré* dreamily reported, 'and the boaters, men and women alike, lie asleep in the shade of the great trees…'

Renoir and Monet set up their special folding easels side by side, unpacked their portable tubes of ready-mixed oil paints and began taking rapid notes of the strollers and capturing the gay animation of that easy-going, colourful crowd. Both experimented with bright colours and used swift, broken brushstrokes to capture the play of light on water, though Monet's focus is on the overall composition while Renoir's fascination is with the figures and their interaction, anticipating his later, more accomplished, painting *The Luncheon of the Boating Party*.

That painting was set on the terrace of the Restaurant Fournaise at Chatou, one of several islands sprinkled along the Seine, where Alphonse Fournaise – an expansive hotelier from Bougival described by Guy de Maupaussant as 'a mighty red-bearded, self-possessed individual of renowned strength' – had built a three-story riverside restaurant and hotel, which still stands today, incongruously surrounded by the untidy towering sprawl of the encroaching modern city. 'I remember an amusing restaurant there called Fournaise's,' Renoir recalled in conversation with his dealer Ambroise Vollard, 'where life was a perpetual holiday. The world knew how to laugh in those days! Machinery had not absorbed all of life; you had leisure for enjoyment and no one was

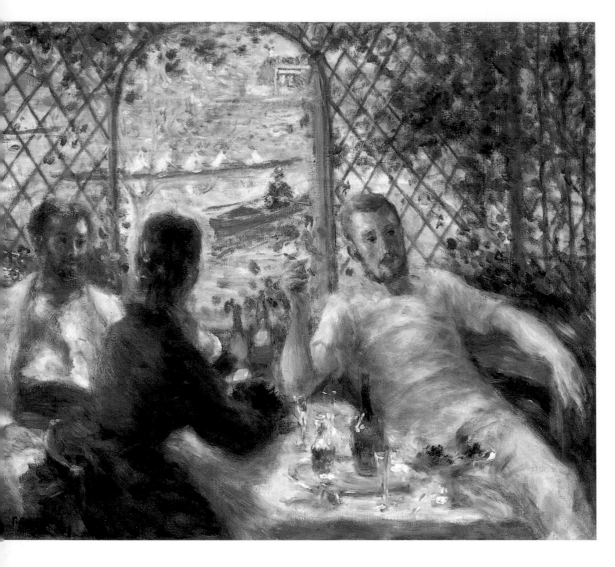

the worse for it.' Fournaise made sure that his restaurant became a magnet for a lively, gregarious and generally hungry new clientele by enlarging one of his buildings, adding a landing-stage and developing a flourishing sideline in boat hire.

Majestic, tall poplars bordered the grey-green glinting river and added their shade to that of the gaily striped awning over the broad terrace of the restaurant where lively parties, like the one depicted in Renoir's joyful painting, would sit over long delicious meals of tiny deep-fried river fish, freshly caught crayfish, and *matelote* – a stew prepared from the daily catch of river fish such as pike, perch, carp and eel – served with a mimosa salad and followed by the local speciality, a tart made with the delicious variety of *verte bonnes*, greengages, that grow throughout the Seine valley.

'I always stayed at Fournaise's,' Renoir recalled. 'There were plenty of pretty girls to paint… and…I brought him a good many customers.' 'Tumultuous' meals were prepared by Madame Fournaise and served by her daughter, 'the lovely Alphonsine', whom Renoir painted three times, and Degas – who stayed at Fournaise's in August 1874 during a walking tour, or 'nature cure' as he called it, along the banks of the Seine as far as Rouen – twice. The terrace provided the perfect place to linger over a cognac or a tiny cup of strong black coffee, fanned by gentle river breezes. Later, the diners could take a stroll in the surrounding fields, which were full of long, lush grass, flowers and a heavy tranquility conducive to a light nap. Alphonse's boats awaited the more energetic.

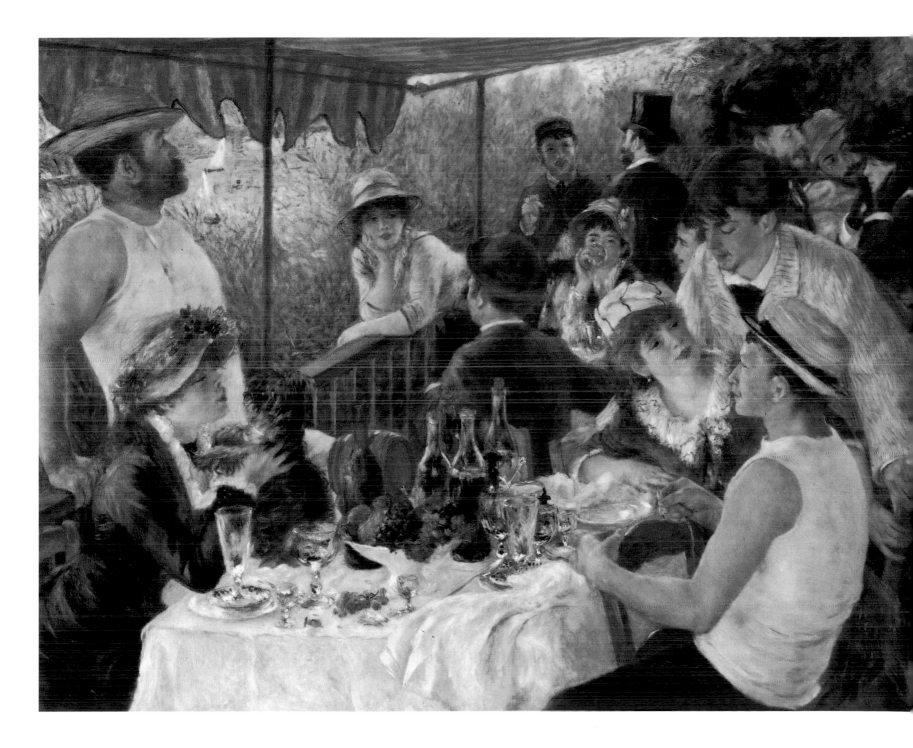

The brightly coloured crowd offered a rare treat to the local inhabitants, who gathered on the bridge to watch Alphonse steady the frail skiffs and offer his hand to the ladies as they stepped laughing into the bobbing boats. With the ribbons on their straw hats fluttering, they allowed themselves to be rowed leisurely down river, skirting the willow-bordered banks of the Seine, shady, still and mysterious in the afternoon warmth, to the rival, less respectable, La Grenouillère, at Croissy. Both establishments attracted a colourful flotilla of canoes and rowing boats, manned by muscular oarsmen with healthy appetites, in white flannels, or bare-armed, with bulging chests, ferrying young women in their Sunday best, their silk parasols blooming like strange flowers. Maupassant described the famous floating café in his short story *La Femme de Paul* (Paul's Mistress) as 'an immense raft, sheltered by a tarpaulin roof, joined to the charming island of Croissy by two narrow footbridges'. There was a riotous atmosphere of holiday and sexual license as the cheerful crowd of athletes, bathers and boatmen escorting their 'grenouillères' (young women of the frog pond) sat on the hard benches at scrubbed tables shouting encouragement to those diving from the roof or splashing about in the cool fish-filled river water. This raffish,

GEORGES SEURAT
Bathers at Asnières, 1884
Seurat shows his typical love of profiles in this stylized yet enchanting work, set in Asnières, an industrialized suburb of Paris (note the chimneys in the background). One can almost hear the boy in the blue and orange dotted hat, whistling or calling to a friend, breaking the otherwise absolute still and calm of the picture. The work was made before Seurat began using his pointillist technique, but he later went back and retouched parts to bring it up to date.

cheerful crowd would stay until evening, when the sinking sun glowed from beneath a sheet of red light and the smell of the grass mingled with the damp scents from the river, filling the air with a soft languor and producing that trick of light the Impressionists mastered so beautifully.

Gradually the idea of an ambitious painting depicting his friends lunching after a boating expedition began to take shape in Renoir's mind. He made preliminary sketches, and when, in 1880, he finally felt ready, his friend Baron Raoul Barbier made the reservation for the terrace of the Restaurant Fournaise and gathered together the friends who were to pose as models. These included the beautiful Geneviève Halévy, Bizet's young widow; the lovely Aline Charigot, whom Renoir would finally marry in 1890; the actresses Jeanne Samary and Ellen Andrée, who were frequent models for Renoir as well as Degas and Manet; the collector Charles Ephrussi; and Renoir's good friend Gustave Caillebotte.

There were times when Renoir felt that the scale and expense of the project might defeat him, though, as he explained to Paul Bérard 'one must from time to time try things beyond one's strength.' Yet, the final picture betrays none of his anxieties and is instead a joyful expression of Renoir's own expansive and harmonious attitude to life. Enjoyment radiates from the canvas and the interaction of the diners, their relaxed postures and garrulous, flirtatious engagement with one another all contribute to the painting's warmth and vibrancy and draw the viewer in. There's a comfortable feeling of plenty: the table in the foreground is generously provided with three opened bottles of wine and grapes trail casually from a laden fruit bowl. Champagne flutes, wine and cognac glasses sparkle on the shimmering white table cloth. And the patron himself leans, like the most cordial and contented of hosts, on the parapet, just behind Renoir's mistress, Aline, surveying the scene with all the benevolence of a man who has no intention of presenting a bill. For the good-hearted Alphonse was always happy to accept paintings instead of money, even though the hard-up Renoir, who was having a great deal of trouble selling anything at the time, warned him they had no value. Alphonse would simply laugh it off and say that he needed another canvas to hide a damp patch on his wall.

In fact Durand-Ruel's records show that Alphonse paid Renoir 16,000 francs in 1881 for *The Luncheon of the Boating Party, On the Terrace* and a group of smaller paintings. This was a considerable sum and meant that Renoir was able to set out on his travels with full pockets. He visited Venice, Rome, Naples. Boxing Day found him on Capri – 'a charming island, very tiny and everything you need to paint, grottoes of all colours, impossible to paint by the way.' Then, four years after his death in 1923, Durand-Ruel handled the sale of the painting once again to the American collector Duncan Phillips for $125,000. A measure of its more recent worth is reflected in the ten million dollar insurance tag attached to it in 1982 when the painting travelled from Washington for an exhibition abroad.

When we look at the painting today it fills us with a nostalgic longing for something past, but for Renoir the scene was intensely, definingly modern and represents a deliberate attempt to record contemporary, everyday life. Sundays in the country, the new enthusiasm for the outdoors and sporting amusements, the fashions of the women and their casual interaction with the men – all these things were new. Renoir was the only true working-class member of the Impressionist group and here he captures a social cosmos at the point of change, as the emerging lower middle classes blur together with the middle class.

This theme Seurat continued a few years later when he peopled both *Bathers at Asnières* and his vast *A Sunday Afternoon on the Island of La Grand Jatte* (see pp. 74–5) with a mixture of people in top hats and cloth caps, all enjoying the stillness and tranquility of a warm summer's day on the banks of the Seine. Seurat's preference was for the ordinary, for suburban and rural sites and for figures, usually anonymous, from the lower echelons of society. But by working on a grand scale (the painting is about three by two metres, or ten by seven feet), he gave his subjects a monumentality which elevated them to the status of high art.

Overleaf EUGÈNE BOUDIN
Beach Scene, Trouville (detail), 1860–70
Boudin's genius is signalled in the way he sandwiches the lively line of holidaymakers in between the expanse of beach and the blue of the sea and the sky.

The thirty-one-year-old James McNeill Whistler and his mistress Joanna Hiffernan (who posed for *Symphony in White, No. 1: The White Girl*) spent the autumn of 1865 in a 'splendid apartment overlooking the sea' at the Hotel du Bras d'Or, in the fashionable resort of Trouville, soaking up the last rays of the sun, bathing in the sea, and – in Whistler's case – painting 'the prettiest women in Trouville'. He was often to be found in the company of the older artist Gustave Courbet, who reminisced in a lyrical letter written a dozen years later about their idyllic 'bathing on a frozen beach, and the salad bowls full of shrimp and fresh butter'; about their opportunities to 'paint the sky, the sea, and the fish all the way to the horizon' for a 'payment' which 'consisted of dreams and sky.'

It may have been the tail end of the season but it proved a productive time for Whistler. He completed thirty-five canvases in three months, including five seascapes and several portraits.

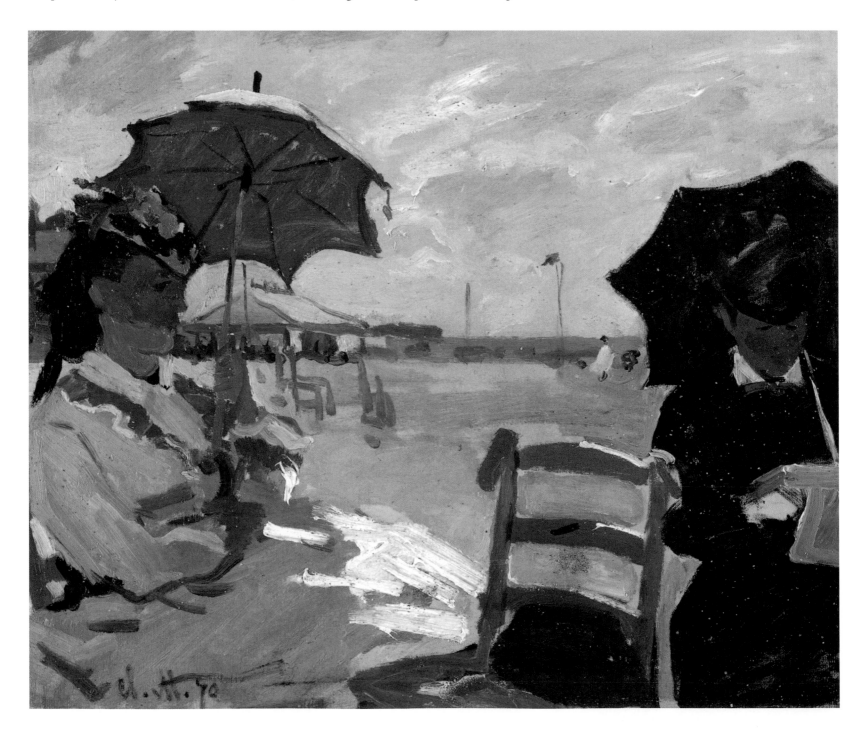

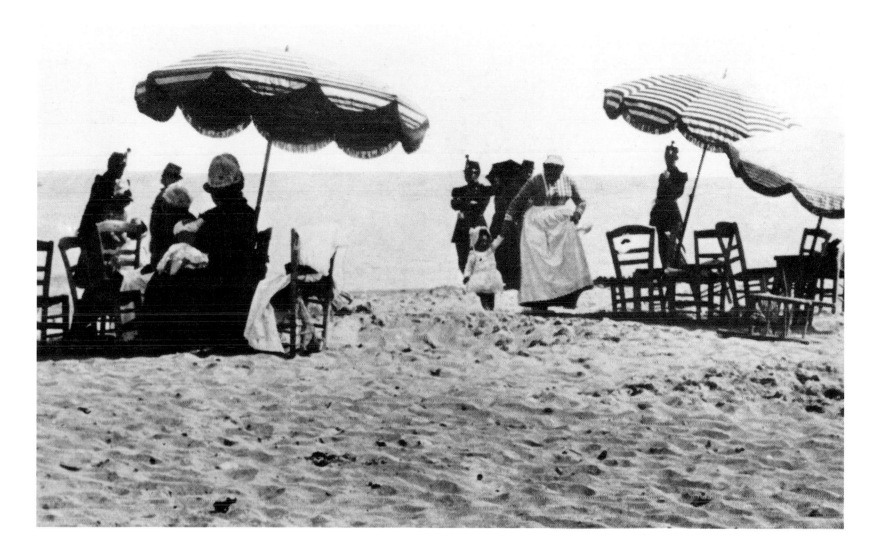

Photograph of the beach at Trouville, c. 1890
A broad-beamed nursemaid leads a small child up the beach past encampments of upright chairs and gay, striped parasols. The uniform of the guardsmen in the background makes this an even more colourful scene.

CLAUDE MONET
Beach at Trouville, 1870
Camille on her honeymoon at the smart watering-hole of Trouville, with Madame Boudin.

Unlike Eugène Boudin, who also painted at Trouville around this time, Whistler often turned his gaze away from the elegant crowd and the busy esplanades and out towards the distant horizon and wide stretch of almost empty beach. Boudin made a special study of the bustling smart set at Trouville, painting the Empress Eugénie and her entourage in a dazzling swirl of crinolines and the fashionable folk clustered together along the margin of a wide sandy stretch in *On the Beach at Trouville* which he submitted to the Salon in 1864.

Monet's links with Boudin encouraged him to spend his honeymoon at the Hotel Tivoli in Trouville, where, in 1870, he painted his new wife Camille three times: in white with her back to the sea, again in blue and white stripes and a third time in a flowered hat and veil, with a jaunty blue parasol raised against the sun as she sat on a straight-backed rush-seated chair in the company of Madame Boudin. The empty seat between the two women might have been Monet's, only just vacated – the painting has sand on its surface, blown onto the wet canvas as Monet worked, confirming that it must have been at least partly executed on the beach. After the poverty of their early life together and the censure she'd suffered from Monet's family as an unmarried mother, these were happier days for Camille, though she would live only another nine years. Boudin, recalling this magical summer before the war and the deaths of Camille and his own wife Marie-Anne, wrote to let Monet know that he still had a sketch of the two women and of 'Little Jean playing in the sand, and his papa sitting with a sketchboard in his hand.'

ADOLPHE MAUGENDRE,
Trouville, View of the Beach and the Roches-Noires, 1867

CLAUDE MONET
On the Boardwalk at Trouville, 1870

Opposite CLAUDE MONET
Hôtel des Roches Noires, Trouville, 1870
While on honeymoon Monet painted the imposing
Hôtel des Roches Noires (named after the seaweed-
covered rocks) with fluttering flags to signal the
international flavour of the clientele. Monet and
Camille were not, however, resident in one of the 150
guestrooms – their finances could stretch only to the
more modest Hôtel Tivoli set well back from the
seafront.

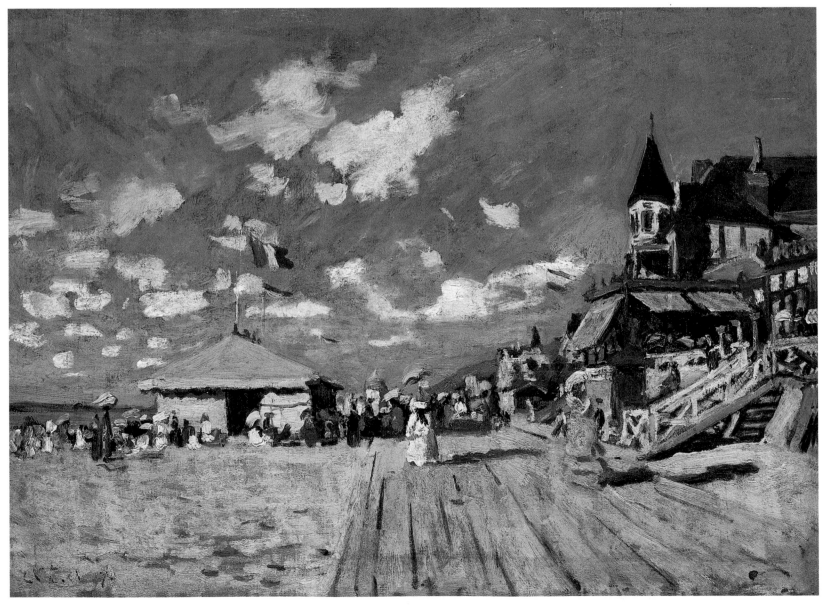

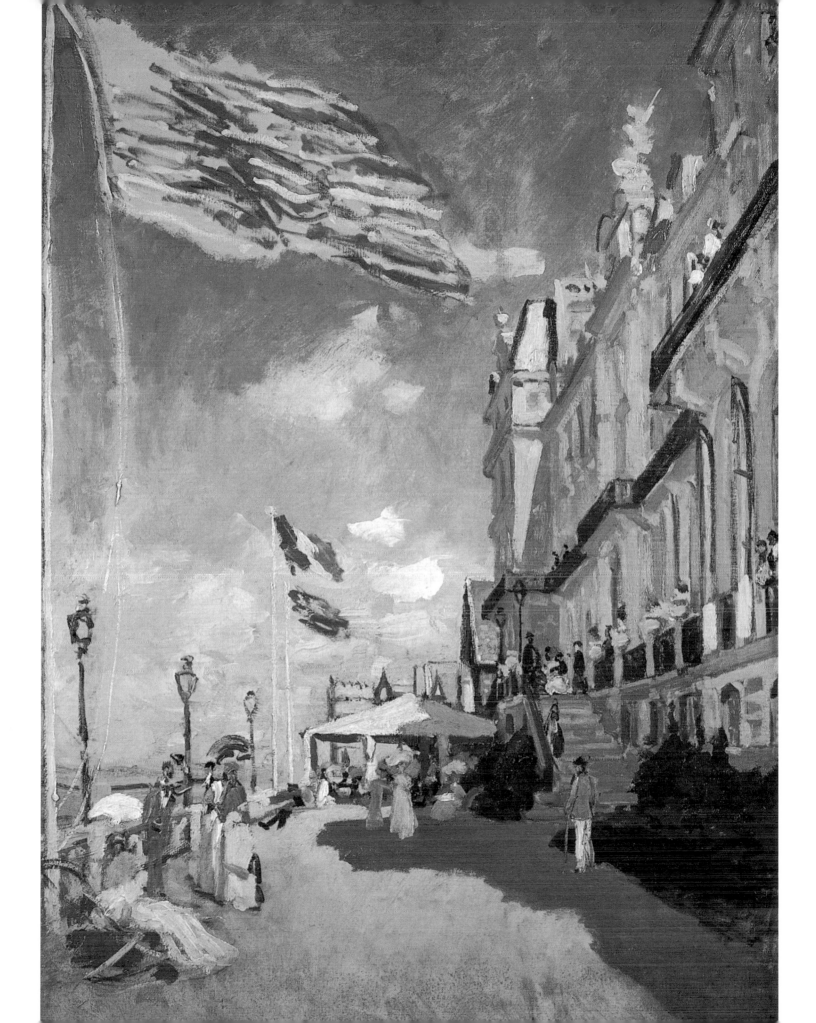

In 1876 Henry James sailed down the Seine from Rouen to Honfleur, which he described laconically, from the window of the Hotel Frascati, as a place which 'has its charms'. The weather was close and James found it 'very agreeable at the end of a hot journey, to sit down to dinner in a great open cage, hung over the Atlantic, and, while the sea breeze cools your wine, watch the swiftly moving ships pass before you like the figures on the field of a magic lantern.' He continued along the coast extolling the 'delightful combination of cheap and pleasant qualities' to be found at another favourite haunt of the Impressionists: Étretat. For James, Étretat was 'sacred to tranquil pleasure.' Everything there delighted him: the fine cliff scenery, the excellence of the five-franc dinner at the resort's principal hotel, the simple seaside life which encouraged the wearing of old clothes, canvas shoes and a fisherman's hat to 'deck your head' and where, for

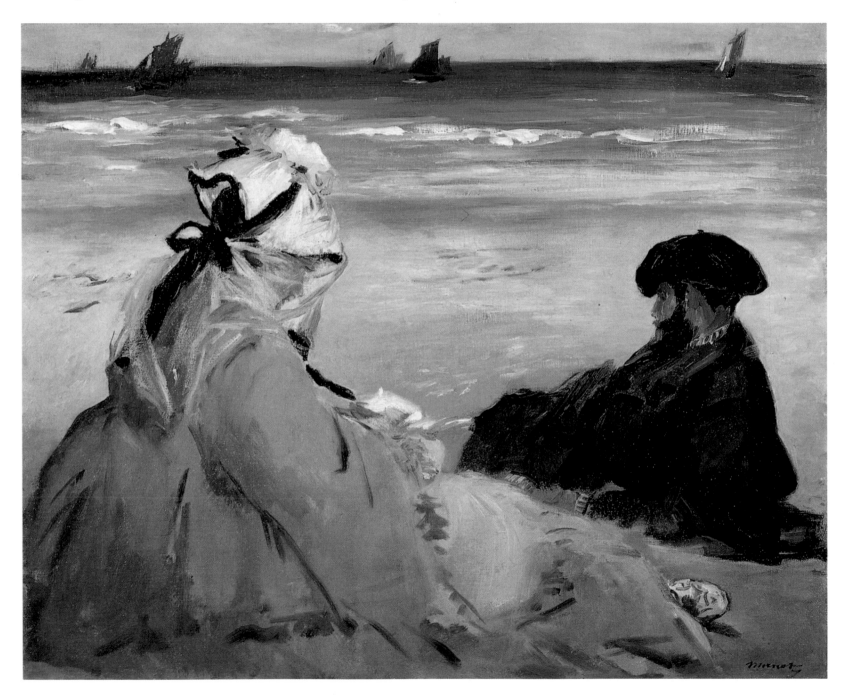

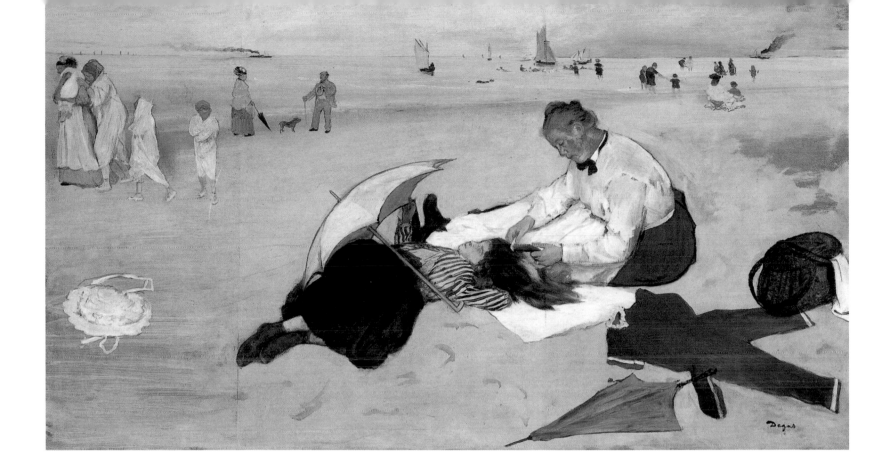

EDGAR DEGAS
Beach Scene, 1869–70
Berthe Morisot – well aware of the demands and contradictions of *plein-air* painting – was full of admiration for this picture. The subject of hair-combing was one Degas would return to again and again in monotypes and pastels, though never again with the transparent innocence of this outdoor scene.

EDOUARD MANET
At the Beach, 1873
Edouard Manet spent a three-week family holiday at Berck-sur-Mer in July 1873. He painted his wife Suzanne seated on the sand reading (through a gauzy veil) while his brother Eugène – who would go on to marry Berthe Morisot the following year – rests on his elbow beside her, lost in thought. Unlike his Impressionist friends, Manet usually painted in his studio but this picture also appears to have been executed on site, for experts have detected grains of sand still in the paint. The monumentality of the figures placed in the foreground of the picture, and occupying most of the space, contrasts sharply with Boudin's wide beach scenes.

'a few coppers daily' you could hire 'bathing toggery' and 'lie on the pebbly strand most of the day, watching the cliffs, the waves, and the bathers.' In the evenings he recommended his American readers to 'loaf about the Casino.'

Just a few years before James was writing, Degas painted *Beach Scene*, a striking composition dominated by the central figure of a young girl lying on her back on the sand half-covered by a parasol, with her dark hair spread out on a white sheet for an older woman carefully to comb through. Beside her, like a sloughed skin, her demure bathing costume is spread. In the background women and children bathe, watched by a seated woman and a small child. A man in a light suit doffs his hat to a woman with a little dog and three children huddled into white sheets hurry after their nurse who is carrying an infant bundled up in her arms. Steamers and sailboats make the scene lively.

James took particular delight in watching the bathers from his camp chair planted among the pebbles. Wearing white flannel for 'coolness, convenience and picturesqueness', he observed how the French used their beaches not 'as places for a glance, a dip, or a trot' as in America, but as outdoor rooms. 'They love them,' he wrote, 'they adore them, they take possession of them, they encamp upon them. The people here sit upon the beach from morning till night; whole families come early and establish themselves, with umbrellas and rugs, books and work. The ladies get sunburnt and don't mind it; the gentlemen smoke interminably; the children roll over on the pointed pebbles and stare at the sun like young eagles.'

But his best amusement was the spectacle of 'the bathing, which has many entertaining features, especially for strangers, who keep an eye upon national idiosyncrasies. The French take their bathing very seriously…it quite fills out their lives. The spectators and the bathers commingle in graceful promiscuity; it is the freedom of the golden age. The whole beach seems to be a large family party.'

A party, moreover, without 'prudish prejudices'. For James found there was 'more or less costume', though 'the minimum rather than the maximum is found to prevail.' He watched

scantily clad bathers emerge from their dressing huts, drop their white sheets on the stones and stand stretching for a few minutes before entering the water. 'Like everything in France, the bathing is excellently managed,' he reassured his American readers. 'You feel the firm hand of a paternal and overlooking government the moment you issue from your hut. The government will on no consideration consent to letting you get drowned. There are six or eight worthy old sons of Neptune on the beach – perfect amphibious creatures – who, as you are a newcomer, immediately accost you and demand pledges that you know how to swim. If you do not, they give you much excellent advice, guide your infant steps, and keep an eye on you while you are in the water. They are, moreover, obliged to render you any service you may demand – to pour buckets of water over your head, to fetch your bathing sheet and your slippers, to carry your wife and children into the sea, to dip them, cheer and sustain them, to teach them how to swim and how to dive, to hover about, in short, like trickling Providences. At a short distance from the shore are two boats, freighted with more of these marine divinities, who remain there perpetually, and take it as a personal offence if you catch a cramp or venture out too far.'

He was delighted to see that everyone swam – the men, the women and the children – and well, too. 'I have been especially struck with the prowess of the ladies,' he confided, 'who take the neatest possible headers from the two long plunging boards which are rigged in the water upon high wheels…the sea is a blue as melted sapphires, and the ragged white faces of the bordering cliffs look like a setting of silver. Everyone is idle, amused, good-natured; the bathers take the water as easily as mermen and mermaids…the swimmers dip and rise, circling round the boats and playing with the children.' Yet this mixed bathing, which Monet and Renoir chronicled at La Grenouillère as early as 1869, was strictly a continental practice; when introduced at a few of the more daring British resorts it provoked much outraged correspondence – indeed, one indignant bather wrote to the *Scarborough Gazette* to rail against 'this French style of bathing' (though mainly, it transpired, because it meant that he could no longer enjoy his 'manly and health-giving exercise as unencumbered as possible' – that is without the bother of having to wear a costume at all).

In fact the attraction was more likely to be the sight of the female form in the clinging stockinette costumes which had replaced the unwieldy and uncomfortable flannel, serge or calico one piece knee-length costumes, though the male body, too, was all too clearly revealed, when the costumes were wet. Bathing costume designers sought to preserve female modesty by devising short frilled false skirts for the ladies' bloomered costume, although the 'bust adjuster' which provided what advertisements called 'that charming dip-front effect' ensured that little was left to the imagination above the waist.

For the children – and for Degas – there were Punch and Judy shows or donkey rides. Degas found the '*vrai Guignol*' he paused to watch on the Esplanade at Cauterets – while holidaying at the Hôtel d'Angleterre in August 1888 – 'preferable to everything' though he told his friend Bartholomé that he was not brave enough to 'speak to Punch like the children sitting on the benches, whose advice Punch takes or scorns according to his mood.' For their mothers there was the passing scene, best viewed from a deckchair, a novel piece of stackable furniture which had first made its appearance on the decks of the Peninsular & Orient Navigation Company's large passenger liners running to and from India and the East. As James noted whole families would stay on the beach all day, taking picnics and making use of the newly invented Thermos vacuum flasks to kept drinks hot or cold.

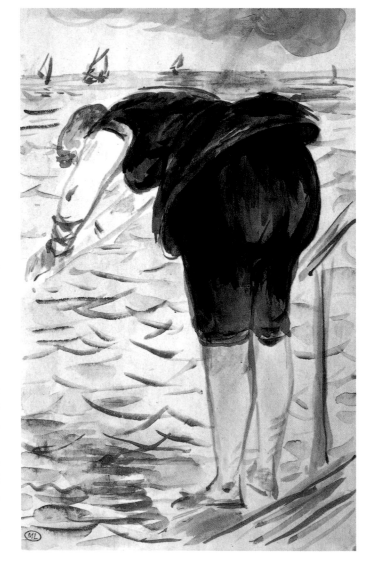

EDOUARD MANET
Isabelle plongeant, 1880
Manet had a special feeling for Isabelle Lemonnier, the daughter of an important jeweler and the younger sister of Madame Georges Charpentier. In the summer of 1880 – while undergoing hydrotherapy treatment and a rest cure at Bellevue – Manet amused himself by sending his young friend a series of charming letters illustrated, like this one, with fresh and spontaneous watercolour drawings.

Photograph of Gustave Caillebotte throwing stones on a beach, 1877–9 Caillebotte's austere city costume makes no concession to the beach, but his enjoyment appears genuine enough.

September 1883 found Renoir and Aline in the Channel Islands. 'Here we bathe among the rocks that serve as cabins since there is nothing else,' Renoir wrote to Durand-Ruel from Guernsey on 27 September. 'There's no better sight than this mixture of women and men crowded together on these rocks. You would think you were in a landscape by Watteau rather than real life.' Renoir loved seaside holidays and returned again and again to Brittany, from where he wrote to Berthe Morisot: 'I have ended up at Pornic, where I'm teaching my boy to swim. All's well in that quarter, but I've got to get down to some landscapes.'

Between 1884 and 1886 Degas was a frequent visitor to the Halévys' large summer house at Dieppe, situated on a strip of pebbled beach between the chalk cliffs and the sea. Dr Emile Blanche – one of Berthe Morisot's old friends and neighbours – owned the next-door villa, to which he had added a studio for his son Jacques-Emile. There Degas met up again with Walter Sickert who Whistler had introduced him to in Paris. 'I think he was happy there', Daniel Halévy wrote.

Photograph of Toulouse-Lautrec swimming, c. 1899
This serene photograph of Toulouse-Lautrec luxuriating on his back in the sea off the Normandy coast belies the fact the year had begun for him with a serious nervous breakdown. Increasingly concerned about his alcoholism, his mother had arranged for Paul Viaud to watch over her son. Lautrec called him his 'dry nurse' but the two men shared a love of the sea and of fishing and, though alcohol would destroy him within two years, here, at least, we see him shiningly happy.

HENRI DE TOULOUSE-LAUTREC
The Passenger from Cabin 54, 1896
Lautrec never learned the name of the orange-haired occupant of cabin number 54 on the Le Havre to Bordeaux steamer whose dreamy gaze he captures in this lithograph.

Sickert and his wife lived in Dieppe at the Maison Goude, 21 rue de Synagogue, where Whistler stayed for a short time in the autumn of 1885. He took the opportunity to dash off a number of fine watercolour sketches. *Green and pearl – La Plage, Dieppe* gives a glimpse of the passing scene on a fine day with tents and bathing machines, changing rooms and groups of people strolling about or sitting on the sands watching the world – described by Baedeker as 'amusing' – go by.

The irrepressibly ebullient American Impressionist Childe Hassam spent the summers in New England where he and his wife Maud mixed with a lively group of artists and writers including Theodore Robinson, John Twachtman and Celia Thaxter. Hassam worked and played hard. He loved swimming, especially in the ocean, which also yielded his favourite foods. At Appledore he boasted in a letter (to Florence Griswold, written July 1907) of having eaten 'the north side of a haddock for breakfast, a bucket of fish chowder for dinner and a few broiled live lobsters for supper.' To his fellow painter J. Alden Weir he wrote: 'The rocks and the sea are the few things that do not change and they are wonderfully beautiful – more so than ever!'

A Time to Shop
STREETS AND THE CITY, DEPARTMENT STORES AND ARCADES

'It was a day to spend in the streets and all the world did so. I passed it strolling half over the city and wherever I turned I found the entertainment that a pedestrian relishes. What people love Paris for became almost absurdly obvious: charm, beguilement, diversion were stamped upon everything.'

Henry James, Parisian Sketches

Henry James's ambulatory inclinations were amply matched by his young compatriot, Childe Hassam, who, in 1886, returned to Paris after an absence of three years. The twenty-seven-year-old painter liked to roam the steep streets of Montmartre, close to the apartment and adjoining studio he and his new wife, Maud, had rented in the heart of the artists' quarter at 11, Boulevard de Clichy. Puvis de Chavannes and Giovanni Boldini were neighbours, as was the American artist Frank Boggs. Renoir, Bazille, van Gogh, Toulouse-Lautrec, Cassatt, Degas, Pissarro, Seurat and Signac all had studios there at one time or another.

The young American never went out without his sketchbook and would make rapid sketches, capturing the lively street scene, his eye often drawn by the attractive young shopkeepers and flower sellers. *La Frutière*, for example, with her pretty ankles and coquettish hand on hip, or the white-aproned dairy woman in *La Bouquetière et la Laitière*. William Henry Howe, writing in 1895, called him 'a sort of Watteau of the Boulevards' and, when asked what his 'greatest amusement' had been, Hassam replied 'To go about Paris.' It was a favourite pastime, too, for many of the French Impressionists who responded with great enthusiasm to

CAMILLE PISSARRO
The Poultry Market, Gisors, 1885
Pissarro captures the bustle of his local Monday market in Gisors. A life-long socialist and 'rustic by nature' he treats his subjects with great simplicity and dignity and focuses on the independent female entrepreneurs standing patiently alongside their poultry and eggs.

CHILDE HASSAM
La Bouquetière et la Laitière, c. 1888
A young dairy woman lounges in her doorway, flanked by a line of milk cans against the wall of her shop, looking down at the blonde flower seller kneeling to rearrange the flowers in her basket.

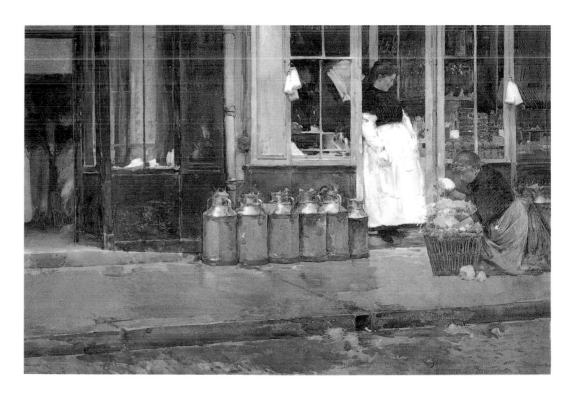

Baudelaire's call 'for the perfect *flâneur*...the passionate spectator,' to 'set up house in the heart of the multitude, amid the ebb and flow of movement, in the midst of the fugitive and the infinite' where he might experience 'immense joy'.

Sunday morning walks in the city had been an important part of Renoir's upbringing. He often recalled how, after attending church, the little family group would stroll along the quays towards Notre Dame, breathing in the scents of the city: the strong smell of leeks from the market mixing with persistent scent of lilac. 'You can't imagine how beautiful and amusing Paris was', he told his son, recalling the narrow streets of his youth. But Paris was changing. It was rapidly becoming the capital of pleasure. A beguiling city through which to stroll certainly, but also a fascinating place in which to lose oneself amid the dreamlike nameless faces of the crowd. Unlike Hassam, who highlighted the 'more smiling aspects of life', the French painters were interested in getting behind and commenting upon the high drama and modernity of the scenes they found being enacted in the streets. Their capital had become a city of tourism, entertainment, shopping and light. The vast circulatory system of the boulevards kept everything moving, while the new shopping arcades provided pleasurable places to pause and marvel. Eager crowds came to consume and enjoy the dazzling display of luxury goods, alluringly arranged against mirrors and glass and brought alive by the soft seductive light of the overhead gas fittings. No other city could boast such brilliance, opulence and display. And – best of all – the splendour of the modern city was available to anyone who walked in these spaces. It proved a heady mix for Manet's friend Charles Baudelaire, who described the erotic charge of yearning after a stranger, a beautiful passer-by, in one of his poems. Both voyeuristic and romantic, he described it as a kind of madness, the 'sweetness that fascinates, the pleasure that kills', as a longing for the impossible and for 'love at last sight.'

CAMILLE PISSARRO
Place du Théâtre Français, 1898
A number of Impressionists made aerial views of the street. Pissarro painted this bustling scene from a rented room in the Hôtel du Louvre. 'I did my painting no matter where,' he boasted in a letter of 1893 to his son Lucien, 'in all seasons, in heatwaves, rain, terrible cold, I found the means to work with enthusiasm.'

JEAN-FRANÇOIS RAFFAËLLI
Boulevard Haussmann, Paris, c. 1880

GUSTAVE CAILLEBOTTE
Paris Street, Rainy Day, 1877
Contemporary critics complained about the lack of
rain in Caillebotte's remarkably modern painting. The
people he pictures almost appear to be using their
steel-framed umbrellas defensively, to carve out a
pocket of private space for themselves, and ward off or
discourage any interaction with passers-by – especially
the two principal figures who seem deliberately to
avoid eye contact with the viewer.

A Rainy Paris Street by Mars in *Paris Brillant*, 1890
A gentleman with his trousers rolled swivels round to
watch a woman with her skirts held up hurry along the
puddled pavements.

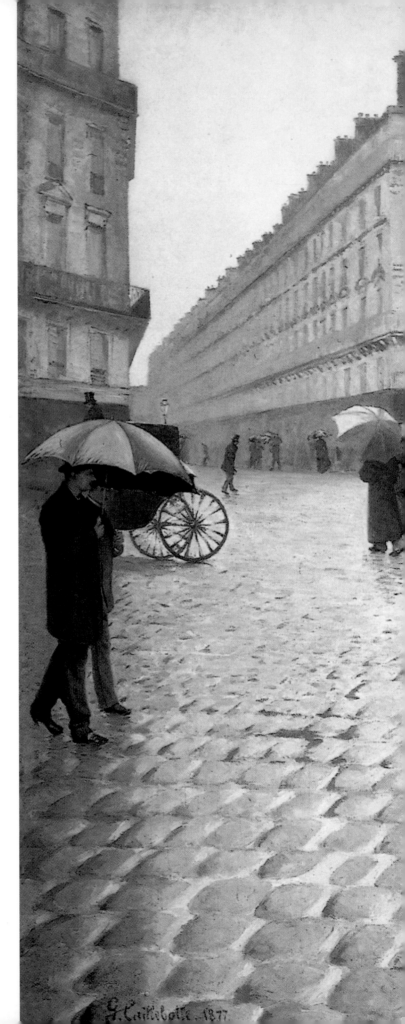

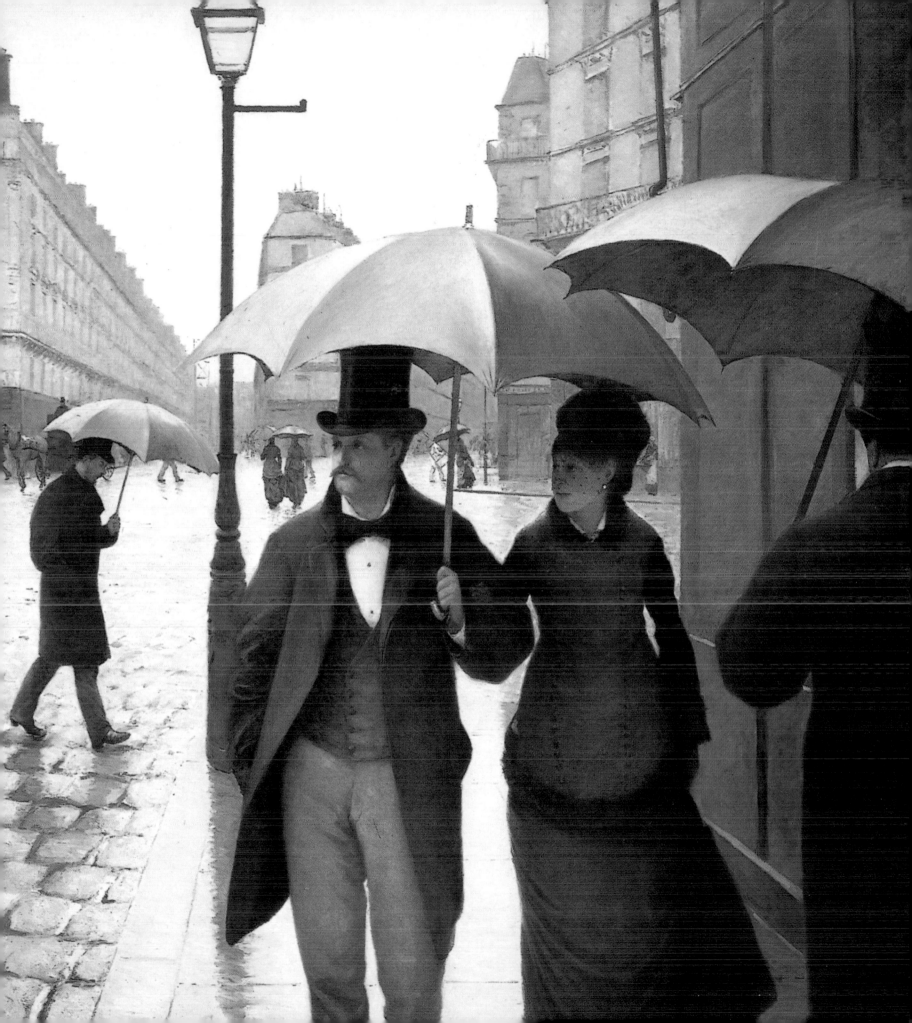

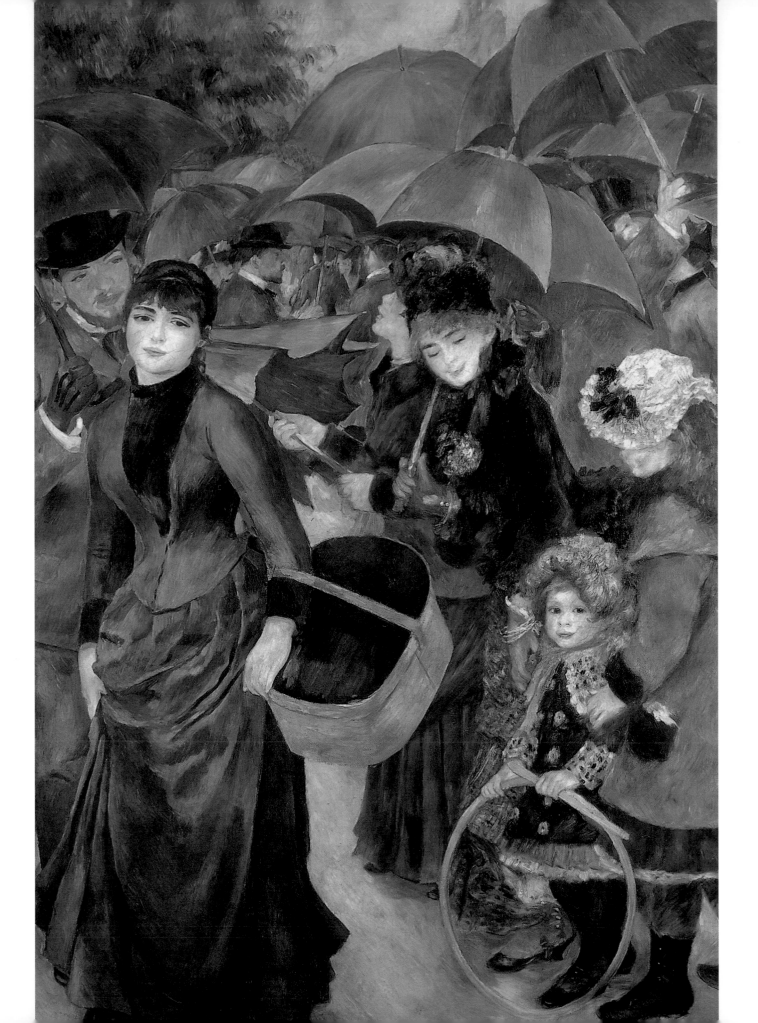

PIERRE-AUGUSTE RENOIR
The Umbrellas, c. 1881–6
Renoir's mistress Aline Charigot modelled for the girl with the basket and his friend Paul Lhote for her rather insistent admirer. The canopy of black silk umbrellas which were lined with a mauve or violet fabric enclose the scene and make the viewer part of the action. Both Aline and the little girl with the hoop appear to be looking directly at us.

Rue Lepic, Montmartre, Paris
Running up to the heights of Montmartre, the rue Lepic was – and is – a shop-lined street, busy here with people on their various errands.

The anonymity of the modern metropolitan crowd provided cover for irresponsibility, voyeurism and exhibitionism. It encouraged small, stealthy acts of sexual subversion and flirtation. In the city street, where almost all passers-by were strangers, the individual could pass through in his own private zone and some commentators have detected evidence of the covert, coded moments such anonymity permitted in paintings like Caillebotte's *Pont Neuf*, with its discreet references to homosexuality, and Renoir's *Umbrellas*, in which the game of sexual attraction, dalliance and the chase is played out.

The idea that respectable women out and about in the street might fall prey to the unwelcome attention of men or simply be exposed to the rude and raking gaze of the inquisitive crowd exercised the minds and ingenuity of the nineteenth-century urban bourgeoisie. An elaborate code of outdoor dress developed to shield women from the perils of the street. Veils, cloaks and bonnets were employed to distance the middle-class woman from the common crowd. These clothes tended to be dark – as they are in Renoir's *Umbrellas* – so that they would not show the mud and marks of the streets.

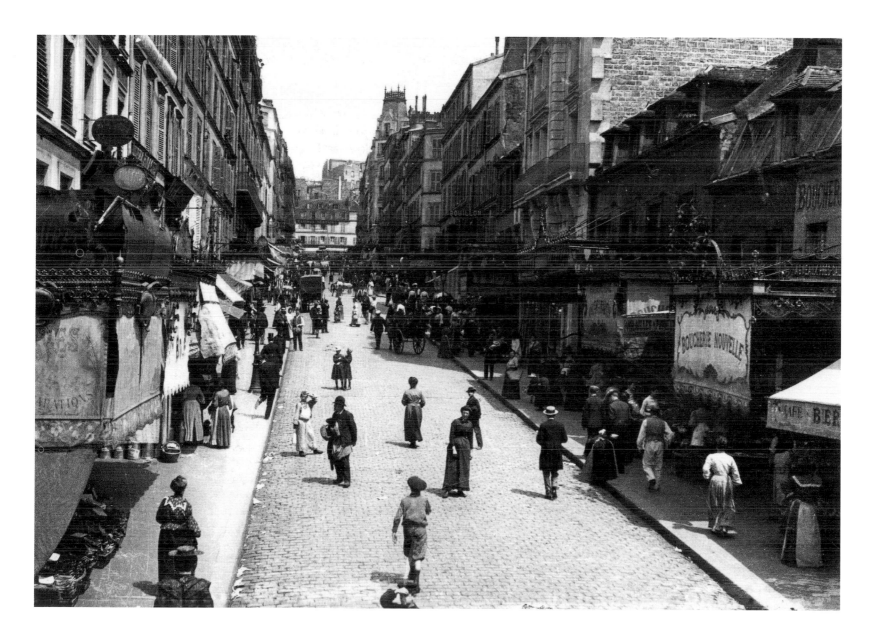

Etiquette manuals were full of advice on perfecting a skillful walking technique: 'It is well known,' Madame Celnart boasted, 'how remarkable Parisian women are in this regard: you can see them, laden with packages, crossing wide muddy streets, avoiding ill-bred passers-by and carriages that come from every direction and returning home without a single spot after shopping for several hours. To effect this prodigious achievement, which arouses admiration and chagrin in newly arrived provincials, they must carefully step only on the centre of the cobblestones and never on the edges, because then they would inevitably slip into the spaces between the stones; they have to put down the ball of the foot before the heel; even when it is quite muddy; the heel should be lowered very rarely...While she "dances lightly over the cobblestones" – this is the customary expression – a lady should raise her dress nicely, slightly above her ankles.' Both Hassam and Jean Béraud painted neat-ankled beauties preparing to cross the street, with a titillating glimpse of lisle stockings on show – indeed Béraud specialized in such scenes – and Balzac claimed that 'from the way in which she lifts her foot in the street, a discerning man can guess the secret of her mysterious errand.' Prudent parents sought to shield their daughters from all this admiring attention by providing them with chaperones, a practice the young naturalist painter Marie Bashkirtseff railed against in a heartfelt diary entry of 2 January 1879: 'What I long for is the freedom of going about alone, of coming and going, of sitting in the seats of Tuileries, and especially in the Luxembourg, of stopping and looking at the artistic shops, of entering churches and museums, of walking about the old streets at night; that's what I long for; and that's the freedom without which one cannot become a real artist.' Sadly she died just five years later, undermined by consumption but aware that few women had achieved as much as she had at such an early age.

The bourgeois female might be retreating behind a shield of dark clothes, which protected her virtue and did not show the dirt and sooty marks of the street, but the bourgeois man was keen to be noticed. The *flâneur*, or dandy – of whom Manet is a prime example – adopted a dress of dark sobriety, distinguished by the elegant cut, and made visible with sparkling white linen, and, perhaps, bright yellow gloves. Baudelaire called modern dark clothing 'the outer husk of the modern hero' and spoke of it as possessing a 'political beauty, which is an expression of the public soul'. The impeccably dressed Manet, with his delight in fashion, his interest in current affairs, his inherited wealth and his urbanity, fulfilled all Baudelaire's requirements for a 'modern hero', who 'is the real subject of the history of his time'.

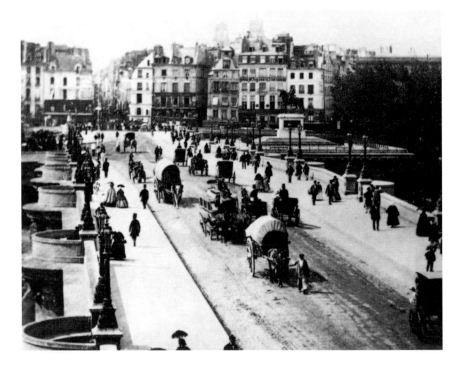

The Pont Neuf photographed by Adolphe Braun, 1855

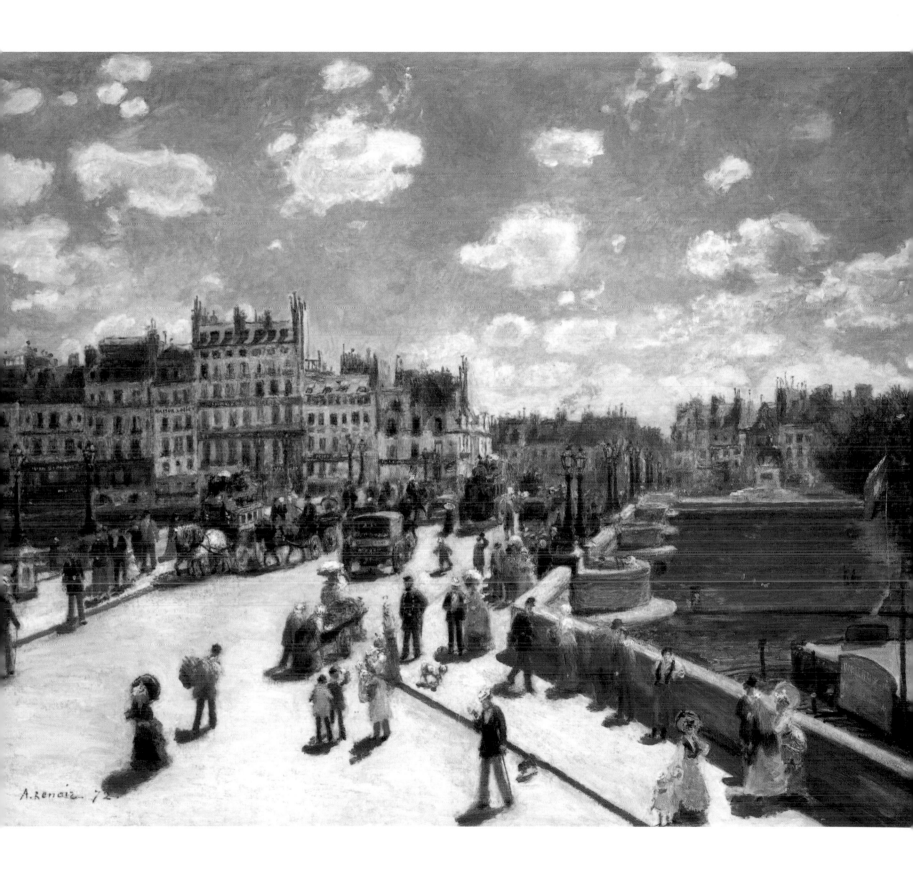

Male Fashion

The top hat was considered an essential item of dress for the intellectual male. Stéphane Mallarmé described it as 'something dark and supernatural' and Manet exulted in wearing one. At a time when a man could be judged by his clothes, Manet's extremely tall top hat with a flat rim – which we can see him wearing in his own painting *Music in the Tuileries* alongside Baudelaire and Offenbach – marked him out as a fashionable man about town. Made from black silk with a narrow impractical brim which provided little or no protection from either rain or sun and a height which rendered it hazardous in high winds, the gleaming cylinder shrieked class and status. Sporting one immediately labelled the wearer aristocratic or bourgeois, though, as far as Armand Silvestre was concerned it marked Manet down as a 'revolutionary – the word is not too strong' though one with 'the manners of a perfect gentleman'. He went on to explain his friend in *Au pays des souvenirs*: 'With his often gaudy trousers, his short jacket, his flat-brimmed hat, always wearing immaculate suede gloves, Manet did not look like a Bohemian, and in fact had nothing of the Bohemian in him. He was a kind of dandy. Blond, with a sparse, narrow beard which was forked at the end, he had in the extraordinary vivacity of his gaze, in the mocking expression on his lips, his

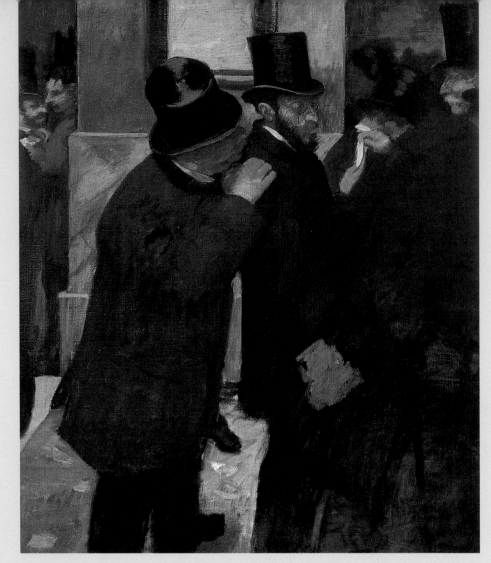

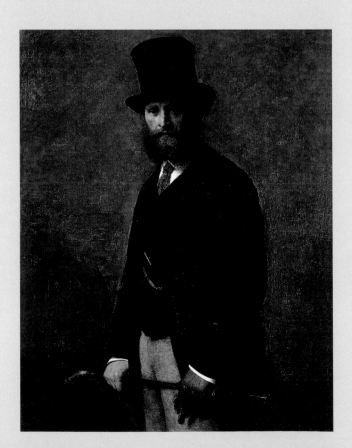

teeth irregular and uneven – a very strong dose of the Parisian urchin. Although very generous, and very good-hearted, he was deliberately ironic in conversation, and often cruel. He had a marvellous command of the annihilating and devastating phrase. '

Black was the dominant shade of men's fashion, though bright colour did not desert the masculine wardrobe altogether. Rather it was concealed beneath collars and lapels, revealed only in the shimmering flash of a frock coat lining or the coattails of a dress suit. Dandies like Manet concentrated sartorial colour in a single garment – the waistcoat – which could be made from brilliant materials like silk, satin or velvet, and served men as a focus for finery, though there were plenty of other peripheral areas where style could out or status announce itself.

'The cravat is to clothes what truffles are to dinner' declared Balzac and Manet's dress coat, cut to smoothly outline his waist, his immaculately starched shirt front and artfully tied cravat represented a veritable feast. He cut quite a

EDGAR DEGAS
Portraits, at the Stock Exchange, 1878–9

HENRI FANTIN-LATOUR
Portrait of Edouard Manet, 1867

GUSTAVE CAILLEBOTTE
The Place Saint-Augustin, 1877

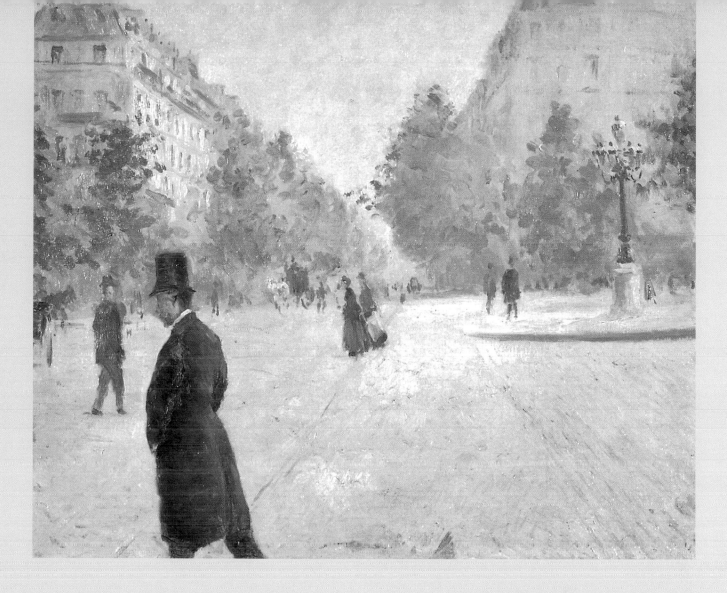

figure at the fashionable Tortoni's on the Boulevard des Italiens. As did Whistler, though Degas, who could at times be even more cutting than his famously spiky friend, enjoyed teasing the American. Watching him stride, chin up, monocle in place, frock-coated, top-hatted and carrying a tall cane, into the restaurant where Degas was waiting, he could not resist a laconic comment: 'Whistler,' he said, 'you have forgotten your muff.'

Indeed Degas was perhaps the only man who daunted Whistler, who, as their mutual friend George Moore observed, was prone to 'brilliant flashes of silence' when Degas was present.

Most men of the time wore their clothes like a shield. Black, white and grey, the very negation of colour became the paradigm of dignity and morality. The more severe male fashion became the more extravagantly female fashion flowered. Bourgeois men displayed their wealth through the sumptuous costume of their wives, or their children, who were dressed as girls in sashed frocks whatever their sex up to the age of four or five, and acted rather as the liveried footman did as a foil to the paternal black and a social signifier. 'As long as men battled for wealth,' wrote the contemporary commentator, Octave Uzanne, 'women's sole resource was to spend their financial conquests.'

The bourgeois' rather stiff black suit became, as Theophile Gautier pointed out, the uniform 'that no man will shed under any pretext. It sticks to him like the pelt of an animal, so that nowadays the real form of the body has fallen into oblivion.' And the *Journal des modes d'hommes*, eager for change, urged its readers to: 'Take a good look at the very elegant gentleman, wearing his short sack coat as befits the taste of our times. Examine carefully the parts of his costume, beginning at the base: two straight pipes containing the legs disappear into a main pipe, from which emerge two appendages, also in the form of pipes in which the arms are enclosed. To crown this there is another pipe, a gutter pipe this time, which he has dubbed "hat".'

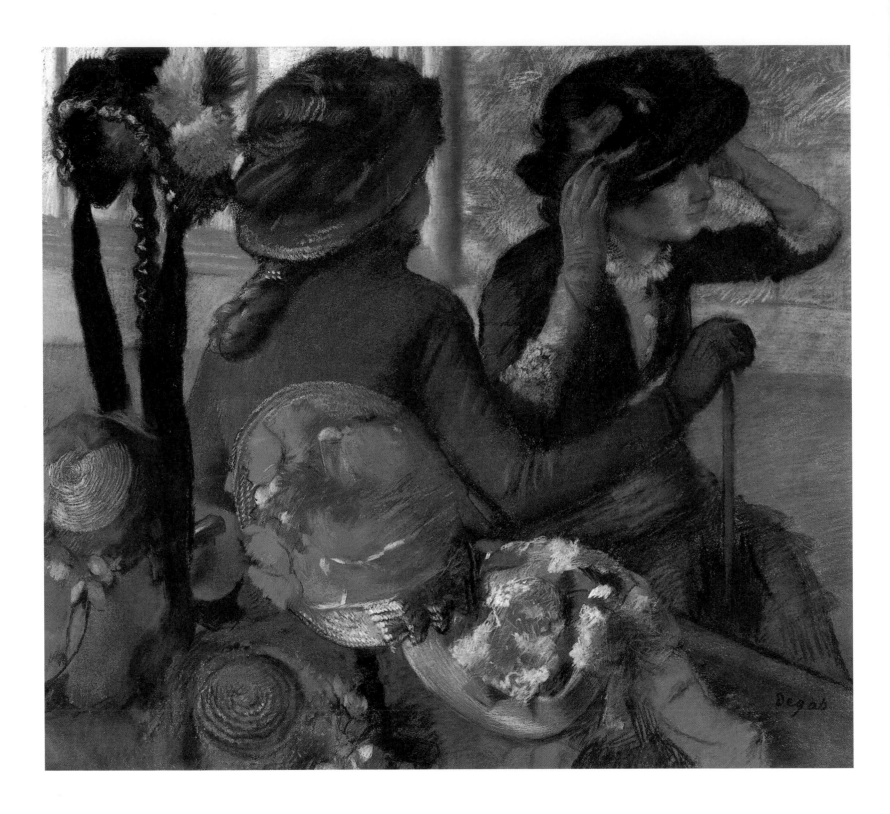

The glove counter in a department store in Paris, from *L'Illustration*, 1880
A woman, shown breathless with excitement at the glove counter, pauses for a moment before launching herself into the fray. Department stores set out deliberately to lure the fluid masses from the traditional shopping channels with low prices and the wide choice of goods on offer, all ravishingly displayed and calculated to fire the feminine imagination.

EDGAR DEGAS
At the Milliner's, 1882
Degas, in mischievous conversation with his dealer, exclaimed: 'Vollard, please do not saying anything against fashions. Have you ever asked yourself what would happen if there were no fashions? How would women spend their time? What would they have to talk about? Life would become unbearable for us men. Why, if women were to break away from the rules of fashion – fortunately there is no danger – the government would have to step in and take a hand.'

Degas's search for authenticity led him to accompany his female friends to dress and millinery shops, though some found this behaviour strange to say the least. Madame Emile Straus – a great beauty whose first husband was Georges Bizet – when she asked what he found so interesting in such a shop, was told: 'The red hands of the little girl holding the pins.' His friend Mary Cassatt understood him better. According to her great supporter, the art collector Louisine Havemeyer, she posed for two pastels of a woman trying on hats helping him 'out of a difficulty by posing for a turn of the head or a movement of the hand.' These pictures, with their unusual croppings and odd overlappings, create a kind of snapshot effect and owe much to Degas's burgeoning interest in the new art of photography.

There was a new realism at work in fiction, too. Emile Zola spent long days visiting department stores and set his 1883 novel *Au Bonheur des Dames* in a thinly disguised fictional version of the Bon Marché, the first of a long line of thrilling new stores, swiftly followed by the Magasin du Louvre, Printemps and the Samaritaine. There were parallel developments, too, in London (Gamages, The Army and Navy and Liberty's), New York (Lord and Taylor's, Macy's and Stewart's) and Chicago (Marshall Field). All these great emporia became dazzling showpieces, modern cathedrals to commerce, places to see and be seen. They used the latest technology – electric lifts and arc lighting – and new construction materials like iron, steel and reinforced concrete. Vast areas of their increasingly grand and lofty spaces were made out of glass to reflect the shimmeringly lit surfaces. The goods – made in their own workshops to fill departments dedicated to trousseaus, baby clothes and white goods; to women's hats, coats and cloaks; to wall hangings, upholstery and furniture – were laid out, often against mirrors, to be gazed at and thus simultaneously formed and supplied middle-class taste. They were exhibited much as paintings were – to attract and stimulate and, of course, to induce desire. Anyone could enter the Bon Marché, look around, and leave without having made a purchase. For women it was extraordinarily liberating. The drudgery of shopping was eliminated or masked by comfortable lounges, reading rooms supplied with newspapers, writing rooms with special headed writing paper, tearooms and

restrooms which mimicked the domestic spaces of a home, and made department stores both desirable and democratic places for women to visit. Shoppers could now spend the whole day in the store. There were spaces where women could park restless children or aged relatives and even, on certain nights, concerts staged for audiences of up to seven thousand in the Bon Marché. The department store had become a meeting ground and place of entertainment.

For Zola, however, the arrangement smacked of manipulation and exploitation. 'It was woman they were continually snaring with their bargains,' the fictional proprietor explained in *Au Bonheur des Dames*, 'They had awoken new desire in her weak flesh, they were an immense temptation to which she inevitably yielded.'

Other voices were also raised in protest. Pierre Giffard – a contemporary of Zola's – in his *Les grands bazars* of 1882 offered a rather fevered presentation of department stores as 'towers of Babel' where 'the husband who has driven his wife to the great bazaar' is foolish enough to leave her 'for long hours as prey to the seductions of lace' in 'the wonderful store-house of attractions where she empties her purse, her eyes on fire, her face reddened, her hand shivering, placed on that of a gloves salesman, while [the husband] goes off during this time with shady women to the furnished hotels of the eighteenth rank.'

While Paul Leroy-Beaulieu, writing in 1875, felt the department store offered women places to meet 'as formerly men did at the barbershop' and Paul Dubuisson, writing at the turn of the century remarked: 'It is necessary that she [the customer] consider the *grand magasin* as a second home, larger, more beautiful, more luxurious than the other, where she will find about her only friendly faces...'.

Over time the whole building became a palace of pleasure, an enchanted space where commerce and culture could combine. Zola cynically noted how 'the department store tends to replace the church. It marches to the religion of the cash desk, of beauty, of coquetry, and fashion. [Women] go there to pass the hours as they used to go to church.' But they also went to escape the confines of their workplace: their own homes. For many women, shopping was a deliciously liberating business.

Mary Cassatt and her sister Lydia belonged to the leisure class targeted by the big department stores. Both women were always fashionably attired and clearly familiar with the new style magazines. Her paintings demonstrate a lively interest in fashion and often depict women participating in the myriad recreations on offer in the capital or engaged in the act of shopping. Louisine Havemeyer, who bought the larger of Degas's two pastels, noted approvingly that 'Miss Cassatt's tall figure, which she inherited from her father, had distinction and elegance and there was no trace of artistic negligence or carelessness which some painters affect. Once having seen her, you could never forget her from her remarkable small foot, to the plumed hat with the inevitable tip upon her head and the Brussels lace veil, without which she was never seen.' This emphasis on fashion reflected the conventions of the day. Women were kept busy shopping for morning gowns, tea gowns, dinner gowns, walking dress, travelling dress, dress for the country and for different kinds of sport – not to mention deep mourning, second mourning or half mourning, when required. While a man rarely changed his clothes more than three times a day – moving from his warm quilted velvet or brocade dressing gown to a black frock coat for daywear and a dress coat for the evening – an upper- or middle-class woman might change her clothes anything between five and eight times in a day. Clothes no longer signified merely rank or status, they indicated a socially defined time of day, an occasion, or an individual state of feeling.

HENRY TONKS
The Hat Shop, 1892

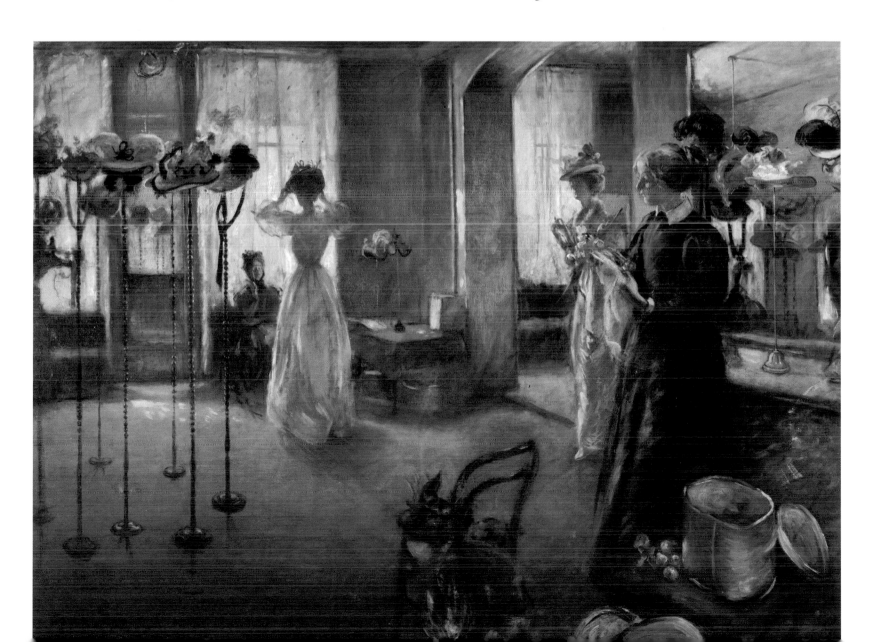

The idea of Parisian chic took powerful hold. Personified by Charles-Frederic Worth, who revived the tradition of tailoring for women, and other great couturiers like Mmes Roger, Laferiere and Pignant, and Mlles Félicie and Laure, who supplied the wealthy with extravagant costumes. Their showrooms and those of high society milliners like Mmes Virot, Rebout and Braudes were concentrated along the rue de Richelieu and the rue de la Paix, streets with an almost magnetic appeal. Wealthy American women began to make annual pilgrimages to Paris to restock their wardrobes and London shops sought to lure them back by advertising 'Fashionable Parisian Millinery' in the windows of shops run by businesswomen shrewd enough to style themselves 'Madame' and affect a French manner.

Fashion – irrational, transient, capricious – played an important part in the work of Manet, Tissot, Hassam and other Impressionists who made the fashion of the day central to their paintings. For the kind of pretty young girl Impressionists like Renoir and Monet painted at picnics or dances, there were *magasins de nouveautés* (fancy goods stores) selling silks, woolens, cloths, shawls, inexpensive lingerie, hosiery, gloves, umbrellas and furs. Yet Renoir, who, according to his son Jean, 'bloomed both physically and spiritually when in the company of women', railed against their slavish devotion to fashion. He liked his models and his mistresses to have curves and felt that all corset-makers ought to be put in prison for 'deforming' young women. He hated narrow shoes and high heels too, though a plethora of petticoats amused him, and his son relates how he sometimes compared a woman undressing to 'one of those circus numbers in which the clown takes off half-a dozen vests.'

Pissarro, for his part, loved the bustle of a local market. Pontoise, where he lived with his growing family, was the major market centre for the whole area of the Vexin and famous for veal and for cabbages. His honest depiction of the humble vegetable in his paintings was one of the many things that drew the scorn of the critic Louis Leroy at the first Impressionist exhibition in 1874. For Leroy such ignoble subject matter was an affront to art. Even the sympathetic critic, Jules Castagnary, bemoaned his 'sober and strong' friend's 'deplorable liking for truck gardens,' going on to complain that he 'does not shrink from any presentation of cabbages or other

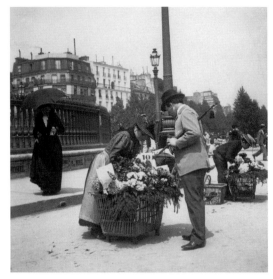

Flower shopping in the Place de la Bastille, Paris, 1900

CHILDE HASSAM
At the Florist, 1889
Town meets tidily packaged country in this colourful depiction of a pavement flower stall. The stall-holder, in rural costume, waits patiently for an elegant customer to make her final selection from the ready-wrapped pots and bouquets.

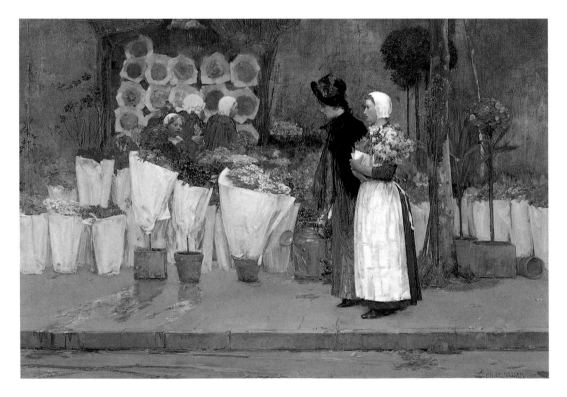

JAMES McNEILL WHISTLER
Variations in Violet and Grey – Market Place, Dieppe,
1885
Whistler painted this complex watercolour in Dieppe
while staying with Walter Sickert and his wife. The
picture, though tiny, is full of life and individuality and
attracted praise and ridicule in almost equal measure.
One critic described 'a market place in Dieppe, with a
crowd of most living little figures' while the *Evening
Sun* saw only 'a confused mass of blotches.'

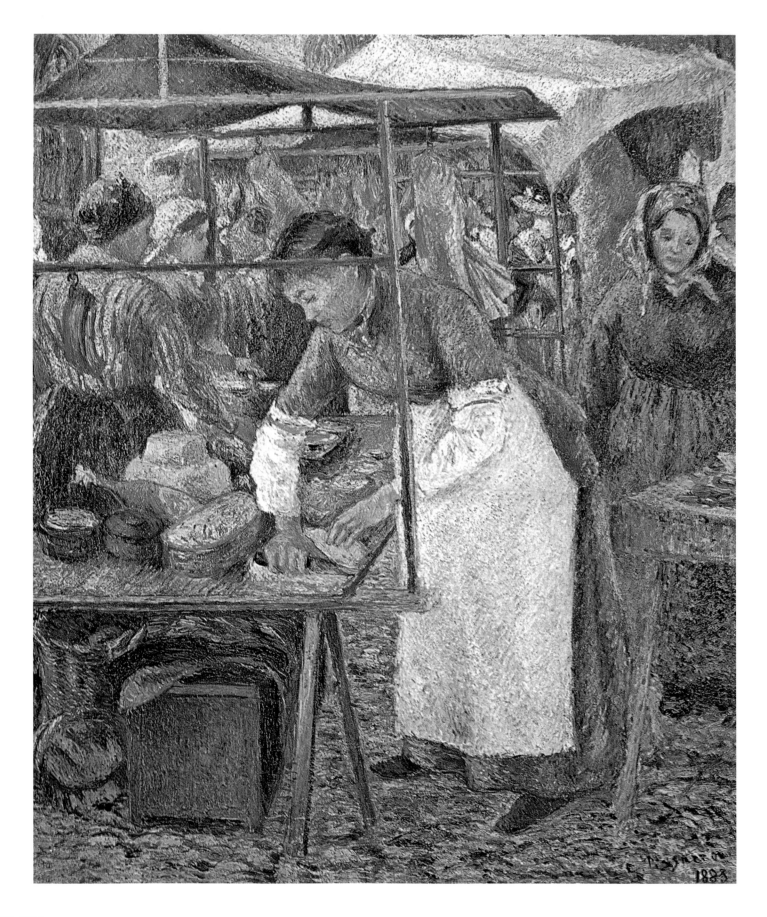

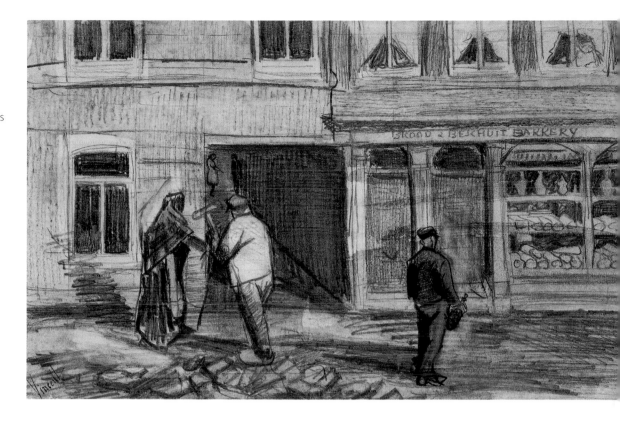

CAMILLE PISSARRO
The Pork Butcher, Market Scene, 1883
Like the peasant producers who sold their goods at them, Pissarro travelled to fêtes, fairs and markets in Paris and the provinces to capture the vibrant scenes. He had a special sympathy for the husband and wife small-holders around Gisors who supported themselves on small farms of less than fifty hectares with a few cows, poultry and pigs.

VINCENT VAN GOGH

The Bakery in de Geest, 1882
Drawn when van Gogh was twenty-nine, before he resolved to join his brother Theo, who was working at Goupil's gallery, in Paris, the immediacy of the scene is captured in this fresh and spontaneous sketch.

domestic vegetables.' Pissarro was unrepentant. He was, he said, 'rustic by nature' and loved the tranquil, simple, rural life which revolved around the continuity of the family and the land. He lived in the landscape that he painted and his artistic identity was shaped by it. His wife Julie had grown up in Grancey-sur-Ource, near Dijon, where her mother farmed a two-acre small-holding and tended two small vineyards. Her roots were deep in the countryside and, like her mother, she was thrifty and industrious. Julie cultivated vegetables in the gardens of the houses Pissarro rented. She raised chickens, rabbits and pigeons to help to feed her family of eight and the many guests Pissarro invited, including the shy and sometimes surly Cézanne, whom Pissarro befriended in 1872.

On Mondays Pissarro would go with Julie to the neighbouring town of Gisors where she would buy cheeses and butter, and possibly barter her own goods, while he sketched the sturdy peasant women haggling over eggs and poultry in the village square or made charcoal drawings of animated scenes in the indoor market. When in Paris, he would find himself drawn to the vast iron pavilions of Les Halles where pyramids of vegetables and salads were laid out among the barrows, baskets, panniers, bundles and crates, and fish reposed on icy marble slabs.

In 1884 Pissarro settled his family in Gisors and over the next fifteen years produced many market scenes, usually in gouache or tempera, though at least five oil paintings exist. His niece Nini – Eugénie Estruc – served as a model for *The Pork Butcher, Market Scene* and *The Market Stall*. It is striking to note that, when we view many of Pissarro's market scenes, we literally side with the stallholders, almost always women, patient and enduring, as they face the bourgeoisie across the cuts of meat, trays of fish or barrels of cabbages. For Pissarro, a life-long socialist, the market was a place of transit and exchange, where the labour of the land met the money of the town.

A Time to Depart

TRAVELLING AND TRANSPORT

'What on earth can you be doing in Paris in such marvellous weather, for I suppose it must be just as fine down there? It's simply fantastic here, my friend, and each day I find something even more beautiful than the day before. It's enough to drive one crazy. Damn it man, come on the sixteenth. Get packing and come here for a fortnight. You'd be far better off; it can't be all that easy to work in Paris.'

Monet to Bazille, writing from Honfleur, 13 July 1864

Claude Monet's spirited letter to his great friend and fellow student Frédéric Bazille captures the youthful zest for life and honest enjoyment of simple pleasures – best shared – which characterized the young Impressionists' approach to life and work.

Theirs was a society in which the steam train, masterfully painted by Monet, had arrived, but which for urban transport relied on the horse. Yet in their lifetimes they were to witness extraordinary change. Renoir, Degas and Monet lived long enough to see a plane service link Deauville to Dieppe and *avions de promenade* fly from Paris to Cabourg. The nineteenth century ushered in the novelty of bicycles and omnibuses, electric trams and automobiles. By 1900 the first underground railway line, which ran from Vincennes to Porte Maillot, had opened despite dire warnings against the dangers of electrocution, suffocation and pickpockets, and Hector Guimard's now familiar romantically wrought entrances to the Paris Metro ushered in a new age of speed and Art Deco design. New canals created seamless avenues for the long-distance barges Pissarro loved to paint and tens of thousands of kilometres of track extended the railway across France, providing important motifs for many Impressionist painters, but particularly for Monet.

CHILDE HASSAM
Carriage Parade (detail), 1888
A line of carriages filled with fashionable folk proceeds towards the Arc de Triomphe. Hassam's cropping invites the viewer to enjoy the spectacle as if from a seat in a carriage following the landau

Claude Monet and his son-in-law Theodore Butler awaiting the arrival of the chauffer, early 1900s

Photograph of Degas on a trip from Paris to Diénay. Degas travelled through Burgundy with his old friend Albert Bartholomé in the autumn of 1890. They journeyed in this hooded two-wheeler, drawn by a white horse, visiting friends like the Halévys in Montgeron and making gastronomic stops along the way.

They were not immune to the charms of travelling by train either. Stations excite the imagination and, in 1893, an uncharacteristically impulsive Berthe Morisot admitted to her friend, the symbolist poet Stéphane Mallarmé, that she and her teenage daughter Julie 'made up our minds to go to Brittany just by looking at the posters in the waiting room of the Gare Saint-Lazare.'

The serenity of the mode of travel and the seductions of the lovely landscape allowed Renoir to forget he had toothache while travelling round the Midi on small branch lines. He mapped out 'the most beautiful excursion one can make in France' for Berthe, drawing up a schedule with stops for meals and accommodation, and urging her to make the trip. 'If you want to see the most beautiful country in the world… One has Italy, Greece, and the Batignolles all in one, plus the sea…', he wrote temptingly.

Monet used the little train on the Pacy-sur-Eure line in 1883 to explore the villages along the Epte River when house-hunting. The train ran slowly along a winding narrow-gauge track, stopping everywhere, once even, to Monet's amazement, in open country to allow a noisy wedding party to board. His search for a suitable house for himself, Alice Hoschedé and their combined children ended, famously, at Giverny, where he rented the large pink-stucco Maison du Pressoir and almost immediately set about creating his magnificent garden.

In the thirty years from 1841, the year Renoir was born, the population of Paris practically doubled. The rich radial symmetry of Baron Haussmann's grand plan opened up and connected neighbourhoods and the burgeoning population was kept bouncing along his broad boulevards in the horse-drawn carriages of the Compagnie Générale des Omnibus. In 1855 there were 347 of these, carrying 36 million passengers, but just ten years later 664 omnibuses were conveying 116 million people. In addition there were horse-drawn cabs and carriages for hire and a plethora of delivery wagons from barouches to baker's vans. In 1876 the Bon Marché alone had forty wagons, pulled by eighty horses delivering to ninety-three suburbs, towns and outlying villages. From above, the wide streets of Paris struck Louis Veuillot, a contemporary commentator, as 'an overflowing river.'

A private carriage, such as the one we see Mary Cassatt's sister Lydia expertly steering, was public proof of social success. Wealthy members of society soon found they needed several to

preserve their distinction from the rising middle classes and to provide suitable vehicles for every aspect of their busy social lives. The wives of successful men had their own carriages, dainty affairs, intended not so much as a means of transport, more a badge of wealth, for the attendant expense was enormous. No first-class carriage horse was expected to travel more than fourteen miles a day (at a maximum speed of nine to ten miles per hour) and even if the lady drove herself a liveried groom was necessary either to follow discreetly behind on horseback in case of an emergency or to perch on the rumble seat behind – as Lydia's groom does. Coachmen competed with each other in turning out the most magnificent equipages. Harnesses were buffed up with a liquid blacking mixture made from mutton suet, beeswax, turpentine and powdered Prussian blue, and carriage lamps were equipped with wax or composition candles which gave out only a weak glow, making night-time driving, especially away from the city centre, full of perils. (Colza lamps were found to give a brighter light but they produced such an abominable smell that they were rarely used.) Instead, the afternoon was the most popular time for middle-class matrons to take to the road with a light (and rarely used) whip in hand and a gaily coloured parasol to draw the eye of envious onlookers.

MARY CASSATT
Woman and Child Driving, 1881
The solemn figure of Degas's five-year-old niece Odile Fevre faces forward beside the artist's sister Lydia, very much in the driving seat, while the top-hatted groom is relegated to the rumble seat behind.

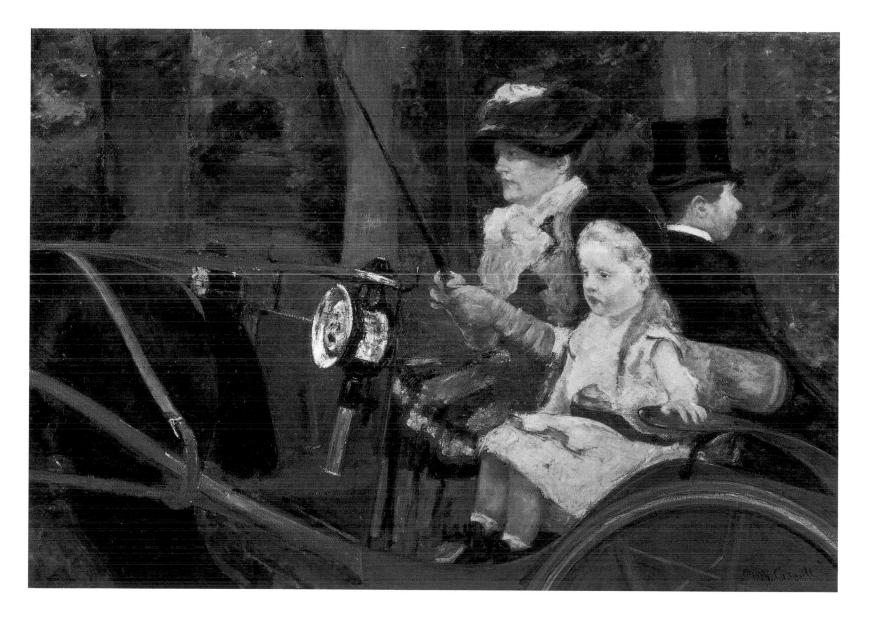

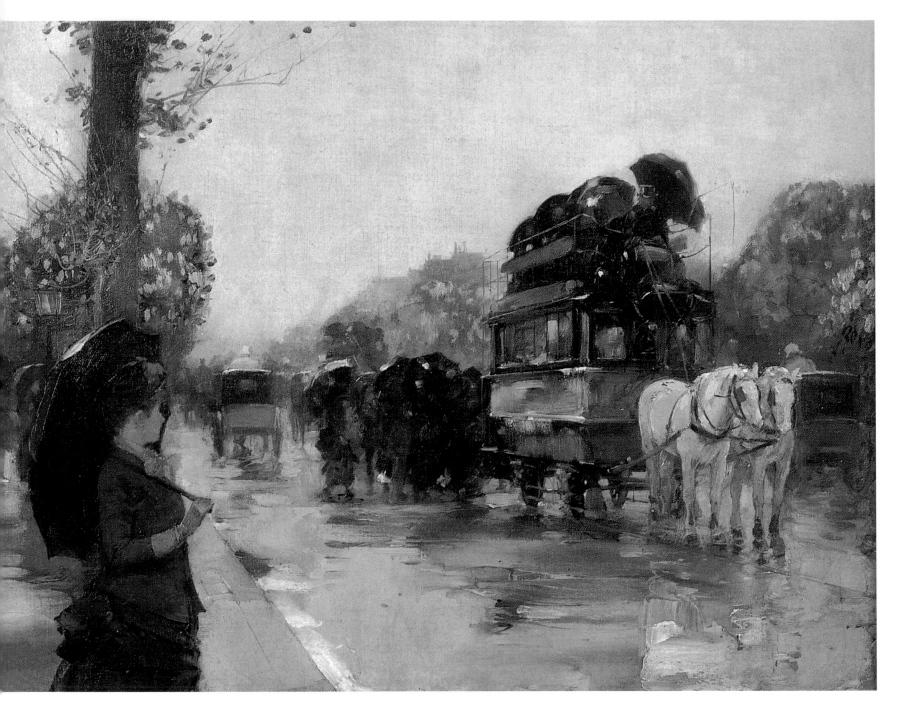

CHILDE HASSAM
April Showers, Champs-Élysées Paris, 1888
The broad new boulevards of Paris captured Hassam's
imagination. He peopled them with picturesquely
pretty young women, like the one sheltering from the
rain on the left of this picture. The casual angle of her
umbrella might suggest the downpour is only
temporary, though the occupants of the splendid
omnibus seem to have armed themselves for a deluge.

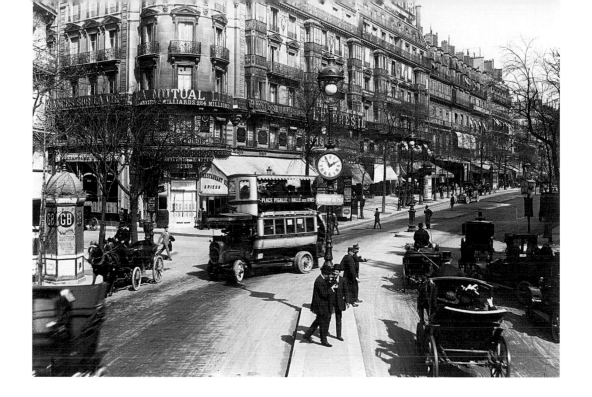

Photograph of the Boulevard Montmartre, Paris, showing a wide variety of carriages and an omnibus.

HENRI DE TOULOUSE-LAUTREC
Country Outing, c. 1897
Lautrec's complete command of line is immediately apparent in this deft drawing.

Just as now, traffic was a problem though, unlike our own urban congestions, a Parisian traffic jam would be accompanied by a rich range of equine aromas from steaming horseflesh to pungent dung. (Copious amounts of it considering that every day a horse excreted on average something like twenty kilos.) Along with the dung, there was the dust, which rose from the macadamized streets and clung to clothes in dry weather, or turned, in the wet, to mud which ruined boots and damaged carriages. Haussmann had recognized the drawbacks of macadam and stood out against Napoleon's enthusiastic plans to cover the whole city with it, claiming that it was an unsatisfactory surface which required Parisians 'either to keep a carriage or walk on stilts.'

A good idea of Paris in the rain is provided by Caillebotte's pedestrians sheltered beneath their gleaming umbrellas in *Paris Street, Rainy Day* (pp. 110–11) and the smudgy splendour of the American Impressionist Childe Hassam's *April Showers, Champs Élysées Paris*, in which an attractive young woman in a jaunty flower-bedecked hat waits beneath her parasol to cross a shimmering puddled road busy with fiacres and other horse-drawn vehicles, including a fabulous public omnibus pulled by two blinkered white horses and topped with passengers sheltering under shiny open black umbrellas on the crowded upper deck.

Before the arrival of automobiles Paris moved at a leisurely pace. Board a horsedrawn omnibus – such as the one Hassam painted – at the Panthéon and you could expect your journey to Courcelles, at the end of the line, to take an hour. The press of traffic meant that little time would be saved by taking a hackney cab, though Hassam found they offered excellent observations posts. 'I paint from cabs a good deal,' he confided to an interviewer in 1892, explaining that he found a cab window provided the best vantage point 'when I want to be on a level with the people in the street and wish to get comparatively near views of them, as you would see them in walking in the street.' Marie Bashkirtseff also painted from cabs in the Bois de Boulogne in the late afternoon, as did Jean Béraud, who reportedly 'lurked' in hackney cabs, making rapid sketches like snapshots as references for pictures he would paint later in his studio. 'Almost all the cab drivers in the city know him,' commented the journalist Paul Hourie, 'He's one of their favourite passengers, because he at least doesn't wear their horses out.'

It was considered immodest for a lady to ride in a cab alone so the ubiquitous Paris omnibus became the preferred mode of practical female transport, enthusiastically employed by women of

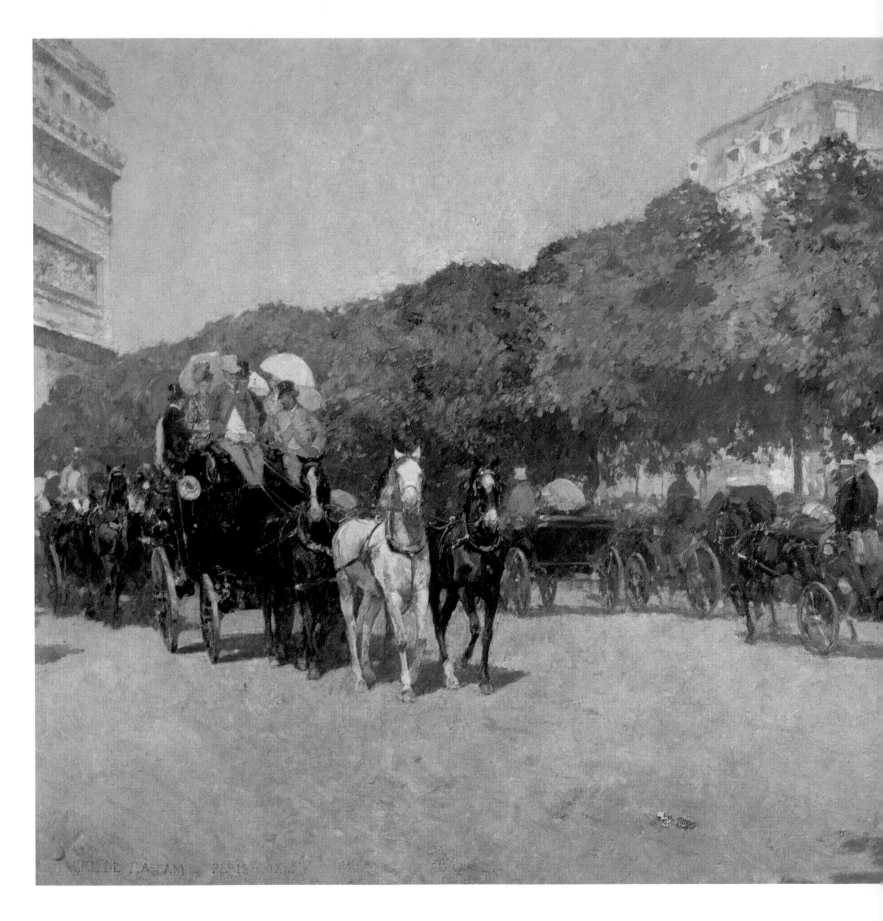

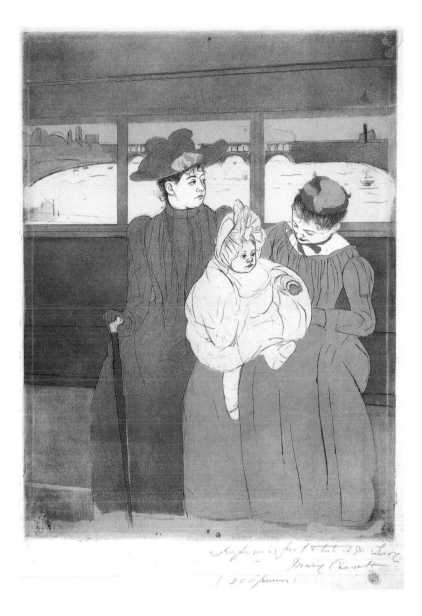

CHILDE HASSAM
Grand Prix Day, 1887
Hassam described this picture to a fellow artist, Rose Lamb: 'I am painting sunlight… a "four in hand" and the crowds of fiacres filled with the well dressed women who go to the "Grand Prix".' The cropping and empty foreground are compositional devices borrowed from Degas and Caillebotte, while the colour and brushstrokes show the influence of Monet.

MARY CASSATT
*Interior of a Tramway
Passing a Bridge*,
1890–91

all classes, though they tended to use the seats on the lower decks, unless the stairway was equipped with a 'modesty panel' which would prevent anyone seeing their legs as they made their ascent to the top deck. Mary Cassatt's drypoint *Interior of a Tramway Passing a Bridge* shows an elegantly dressed young mother crossing the Seine on an omnibus in the company of her extravagantly wrapped baby seated on the capacious lap of an attentive nursemaid. The mother looks away rather sulkily across the head of the baby, while the nursemaid concentrates on her cheerful charge. In the original drawing, Cassatt placed a man on the mother's right, then changed her mind and lightly sketched in a standing woman. In the final print, all other figures are absent though the suggestion of other passengers, seated opposite the little group, observing them – as Cassatt herself had done and as we do when we look at the print – is strong.

Cassatt captures something of the unease women felt at being thrown into close proximity with strangers on public transport. It was a novel and not altogether welcome sensation. George Simmel, a German sociologist of the later nineteenth century, noted that 'before the development of buses, railroads, and trams in the nineteenth century, people had never been in a position of

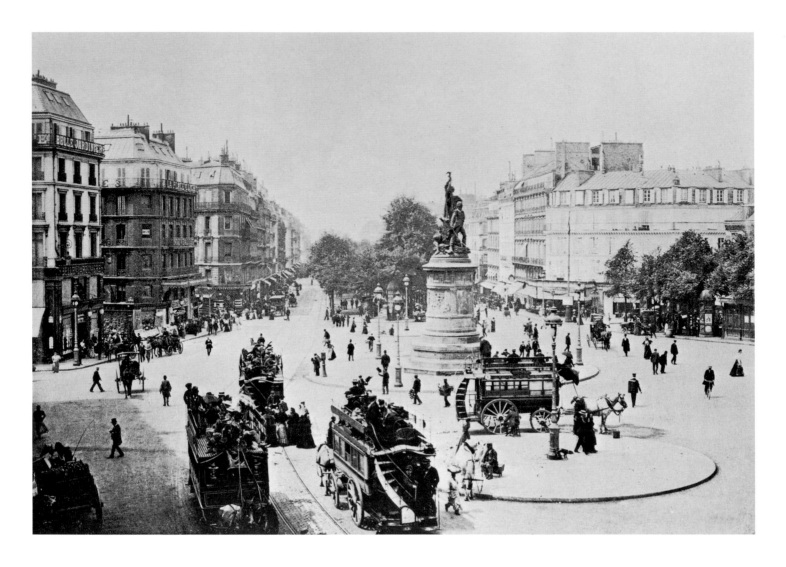

having to look at one another for long minutes or even hours without speaking to one another'. The Impressionists explore this sense of discomfort, though without subduing their own natural high spirits. In 1886 a boisterous party of Impressionists travelled by omnibus to a restaurant Gauguin had chosen as the site for a small dinner to celebrate the success of the eighth and last Impressionist exhibition. It was a gregarious gathering as the symbolist poet Gustave Kahn recalled in *L'Art et les Artistes*: 'It was a Saturday, a day for business and wedding parties; it would be picturesque!…. Camille Pissarro wanted all of us to arrive together at the Château-Rouge, and he told how it would be done. An omnibus – one only – went to Lac St-Fargeau, an old double-decker omnibus with stirrups hooked on rods at the side for climbing into the upper seats; it left from the Place des Arts-et-Métiers. We agreed to take one of these vehicles together and so arrived at the Arts-et-Métiers stop from all corners of Paris: Montmartre, the Latin Quarter, Vaugirard – except for Pissarro and his son Lucien, who lived, if I remember correctly, in the rue Paradis-Poissonnière. We took over the upper seats, and Gauguin was very cheerful. The dinner was great fun…'

Radical change was afoot, however. In Germany, in the same year as the Impressionists' final exhibition – 1886 – Gottlieb Daimler and Karl Benz both produced a four-wheeled motor-car and it wasn't long before France followed with models from Louis Renault and Armand Peugeot, who had switched the family manufacturing firm from the production of umbrella spokes, corset

Photograph of the Place de Clichy, Paris, Batignolles, *c.* 1900
This turn of the century photograph shows a fair number of pedestrians strolling unconcernedly across the broad boulevards before the arrival of automobiles made this an altogether more hazardous activity.

CAMILLE PISSARRO
Place Saint-Lazare, 1893
Pissarro suffered from a condition which meant that his eyes were easily aggravated by wind and dust, making it difficult for him to work out of doors. As a result, he often worked from windows, which explains the steep perspective of this lovely painting.

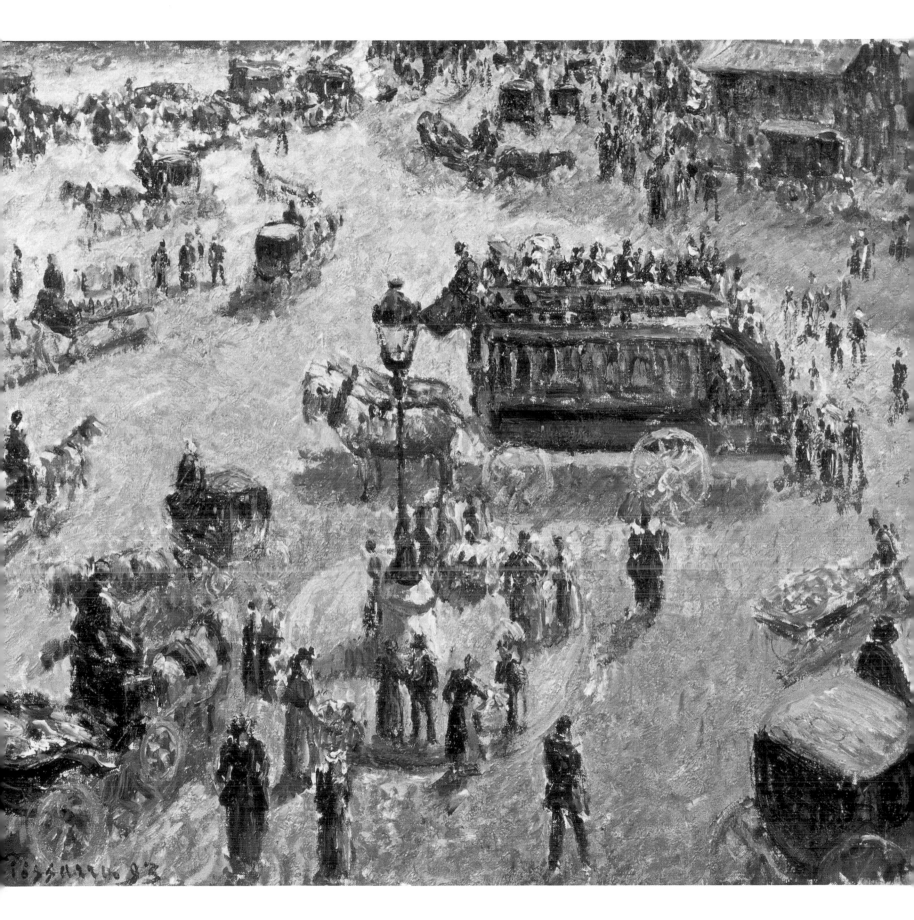

JEAN-LOUIS FORAIN
Deuxième Salon du Cycle, poster, 1894
The evolution of the modern bicycle was accelerated by Edouard Michelin's innovative inner tube, which meant that roadside punctures could be attended to swiftly by the cyclist herself, rather than resorting to a mechanic with specialized tools. This brought the cost of cycling down considerably and it became a very popular activity. We know from taxation figures that there were around 130,000 bicycles in France in 1893 – a figure which would triple over the next five years.

stays and farm implements to bicycles and small cars. Speed limits were set at twenty kilometres per hour and the streets became even more busy with traffic. Tar and bitumen surfaces were laid to prevent the fast-spinning pneumatic tyres sucking up the dust from macadam roads in such dense clouds that people could scarcely see or breathe.

The late eighties also saw the arrival of practical bicycles. One, two, three or even four wheel bone-shaking varieties had been entertaining small children for years, but the invention – by J. K. Starley of Coventry in 1885 – of the first safety cycle with a chain-driven rear wheel, followed three years later by the Scottish veterinary surgeon John Boyd Dunlop's patented pneumatic tyre (which in turn paved the way for André and Edouard Michelin to develop their detachable tyres), brought them to a wider public. The very first cyclists were unpopular because people feared they would frighten the horses, but the horses were already having to cope with cars and the newly introduced electric trams and Paris soon succumbed to cyclomania. Even Renoir tried one, though he fell off going down a hill too fast and broke his arm, after which he attacked 'all *mecaniques*, saying that we're in decadence,' and demanding of Berthe Morisot's daughter, Julie: 'What's the point of going so fast?' None, she politely agreed with her mother's great friend, but privately in her journal she admitted that she longed to ride one, and was indeed already learning how to. And she was far from alone. Noury Choubrac, Grun and Grasset had made reasonably priced bicycles available to the middle classes, who – despite Zola's description of mastering one as 'a continuous apprenticeship of the will, an admirable lesson in steering and defense' – enthusiastically took to cycling in the countryside, causing a somewhat overpowered Degas, on holiday with his friend Bartholomé in 1890, to observe sourly that 'hotels will find the income from the stage coach in the bicycle.'

Toulouse-Lautrec was an immediate convert, however. He had been introduced to the charms of the cycle track by Tristan Bernard, author, playwright and editor of *Le Journal des Velocipedistes*, and made a number of lithographs set at Bernard's Vélodrome Buffalo (built, extraordinarily, on the site of Buffalo Bill's Circus). His lithograph of Zimmermann, the two hundred metres cycling champion, was seen by Louis Bouglé, the French agent for Simpson bicycle-chains, who commissioned him to do a poster portraying the popular heroes of the day – the racing cyclists Choppy and Jimmy Michael – but it was rejected by Simpsons because of its inaccurate representation of the very thing it was meant to sell: the bicycle's chain. Commercial failure did not dampen Lautrec's enthusiasm, however, for the spectacle of the circling riders in their multicoloured jerseys. He loved to watch competitive cycling and enjoyed the steep climbs, cornering and flag-waving of the six-day race at the Vélodrome d'Hiver.

New developments in fashion matched advances in transport. Waterproof clothing was first developed in the early nineteenth century and given a boost by the arrival of the motor car. Wearing dust coats, capes, gloves and a cap or a hat with a veil and equipped with a whip (to ward off dogs), begoggled motorists rode 'on' not 'in' an automobile and the idea of motoring as a 'sport'

FRÉDÉRIC RÉGAMEY
The Enemies of the Cyclist, 1898, from *Vélocipédie et automobilisme* (Cycling and motoring), a work on the social or humorous aspects of road use, published in Tours in 1898.

was fostered by manufacturers like Burberry and Aquascutum (who advertised leather motoring knickers with a detachable flannel lining in the sportswear section of their catalogue), and department stores like the Bon Marché, whose 1890 summer season catalogue featured cyclists' apparel for both men and women, alongside tennis clothes and rather daring swimwear.

Impressionist painters reacted differently to the arrival of the motor car. Julie Manet, in her memoir, *Growing up with the Impressionists*, recalled how Renoir complained of the decadence of his age 'where people think of nothing but travelling at dozens of kilometres an hour' and maintained that 'the automobile is an idiotic thing…there is no need to go so fast.' And even she, who longed to cycle, confessed 'I watch the arrival of the automobile with horror.'

Monet, on the other hand, was an early convert to the motorcar. He never learned to drive himself but he was an enthusiastic passenger and the proud possessor of a number of elegant custom-made Panhard-Levassors, the first of which (along with a chauffeur) he acquired in 1901. He used his automobile for outings and work alike, often being driven to his painting site, and, in 1904, to Madrid. As he explained to his dealer in a letter cancelling lunch, he had decided at the last minute to 'put a long-cherished plan of mine into practice: to go to Madrid to see the Velázquez. We are leaving by car on Friday morning for about three weeks'.

As late as 1915 Renoir was still grumbling about cars though he, too, now owned one and employed a chauffeur. His dealer Ambroise Vollard, while visiting the Renoirs at Les Collettes in the South of France, recorded a terse little exchange between the couple on the vexed business of speed. Renoir's wife Aline entered the studio holding a blue telegram she had just received from Rodin, notifying Renoir that he would arrive at noon and expected lunch. 'He has very little time to spare,' she informed Renoir, adding: 'I have told Baptistin to get the car ready; I am going over to Nice to get a chicken, and some pâté, and a lobster. I'll be back in an hour.' To Vollard she said: 'Renoir can say what he likes, but an automobile is a great convenience.'

'I suppose you agree with my wife,' Renoir said gloomily to the younger man, once Aline had bustled off. But then urged him wistfully to 'just think a minute; if we knew nothing about motor cars or railroads, or telegrams, Rodin would have come by the diligence, we would have been notified a month ahead of time, the chicken would have been fattening in the poultry yard, the pâté made here; and it would have been a lot better than the tinned stuff my wife will bring back from Nice!… Furthermore…I wouldn't be always bothered by a swarm of people coming in to see me. If we lived in the good old times, without any railroads, tramways or autos, they would have all stayed at home.' Nevertheless, despite his horror of things mechanical, Vollard observed that Renoir's automobile saw plenty of use, for it provided the most convenient means of getting out to paint in the country when he could no longer use his legs and the Renoirs employed it as a matter of course to drive from Nice to Paris, which took two days by car.

THÉOPHILE-ALEXANDRE STEINLEN
A Paris Traffic Jam, from *Gil Blas*, 27 September 1891
A concentrated image packed with all the seething frustrations of a log-jam.

Trains (and stations) were not merely conveniences to the Impressionists but compelling symbols of modernity which they claimed as their own. Monet adored them. The Paris to Rouen service had opened when he was just a toddler, built by British engineers who brought not just their expertise but their favourite leisure pursuits of sailing and rowing to his home town of Le Havre, providing two of his great motifs. As an artist he was fascinated by the play of sunlight on the clouds of smoke and steam belched out by the trains as they sliced through the landscape or chugged across bridges and viaducts. The grand style and imposing elegance of French stations, which provided a model for big bold passenger pavilions throughout Europe, captivated Monet.

Eugène Flachat's Gare Saint-Lazare was close by Caillebotte's home and Manet's studio, and served the Impressionists' preferred places of Argenteuil, Chatou, Louveciennes and Bougival. Its light, airy engine-sheds and lofty departure hall exerted a tremendous pull on Monet and in 1877

CLAUDE MONET
Arrival of the Normandy Train, Saint-Lazare Station, 1877

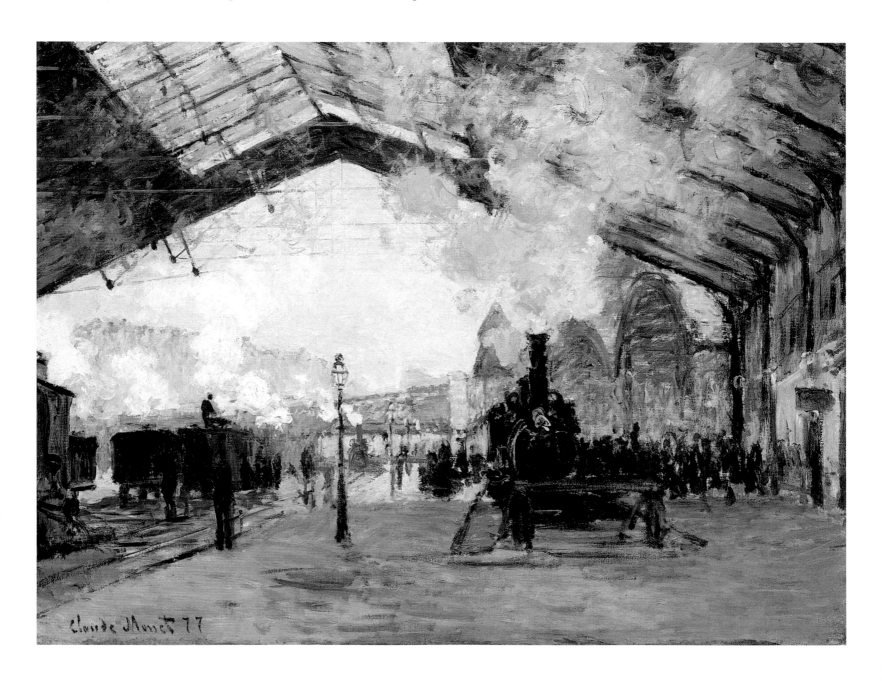

CLAUDE MONET
The Gare Saint-Lazare, Arrival of a Train, 1877
Monet set up his easel inside the station itself to paint
this pair of pictures from his great station series. The
dim interior is contrasted with the luminous outside
and the two worlds are joined and reshaped by the
billowing steam and smoke which rises up to the
pitched roof of the station.

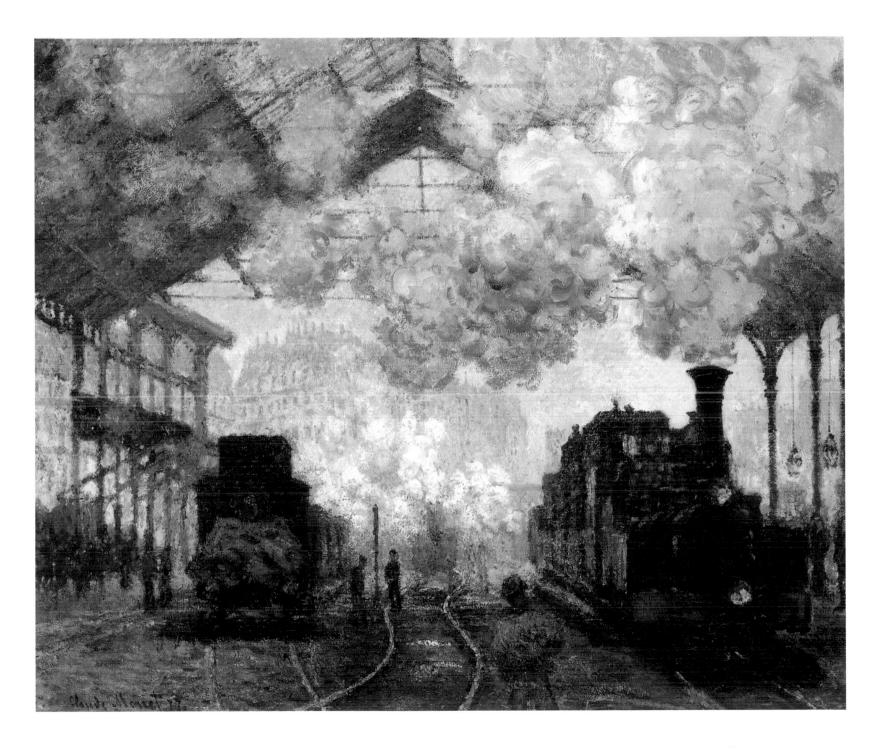

GUSTAVE CAILLEBOTTE
The Pont de l'Europe, 1876
One of three paintings of Parisian street life exhibited by
Caillebotte at the third Impressionist exhibition of 1877,
it depicts the huge, six-spurred metal bridge which
overlooks the tracks and train yards of the Gare Saint-
Lazare. Caillebotte lived close by and had watched the
iron geometry of the girders rise during his teenage years.
Painted in situ, he includes a portrait of himself (in the
gleaming top hat) strolling towards the viewer on the left.

he began an impressive series of paintings set within or around the rigid glass-and-steel frame of that great modern cathedral. With typical *élan* he persuaded the station master that he was an important painter, a Salon celebrity, and thus, as Renoir reported to his son Jean, 'the trains were halted; the platforms cleared; and the engines were crammed with coal so as to give all the smoke Monet desired.'

Smoke fills the background of Manet's painting *The Railroad* too, though it is the two figures, facing in different directions, who dominate the composition. The seated woman (once again posed by Victorine Meurent, Manet's model for *Olympia*) gazes levelly out at us while the little girl (the daughter of Manet's friend and neighbour, Alphonse Hirsch) stares solemnly down at the only thing which justifies or explains the painting's title. Manet was keenly aware of the station. His studio in the rue de St Petersbourg was just a short step away and the floor trembled each time a train passed close by. 'The trains send up their agitated clouds of white steam,' commented one visitor to the studio, 'The ground, constantly agitated, trembles under our feet and shakes like a fast-moving boat.'

EDOUARD MANET
The Railroad, 1872–3
Victorine Meurent, Manet's model in this striking picture, was a painter herself, talented enough to have several pictures shown at the Salon, though, tragically, she ended her life a hopeless alcoholic, playing the guitar in down-at-heel cafés in Montmartre for drinks and a few francs.

CAMILLE PISSARRO
Cour du Havre (Gare Saint-Lazare), 1893
Pissarro captures all the bustle of a big terminus in this fabulous aerial view of the station concourse. He believed that the artist was on a par with 'the poet farmer, doctor, blacksmith, chemist [or] industrial worker' and that 'Like all the latter, who produce something useful and beautiful, he plays a part in that general effort towards harmony, which consists in finding expression for the universe [by] following the individual aptitudes granted us by nature, education and environment.'

The disconnectedness of the figures in *The Railroad*, together with the oblique view of the station – seen through bars like some caged exhibit – lends the painting an unsettling quality of strangeness that underscores the social change that was occurring at this time. Passengers in trains still faced one another much as they had in old horse-drawn carriages, but the noise of the horses had been done away with, and with the pervasive silence came a new mutual embarrassment. People armed themselves with books to discourage conversation. They settled into the comfortable upholstered seats and drew the silence about them to protect their individual privacy. For the first time they began to treat the speech of strangers as a violation. The railway changed social patterns in other ways too. Speeding trains brought fresh produce into the capital from further and further away. In November 1871 fresh flowers from the Côte d'Azur were sold in Paris for the first time. A new commuting society of workers, clerks, business people and shoppers was brought into the capital each working day and Parisians were able to travel further out beyond the suburbs into the surrounding countryside on their days off. More and more people were able to enjoy a Sunday in the country.

Holidaying in Venice

Manet visited Venice twice, with a twenty-one year interval – the first time, as a young man in the company of his brother Eugène (who would go on to marry Berthe Morisot) and the second time with James Tissot in 1875. The painter Charles Toché met Manet by chance at the Café Florian and gained the painter's permission to watch him as he worked on his painting of *The Grand Canal* from a gondola moored near the Rio del Santissimo. 'I shall not forget Manet's enthusiasm for that motif,' he told Ambroise Vollard, 'the white marble staircase against the faded pink bricks of the façade, and the cadmium and greens of the basements. Oscillations of light and shade made by the passing barges in the rough water that drew from him the exclamation, "Champagne-bottle ends floating!"'

Renoir also visited Venice, arriving from Florence, which had bored him, in late 1881 and staying long enough to paint a number of pictures, including a large painting of the Grand Canal which was shown at the seventh Impressionist exhibition in 1882

But it was Monet who was the most enthusiastic about the city. He came to Venice late – indeed his visit in 1908 was his last foreign trip – and regretted immediately that he had not visited as a young man 'when I was full of daring.' Like London a few years before, Venice allowed Monet to develop his interest in the effects of light and water and the pictures he made there were among the most ravishingly coloured canvases of his career.

He was then seventy and Alice four years younger. A photograph of the pair shows them feeding the pigeons in St Mark's Square, close to where they were staying at the Grand Hotel Britannia, from where he wrote enthusiastic letters to his friends, expressing his excitement. 'I am overcome with admiration for Venice,' he told Paul Durand-Ruel. 'It's so very beautiful,' he confided to Gustave Geffroy, adding that he was 'very sad that I'll soon have to leave this unique light.' He planned to return and spend a whole season in Venice the following year, but Alice's illness intervened and he was left too distressed by her death in 1910 to contemplate travel; in any case he had begun to have trouble with his eyesight, a forerunner of the cataracts that would later become a pressing problem.

Pissarro's protégé Paul Signac visited Venice twice in the early years of the twentieth century. In 1905 he painted this picture of the Salute rising up out of a shimmering Grand

EDOUARD MANET
The Grand Canal, Venice, 1874

Claude Monet and Alice in the Piazza San Marco, 1908

Canal with gondolas moored in the basin of San Marco. 'Whether Signac paints a stormy sea with bobbing Dutch vessels or tranquil waters reflecting ancient Venetian palaces, it is always this sparkling miracle, this rushing palpitation,' wrote the critic Louis Vauxcelles, reviewing the Signac exhibition at the Galerie Bernheim-Jeune. 'Signac is one of the greatest painters of water I know,' he went on. 'Opal, emerald, amethyst, pink, creamy or milk white, all of these vivid tones are at play in his paintings.'

PAUL SIGNAC
Grand Canal, Venice, 1905

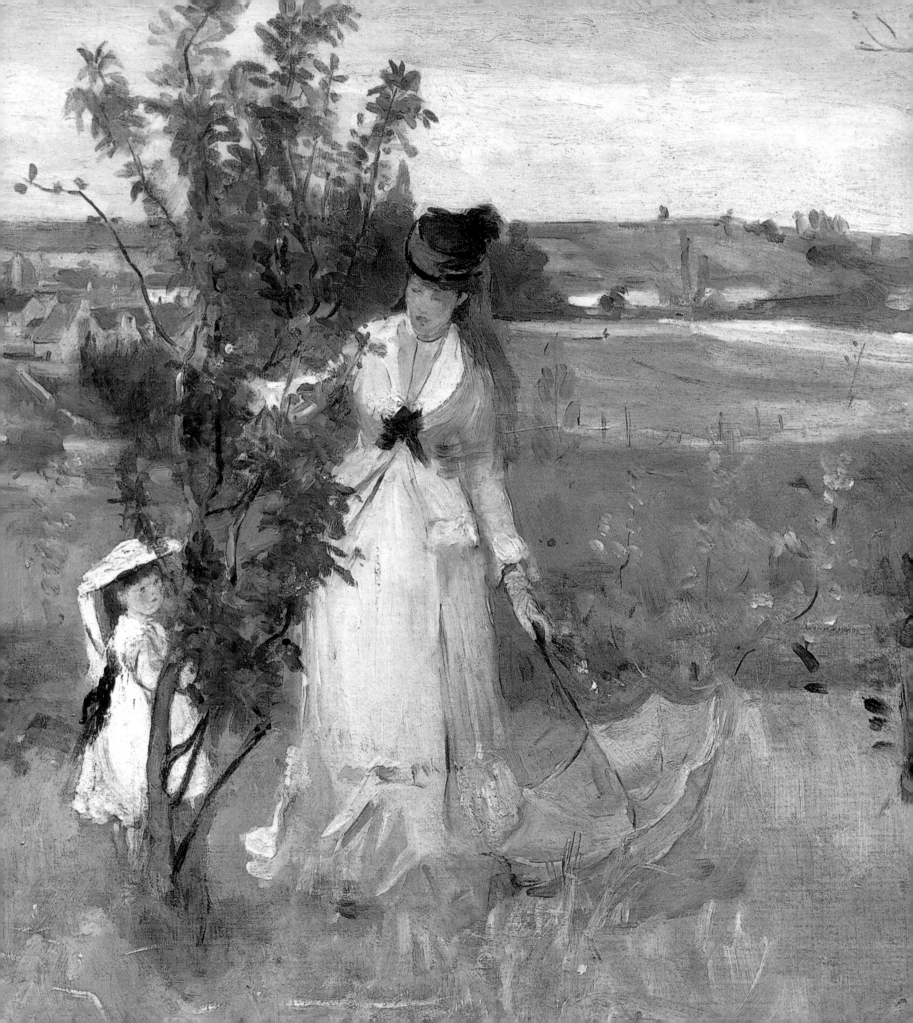

CHAPTER 7

A Time to Escape
FRESH AIR, RURAL LIFE, WALKING AND THE COUNTRYSIDE

'A blond light illuminates them, and all is gaiety, clarity a springtime holiday, evenings of gold, or apple trees in flower...Their paintings open [like] windows on to a joyous countryside, on to a river laden with skimming boats, on to a sky streaked with light mists, on to an enlivening and charming outdoor life. Dream infuses them, and, completely impregnated by them, it flees towards loved landscapes which they recall all the more surely because the reality of their appearance is there most striking.'
Armand Silvestre's preface to Durand-Ruel's show of Impressionist paintings

Here they come, over the brow of a sunlit field of scarlet poppies, a woman in a jaunty hat with a small boy beside her, taking surely one of the most enviable strolls imaginable in art. And here's another couple, or perhaps the same pair, at the bottom of the slope, the boy – Monet's son Jean – almost submerged in the sea of flaming flowers, their crimson colour echoed in the scarlet hatband round his straw boater, while the woman – Camille Monet – puts out her left hand to steady herself, or perhaps to brush the frondy tips of the tall grass. Behind them, a line of trees and a single red-roofed house against a soft blue and white sky. The untroubled, luminously happy mood of this painting is manifested in the abundance of the flowers, which are expressed in warm red, almost abstract dabs and flicks of paint, and which melt, like the figures who amble through this charming idyll, into the soft slope.

BERTHE MORISOT
Hide and Seek (detail), 1873
'Berthe Morisot has wit to the tips of her fingers, especially at her fingertips,' commented Jules Castagnary. 'What fine artistic feeling! You cannot find more graceful images handled more deliberately and delicately than in *The Cradle* and *Hide and Seek*. I would add that her execution is in complete accord with the idea to be expressed.'

CLAUDE MONET
Poppies, near Argenteuil, 1873
This painting is a small masterpiece. Monet sets up the sense of movement and rhythm by the duplication of the group, showing a woman with an umbrella and a small child at the top of the slope and again on the right, advancing into the artist's space.

CLAUDE MONET
La Promenade (Woman with a Parasol), 1875
Monet paints his wife Camille in a striking pose against the scumbled sky. Their little son Jean appears on the left in his straw hat.

Poppies, near Argenteuil is just one of a series of lush and lovely paintings Monet made around 1873. It was a financially successful and creatively rich period for the thirty-three-year-old artist and this carefree quality is reflected in the shiningly happy and harmonious paintings he made during his time at Argenteuil. Camille and Jean appear in many of them, as do friends who visited the little family in the Maison Aubrey, including Renoir and Manet, who were frequent guests and set up their easels side-by-side with Monet in the garden or painted the artist at work in his specially adapted studio-boat. Renoir was tremendously fond of the country. 'When I was young,' he recalled in a letter of 1892 to Adolphe Tavernier, 'I would take my paintbox and a shirt, and Sisley and I would leave Fontainebleau, and walk until we reached a village. Sometimes we did

PIERRE-AUGUSTE RENOIR
Road Rising into Deep Grass (detail), c. 1876–7
Clearly influenced by Monet's experiments, Renoir paints this lovely image from life. Later this kind of landscape painting would become 'pure torture' to him. 'Of course, it's the only way to learn a little about one's craft,' he wrote to Berthe Morisot in the early 1900s, 'but to stand outdoors like an acrobat, I can't do it anymore.'

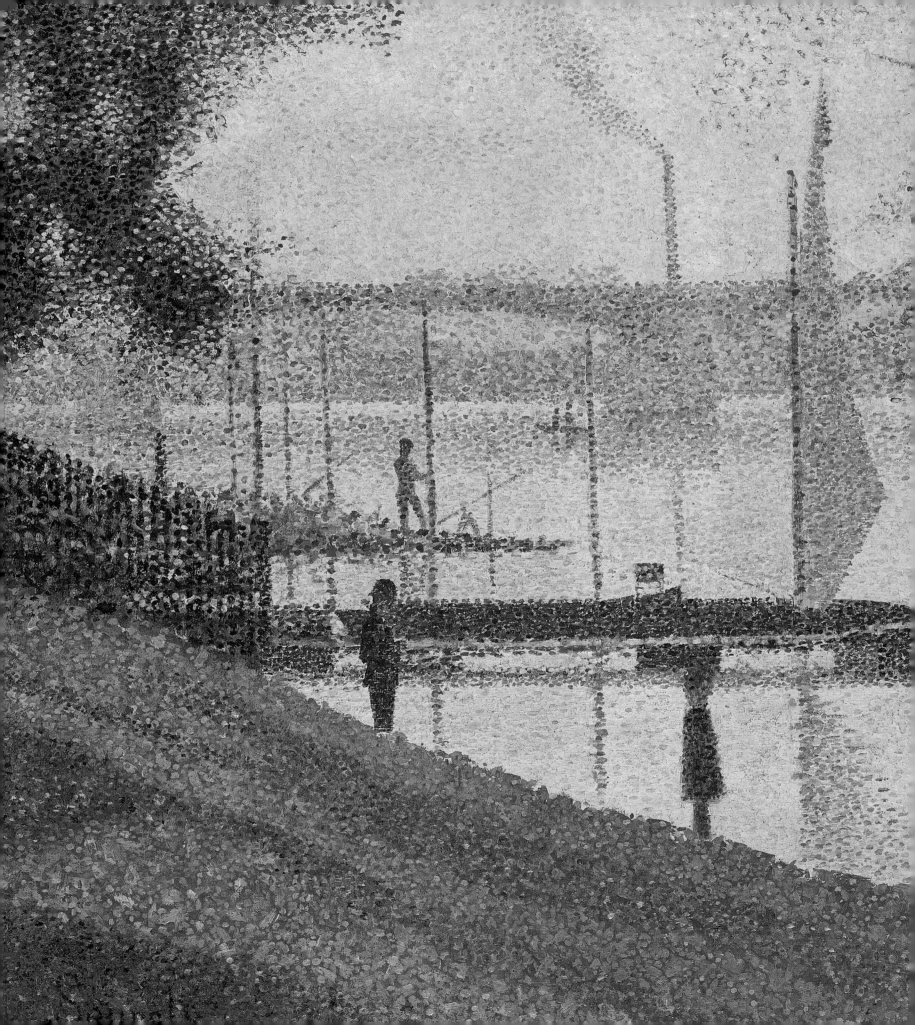

not come back until we had run out of money about a week later.' Degas, too, liked to take what he called 'nature cures' and often commented on the 'lovely country' he found himself in in letters to friends. 'Every day,' he wrote to his dealer Durand-Ruel from Dieppe where he was staying with Halévy, 'we go for walks in the surroundings, which will finish up turning me into a landscapist. But,' he added sadly, 'my unfortunate eyes would reject such a transformation.'

Berthe Morisot loved the countryside, too, though she often found it fraught with difficulties, as she explained in a letter of 1888 to Claude Monet: 'One doesn't know where to go. I tried a field. I had no sooner sat down than I had more than fifty boys and girls around me, shouting and gesticulating. It ended in a pitched battle. The owner of the field came and told me quite crossly that we ought to ask permission to work…' And to her husband, Eugène, she described how, taking a walk 'with Bibi in the country, in a very pretty place, in a direction we have never taken together' she and her daughter's nurse had to ask local washerwomen to help them step over the little streams which cut the ground.

GEORGES SEURAT
Le Pont de Courbevoie, 1886–7
Fishing was a popular sport of the period favoured by lower-class men in middle age. When the novelist J.-K. Huysmans first saw Seurat's paintings he was 'intoxicated with sunlight' and rhapsodized on the way 'they reveal a very personal yet very accurate approach to nature.'

Claude Monet and Pierre-Auguste Renoir
at La Grenouillère, c. 1869

In 1889 Sisley settled in the country town of Moret. There he immortalized watermills, bridges, river banks and country churches. His paintings were often dominated by a wide expanse of sky and an atmosphere of delicate melancholy. Berthe Morisot, visiting Mallarmé at nearby Valvins, paid her old friend Sisley a visit in September 1893 and found him cheerful despite the fact that his work was not selling. They took a carriage out to the forest and she painted beneath big beech trees that Mallarmé likened to a dance hall, which, he said, would be the scene of his daughter's wedding.

Gustave Geffroy visited Sisley not long before the artist's death and recalled a 'marvellous day, perfect in its ambience of welcome and friendship…everything was magnificent, and harmonious. We spent the morning in the studio and after lunch everybody took charabancs to Moret, on the banks of the Loing, and the Forest of Fontainebleau where Sisley, acting as master of ceremonies, spoke with unforgettable charm.'

ALFRED SISLEY
A Meadow in Springtime at By, 1881
Unlike his fellow Impressionists, Sisley eschewed the urban environment of Paris, preferring the small rural villages nearby. His paintings, which explore the momentary effects of light and atmosphere on a landscape, never sold well in his lifetime, though he was recognized after his death.

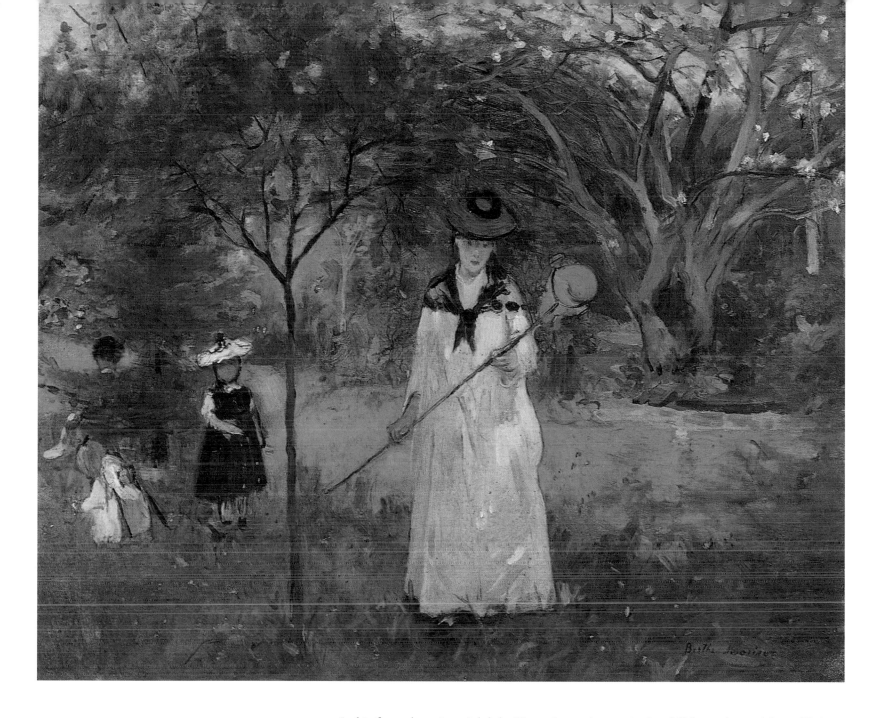

BERTHE MORISOT
The Butterfly Hunt, 1874
Berthe Morisot's view of the countryside is always that of a town dweller – she is just passing through and her taste is not for showy or even particularly picturesque effects. Rather, the countryside becomes an extension of her domestic or private space. She paints her family in quiet moments and engages in a vocabulary of modernism by breaking up the surface with the paintwork and creating an apparently effortless ease, a buoyant intimacy.

In his funeral oration, Adolphe Tavernier spoke movingly of Sisley as 'a magician of light, a poet of the heavens, of the waters, of the trees – in a word one of the most remarkable landscapists of his day.'

The American Impressionist J. Alden Weir, while out walking 'several miles over the rolling country' in Brittany in the summer of 1874, recalled watching as 'two peasant girls with their reapers in their hands came towards me out of some wheat, they had their arms over each other's shoulders and were singing together…it struck me as picture of perfect happiness…' he wrote home to his mother, adding that he had resolved to start a picture of this as he had been so forcibly impressed by the whole scene.

Together the Impressionists overturned the old ideas and set out to forge a distinctive, modern and novel form of landscape, which reflected and encompassed the complexities and changes they could see transforming the countryside. They rejected traditional picturesque ideas, included

Hunting and fishing

As a ten-year-old boy Renoir used to go out on hunting expeditions in the 'village of Batignolles' with a neighbour. He was allowed to carry the game-bag and to watch as his neighbour shot hares in a field which would soon become the Gare Saint-Lazare. When he grew up, however, he found the privileged classes' predilection for stag-hunting revolting. 'Those imbeciles in their red hunting-coats!' he railed, 'I'd like to shoot them all! If there is a hell, they'll be hunted by deer until they drop from exhaustion!'

In the spring of 1877 the American Impressionist J. Alden Weir wrote home from Barbizon to tell his parents all about his hunting exploits in the forest. He was staying in 'the artists' hotel in the place where the great Millet lived' and painting each day *en plein air*, though he was careful always to wear high gaiters and heavy shoes to shield himself against the hunters' hare traps. 'I am invited to go on a wild boar hunt,' he wrote excitedly, 'and will, I think, accept if the time is fine.' He spoke of nightingales and the lovely song of the merle 'which makes the woods echo with its notes' and described the dining room walls 'all covered with pictures which have been given by the artists' and the deer horns 'hung up as hat racks and an immense deer's head, stuffed, [which] hangs opposite the door…'.

Seurat's serene anglers are typical of working men who relaxed at the end of a long toilsome week with a rod in their hands, while Caillebotte's light summer-suited angler in *Fishing (Pêche à la ligne)*, 1878, shyly accompanied by a dreamy young girl (said to be Zoé Caillebotte, the artist's cousin) plainly belongs to the leisured class.

Cézanne's preferred method of fishing was a little more individual. He dispensed with the need for a rod altogether and, in a letter to Zola dated 30 June 1866, describes an evening fishing trip with a friend, during which 'with my hands in the holes' he caught over twenty fish. 'In a single hole I took 6, one after the other, and once I got 3 at one go, one in the right and two in the left,' he reported, adding 'they were rather beautiful. All this is easier than painting but it does not lead far.'

Both Berthe Morisot and Mary Cassatt were competent horse women, though a fall from a horse immobilized the latter through the summer of 1888 and the former found that even the prospect of vigorous riding could not shake her from feelings of melancholy brought about by a

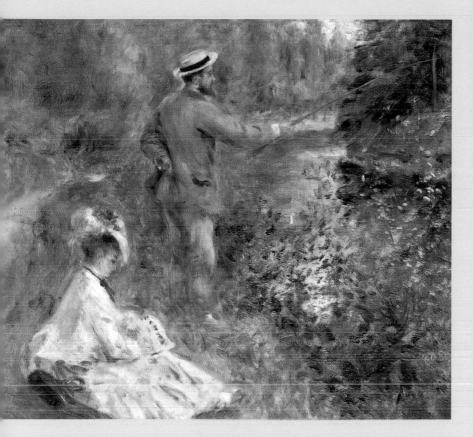

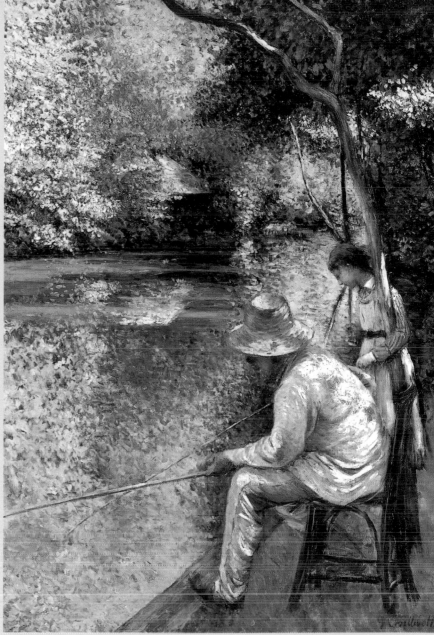

misguided sense of her own artistic inadequacy and –
as seems probable – a hopeless infatuation with the
controversial, audacious and married Manet. In 1872
Berthe Morisot wrote rather languidly to her mother of her
plans for the summer: 'I am invited to go to the country,
where I could ride horse-back, paint, etc., but all that
scarcely tempts me. I am sad, sad as one can be… What I
see most clearly is that my situation is impossible from every
point of view.' Two years later, the Manet and Morisot
families spent part of the summer together at Fécamp and
there Manet's brother, Eugène, cast aside his usual reserve
and revealed his true feelings for Berthe. They were married
in 1879.

CLAUDE MONET
The Shoot, 1876

CLAUDE MONET,
The Bark at Giverny,
c. 1887

PIERRE-AUGUSTE
RENOIR
The Fishermen, 1874

GUSTAVE CAILLEBOTTE
*Fishing (Pêche à la
ligne)*, 1878

Gaillaumin, Pissarro, Gauguin, Cézanne, madame Cézanne, le petit manzana. manzana - Pissarro.

mundane subjects such as bridges and steam trains and threw open the doors, insisting upon the honesty of the countryside and introducing each other to the parts they knew best.

'I imagine the countryside I'm in would be just the kind of thing you like most…', Cézanne wrote to Pissarro from the south of France at the beginning of July 1876. He had already introduced Renoir to the extraordinary village of L'Estaque, huddled between the sea and a vertiginous succession of rocks and ravines. The views and the walks were superb. It put Renoir in mind of Seine-side villages and he described it in a letter to Durand-Ruel as 'a small place like Asnières but on the seaside…' Later, he moved his family south, for the light and the healthier climate, settling in Cagnes-sur-Mer, a thriving village of prosperous peasants whose gentle, unhurried style of life appealed to him greatly. There he built himself a large house with spectacular views of the Mediterranean in the midst of old oaks and olive groves and spent the final dozen years of his long life painting, enjoying the olive harvest and his garden. He was surrounded by his rumbustious boys, Jean, Claude and Pierre, his loving wife Aline, and a bustling household full of models like the sixteen-year-old Andrée Henschling (fondly nicknamed Dédée), Marie Depuis (known as La Boulangère because, when Renoir first met her in 1895, she was living with a baker's boy), and his lovely nymph and bather, Madeleine Bruno. In addition there were the servants: Grand Louise, the cook; Nenette, the maid; Bistolfi, the chauffeur; Old Jean the gardener; and, of course,

CAMILLE PISSARRO
Apple Picking at Eragny-sur-Epte, 1888
The rural village of Eragny on the River Oise, north of Paris, was to Pissarro what Giverny was to Monet. He moved there in 1884, buying the house – with financial assistance from Monet – in which he would live and paint for the next twenty years. Pissarro preferred the autumn months when 'the sensations revive' to the 'fat green monotony' of summer and this luminously lovely portayal is just one ot many Pissarro made of meadows, farmland and workers during the 1880s and 1890s.

Gabrielle Renard, his wife's young cousin, whose arrival in the household coincided with the birth of Jean and who featured in literally hundreds of Renoir's paintings over the years.

Many of the Impressionists were at their best in the country. Monet declared himself 'as happy as a *coq en pâté*' in Normandy and famously spent the last forty -three years of his life in the verdant village of Giverny in a house of such pleasing proportions and resonance that simply to stroll through the rooms, and especially through the lovely garden, is to feel the presence of the painter all around. Pissarro, who described himself as 'rustic by nature' was most at home in the country. As early as 1867 he settled in Pontoise and lived and worked in the Vexin for over three decades. A tireless walker, he would leave home at six in the morning, dressed like a hunter with high boots protecting his trousers from the dew, a wide-brimmed felt hat on his head, a rucksack on his back and a stout stick in his hand and trek east along winding paths until he reached the small villages of Chou and Auvers on the Oise, or north to Ennery, Montgeroult, Valhermeil and Chaponval.

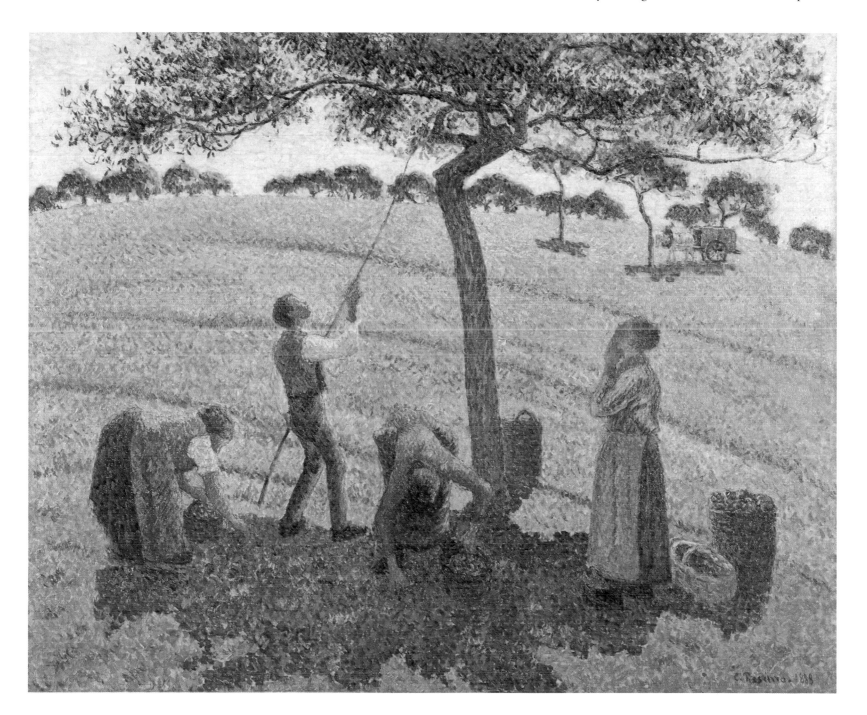

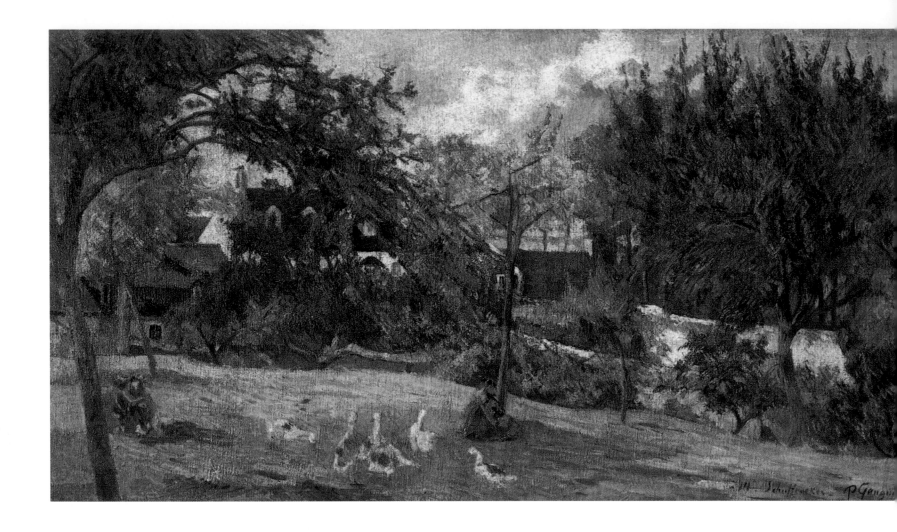

PAUL GAUGUIN
Near the Farm, 1885
Gauguin loved to work out of doors, in the countryside, and farms feature not infrequently in his work. His landscapes speak of openness and freedom, as well as an earthly connection with the land.

On painting days, he carried an easel over his shoulder and left at dawn for he liked, where possible, to capture the essence of a picture in a single sitting. Cézanne, too, was up and about at five or six painting in the open air, but he worked much more slowly. 'Nature presents itself to me as something very complex,' he confided to the young painter Emile Bernard. Often he would simply contemplate the scene before him for hours for 'every stroke must contain air, light, composition, character, outline and style', and a painting could take as many as a hundred working sessions to finish.

Cézanne and Pissarro were drawn by the subtleties of light and pastoral landscapes they found at Auvers and Pontoise where from 1872 they painted together, often joined by Armand Guillaumin, a self-taught artist who exhibited in many of the Impressionist group shows, and, in 1881, by an aspiring amateur, Paul Gauguin, who arrived with his Danish wife Mette and spent a few days with them. The younger Gauguin found these open-air working sessions extremely valuable. He had long conversations with Pissarro, during which the older man generously passed on his experience and offered advice, and though Cézanne's sullen silence could be daunting, the example he set of concentration and single-mindedness taught Gauguin a great deal.

Cézanne thought nothing of walking fifteen kilometres to Medan to see his old friend Zola. The two men had grown up together in the small provincial town of Aix-en-Provence and had been inseparable friends in their youth, embarking on 'mad treks across the countryside', roaming through the olive groves and throwing themselves down on warm stony hillsides, fragrant with thyme, mint and marjoram, where they read the Romantic poets and made elaborate plans for their

futures. Emile decided he would become a novelist; Paul a poet, though he also harboured vague dreams of becoming a painter. 'I have been dreaming of pictures, a studio on the fourth floor, you and me, then we really would have had some fun,' Cézanne had written enticingly to Zola in the early days. As boys they had fished and swum in cool rivers together but the publication in 1886 of *L'Oeuvre*, which included a barely disguised portrait of the young Cézanne, in the person of the disturbed artist Claude Lantier, spelled the end of their friendship. Cézanne curtly acknowledged receipt of the copy of the novel that Zola sent to him, and scarcely spoke to him ever again, despite the fact that Zola had unfailingly responded over the years to Cézanne's pleas for financial assistance, regularly sending sums to his mistress Hortense Fiquet and their son, Paul, whom Cézanne was eager to keep secret from his dictatorial father.

Cézanne retreated south to Provence. He was passionately attached to the area. 'When you were born there,' he once said, 'nothing else has any meaning.' The small pink and peach houses, the sun-bleached, gently sloping terracotta roofs, the steep terraced slopes of rich, red earth, the orange and lemon trees and ancient olive orchards were so much a part of Cézanne that whenever he tried to live and paint in the northern light of Paris he found that 'the sun dragged me back.' He lived in his father's house, Jas de Bouffan, which was secluded by chestnut trees and pinewoods and surrounded by vineyards shading off into the sweet-scented wilderness of the furthest reaches of the fifteen-hectare estate. One theme obsessed him: his beloved Mont Sainte-Victoire. It provided him with one of his most enduring motifs and he would set out at dawn to paint it, with his materials on his back, and not return until evening.

PAUL CÉZANNE
Mont Sainte-Victoire, 1902–1904
Never truly happy in Paris, Cézanne felt a great connection with the Provençal landscape. In the final years of his life he produced over fifty paintings of this mountain, and to this mountain in particular.

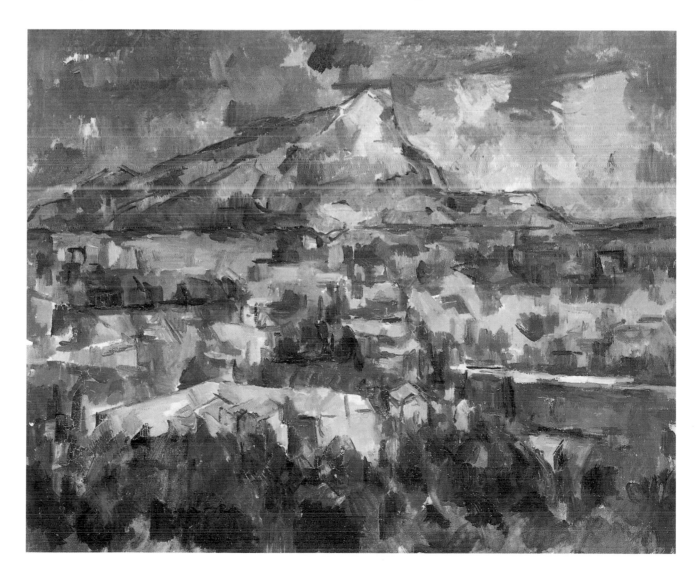

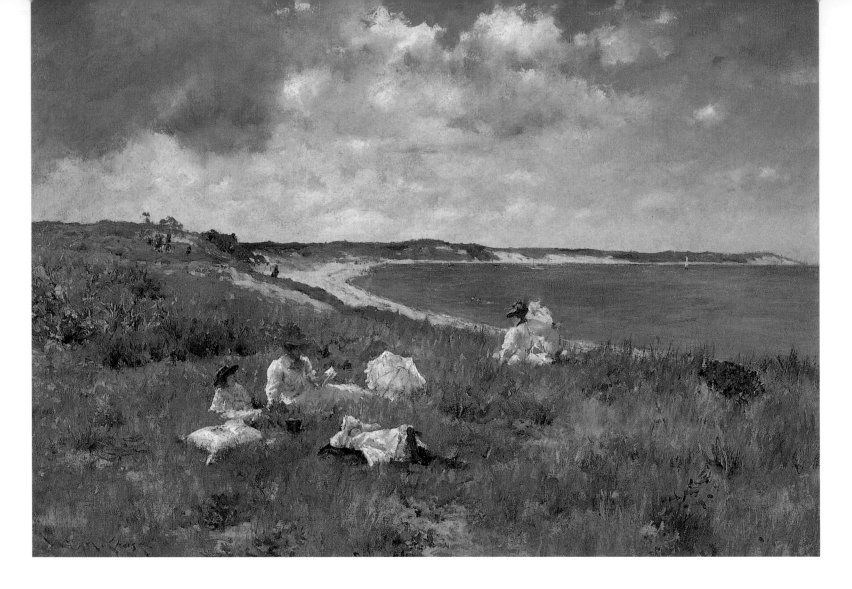

WILLIAM MERRITT CHASE
Idle Hours, c. 1894
All but the wealthiest leisure-class American men worked; therefore women and children had the most leisure time. Here we see a group on the cliffs above the beach. The woman in the red hat reads, while the little girl sprawled on her back watches the clouds high above her.

Monet was another great walker. On arriving in a new place, he would investigate the area by foot, constantly on the look out for sites to paint, and on family holidays he would press his children into service, as Guy de Maupassant recalled: 'I often followed Claude Monet in his search of impressions. He was no longer a painter, in truth, but a hunter. He proceeded, followed by children who carried his canvases, five or six canvases representing the same subject at different times of day and with different effects. He took them up and put them aside in turn, according to the changes in the sky. Before his subject, the painter lay in wait for the sun and shadows, capturing in a few brush strokes the ray that fell or the cloud that passed…I have seen him seize a glittering streak of light on the white cliff face and capture it in a flow of yellow hues that rendered particularly well the startling, fleeting impression left by that almost imperceptible, yet blinding, dazzlement. On another occasion, he plunged his hands into a rainstorm that had swept down on to the sea and flung it against his canvas. And it was indeed rain that he painted in his way, rain and nothing but rain obscuring the waves, the rocks and the sun so that they were barely discernible in the deluge.'

In search of new motifs, Monet set out alone for extended periods, exploring and painting in unfamiliar regions of France, Italy, Norway and Holland, just as Renoir travelled to Algeria, Florence, Venice and Naples, Pissarro to London, Degas to America and Manet to Venice, but it was the countryside along the Seine from Paris to the sea which provided the Impressionists with their best-loved open-air studio. Even the metropolitan Mary Cassatt cultivated a corner in the French countryside. She spent the summers of 1880–82 in Louveciennes and Marly-le-roi, experiment-

ing with *plein-air* painting and, from 1889, rented a large house – the Château de Bachivillers – near Gisors. Five years later, increasingly interested in gardening, she bought herself a property, a romantically rambling château, Beaufresne, in Mesnil-Théribus, fifty miles northwest of Paris.

In the autumn of 1890, at the age of 56, Degas made a journey through Burgundy with his old friend Albert Bartholomé, in a tilbury drawn by a white horse with a trot that was 'gentler than a woman's gait.' The short letters Degas sent the Halévys every day of their trip reveal that behind that famously cantankerous façade there lurked a cheerful gourmet and *bon vivant* who genuinely liked the countryside. 'There's only one country, Sir: ours!' he exclaimed in one of his letters after tasting 'some unbelievable gherkins – a garden in vinegar' at Aignay-le-Duc. At Montgeron they polished off a dinner of sheep's foot, fried gudgeon, some 'admirable' sausage and mash, beef steaks with cress, followed by cheese and fruit. 'No more thoughts,' Degas ended his letter to Halévy, 'one eats too much.' And then added: 'Each meal 3 francs.' Their revels ended on 7 October at Diénay, where they were welcomed with open arms by the *sous-prefet* and Degas's friend Georges Jeannoit, dressed up as a gendarme on horseback. Young girls garlanded the travellers with flowers and Degas was presented with the keys of the city. 'It's only when one has been sad and gloomy for a long time that one can enjoy oneself as much as this,' Degas remarked delightedly. The trip prompted him to produce a series of monotypes on landscape themes which he printed in oil colours in Jeannoit's studio and exhibited at Durand-Ruel's in 1892.

A fair number of Impressionist painters gravitated south as they grew older. Cézanne was already ensconced, of course, and Toulouse-Lautrec was a native, but the dazzling, clear light of Provence was a revelation for Vincent van Gogh, prompting some of his finest work. It was also a powerful draw for Renoir, Monet, who painted in the south from time to time, Bonnard, who settled at Cannet, and Paul Signac, who found a haven in a small unknown fishing village called Saint-Tropez and there was able to combine his love of the sea, of ships and harbours, with his passion for painting.

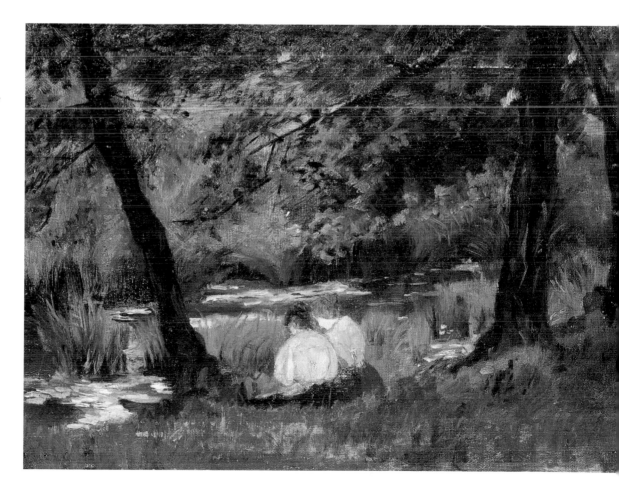

MARY CASSATT
Two Seated Women, 1869
In the summer of 1869 Mary Cassatt travelled through the south of France to Beaufort-sur-Doron, in Savoy, near the Italian border, in the company of Miss Gordon, a fellow Philadelphian and amateur painter. To her sister-in-law Lois she wrote of putting up 'with all discomforts for a time' because 'the surroundings are good for painters.'

In the autumn of 1888 Berthe Morisot and her husband Eugène Manet rented the spacious Villa Ratti at Cimiez just outside Nice for the winter. The green and white country house was surrounded by a large garden full of fig, orange, aloe and olive trees, which reflected the light 'in a spectacular way' and beyond which the sea could be glimpsed. Berthe pronounced herself 'delightfully comfortable' there and, in a brimmingly happy letter to her sister Edma, attributed the glowing health of her family to their habit of lunching outdoors each day on 'bella sardina'. She wrote seductive letters of invitation to all her friends – to Renoir, Mallarmé, Puvis de Chavannes and Monet – reminding them that she was 'positively counting on your visit' for she loved company and her friends knew they were always welcome in any of her homes.

Berthe's idea of a perfect day chimes with many of us: sunshine, simple fresh food, beautifully presented, and eaten with friends and family in stunning surroundings. The Impressionists knew how to enjoy themselves and in their paintings left a map we can all follow.

CLAUDE MONET
Meadow at Bezons, 1874

CLAUDE MONET
The Stroll at Giverny, 1888

Two paintings fourteen years apart in both of which Jean Monet appears, first as a small boy beside his mother in the meadow at Bezons, and then as a tall etiolated figure standing beside Monet's step-daughter Suzanne Hoschedé watching as his younger brother Michel and Germaine and Jean-Pierre Hoschedé advance endlessly into the artist's space. Nine years after this picture was painted Jean would marry Suzanne's sister – his step-sister – Blanche Hoschedé.

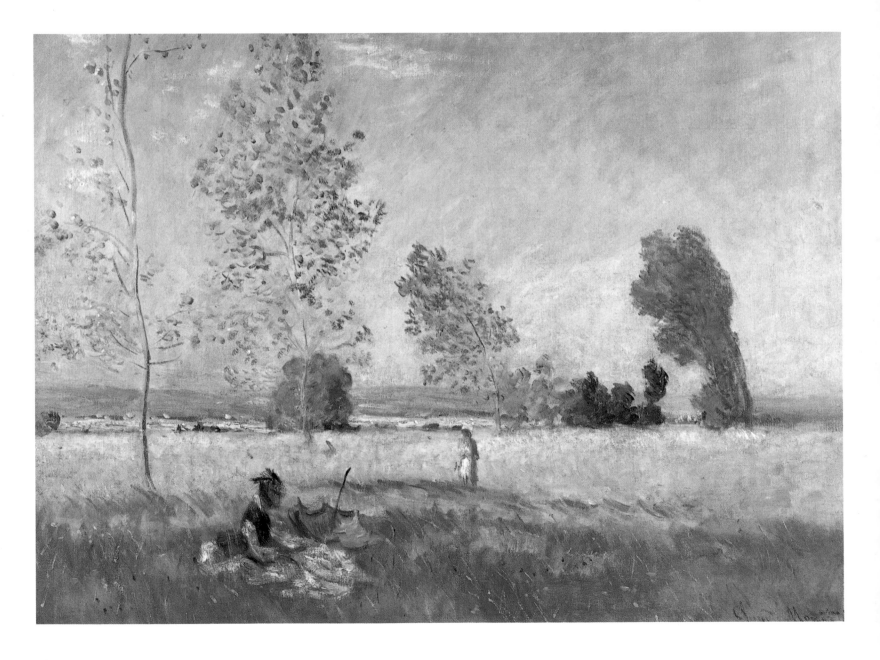

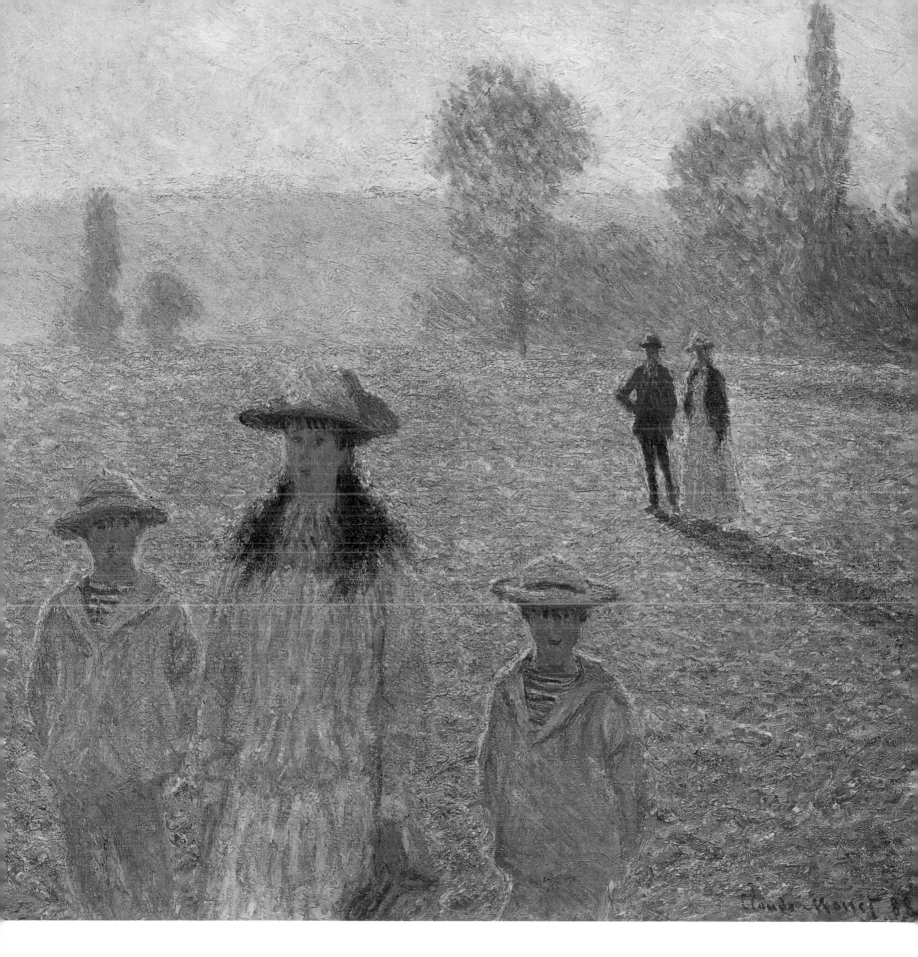

BIOGRAPHIES

Eugène BOUDIN

Gustave CAILLEBOTTE

Mary CASSATT

ANDRÉE, Ellen (1857–1915) Modelled for Manet (*La Parisienne*), Degas (*The Absinthe Drinker*) and Renoir (*Luncheon of the Boating Party*). A lively, witty, independent actress and talented comedienne, she performed at the Folies-Bergère and went on to achieve success on the traditional stage. She married the painter Henri Dumont.

AVRIL, Jane (1868–1943) Immortalized by Toulouse-Lautrec in the posters he made of her at the Divan Japonais and the Jardin de Paris, she was first spotted by Zidler, who engaged her to dance at the Moulin Rouge after seeing her perform her bareback riding routine at the Hippodrome in the Place d'Alma. Despite the vicissitudes of her early upbringing she was cultivated and fond of pictures, books and beautiful things. Her platonic friendship with Lautrec was important to them both.

BARTHOLOMÉ, Paul Albert (1848–1928) A sculptor and great friend of Degas with whom he travelled and visited the ballet. He advised Degas with his sculpting and after his death, supervised the casting in bronze of various wax figures found in his studio.

BAZILLE, Frédéric (1841–70) Born in Montpellier to a wealthy family, the tall, handsome Bazille arrived in Paris at the age of twenty-one to continue his medical studies but soon enrolled at the studio of Charles Gleyre. He shared a studio with Monet and Renoir. A talented artist, his friendship and financial support were important to the young painters and the tragedy of his untimely death at the battle of Beaune-la-Rolande during the Franco–Prussian War deprived the Impressionist movement of one of its most promising painters.

BÉRAUD, Jean (1849–1935) Born in St Petersburg where his sculptor father was completing a commission, Béraud studied with Léon Bonnat and first exhibited his paintings at the Salon in 1872. Best known for his scenes of Parisian daily life during the Belle Époque.

BOUDIN, Eugène (1824–98) A self-taught painter of peopled strands and wide Normandy seascapes who went on to have a great influence on the young Monet. His *plein-air* example contributed significantly to the ideas behind Impressionism and he participated in the first Impressionist exhibition in 1874.

CAILLEBOTTE, Gustave (1848–94) The son of a wealthy Paris businessman, Caillebotte trained to be an engineer, but became increasingly interested in painting, enrolling at the École des Beaux-Arts and taking up with the Impressionists. Both patron and participant, he became a vital figure in the group exhibitions, which he helped to organize. A passionate yachtsman and vice president of the Cercle de la Voile de Paris, he brought his engineering skills to the task of helping Monet construct the covered floating studio he used at Argenteuil. Caillebotte lived in a house on the banks of the Seine at Petit Gennevilliers with his mistress, Charlotte Berthier, and her little daughter, Jenny, until his premature death aged just forty-five. He was buried in the Père Lachaise cemetery; his funeral was attended by all the major Impressionists.

CARON, Rose (1857–1930) Famous French singer much admired by Degas for the purity of her voice and her slim figure. She created the role of Brünnhilde in *Sigurd* and excelled as Elisabeth in *Tannhauser*, Elsa in *Lohengrin* and Iphigenia in *Iphigenia in Tauris*. Degas called her the 'Divine Madame Caron' and dedicated a sonnet he had written himself to her.

CASSATT, Mary Stevenson (1844–1926) Pennsylvania born painter, who travelled to Paris in 1866 and was accepted by the Salon two years later. Enjoyed the strong support of her family and often used them as models in her paintings. She met Degas in 1877 who urged her to exhibit with the Impressionists. A keen admirer of Pissarro as a painter and a person she was, for a time, his near neighbour at Pontoise until, in 1894 she bought and renovated the Château de Beaufresne, northwest of Paris, which would become her country house for the rest of her life, though she kept an apartment and studio in Paris. She suffered, like her great friend Degas, from deteriorating eyesight, which curtailed her career though she remained active in the art world, advising American friends on the purchase of paintings. She never married.

CÉZANNE, Paul (1839–1906) Born in Aix-en-Provence, he disappointed his father by abandoning law in favour of the École des Beaux-Arts, where he met up with Pissarro and Monet and other members of the budding Impressionist circle. Apart from a brief interval working for his father's bank in Aix, he worked as a painter all his life, often struggling on an allowance from his father, especially after the birth of his son, Paul, in 1872, to his model and mistress Hortense Fiquet. He exhibited twice with the Impressionists and divided his time between Paris and the family home Jas de Bouffan. In 1886 he married Hortense and the same year his father died, leaving him a substantial legacy which removed all financial worries. He spent most of his last years in Aix, making studies and paintings of Mont Sainte-Victoire, his favourite subject.

CHARIGOT, Aline (1859–1915) Born in Burgundy, she worked as a laundress and a seamstress in Paris before meeting Renoir in his local lunchtime restaurant and becoming first his model and then his mistress. Renoir kept their relationship a secret from his friends and patrons, even after their son Pierre was born in 1885. The couple married in 1890 and went on to have two more children, Jean (who became a film director and wrote a vivid memoir of his father), born 1894 and Claude, known as Coco, born 1901 when Renoir was sixty and Aline forty-two. Described as an almost compulsive eater, Aline died of a heart attack in 1915.

CHASE, William Merritt (1849–1916) American Impressionist painter with a particularly European style. He studied

for six years at the Royal Academy in Munich and in Venice before returning to New York in 1878.

CHOQUET, Victor (1821–91) French civil servant and friend to the Impressionists, whose work he first saw in 1875 at the Hôtel Drouot. He commissioned portraits of himself and his wife from Renoir and Monet described him as the only person he ever met 'who truly loved painting with a passion'. Monet and Renoir both painted views of the Tuileries Gardens from his apartment. An engaging personality, by the 1890s his collection included thirty-five works by Cézanne.

DEGAS, Hilaire Germain Edgar (1834–1917) Born into a wealthy banking family of noble descent, he entered the École des Beaux-Arts in 1855 where he worked under a pupil of Ingres, his great hero. His friendship with Manet and other members of the Batignolles group encouraged his interest in contemporary Parisian subjects. A lifelong bachelor, and famously prickly, he nevertheless excited great loyalty from his friends. His experiments with pastels, print-making, photography and sculpture give an idea of his breadth and innovation.

DESBOUTIN, Marcellin (1823–1902) Exhibited with the Impressionists in 1876 but is best known as the rather rackety central figure in Degas's *Absinthe Drinker*. A lively conversationalist, he frequented the Cafés Guerbois and Nouvelle-Athènes and managed to squander a considerable fortune.

DIHAU, Desire-Hippolyte (1833–1909) Lille-born bassoonist in the orchestra of the Paris Opéra and an intimate friend and Montmartre neighbour of Degas, who represented him at the centre of his painting *The Orchestra of the Opéra*. He was a cousin of Toulouse-Lautrec, who provided lithographs to illustrate his published songs.

DURAND-RUEL, Paul (1831–1922) One of the most important of the Impressionists' art dealers, he met Pissarro and Monet in London (following the outbreak of the Franco–Prussian War) in 1871 and mounted an exhibition

of their work the following year. Almost ruined by continuing to buy Impressionist paintings, though his faith paid off and he passed a flourishing business over to his son, Charles.

DURET, Théodore (1838–1927) French journalist, politician and loyal supporter of the Impressionists, who wrote about and collected their work.

EPHRUSSI, Charles (1849–1905) Born into a family of Jewish bankers in Odessa, he arrived in Paris in 1871 and began collecting Japanese prints and Impressionist art. An expert on Albrecht Dürer, he became the director and owner of the *Gazette des Beaux-Arts* in 1885 and supported Renoir during the painting of *The Luncheon of the Boating Party*, in which he appears.

FIQUET, Hortense (1850–1918) First met Cézanne when she was working as an artist's model in Paris in 1869 and shortly afterwards began living with him in Paris, L'Estaque and Auvers where the couple and their son, Paul (born 1872), were befriended by Julie and Camille Pissarro. Cézanne tried to keep his liaison with Hortense a secret, only marrying her when Paul was fourteen in 1886, by which time the constant secrecy had had a corrosive effect on their relationship.

FORAIN, Jean Louis (1852–1931) French painter who became friendly with the Impressionists during the 1870s and participated in their exhibitions in 1879, 1881 and 1886. Best known for his drawings and caricatures, he was held in high regard by Degas.

GACHET, Paul (1828–1909) A homeopathic doctor and enthusiastic engraver (under the pseudonym Paul van Ryssel), who befriended the Impressionists – particularly Pissarro, Cézanne and van Gogh – treating Pissarro's children and his mother Rachel, Renoir's model Anna Leboeuf and taking charge of the troubled Vincent van Gogh when he came to live in Auvers-sur-Oise in 1890, though he was unable to prevent him from committing suicide.

GAUGUIN, Paul (1843–1903) The son of a French journalist, he was brought up

in Peru and travelled widely before settling down in Paris, where he worked as a stockbroker. A tumultuous marriage to the Danish Mette Sophie Gad (born 1850) in November 1873 produced five children between 1874 and 1883. Restless, troubled and ambitious he began as a collector of Impressionist paintings before, relatively late in life, deciding to become an artist himself. He worked with Pissarro and Cézanne in Pontoise, exhibiting five times with the Impressionists and became the leader of the Pont-Aven group in Brittany in 1886. A sojourn in the south of France with Vincent van Gogh was a notable disaster. He first visited Martinique in 1887 and lived in Tahiti from 1891–3 and 1895–1901. He died in the Marquesas Islands.

GOENEUTTE, Norbert (1854–94) Studied art at the École des Beaux-Arts and first exhibited his paintings at the Salon in 1876. Met Renoir – for whom he modelled – while living in Montmartre and Degas, Manet and Desboutin, who sparked a lifelong interest in the art of engraving and etching. He provided etchings for Emile Zola's novel, *La Terre*. He declined an invitation to exhibit with the Impressionists. In 1891, suffering from tuberculosis, he moved to Auvers-sur-Oise and placed himself under the care of his friend Dr Gachet.

HALÉVY, Ludovic (1833–1908) French novelist, dramatist and friend of Degas from childhood. He wrote the libretti for Bizet's *Carmen* and many of Offenbach's operas. Degas frequently stayed at his house in Dieppe and often dined with the family in Paris, though they fell out over the Dreyfus affair

HASSAM, Frederick Childe (1859–1935) Boston-born painter who travelled throughout Europe. In 1884 he married Kathleen Maud Doane and two years later moved to Paris for a period of study at the Académie Julian, before returning to America where he painted impressionistic pictures recording pleasurable scenes from leisured life.

HAUSSMANN, Georges Eugène (1809–1891) French city planner and Prefect of Paris who, armed with the

Paul CÉZANNE

Edgar DEGAS

Childe HASSAM

Edouard MANET

Claude MONET

Berthe MORISOT

imperial mandate of Napoleon III, blasted a vast network of broad boulevards through the heart of the old medieval city of Paris and radically reorganized the city.

HOSCHEDÉ, Alice (1845?–1911) Monet met Alice, who would become his second wife, through her husband Ernest Hoschedé, a major collector and patron of the Impressionists in the 1870s. In 1878 a financial crash ruined Hoschedé and Alice and her six children joined forces with the Monet family at Vétheuil, eventually moving, after the death of Monet's wife Camille, to Giverny where Alice ran Monet's household and helped him to plan his famous garden. They married after Ernest's death in 1892. Her eldest daughter Blanche married Monet's son Jean in 1897.

HUYSMANS, Joris-Karl (1848–1907) French novelist and critic (of Dutch extraction) whose novel *À Rebours* caused a storm and became the bible of the 'decadent' movement. He was one of the first critics to appreciate the work of the Impressionists and wrote extensively about them.

JAMES, Henry (1843–1916) Distinguished American born author of over forty books including *The Turn of the Screw, The Europeans* and *Portrait of a Lady,* James is an almost exact contemporary of the major Impressionist painters. He preferred Europe to America and spent a great deal of time in France, reporting, with characteristic elegance, on the same novel leisure activities and the pleasures of Paris which the Impressionists captured on canvas. He settled in England, making his home first in London and later Rye in Sussex. He was naturalized as a British subject in 1915, a year before his death.

KAIRA, Olga (b. 1858) Born in Stettin, Germany (now Poland) she was the black acrobatic star of the Cirque Fernando who went under the stage name Miss La-La and was immortalized by Degas. Described as a 'wirewalker, trapeze artist and strongwoman' she performed aerial stunts and was supposed to have been able to support a cannon from her teeth.

LAURENT, Méry (1849–1900) A woman of great charm and beauty, described as an indifferent actress but a courtesan of genius, who excited the devotion of, among others, Manet and Stéphane Mallarmé whose mistress and muse she was for seven years after Manet's death. When she first posed for Manet she was living in an apartment in the rue de Rome paid for by Louis Napoleon's dentist, who was also her lover. She posed for 'Autumn' and sent frequent gifts of flowers and delicacies to Manet during the last years of his illness.

LE COEUR, Jules (1832–82) French architect and self-taught painter who never enrolled at art school though he frequented 'free' academies and relied on the advice and guidance of artist friends like Monet, Sisley and Renoir, with whom he painted in the forest of Fontainebleau. A widower at the time he befriended the young Impressionist painters, he began a liaison with Clémence Tréhot, whose sister Lise was Renoir's mistress in the mid-1860s.

MALLARMÉ Stéphane (1842–98) Symbolist poet and great friend of Manet, Morisot, Renoir and Monet, whose art he supported in his writings. Manet illustrated his poem *L'Après midi d'un faune.*

MANET, Edouard (1832–83) Wealthy, talented and controversial figure around whom a group of young Impressionist painters gathered in the 1860s. Began a secret affair with his mother's music teacher, Suzanne Leenhoff, whom he later married in 1862. While he never acknowledged Suzanne's son Léon (born 1852) as his own, he made generous provision for the boy in his will. Despite his close friendship with Degas, Morisot, Monet and Renoir, Manet never officially joined the Impressionists, nor did he participate in any of their group exhibitions. A sophisticated socialite, he owned property at Gennevilliers and Asnières and, with his friend Theodore Duret, tried to help the impecunious Monet by anonymously buying ten of his paintings. After years of suffering from syphilis and ten days after the amputation of his left leg, he died on 30 April 1883.

MANET, Julie (1879–1966) Daughter of Berthe Morisot and Manet's brother Eugène, she became Mallarmé's ward after the death of her parents. The diary she kept as a teenager was published under the title *Growing up with the Impressionists* and provides some fascinating insights.

MEURENT, Victorine Louise (1844–85) Brought up in poverty and with a hankering to become an actress, the fair, almost red-haired, beauty met Manet when she was just twenty and became his model for *Olympia* and *Déjeuner sur l'herbe,* A talented enough artist to have a self-portrait accepted by the Salon in 1876, she sadly succumbed to alcoholism and died in abject poverty two years after Manet.

MONET, Claude (1840–1926) The eldest son of a Parisian shopkeeper, Monet was brought up in Le Havre, where Eugène Boudin encouraged him to paint out of doors. He enrolled at the Académie Suisse in Paris, where he met Pissarro, and two years later entered the atelier of Charles Gleyre, where he joined forces with Bazille, Renoir and Sisley. In 1866 he met Camille Doncieux, who modelled for *Women in the Garden,* and the following year their son, Jean, was born. His family disapproved of his relationship and he and Camille lived in straitened circumstances in a number of rented houses in the suburbs around Paris. A second son was born in 1871. In 1883 Monet, by now a widower, moved with Alice Hoschedé and her children to the house at Giverny which would become his home for the next forty-three years. Monet and Alice were married in 1892.

MOORE, George (1851–1933) Irish novelist and habitué of the Nouvelle-Athènes who during his time in Paris became friendly with, and a great champion of, the Impressionists.

MORISOT, Berthe Marie Pauline (1841–95) Born into a wealthy haut bourgeois family, Berthe Morisot and her sister, Edma (1839–1921), showed early artistic promise. This was encouraged by their mother, who introduced them to Corot, Puvis de Chavannes and Fantin-Latour. Her work was exhibited regularly at the Salon from 1864 and was praised

by the critics. In 1867 she was introduced to Manet by Fantin-Latour and he became a keen admirer, inviting her to pose for some memorable paintings. In 1874 she married Manet's younger brother Eugène and in 1879 her daughter Julie was born. She met Mary Cassatt in the late 1870s and collaborated with her in printmaking but her closest friendship – after Manet – was with Renoir. She did not long outlive her husband, who died aged 59 in 1892, falling ill herself in February 1895 and dying a few weeks later. She was buried in the Manet family tomb in Passy alongside Eugène, Edouard and Suzanne.

MURER, Eugène (1845–1906) French poet, painter and pastry cook who bought and sold Pissarro's paintings and was willing to exchange paintings for meals at the crémerie he and his sister ran at 95 Boulevard Voltaire during the 1870s. He held open house for the Impressionists every Wednesday and encouraged his customers to buy their paintings

NITTIS Giuseppe de (1846–84) Italian painter and lifelong friend of Degas and Manet, he participated in the first Impressionist exhibition but pursued the very successful path of a society portrait painter.

PISSARRO, Camille (1830–1903) Born in the West Indies, Pissarro was sent to Paris by his affluent Jewish family to complete his education. He enrolled at the Académie Suisse, where he met Monet, and was a regular at the Café Guerbois, haunt of Manet, Degas, Renoir and Cezanne. A lifelong socialist, he poured great energy into organizing the Impressionist exhibitions and was an indefatigable supporter of younger new talent, befriending Signac, Seurat and van Gogh. His affair with his mother's maid Julie Vellay was frowned upon, but the couple married in 1870 and went on to have six children, all of whom proved artistic.

RAFFAËLLI, Jean-François (1850–1924) French painter, sculptor and habitué of the Café Guerbois, who was invited by Degas to participate in two Impressionist exhibitions.

RENARD, GABRIELLE (1878–1959) Maid, model and nanny to Renoir's children for over twenty years from 1894. Later she graduated to secretary and assistant, preparing and cleaning Renoir's palettes when his rheumatoid arthritis made such work impossible for him.

RENAUDIN, Etienne (1843–1907) Male dancer at the Moulin Rouge who features in the posters of Toulouse-Lautrec and went under the stage name of Valentin le Désossé,

RENOIR, Edmond (1849–1923) Renoir's younger brother, he founded *La Vie Moderne* with the Charpentiers and often posed for Renoir.

RENOIR, Pierre-Auguste (1841–1919) The fourth child of a tailor and a seamstress, Renoir was brought up in humble circumstances. Apprenticed at twelve as a painter in a porcelain factory, he took on extra work to pay for art school. In 1861 he met Monet, Sisley and Bazille while attending Charles Gleyre's studio and in 1862 was accepted by the École des Beaux-Arts. A man of great personal charm, he was adept at forging influential connections with patrons like the publisher Georges Charpentier and the banker Paul Bérard. From 1867 to 1872 Renoir's mistress and favourite model was a young woman called Lise Tréhot, younger daughter of the postmaster at Ecquevilly. In 1879 he began living with a young seamstress from Burgundy named Aline Charigot and they had three sons together and married in 1890. The family lived first at Montmartre, then in Aline's home village of Essoyes before moving permanently to the south of France for the sake of Renoir's failing health. In 1907 he bought a piece of land on the hillside at Cagnes-sur-Mer and built Les Collettes, a substantial house with generous gardens.

RIVIÈRE, Georges (1855–1943) French writer and great friend of Renoir's, who started *L'Impressioniste*, which was published from the offices of Alphonse Legrand's art gallery each Thursday throughout the third Impressionist exhibition. Much later he published fascinating books of reminiscences about Renoir, Cézanne and Degas.

ROBINSON, Theodore (1852–96) American Impressionist artist who trained in Paris and was profoundly influenced by Millet and Monet, whom he met in 1888 and became very friendly with. Spent most of 1884–92 in France, in Barbizon and Grez, and established a small but important artists' colony at Giverny with Twachtman and Weir in 1888. Suffered from chronic asthma and died young and impoverished in New York in 1896.

ROUART, Henri (1833–1912) French businessman and keen amateur painter who participated in all the Impressionist exhibitions and who was a close friend of Degas's since childhood.

SAMARY, Jeanne (1857–90) Beautiful and renowned actress at the Comedie-Française who modelled for Renoir.

SARGENT, John Singer (1856–1925) The most European of American artists, Sargent was born in Florence, studied in Paris and lived in London. He experimented along the innovative lines of his friend Monet, whom he visited several times in Giverny between 1885–9.

SEURAT, Georges (1859–91) Born in Paris to solid middle-class parents, he studied at the École des Beaux-Arts and exhibited his major work *Sunday Afternoon on the Island of La Grande Jatte* in the last Impressionists show of 1886. However, a meeting with Signac in 1885 led him to develop the pointillist style with which he became best known. Extremely tall, self-contained and regular in his habits, he was not an easy man to know, though Pissarro and the other Impressionists were shocked and saddened to hear of his premature death, aged just thirty-two, following a short illness.

SICKERT, Walter Richard (1860–1942) Son of a painter, Sickert studied at the Slade School of Fine Art, and, following a meeting with Degas, arranged by Whistler in 1883, became a leading light in English Impressionism. A flamboyant personality, he lived abroad in Dieppe, Venice and Paris, before returning to London in 1905, where he formed the Fitzroy Street Group and was taken up by younger painters.

Camille PISSARRO

Pierre-Auguste RENOIR

John Singer SARGENT

Walter SICKERT

Henri TOULOUSE-LAUTREC

Vincent VAN GOGH

SIGNAC, Paul (1863–1935) Largely self-taught artist, influenced by the work of Monet and Degas, and introduced by Guillaumin to Pissarro, who invited him and Seurat to participate in the last Impressionist exhibition of 1886. More gregarious than Seurat, he became friendly with van Gogh and Caillebotte, who sailed down the Seine with him to visit Seurat at the Ile de la Grande Jatte while he was working on his large canvas. He moved to the south of France in 1887, became president of the Société des Artistes Indépendants and had decidedly Anarchist sympathies.

SISLEY, Alfred (1839–99) Genial Impressionist, born in Paris to prosperous English parents, he lived all his life in France and rarely visited England. Quiet, determined and rather shy, he enrolled at Charles Gleyre's studio and worked mainly in Paris and Louveciennes, Marly-le-Roi and Sèvres, painting landscapes of great power, often imbued with an exquisite sense of melancholy. In 1870 his father's artificial flower business was ruined by the Franco–Prussian war, leaving Sisley without means, and he and his partner Marie Lescouezec and their two children, Jeanne and Pierre, experienced periods of extreme financial hardship. In 1882 he settled in Moret-sur-Loing and died in poverty in his sixtieth year after a lifelong struggle for the recognition that never came.

TRÉHOT, Lise (1848–1924) Renoir's mistress and model for many important paintings between 1867 and 1872.

TOULOUSE-LAUTREC, Henri de (1864–1901) Born at Albi into an old aristocratic family, a rare bone disease stunted the growth of his legs after two fractures. He studied at Cormon's studio in Paris with van Gogh and produced vibrant paintings and pioneering posters depicting Parisian nightlife, but his wild lifestyle and excessive drinking contributed to his premature death aged thirty-seven.

VALADON, Suzanne (1865–1938) Strikingly beautiful illegitimate daughter of a laundress, who began working as a circus acrobat at fifteen, went on to model for Degas, Lautrec and Renoir and became the first female painter to be admitted to the Société Nationale des Beaux-Arts. A free-spirited woman she had affairs with Renoir and Erik Satie, and married twice. Her son Maurice Utrillo went on to become an even more famous painter than his mother.

VALPINÇON, Paul (1830–1894) Close friend of Degas's since schooldays whose father, Edouard, introduced the painter to Ingres. Degas often stayed at the family's château at Menil-Hubert in Normandy and painted members of the family on numerous occasion.

VAN GOGH, Vincent (1853–90) A Dutch pastor's son, van Gogh's early sombre palette was lightened by his contact with the Impressionists and exploded into vibrant colour on his move to Arles in 1886. His last two years were spent in asylums at St-Remy and at Auvers-sur-Oise, where his brother Theo – manager of the Montmartre branch of the Bousod and Valadon gallery and constant supporter – had sent him to recuperate under the care of Dr Gachet. There he died a few days after a suicide attempt.

VELLAY, Julie (1838–1922) Daughter of a Burgundian vine-grower, Julie Vellay came to Paris in 1860 to work as a maid to Pissarro's mother Rachel. Their affair, and particularly the birth of their son, estranged Pissarro from his family, who cut off his allowance. The couple had two children by the time they married in London in 1870 and went on to have four more, though one, Jeanne-Rachel, died tragically young at nine. Hard-working and resourceful, Julie supported her husband during years of privation.

VOLLARD, Ambroise (1867–1939) A flamboyant figure in the art world who opened a gallery at 39 rue Laffitte with an exhibition of sketches by Manet and went on to champion Pissarro, Renoir and Degas. He gave Cézanne his first one-man show in 1895 and promoted Bonnard, Vuillard and van Gogh, as well as Picasso and Matisse.

WEBER, Louise (1870–1929) At nineteen the star attraction at Charles Zidler's newly opened Moulin Rouge, the flame-haired dancer became famous as La Goulue and was a constant subject for Lautrec.

WEIR, Julian Alden (1852–1919) American painter who studied academic painting at the École des Beaux-Arts before converting to Impressionism. An admirer of Manet and Whistler, his advantageous marriage to Anna Dwight Baker provided financial support at a time when he was struggling for recognition. He divided his time between a townhouse in New York and a farm in Branchville, Connecticut, and corresponded regularly with Mary Cassatt in Paris.

WHISTLER, James Abbott McNeill (1834–1903) American-born artist whose aesthetic ideas had a profound effect on Gauguin, Monet and other Impressionists in Paris and on painters like Sickert and Menpes during his sojourn in London. His painting *The White Girl* was exhibited along with Manet's *Déjeuner sur l'herbe* at the Salon des Refusés in 1863. In 1888 he married E. V. Godwin's widow and they settled in a small house in the rue du Bac. Became an intimate friend of Mallarmé and regularly attended Mallarmé's famous Tuesday evening soirées in company with a select circle of Symbolist poets, painters and critics.

ZOLA, Emile (1840–1902) Celebrated French novelist and champion of 'realism' who moved in Impressionist circles but lost the friendship of his old classmate Cézanne after the publication of his novel *L'Oeuvre*, a *roman à clef* about the Parisian art scene, which included an unflattering description of a struggling artist named Claude Lantier who bore a striking (and painful) resemblance to Cézanne.

Paris is the place to start. The streets and boulevards, squares and bridges are unchanged in places: the Pont Neuf looks much as it did when Monet, Renoir and Pissarro were painting it, the elegant façades of Haussmann's uniform six- and seven-storey blocks with their wrought-iron balconies are straight out of a Caillebotte painting; at the Place de l'Europe you can still look down on the massive masonry piers and iron trellises of the bridge he painted and across the rail tracks to Monet's Gare Saint-Lazare. Marks and Spencers may have joined the *grands magasins* on the right bank, but you can still shop at Printemps on the Boulevard Haussmann and at Le Bon Marché on the *rive gauche*. Although few of the Impressionists' haunts survive, the streets in which they were located do and a stroll around, say, Montmartre or the Batignolles district can, with a little imagination, be an immensely rewarding experience, especially if it is preceded by a trip to the Louvre, the Musée Marmottan, the Orangerie, or the Musée d'Orsay, which are all packed with paintings by the Impressionists. Some streets have been renamed – the rue de Laval is now rue Victor-Massé – and others renumbered since the time of the Impressionists, but a plaque commemorates Manet's birthplace at 5 rue Bonaparte and the elegance of the town houses beyond the gate giving on to the Avenue Frochot has scarcely changed since Toulouse-Lautrec lived at number 5. Le Chat Noir is no more but the Folies Bergère still stands in the rue Richer and the can-can is still danced at the Moulin Rouge, though you may be ill advised to lavish 214 euros on the 'Toulouse-Lautrec Menu' (half bottle of champagne included per person plus a minivan pick up and drop off). Sadly, the Nouvelle-Athènes is no more and the Café Guerbois, where the painters met in the evenings to energetically debate the artistic questions of the day, is now a shoe shop. Les Ambassadeurs, so beloved by Degas, has gone and the Café Riche burned down, though a gleam of old Paris can still be found in the time-mellowed panelling of the surviving restaurant, Au Petit Riche, on the rue Le Peletier. The once

fashionable Boulevard des Italiens has lost Tortoni's and the Maison Doré closed its doors in 1902. The Café Anglais was gone by 1913 but the shimmering Grand Café survives on the Boulevard des Capucines, along with that quintessentially elegant nineteenth century gem, the Café de la Paix, designed by Charles Garnier and just a short distance from his still opulent Opéra, which nowadays stages mainly ballets, the operas having moved to the Opéra Bastille. Backstage is the Foyer de la Danse Degas painted so often and the six-tonne chandelier still graces the auditorium.

Montmartre offers the best views across Paris and Le Moulin de la Galette (minus the old windmill) has been turned into a stylish restaurant. The old cobbled streets and alleyways are hardly changed and it is still possible to look over the wall of Renoir's house at 6 rue Giraudon, though it is now in private hands. More tangibly, the site of Renoir's old Montmartre studio at 12 rue Cortot has been turned into a museum of old Montmartre, and is worth a visit.

Parisian parks continue to delight. To stroll through the Tuileries Gardens after a visit to the Louvre, to wander past the statues, fountains and flowers in the Luxembourg Gardens on the left bank, or spend an hour on a bench in the Parc Monceau – surely the prettiest park in Paris – is to step back in time. The vast Bois de Boulogne is delightful by day, though seedy at night when the kerb-crawlers come out in force. There's a breathtaking rose exhibition in June and business is still brisk at the racecourses at Longchamp and Auteuil.

The forest of Fontainebleau, which provided our young artists with sites for *plein-air* painting in the 1860s, and the small villages of Barbizon, Marlotte and Chailly-en-Bière are well worth a visit. The Auberge du Père Ganne at Barbizon is now a museum and the Musée Municipal de l'École de Barbizon is rewarding.

The suburbs to the west of Paris provided homes and recreational sites for the Impressionists. Sisley is closely associated with Marly-le-Roi and the charming village of Moret-sur-Loing and

Pissarro with Louveciennes. Monet painted his first major *plein-air* picture in Ville-d'Avray, but spent more time at Argenteuil, which is also Caillebotte country. The Seine of course is the great motif of many Impressionist paintings and, although the river is no longer as lovely at Chatou as it was when Renoir painted *The Luncheon of the Boating Party*, it is still possible to eat in the Restaurant Fournaise and to visit the Musée Fournaise on the Ile de Chatou. The park at Chatou has been renamed the Ile des Impressionistes and, although the riverbed has changed greatly, it is still possible to conjure Monet and Renoir's La Grenouillère, just as it is possible to imagine Seurat's park on the Ile de la Jatte (no longer Grande) so long as you edit out the skyscrapers.

Less spoiled are the towns of Pontoise and Auvers-sur-Oise, which were important locations for Pissarro, Gauguin and van Gogh. The Auberge Ravoux on the Place de la Mairie, where van Gogh died, is now renamed the Maison de van Gogh and open to the public. Vincent and his brother Theo are buried side by side in the cemetery at Auvers. The museum dedicated to Pissarro at 17 rue du Château in Pontoise is also worth a visit.

Monet's three-year sojourn in Vétheuil is commemorated by a plaque on the (inaccessible) house at number 16 Avenue Claude Monet that he shared with his wife, Camille, and the Hoschedé family for three years from 1878 but the real jewel in any Impressionist pilgrimage is to be found at Giverny, where Monet's home for the last forty-three years of his life has been painstakingly restored to provide surely the most rewarding site for visitors, who can walk around the gardens, stand on the famous green Japanese bridge, and visit the house and its studios. The elegant and serene American Art Museum in the rue Claude Monet, which celebrates the work of the colony of pioneer American Impressionist painters, is also worth a visit, as is the Hôtel Baudy, where the young American artists stayed when they first arrived in Giverny.

The Normandy coastal town of Fécamp was frequented by Monet and

Berthe Morisot. Étretat, Deauville and Trouville, where Monet and his first wife Camille spent their honeymoon, were also favourites. Renoir preferred Pornic on the Atlantic coast and Signac made his home in Saint Tropez. At Honfleur the charms of the Musée Eugène Boudin on the Place Erik Satie and Mère Toutain's Ferme Saint Siméon – once frequented by artists, including Monet and Pissarro, and still serving food – await you.

The limpid light and warm weather of the South drew Monet, Renoir, Morisot, Signac and Bonnard to Provence and the Mediterranean coast and reclaimed Cézanne, a native of Aix-en-Provence, who returned to the family home of Jas de Bouffan after an unhappy time in Paris. He sold the house in 1899 and built himself a studio on the road leading to Les Lauves (now named the Avenue Paul Cézanne) which is still preserved and open to the public. Les Collettes, the house Renoir had built for himself and his family in the midst of olive and orange trees at Cagnes-sur-Mer, now houses the Musée Renoir and, along with the gardens, is open to the public.

Finally, it is possible to visit J. Alden Weir's 153-acre farmhouse home in Wilton, Connecticut, where, for thirty-seven years, he and visiting American Impressionist friends, like Childe Hassam and John Twachtman, indulged their love of landscape painting. His legacy is continued by the artist-in-residence programme offered to professional artists by the Weir Farm Trust.

Abelson, E. S., *When Ladies Go A-thieving: Middle-class Shoplifters in the Victorian Department Store*, Oxford, 1989

Adams, S., *The World of the Impressionists*, London, 1989

Adburgham, A., *Shops and Shopping 1800–1914*, London, 1964

Adler, K., *Camille Pissarro, a biography*, London, 1978

Adler, K., and T. Garb, *Berthe Morisot*, London, 1987

Aldcroft, D. H., *Transport in the industrial revolution*, Manchester, 1983

Anderson, J., and E. Swinglehurst, *The Victorian and Edwardian Seaside*, Country Life Books, 1978

Barter, J. A., *Mary Cassatt: Modern Woman*, New York and Chicago, 1998

Bashkirtseff, M., *Journal*, 1891 (trans. M. Blind), reprinted London, 1985

Baudelaire, C., 'Le Peintre de la vie moderne' (1863) in *The Painter of Modern Life and Other Essays* (trans. and ed. J. Mayne), London, 1964

Bellony-Rewald, A., *The Lost World of the Impressionists*, London, 1976

Benjamin, W., 'Paris – the Capital of the Nineteenth Century' in *Charles Baudelaire: A lyric Poet in the Era of High Capitalism* (trans. H. Zohn), London, 1976

Berman, M., *All That is Solid Melts into Air: The Experience of Modernity*, London, 1983

Blanche, J.-E., *Manet* , Paris, 1924

—, 'Les Dames de la Grande-rue, Berthe Morisot', *Ecrits Nouveaux*, Paris, 1920

Booth, M. R, *Victorian Spectacular Theatre, 1850–1910*, London, 1981

Bouret, J., *Toulouse Lautrec*, London, 1964

Brettell, R., and A.-B. Fonsmark, *Gauguin and Impressionism*, New Haven, 2005

—, *A Day in the Country: Impressionism and the French Landscape*, exh. cat., Grand Palais, Paris, and Los Angeles County Museum of Art, 1984

—, *Pissarro and Pontoise*, New Haven, 1990

Broude, N., *Gustave Caillebotte and the Fashioning of Identity in Impressionist Paris*, Chapel Hill, 2002

Brown, M., *Gypsies and other Bohemians*, Ann Arbour, 1985

Cachin, F., et al., *Cézanne*, Philadelphia Museum of Art, 1996

Cézanne, P., *Correspondance* (ed. J. Rewald), Paris, 1978

Clark, T. J., *The Painting of Modern Life: Paris in the Art of Manet and his Followers*, London and New York, 1985

Cogniat, R., *Sisley* , Bergamo, 1978

Comment, B., *The Panorama* (trans. A.-M. Glasheen), London, 1999

Couldrey, V., *Alfred Sisley: The English Impressionist*, Newton Abbot, 1992

Courthion, P., *Montmartre* (trans. by S. Gilbert), Milan, 1956

—, *Portrait of Manet by Himself and his Contemporaries* (eds P. Courthion and P. Cailler, trans. M. Ross), London, 1960

Crossick, G. and H.-G. Haupt, *Shopkeepers and Master Artisans in Nineteenth-Century Europe*, London, 1984

Denvir, D., *The Chronicle of Impressionism*, London, 1993

Distel, A*., Renoir, A Sensuous Vision*, London, 1995

Dorment, R., and M. F. Macdonald, *James McNeill Whistler*, London, 1994

Dumas, A. (and other contributors) *The Private Collection of Edgar Degas*, New York, 1997

Duret, T., *Manet and the French Impressionists (Pissarro, Claude Monet, Sisley, Renoir, Berthe Morisot, Cézanne, Guillaumin)* (trans. J. E. Crawford Flitch), London, 1910

Fitzgerald, P., *The World Behind the Scenes*, London, 1881

Flugel, J. C., *The Psychology of Clothes*, London, 1930

Fosca, F., *Renoir, his Life and Work*, London, 1961

Frisby, D., *Fragments of Modernity*, Oxford, 1988

Frascina, F., and C. Harrison (eds), *Modernity & Modernism: French Painting in the Nineteenth Century*, New Haven, 1993

Gerdts, W. H., et al., *Lasting Impressions: American Painters in France, 1865–1915*, Giverny, 1992

Goncourt, E. and J. de, *Pages from the Goncourt Journal* (ed., trans. and intro. R. Baldick), Oxford, 1978

Gronberg, T. A., 'Femmes de brasserie', in *Art History*, September 1984

Guerin, M., *Degas Letters* (ed. and trans. M. Kay and B. Cassirer), Oxford, 1947

Halévy, D., *My Friend Degas* (trans. and ed. M. Curtiss and R. Hart-Davis), 1966

Hanson, A. C., *Manet and the Modern Tradition*, New Haven, 1977

Harvey, D., *Paris, Capital of Modernity*, London, 2003

—, *Consciousness and the Urban Experience*, Oxford, 1985

Herbert, R. L, *Impressionism: Art, Leisure and Parisian Society*, New Haven, 1988

Hern, A., *The Seaside Holiday*, London, 1967

Holt, R., *Sport and Society in Modern France*, London, 1981

Howard, M., *The Impressionists by Themselves*, London and New York, 1998

Hugget, F. E., *Carriages at Eight: Horse-drawn society in Victorian and Edwardian times*, New York, 1980

Huysmans, J.-K., *Parisian Sketches* (trans. with intro. and notes by B. King), London, 2004

James, H., *Parisian Sketches, Letters to the New York Tribune 1875–1876* (ed. with intro. by L. Edel and I. D. Lind), New York, 1957

Kendall, R., *Degas by Himself*, London, 1987

—, *Monet by Himself*, London, 1989

—, *Cézanne by Himself*, London, 1990

—, *Degas, Beyond Impressionism*, London and Chicago, 1996

King, E., *My Paris, French Character Sketches*, Boston, 1868

Kington, M. (ed. and trans.), *The World of Alphonse Allais*, London, 1976

Lanier, D., *Absinthe, the Cocaine of the Nineteenth Century*, Jefferson, 1995

Lansdell, A., *Seaside Fashions 1860–1939*, Princes Risborough, 1990

Latouche, G., 'Edouard Manet souvenirs intimes', *Le Journal des arts*, Jan. 15, 1884

Lethève, J.-J., *Daily Life of French Artists in the Nineteenth Century* (trans. H. Paddon), London, 1972

Mancoff, D. N., *Mary Cassatt: Reflections of Women's Lives*, London, 1998

Manet, J., *Growing up with the Impressionists*, (trans., ed. and introd. R. De Boland Roberts and J. Roberts), London, 1987

Mathews, N. M., *Cassatt and her Circle: Selected Letters*, Abbeville, 1984

Maupassant, G. de*., Selected Short Stories*, Harmondsworth, 1971

McMullen, R., *Degas, His Life, Times, and Work*, London, 1985

Miller, M. B., *The Bon Marché, Bourgeois Culture and the Department Store, 1869–1920*, Princeton, 1981

Moore, G., *Confessions of a Young Man*, London, 1886

Morisot, B., *The Correspondence with Her Family and Friends* (ed. D. Rouart and intro. by K. Adler and T. Garb), London, 1986

Nead, L., *Victorian Babylon*, New Haven, 2000

Offenstadt, P., *Jean Béraud 1849–1935, The Belle Epoque*, Cologne, 1999

Perrot, P., *Fashioning the Bourgeoisie* (trans. R. Bienvenu), Princeton, 1994

Perruchot, H. *Manet* (trans. H. Hare), London, 1962

Pinkney, D., *Napoleon III and the Rebuilding of Paris*, Princeton, 1972

Pitman, D. W., *Bazille: Purity, Pose and Painting in the 1860s*, Pennsylvania, 1998

Pollock, G., 'Modernity and the Spaces of Femininity' in *Vision and Difference*, London, 1988

Reff, T., *Degas, The Artist's Mind*, London, 1976

—, *The Notebooks of Edgar Degas*, Oxford, 1976

Renoir, J., *Renoir, My Father*, London, 1958

Rewald, J., *Studies in Impressionism* (ed. I. Gordon and F. Weitzenhoffer), London, 1985

—, *Paul Cézanne, Letters*, London, 1941

—, *Camille Pissarro, Letters to his son Lucien*, (trans. L. Abel), London, 1944,

—, *Seurat: A Biography*, New York, 1990

Rhodes, A., *Louis Renault: A Biography*, London, 1969

Richardson, J., *The Bohemians, La vie de Boheme in Paris, 1830–1914*, London, 1969

Rivière, G., *Renoir et ses amis*, Paris, 1921

Roskill, M. (ed.), *The Letters of Vincent van Gogh*, London, 1963

Rothenstein, W., *Men and Memories*, London, 1931

Rouart, D., *Claude Monet*, Milan, 1958

Schimmel, H. (ed.), *The Letters of Henri de Toulouse-Lautrec*, Oxford, 1991

Sennett, R., *The Conscience of the Eye*, London, 1991

—, *Flesh and Stone The Body and the City in Western Civilization*, London, 1994

Shone, R., *Sisley*, London, 1979

Simmel, G., 'The Metropolis and Mental Life, 1903, repr. in R. Sennett, *Classic Essays on the Culture of Cities*, 1969

Smith, B. G., *Ladies of the Leisure Class*, Princeton, 1981

Spate, V., *The Colour of Time: Claude Monet*, London, 1992

Surtees, R. S., *Mr Sponge's Sporting Tour*, Bradbury and Evans, 1853

Sutcliffe, A., *The Autumn of Central Paris: The Defeat of Town Planning 1850–1970*, London, 1970

Thomson, R., *Camille Pissarro: Impressionism, Landscape and Rural Labour*, London, 1990

Timms, E., and D. Kelley, *Unreal City: Urban Experience in Modern European Literature and Art*, New York., 1985

Todd, P., *The Impressionists at Home*, London and New York, 2005

Tucker, P. H., *Monet at Argenteuil*, New Haven, 1982

Uzanne, O., *Les Modes de Paris*, London, 1912

—, *The Modern Parisienne*, London, 1912

Valery, P., *Degas, danse, dessin*, Paris, 1938

Varnedoe, Kirk, *Caillebotte*, Yale University Press, 1987

Venturi, L., *Les Archives de l'impressionism, I & II*, Paris and New York, 1939

Vidler, A., *The Architectural Uncanny: Essays in the modern unhomely*, Cambridge (Mass.), 1992

Vollard, A., *Degas, An Intimate Portrait* (trans. R. T. Weaver), London, 1928

—, *Renoir: An Intimate Record* (trans. H. L. Van Doren and R. T. Weaver), New York, 1925

Wadley, N., *Renoir: A Retrospective*, New York, 1983

Weber, E., *France, Fin de Siècle*, Cambridge (Mass.), 1986

Weinberg, H. B., D. Bolger and D. Park Curry, *American Impressionism and Realism: The Painting of Modern Life, 1885–1915*, New York, 1994

—, *Childe Hassam: American Impressionist*, New Haven, 2004

White, B. E., *Renoir His Life, Art and Letters*, New York, 1984

—, *Impressionists Side by Side, Their Friendships, Rivalries and Artistic Exchanges*, New York, 1996

Wilson, E., *Adorned in Dreams, Fashion and Modernity*, London, 1985

—, *The Sphinx in the City: Urban Life the Control of Disorder and Women*, London, 1991

Wilson-Bareau, J., *Manet by Himself*, London, 1991

Young, D. W., *The Life and Letters of J. Alden Weir* (ed. with intro. by L. W. Chisolm), New Haven, 1960

Zola, E., *L'Assommoir* (ed. L. Tancock), Harmondsworth, 1970

—, *Au bonheur des dames* [Paris, 1883], (trans. B. Nelson), Oxford, 1995

LIST OF ILLUSTRATIONS

Dimensions of works are given in centimetres then inches, height before width.

p. 1 Cassabois, Gallo, Susse and Fournier playing boules at Petit Gennevilliers, February 1892. Photograph by Martial Caillebotte. Private Collection

p. 2 Pierre-Auguste Renoir, *Dance at Bougival*, 1882–3. Oil on canvas, 182 x 98 (71⅝ x 38⅝). Museum of Fine Arts, Boston

p. 3 John Singer Sargent, *Claude Monet Painting by the Edge of a Wood*, c. 1887. Oil on canvas, 54 x 64.8 (21¼ x 25½). Tate, London

p. 4 Edouard Manet, *Skating*, 1877. Oil on canvas, 88.3 x 69.9 (34¾ x 27½). Photo Francis G. Mayer/Corbis

p. 6 Pierre-Auguste Renoir, *At the Theatre (La Première Sortie)*, 1876–7. Oil on canvas, 65 x 49.5 (25⅝ x 19½). National Gallery, London

p. 7 Claude Monet, *The Bank on the Seine (Bennecourt)*, 1868. Oil on canvas, 81.5 x 100.7 (32⅛ x 39⅝). Art Institute of Chicago, Potter Palmer Collection

p. 8 Edouard Manet, *Monet Working on his Boat in Argenteuil*, 1874. Oil on canvas, 80 x 98 (31½ x 38⅝). Bayerische Staatsgemäldesammlungen, Munich

p. 9 Pierre-Auguste Renoir, *Picnic*, c. 1893. Oil on canvas. Photo © The Barnes Foundation, Merion Station, Pennsylvania/Corbis

p. 10l The Avenue du Bois de Bologne. Photograph. Sirot-Angel, Paris

p. 10r Claude Monet, *Interior of the Gare Saint-Lazare*, c. 1877. Pencil on paper, 34 x 25.5 (13⅜ x 10). Musée Marmottan, Paris. Photo Giraudon/Bridgeman Art Library

p. 11 Norbert Goeneutte, *The Boulevard de Clichy under Snow*, 1876. Oil on canvas, 60 x 73.5 (23⅝ x 28⅞). Tate, London

p. 12 Alfred Sisley, *Promenade des Marronniers*, 1878. Oil on canvas, 51.8 x 62.5 (20⅜ x 24⅝). Photo Christie's Images Ltd

p. 13 Pierre-Auguste Renoir, *The Beach at Pornic*, 1892. Oil on canvas, 66 x 81.3 (26 x 32). Private Collection

p. 14 Edgar Degas, *At the Louvre*, c. 1879. Pastel on 7 pieces of paper, 71 x 54 (28 x 21¼). Private Collection

p. 15 Pierre-Auguste Renoir, *The Swing*, 1876. Oil on canvas, 92 x 73 (36¼ x 28⅝). Musée d'Orsay, Paris

p. 16 Edouard Manet, *The Waitress* (detail), c. 1878–80. Oil on canvas, 97.1 x 77.5 (38¼ x 30½). National Gallery, London

p. 17 Edouard Manet, *At the Café*, 1869. Pen and ink, 29.5 x 39.4 (11⅝ x 15½). Fogg Art Museum, Harvard University, Cambridge, Massachusetts

p. 18 Willard Metcalf, *In the Café (Au Café)*, 1888. Oil on panel, 34.8 x 15.4 (13⅝ x 6⅛). Terra Foundation for American Art, Chicago, Illinois

p. 19 Luigi Loir, *The Night Café*, c. 1910. Oil on card, 21.9 x 16.2 (8⅝ x 6⅜). Photo Christie's Images Ltd

p. 20 Edgar Degas, *Woman, on a Café Terrace*, 1877. Pastel, 54.5 x 71.5 (16½ x 21¾). Musée d'Orsay, Paris

p. 21 The Nouvelle-Athènes, Montmartre, c. 1890. Photograph. Bibliothèque Nationale, Paris

p. 22 Edgar Degas, *The Absinthe Drinker*, 1875–6. Oil on canvas, 92 x 68 (36¼ x 26¾). Musée d'Orsay, Paris

p. 23l Tamagno, Poster advertising 'Oxygénée Cusenier Absinthe', 19th century. Colour lithograph. Private Collection. Photo Roger Perrin/Bridgeman Art Library

p. 23r Jean-François Raffaëlli, *The Absinthe Drinkers*, 1881. Oil on canvas, 110.2 x 110.2 (43⅜ x 43⅜). Private Collection

p. 24t Edouard Manet, *George Moore (Au Café)*, 1879. Oil on canvas, 65.4 x 81.3 (25¾ x 32). Metropolitan Museum of Art, New York

p. 24b Frédéric Regamey, *Gervaise and Coupeau*. Illustration from Zola *L'Assommoir*, 1878

p. 25 Edgar Degas, *The Nouvelle-Athènes*, 1878. Pencil on paper. Private Collection

p. 26 Edouard Manet, *La Prune (The Plum Brandy)*, 1878. Oil on canvas, 73.6 x 50.2 (29 x 19¾). National Gallery of Art, Washington, D.C.

p. 27 Jean-François Raffaëlli, *Young Woman in a Café*, date unknown. Oil on paper laid down on canvas, 35 x 27.3 (13¾ x 10¾). Photo Christie's Images Ltd

p. 28 Edouard Manet, *Chez le Père Lathuille*, 1879. Oil on canvas, 92 x 112 (36¼ x 44⅛). Musée des Beaux-Arts, Tournai

p. 29 Vincent van Gogh, *Café Terrace on the Place du Forum*, 1888. Oil on canvas, 81 x 65.5 (31⅞ x 25¾). Rijksmuseum Kröller-Müller, Otterlo

p. 30 Pierre-Auguste Renoir, *The Ball at the Moulin de la Galette* (detail), 1876. Oil on canvas, 131 x 175 (51½ x 69). Musée d'Orsay, Paris

p. 31 The Moulin de la Galette, 1898. Photograph. Mary Evans Picture Library

p. 32l Henri de Toulouse-Lautrec, *Café-concert in Montmartre*, 1888. Ink and pencil and coloured crayons on gilot paper, 40.4 x 32.5 (15⅞ x 12¾). Photo Christie's Images Ltd

p. 32r Adolph Menzel, *Breakfast at the Café*, 1894. Gouache on paper, 19 x 12 (7½ x 4¾). Hamburger Kunsthalle, Hamburg. Photo Bridgeman Art Library

p. 33 Jean-Louis Forain, *Bar at the Folies-Bergère*, 1878. Oil on canvas. Photo Brooklyn Museum of Art/Corbis

p. 34 Childe Hassam, *At the Grand Prix in Paris*, 1887 (detail). Pastel and pencil on tan board, 45.7 x 30.5 (18 x 12). Corcoran Gallery of Art, Washington, D.C.

p. 35 Edouard Manet, *Race Course at Longchamp*, 1864. Watercolour and gouache on paper, 22.1 x 56.4 (8¾ x 22¼). Fogg Art Museum, Harvard University, Cambridge, Massachusetts

p. 36 Grand Prix at the Longchamp racecourse, Paris, 1895. Photograph. Photo LL/Roger-Viollet, Paris

p. 36–7 Edgar Degas, *At the Races in the Country* (detail), 1869. Oil on canvas, 36.5 x 55.9 (14⅜ x 22). Museum of Fine Arts, Boston

p. 38 Edgar Degas, *False Start*, 1869–72. Oil on panel, 32.1 x 40.3 (12⅝ x 15⅞). Yale University Art Gallery, New Haven, Connecticut

p. 39 Edouard Manet, *Les Courses*, 1865–78. Lithograph, 36.6 x 51.3 (14⅜ x 20¼). Bibliothèque Nationale, Cabinet des Estampes, Paris

p. 40 Edouard Manet, *A Bar at the Folies-Bergère*, c. 1882. Oil on canvas, 96 x 130 (51 x 37¾). Courtauld Institute of Art, London

p. 41l The Hall of the Folies-Bergère, 1898. Photograph. Mary Evans Picture Library

p. 41r Jules Chéret, *Aux Folies-Bergère*, 1875. Poster. Musée de la Publicité, Paris

p. 42 Edgar Degas, *Miss La-La at the Cirque Fernando* (detail), 1879. Oil on canvas, 116.8 x 77.5 (46 x 30½). National Gallery Collection; By kind permission of the Trustees of the National Gallery, London/Corbis

p. 43t Pierre-Auguste Renoir, *Acrobats at the Cirque Fernando*, 1879. Oil on canvas, 130 x 98 (51⅛ x 38¾). Art Institute of Chicago

p. 43b Georges Seurat, *The Circus*, 1891. Oil on canvas, 185.4 x 150.2 (73 x 59⅛). Musée d'Orsay, Paris

p. 44 Theophile-Alexandre Steinlen, *Aux Folies-Bergère*, c. 1894. Charcoal, coloured crayon, pen and ink on paper, 31.9 x 25 (12½ x 9⅞). Photo Christie's Images Ltd

p. 45 Edgar Degas, *The Café-Concert – Aux Ambassadeurs*, 1876–7. Pastel over monotype in black ink on heavy white laid paper, 36 x 28 (14³⁄₁₆ x 11). Musée des Beaux-Arts, Lyon

pp. 46–7 Henri de Toulouse-Lautrec, *At the Moulin Rouge*, 1892. Oil on canvas, 123.8 x 140.3 (48¾ x 55¼). Art Institute of Chicago

p. 48 Pierre-Auguste Renoir, *La Loge*, 1874. Oil on canvas, 80 x 63.5 (31½ x 25). Courtauld Institute of Art, London

p. 49 The Place de l'Opéra, Paris, IXth District, 1900. Photo ND/Roger-Viollet, Paris

p. 50 Edgar Degas, *The Orchestra of the Opéra*, c. 1868–9. Oil on canvas, 56.5 x 46 (22¼ x 18). Musée d'Orsay, Paris

p. 51 Mary Cassatt, *At the Français, a Sketch*, 1877–8. Oil on canvas, 81 x 66 (31⅞ x 26). Museum of Fine Arts, Boston

p. 52 John Singer Sargent, *Rehearsal of the Pasdeloup Orchestra at the Cirque d'Hiver*, c. 1879–80. Oil on canvas, 57.2 x 46.1 (22½ x 18⅛). Museum of Fine Arts, Boston

p. 53 Staircase in the Opéra, Paris, 1861–75. Photograph. Conway Library, Courtauld Institute of Art, London

pp. 54–5 Edgar Degas, *The Rehearsal of the Ballet on Stage*, c. 1873. Oil with traces of water-colour and oil paint over pen and ink drawing on paper, mounted on canvas, 54.3 x 73 (21¾ x 28⅝). Metropolitan Museum of Art, New York

p. 56 Edgar Degas, *Danseuses Basculant (Green Dancer)*, c. 1880. Pastel and gouache, 66 x 36 (26 x 14³⁄₁₆). Thyssen-Bornemisza, Lugano, Switzerland

p. 57 Jean-Louis Forain, *Dancers in the Wings at the Opéra*, c. 1900. Oil on canvas, 81 x 64 (31⅞ x 25¼). Photo Lauros/Giraudon, Federation Mutualiste Parisienne, Paris/Bridgeman Art Library

p. 58 Claude Monet, *Parisians Enjoying the Parc Monceau*, 1878. Oil on canvas, 72.7 x 54.3 (28⅝ x 21⅜). Metropolitan Museum of Art, New York

p. 59 Bois de Bologne, 1890. Illustration by Mars in *Paris Brilliant*, 1890. Mary Evans Picture Library

p. 60 Pierre-Auguste Renoir, *Le Cabaret de la mère Antony*, 1866. Oil on canvas, 195 x 131 (76¾ x 51⅝). Nationalmuseum, Stockholm

p. 61 Claude Monet, *Le Déjeuner sur l'herbe (study)*, 1865. Oil on canvas, 129.5 x 181 (51 x 71¼). Pushkin Museum, Moscow

pp. 62–3 Edouard Manet, *Music in the Tuileries*, 1862. Oil on canvas, 76.2 x 118.1 (30 x 46½). National Gallery, London

p. 64 Adolph Menzel, *In the Luxembourg Gardens*, date unknown. Oil on canvas. Pushkin Museum, Moscow. Photo Bridgeman Art Library

p. 65 Charles Courtney Curran, *In the Luxembourg Gardens*, 1889. Oil on panel, 23.3 x 31.1 (9⁹⁄₁₆ x 12¼). Terra Foundation for American Art, Chicago

p. 66t William Merritt Chase, *The Lake for Miniature Yachts*, c. 1888. Oil on canvas, 40.6 x 61 (16 x 24). Private Collection

p. 66b William Merritt Chase, *Park in Brooklyn*, 1887. Oil on panel, 41 x 61.3 (16⅛ x 24⅛). Parrish Art Museum, Southampton, New York, Littlejohn Collection

p. 67 Childe Hassam, *Descending the Steps, Central Park*, 1895. Oil on canvas, 57.2 x 57.2 (22½ x 22½). Virginia Museum of Arts, Richmond, Virginia

p. 68 John Singer Sargent, *In the Luxembourg Gardens*, 1879. Oil on canvas, 65.7 x 92.4 (25⅞ x 36⅜). Philadelphia Museum of Art, Pennsylvania

p. 69 Maurice Brazil Prendergast, *Sketches in Paris*, c. 1892–4. Seven oil on wood panels, each 17.1 x 9.5 (6¾ x 3¾). Addison Gallery of American Art, Phillips Academy, Andover, Mass.

p. 70t Pierre-Auguste Renoir, *Skaters in the Bois de Boulogne*, 1868. Oil on canvas, 72 x 90 (28¾ x 35½). Private Collection

p. 70b Skaters in the Bois de Boulogne, 1870s. Photograph. Photo Roger-Viollet, Paris

p. 71 Jules Chéret, *Palais de Glace*, 1893. Poster. Corbis

pp. 72–3 Edouard Manet, *The Game of Croquet*, 1873. Oil on canvas. Stadelsches Kunstinstitut, Frankfurt-am-Main. Photo Bridgeman Art Library

p. 73t Edouard Manet, *Summer at Boulogne, sketch of a game of croquet*, 1868–71. Graphite and watercolour, 10 x 6.4 (3⅞ x 2½). Arts graphiques, Musée du Louvre, Paris

p. 73b Winslow Homer, *Croquet Scene*, 1866. Oil on canvas, 40.3 x 66.2 (15⅞ x 26ⁱ⁄₁₆). Photo Albright-Knox Art Gallery, Buffalo, New York/Corbis

p. 74 Claude Monet, *People in the Open Air*, 1865. Musée Marmottan, Paris. Photo Studio Lourmel/Musée Marmottan, Paris

pp. 74–5 Georges Seurat, *A Sunday Afternoon on the Island of the Grande Jatte*, 1884–6. Oil on canvas, 207.6 x 308 (81¾ x 121¼). Photo Bettmann/Corbis

p. 76 Claude Monet, *Le Déjeuner (The Luncheon)*, 1873. Oil on canvas, 162 x 203 (63¾ x 79⅞). Musée d'Orsay, Paris

p. 77 Mary Cassatt, *Children in a Garden* (detail), 1878. Oil on canvas, 73.6 x 92.6 (29 x 36½). Private Collection

p. 78 Alice Barber Stephens, *A Spring Morning in the Park*, 1892. Oil on canvas, 45.7 x 66 (18 x 26). Private Collection

p. 79t Photograph of people relaxing on the Island of the Grande Jatte, Paris

p. 79b Wilhelm Bernatzik, *Mother and Child in the Tuileries Gardens*, 1883. Drawing in the *Neue illustrirte Zeitung*, 15 April 1883, p. 457. Mary Evans Picture Library

p. 80 Childe Hassam, *The White Dory, Gloucester* (detail), 1895. Oil on canvas, 66.4 x 53.7 (26 x 21). Private Collection

p. 81 Pierre-Auguste Renoir, *Oarsmen at Chatou*, 1879. Oil on canvas, 81.3 x 100.3 (32 x 39½). National Gallery of Art, Washington, D.C.

p. 82 Pierre-Auguste Renoir, *The Return of the Boating Party*, 1862. Oil on canvas, 50.8 x 61 (20 x 24). Private Collection

p. 83 Pierre-Auguste Renoir, *Boating on the Seine* (detail), 1879. Oil on canvas, 72 x 92 (28⅜ x 36¼). National Gallery, London

p. 84t Pierre-Auguste Renoir, *La Grenouillère*, 1869. Oil on canvas, 66 x 86 (26 x 33¾). Nationalmuseum, Stockholm

p. 84b D. Yon, *La Grenouillère*, 1873. Engraving from *L'Illustration*, 16 August 1873, pp. 112–13

p. 85 Claude Monet, *Bathers at La Grenouillère*, 1869. Oil on canvas, 73 x 92 (28¾ x 36¼). National Gallery, London

p. 86 John Lavery, *The Bridge at Grez*, 1883. Oil on canvas, 76.2 x 183.5 (30 x 72¼). Photo Christie's Images Ltd

p. 87t Gustave Caillebotte, *Oarsman in a Top Hat*, 1877–8. Oil on canvas, 90 x 117 (35⅜ x 46⅛). Private Collection

p. 87bl Claude Monet, *Boating on the River Epte*, 1890. 133 x 145 (52⅜ x 57¹⁄₁₆). Museu de Arte de São Paulo Assis Chateaubriand

p. 87br Gustave Caillebotte, *Oarsmen (Canotiers)*, 1877. Oil on canvas, 81 x 116 (31⅞ x 45⅝). Private Collection

pp. 88–9 Berthe Morisot, *Summer's Day*, c. 1879 (detail). Oil on canvas, 45.7 x 75.2 (18 x 29⅝). Photo National Gallery Collection; By kind permission of the Trustees of the National Gallery, London/Corbis

p. 89 Pierre-Auguste Renoir, *Rowers at Argenteuil*, 1873. Oil on canvas, 50.2 x 61 (19¾ x 24). Photo Christie's Images Ltd

p. 90 Pierre-Auguste Renoir, *Lunch at the Restaurant Fournaise (The Rowers' Lunch)*, c. 1875. Oil on canvas, 55.1 x 65.9 (21¾ x 26). Art Institute of Chicago, Potter Palmer Collection

p. 91 Pierre-Auguste Renoir, *The Luncheon of the Boating Party*, 1880–81. Oil on canvas, 129.5 x 172.7 (51 x 68). The Phillips Collection, Washington, D.C.

p. 92 Georges Seurat, *Bathers at Asnières*, 1884. Oil on canvas, 201 x 300 (79⅛ x 118⅛). National Gallery, London

pp. 94–5 Eugène Boudin, *Beach Scene, Trouville* (detail), 1860–70. Oil on wood, 21.6 x 45.8 (8½ x 18). National Gallery, London

p. 96 Claude Monet, *Beach at Trouville*, 1870. Oil on canvas, 37.5 x 45.7 (14¾ x 18). National Gallery, London

p. 97 Photograph of the beach at Trouville, c. 1890. Sirot Angel, Paris

p. 98t Adolphe Maugendre, *Trouville, View of the Beach and the Roches-Noires*, 1867. Lithograph. Bibliotheque Nationale, Série Topographique

p. 98b Claude Monet, *On the Boardwalk at Trouville*, 1870. Oil on canvas, 50 x 70 (19⅝ x 27½). Photo Christie's Images Ltd

p. 99 Claude Monet, *Hôtel des Roches Noires, Trouville*, 1870. Oil on canvas, 81 x 58.5 (32 x 23). Musée d'Orsay, Paris

p. 100 Edouard Manet, *At the Beach*, 1873. Oil on canvas, 59.5 x 73 (23½ x 28¾). Musée d'Orsay, Paris

p. 101 Edgar Degas, *Beach Scene*, 1869–70. Oil (essence) on paper, three pieces, mounted on canvas, 47.5 x 82.9 (18¾ x 32⅝). National Gallery, London

p. 102 Edouard Manet, *Isabelle plongeant*, 1880. Watercolour, 20 x 12.3 (7⅞ x 4⅞). Cabinet des Arts graphiques, Musée du Louvre, Paris

p. 103 Martial Caillebotte, Caillebotte throwing stones on a beach, 1877–9. Photograph. Private Collection

p. 104 Henri de Toulouse-Lautrec, *The Passenger from Cabin 54*, 1896. Colour lithograph, 61 x 44.7 (24 x 17⅝). Art Institute of Chicago

p. 105 Henri de Toulouse-Lautrec swimming, c. 1899. Photograph. Bibliothèque Nationale, Paris

p. 106 Camille Pissarro, *The Poultry Market, Gisors*, 1885. Tempera on canvas, 82.2 x 82.2 (32⅜ x 32⅜). Museum of Fine Arts, Boston. Photo Burstein Collection/Corbis

p. 107 Childe Hassam, *La Bouquetière et la Laitière*, c. 1888. Watercolour on paper, 43.2 x 66 (17 x 26). Private Collection

p. 108 Jean-François Raffaëlli, *Boulevard Haussmann, Paris*, c. 1880. Oil on canvas. Fine Art Photographic Library/Corbis

p. 109 Camille Pissarro, *Place du Théâtre Français*, 1898. Oil on canvas, 72.4 x 92.6 (28½ x 36½). Los Angeles County Museum of Art

p. 110 *A Rainy Paris street*, 1890. Illustration by Mars in *Paris Brilliant*, 1890. Mary Evans Picture Library

pp. 110–11 Gustave Caillebotte, *Paris Street, Rainy Day*, 1877. Oil on canvas, 212.2 x 276.2 (83½ x 108¾). Art Institute of Chicago. Photo Berstein Collection/Corbis

p. 112 Pierre-Auguste Renoir, *The Umbrellas*, c. 1881–6. Oil on canvas, 180.3 x 114.9 (71 x 45¼). National Gallery, London

p. 113 Rue Lepic, Montmartre, Paris. Photograph. Photo Roger-Viollet, Paris

p. 114 Adolphe Braun, The Pont Neuf, 1855. Photograph

p. 115 Pierre-Auguste Renoir, *The Pont Neuf*, 1872. Oil on canvas, 75.3 x 93.7 (29⅝ x 36⅞). National Gallery of Art, Washington, D.C.

p. 116t Edgar Degas, *Portraits, at the Stock Exchange*, 1878–9. Oil on canvas, 100 x 82 (39⅜ x 32¹⁄₁₆). Musée d'Orsay, Paris

p. 116b Henri Fantin-Latour, *Portrait of Edouard Manet*, 1867. Oil on canvas, 117.5 x 90 (46¼ x 35⁷⁄₁₆). Art Institute of Chicago. Photo Bettman/Corbis

p. 117 Gustave Caillebotte, *The Place Saint Augustin*, 1877. Oil on canvas, 54 x 65 (21¼ x 25⅝). Private Collection

p. 118 Edgar Degas, *At the Milliner's*, 1882. Pastel, 75.9 x 84.8 (29⅞ x 33⅜). Thyssen-Bornemisza Collection, Lugano, Switzerland

p. 119 *The glove counter*, 1880. Unattributed engraving of a Paris department store in *L'Illustration*. Mary Evans Picture Library

p. 120 The department store Bon Marché, Paris, 1880s

p. 121 Henry Tonks, *The Hat Shop*, 1892. Oil on canvas, 67.7 x 92.7 (26⅝ x 36½). Birmingham Museums and Art Gallery

p. 122t Flower shopping in the Place de la Bastille, Paris, 1900. Photograph. Photo Alinari Archives/Corbis

p. 122b Childe Hassam, *At the Florist*, 1889. Oil on canvas, 93.4 x 137.8 (36¾ x 54¼). The Chrysler Museum, Norfolk, Virginia

p. 123 James McNeill Whistler, *Variations in Violet and Grey – Market Place, Dieppe*, 1885. Watercolour and gouache on off-white wove paper, 20.2 x 12.7 (8 x 5). Metropolitan Museum of Art, New York

p. 124 Camille Pissarro, *The Pork Butcher, Market Scene*, 1883. Oil on canvas, 65.1 x 54.3 (25⅝ x 21⅜). National Gallery, London. On loan from Tate, London since 1997

p. 125 Vincent van Gogh, *The Bakery in de Geest*, 1882. Pencil, and charcoal on vellum, 20.4 x 33.6 (8 x 13¼). Haags Gemeentemuseum, The Hague, The Netherlands. Photo Bridgeman Art Library

p. 126 Childe Hassam, *Carriage Parade* (detail), 1888. 41.5 x 33 (16¼ x 12⅞). Haggin Museum, Stockton, California

p. 127 Claude Monet and his son-in-law Theodore Butler awaiting the arrival of the chauffeur, early 1900. Photograph. Toulgouat Collection, Giverny

p. 128 Edgar Degas on a trip from Paris to Diénay, Autumn 1890. Photograph. Bibliothèque Nationale, Paris

p. 129 Mary Cassatt, *Woman and Child Driving*, 1881. Oil on canvas, 89.3 x 150.8 (35⅛ x 59¾). Philadelphia Museum of Art, Pennsylvania

p. 130 Childe Hassam, *April Showers, Champs-Élysées Paris*, 1888. 31.8 x 42.5 (12½ x 16¾). Joslyn Art Museum, Omaha, Nebraska

p. 131t Boulevard Montmartre, Paris. Photograph. Photo Roger-Viollet, Paris

p. 131b Henri de Toulouse-Lautrec, *Country Outing*, c. 1897. Colour lithograph, 40.5 x 52 (15¹⁵⁄₁₆ x 20½). Private Collection

pp. 132–3 Childe Hassam, *Grand Prix Day*, 1887. Oil on canvas, 61 x 78.7 (24 x 34). Museum of Fine Arts, Boston

p. 133 Mary Cassatt, *Interior of a Tramway Passing a Bridge*, 1890–91. Drypoint and aquatint on cream laid paper, 38.4 x 26.7 (15⅛ x 10½). Art Institute of Chicago

p. 134 Place de Clichy, Paris, Batignolles, c. 1900. Photograph. Bibliothèque Nationale, Paris

p. 135 Camille Pissarro, *Place Saint-Lazare*, 1893. Oil on canvas, 38 x 46 (15 x 18⅛). Photo Christie's Images Ltd

p. 136t Jean-Louis Forain, *Deuxième Salon du Cycle*, 1894. Poster. Photo Historical Picture Archive/Corbis

p. 136b Frédéric Régamey, *The Enemies of the Cyclist*, 1898. Illustration from *Velocipedie et automobilisme (Cycling and Motoring)*, published in Tours, 1898. Photo Science Museum/Science & Society Picture Library

p. 137 Theophile-Alexandre Steinlen, *A Paris Traffic Jam*, 1891. Illustration in *Gil Blas*, 27 September, 1891. Mary Evans Picture Library

p. 138 Claude Monet, *Arrival of the Normandy Train, Saint-Lazare Station*, 1877. Oil on canvas, 59.6 x 80.2 (23½ x 31½). Art Institute of Chicago

p. 139 Claude Monet, *The Gare Saint-Lazare, Arrival of a Train*, 1877. Oil on canvas, 81 x 101 (31⅞ x 39¾). Fogg Art Museum, Harvard University, Cambridge, Massachussets

pp. 140–41 Gustave Caillebotte, *The Pont de l'Europe*, 1876. Oil on canvas, 124.7 x 180.6 (49⅛ x 71⅛). Musée du Petit Palais, Geneva

p. 142 Edouard Manet, *The Railroad*, 1872–3. Oil on canvas, 93 x 114 (36⅝ x 44⅞). National Gallery of Art, Washington, D.C.

p. 143 Camille Pissarro, *Cour du Havre (Gare Saint-Lazare)*, 1893. Oil on canvas, 38 x 46 (15 x 18⅛). Private Collection. Photo Bridgeman Art Library

p. 144t Edouard Manet, *The Grand Canal, Venice*, 1874. Oil on canvas, 57 x 48 (22½ x 18⅞). Private Collection

p. 144b Claude Monet and Alice in the Piazza San Marco, Venice. October 1908. Photograph. Private Collection

p. 145 Paul Signac, *Grand Canal, Venice*, 1905. Oil on canvas, 73.5 x 92.1 (28⅞ x 36¼). The Toledo Museum of Art, Toledo, Ohio

p. 146 Berthe Morisot, *Hide and Seek* (detail), 1873. Oil on canvas, 45.1 x 54.9 (17¾ x 21⅝). Private Collection

p. 147 Claude Monet, *Poppies, near Argenteuil*, 1873. Oil on canvas, 19¾ x 25½ (50 x 65). Musée d'Orsay, Paris

p. 148 Claude Monet, *La Promenade (Woman with a Parasol)*, 1875. Oil on canvas, 100 x 65 (39⅜ x 25⅝). Musée d'Orsay, Paris

p. 149 Pierre-Auguste Renoir, *Road Rising into Deep Grass* (detail), c. 1876–7. Oil on canvas, 60 x 74 (23⅝ x 29⅛). Photo The Art Archive/Corbis

pp. 150–51 Georges Seurat, *Le Pont de Courbevoie*, 1886–7. Oil on canvas, 45.7 x 54.6 (18 x 21½). Courtauld Institute of Art, London. Photo Francis G. Mayer/Corbis

p. 151 Claude Monet and Pierre-Auguste Renoir at La Grenouillère, c. 1869

p. 152 Alfred Sisley, *A Meadow in Springtime at By*, 1881. Oil on canvas, 54 x 72.1 (21¼ x 28¾). Museum Boijmans Van Beuningen, Rotterdam

p. 153 Berthe Morisot, *The Butterfly Hunt*, 1874. 46 x 56 (18 x 22). Musée d'Orsay, Paris

p. 154t Claude Monet, *The Shoot*, 1876. Oil on canvas. Private Collection. Photo Peter Willi/Bridgeman Art Library

p. 154b Claude Monet, *The Bark at Giverny*, c. 1887. Oil on canvas, 97.8 x 130.8 (38½ x 51½). Musée d'Orsay, Paris

p. 155l Pierre-Auguste Renoir, *The Fisherman*, 1874. Oil on canvas, 54 x 64 (21¼ x 25¼). Private Collection

p. 155r Gustave Caillebotte, *Fishing (Pêche à la ligne)*, 1878. Oil on canvas, 157 x 113 (61¾ x 44½). Private Collection

p. 156 Georges Manzana Pissarro, 'An Impressionist Picnic with Guillamin, Pissarro, Gauguin, Cézanne, Malarmé, Cezanne and petit Manzana', 1881. Drawing. Whereabouts unknown

p. 157 Camille Pissarro, *Apple Picking at Eragny-sur-Epte*, 1888. Oil on canvas, 60 x 73 (23⅜ x 28⅛). Dallas Museum of Art, Texas

p. 158 Paul Gauguin, *Near the Farm*, 1885. Oil on canvas. Joan Whitney Payson Gallery of Art, Westbrook College, Portland, Maine

p. 159 Paul Cézanne, *Mont Sainte-Victoire*, 1902–1904. Oil on canvas, 69.8 x 89.5 (27½ x 35¼). Philadelphia Museum of Art, Pennsylvania

p. 160 William Merritt Chase, *Idle Hours*, c. 1894. Oil on canvas, 64.8 x 90.2 (25½ x 35½). Amon Carter Museum, Fort Worth, Texas

p. 161 Mary Cassatt, *Two Seated Women*, 1869. Oil on canvas. Private Collection. Photo Giraudon/Bridgeman Art Library

p. 162 Claude Monet, *Meadow at Bezons*, 1874. Oil on canvas, 57 x 80 (22½ x 31½). Nationalgalerie, Berlin

p. 163 Claude Monet, *The Stroll at Giverny*, 1888. Oil on canvas, 80 x 80 (31½ x 31½). Private Collection

p. 164t Eugène Boudin painting on the boardwalk at Deauville, 1896. Musée Eugène-Boudin Honfleur

p. 164m Gustave Caillebotte, c. 1878. Photograph. Private Collection

p. 164b Mary Cassatt at Beaufresne, 1903. Photograph courtesy Hill-Stead Museum, Farmington, Connecticut

p. 165t Paul Cézanne starting out on an open-air painting expedition in Anvers, c. 1874. Photograph

p. 165m Edgar Degas, c. 1862. Bibliothèque Nationale, Paris

p. 165b Childe Hassam, 1889. Photograph Eugène Pirou

p. 166t Edouard Manet. Photograph. Private Collection

p. 166m Claude Monet, beside the water-lily pond, c.1904. Photo Bulloz, Paris

p. 166b Berthe Morisot. Photograph. Private Collection

p. 167t Camille Pissarro, c. 1893. Photo Durand-Ruel Archives, Paris

p. 167m Pierre-Auguste Renoir, c.1910. Photo Roger Viollet, Paris

p. 167b John Singer Sargent painting outdoors, c. 1883–5. Photograph. Private Collection

p. 168t Walter Sickert in bathing suit, Dieppe, 1920. London Borough of Islington Libraries

p. 168m Henri de Toulouse-Lautrec. Photograph

p. 168b Vincent van Gogh, c. 1872. Rijksmuseum Vincent van Gogh, Amsterdam

Illustrations and captions are indexed by page number, given in *italic*.

absinthe 22–23, *22–23*, *24*, 70
Académie Julian *24*, 165
Aigny-le-Duc 161
Aix-en-Provence 158, 164, 169
Alcazar 44
Alcott, May 70
Ambassadeurs, Les 44, *45*, 47, 169
Ambigu Theatre *25*
Andrée, Ellen 22, *22*, *91*, 93, 164
Appledore 105
Aquascutum 137
Arc de Triomphe 39, *126*
archery 70
Argentan (racecourse) 36, *36–7*
Argenteuil *76*, 138, *147*, 148
Arles 22, *29*, 168
Army and Navy 119
Artistes Indépendants 43; *see also* Impressionist exhibitions
Asnières *83*, *92*, 156, 166
Auberge du Cheval Blanc 59
Auberge Ganne 59, 169
Auteuil 35, 169
automobiles 127, *127*, 131, 134, 136, 137
Auvers 157, 158, 165, 168, 169
Avril, Jane 47, *47*, 164

ballet 10, 12, 35, 53, *54–7*, 55–7
Bal Mabille 40
Balzac, Honoré 114, 116
Barbier, Baron Raoul 93
Barbizon 60, 154, 167, 169
Bartholomé, Paul Albert 57, *128*, 136, 161, 164
Bashkirtseff, Marie 114, 131
bathing 8, 89, 96, 101, 105, *105*; mixed 12, 102
Batignolles 17, 18, 49, 128, *134*, 154, 169
Baudelaire, Charles 8, 22, 53, *62–3*, 108, 114, 116; *Fleurs du Mal* 22
Baudot, Jeanne 49
Bazille, Frédéric 8, 17, 59, 81, 107, 127, 164, 166
Beaufresne 161, 164
beer *16*, 47
Benz, Karl 134
Bérard, Paul 93, 167
Béraud, Jean 49, 114, 131, 164
Berck-sur-Mer *101*
Berlioz, Hector 53, *57*
Bernard, Emile 158
Bernard, Tristan 136
Bernatzick, Wilhelm: *Mother and Child in the Tuileries Gardens, Paris 79*
betting 35
beuglants 44
Bezons *162*
bicycling 8, 127, 136, *136*
billiards 18
Biot, Alice 55
bistros 18, *28–9*
Bizet, Georges 19, 53, 93, 165
Blanche, Dr Emile 103

boating 8, *8*, 70, 80ff., 86, 138, 147; *see also* rowing
Boggs, Frank 107
Bois de Boulogne *10*, 12, 13, *35*, 39, *59*, 65, 69, 70, *70*, *88–9*, 131, 169
Boldini, Giovanni 107
Boldini's 55
Bon Marché 12, 119, 120, *120*, 128, 169
Bonnard, Pierre 43, 161, 168, 169
Bordeaux *105*
Boudin, Eugène 82, 97, 164, *164*; *Beach Scene, Trouville 94–5*; *On the Beach at Trouville 97*
Boudin, Marie-Anne *96*, 97
Bougival *2*, 85, 138
Boulanger-Cavé, Albert 53, 55
boules *1*
Boulevard des Capucines 169
Boulevard de Clichy *11*, 107
Boulevard Haussmann *108*, 169
Boulevard des Italiens 18, 117, 169
Boulevard Montmartre *131*
Boulevard de Rochechouart 43
Boulogne *72–3*
bourgeoisie 44, 117
Bracquemond, Marie 20
Braun, Adolphe *114*
Brittany 103, 128, 153
Bruant, Aristide 47
Bruno, Madeleine 156
Burberry 137
Burgundy *128*

cafés 8, 10, *17*, 69; *cafés-intimes* 18; *see also* names of individual cafés
café-concerts 10, 12, 32, *32*, 44, *45*
Café Americain 18
Café Anglais 18
Café Guerbois 17, *17*, 18, *20*, 27, 165, 167, 169
Café du Helder 18
Café Riche 18, 27, 169
Cagnes-sur-Mer 156, 167
Caillebotte, Gustave 27, *31*, 64, 74, 86, *91*, 93, *103*, 138, 164, *164*, 168; works by: *Fishing (Peche à la ligne)* 154, *155*; *Oarsmen (Canotiers)* 87; *Oarsman in a Top Hat* 86, *87*; *Paris Street, Rainy Day* *110–111*, 131; *The Place Saint Augustin* *117*; *The Pont de l'Europe* *140–41*; *Pont Neuf* *113*; *Self-Portrait at the Easel* *31*
Caillebotte, Martial *1*
Caillebotte, Zoé 154, *155*
can-can 47, 169
Caron, Rose 55, 164
carriages *11*, 12, 35, *35*, 39, 70, 113, *126*, 128–9, *128*, *129*, *131*, *152*
Cassabois, M. *1*
Cassatt, Lydia 12, 52, 69, 121, 128–9, *129*
Cassatt, Mary 8, 12, 20, 49, 64, 74, 107, 119, 121, 128–9, 154, 160, 164, *164*, 167, 168; works by: *At the Français, a Sketch* 49, *51*, 52; *Children in a Garden* 77; *Interior of a Tramway Passing a Bridge* *133*; *Lydia Seated in a Loge, Wearing a Pearl Necklace* 49–52, 69, 70; *Two Seated Women* 161; *Woman and Child Driving* 129
Castagnary, Jules 122, *147*

Celnart, Madame 114
Central Park 66, *67*
Cézanne, Paul 8, 17, 24, 25, 60, 125, 154, 156, *156*, 158–9, 164, 165, *165*, 168, 169; *Mont Sainte-Victoire 159*
Chailly 59, 60, 61
Chailly-en-Bière 60, 169
Chaliapin, Feodor 49
Champs-Élysées 18, 35, 44, *130*; Palais de Glace 70, *71*
Channel Islands 103
Chantilly 35
Charigot, Aline 49, *81*, *91*, 93, 103, *113*, 137, 156, 164, 167
Charivari, Le 86
Charpentier, Georges 167
Charpentier, Madame *102*
Chase, William Merritt 66, 164; *Idle Hours 160*; *The Lake for Miniature Yachts* 66; *Park in Brooklyn* 66
Château-Rouge 134
Chat Noir, Le 29, 47, 169
Chatou 89, 138, 169
Chéret, Jules 71
Choquet, Victor *82*, 165
circuses 8, 10, 12, 42–3, *42–3*, 122
Cirque Fernando 8, *42*, 43, *43*
Clichy 18
clothes 25, 32, 35, 86, 102, 113, *119*, 136; dresses 39, 52, 53, 82; *see also* fashion
cognac 24
Comedie-Française 55, 167
Cordey, Frédéric *31*
Corot, Jean-Baptiste Camille 59, 167
Côte d'Azur 143
countryside 7, 60–61, 93, *131*, 151ff.
Courbet, Gustave 59, 96
Couture, Thomas 22
Crane, Walter 22
cravats 116
Croissy 92
croquet 70, *72–3*
Curran, Charles Courtney: *In the Luxembourg Gardens* 65

Daimler, Gottlieb 134
dance-halls 8, 40; *see also* dancing
dancing *2*, 13, 28, *30*, *31*, 40, 47
Deauville 8, 127, 169
Debussy, Claude 53
décôlletage 53
Degas, Edgar 8, 14, 35, 36, 53, 69, 90, 93, 107, 119, *128*, 136, 151, 164, *165*; character 18, 25, 117; and racing 12; love of music 44, 49; friendships 103; works by: *The Absinthe Drinker* 22, 164, 165; *At the Louvre* 14; *At the Milliner's* 118; *At the Races in the Country* 36, *36–7*; *Beach Scene* 101, *101*; *The Café-Concert – Aux Ambassadeurs* 45; *Danseues Basculant (Green Dancer)* 56; *False Start* 38; *Manet at the Races* 35; *Miss La-La at the Cirque Fernando* 42, 43; *The Nouvelle-Athènes* 25; *The Orchestra of the Opéra* 50, 165; *Portraits at the Stock Exchange* 116; *The Rehearsal* 54–5; *Woman on a Café Terrace* 20

department stores 10, 119–20, *119*
Depuis, Marie 156
Desboutin, Marcellin 22, 165
Diénay 128, 161
Dieppe 103, 105, *123*, 127, 151 168
Dihau, Desiré *50*, 165
Doncieux, Camille *59*, 60, 74, *76*, 82, 97, *98*, 147, *148*, 166, 169
Dubison, Paul 120
Dumas, Alexandre 49
Dunlop, John Boyd 134
Durand-Ruel, Paul 144, 151, 156, 165
Duranty, Edmond 17, 25
Duret, Theodore 18, 165, 166

École des Beaux-Arts 14, *24*, 164, 165, 167
Eiffel Tower 29
Eldorado 44
electricity 10
Empire style 18, *52*
Ephrussi, Charles 93, 165
Epte 86
Eragny *157*
Estruc, Eugénie *see* Nini
Étretat 100
Eugénie, Empress 97
Evénement Illustré, L' 85, 89

Fantin-Latour, Henri 17, 167; *Portrait of Edouard Manet 116*
fashion 116–17, *119*, 121, 122; *see also* clothes
Fauré, Gabriel 52
Fécamp 155, 169
Félicie and Laure, Mlles 122
Fénéon, Félix *47*
Fevre, Odile 69, *129*
Figaro, Le 35, 40
Fiquet, Hortense 159, 164, 165
fishing 154–5, *154*, *155*
Flachat, Eugène 138
flâneurs 108, 114
flowers 107, *122*
Folies-Bergère 8, 40–41, *40*, *41*, 44, 164 ,169
Fontainebleau 12, 59, 60, 61, 148, 152, 166, 169
food 10, 27, 47, 90, 96, 105, 137, 161
Forain, Jean-Louis 24, *33*, 165; *Bar at the Folies-Bergère 33*; *Dancers in the Wings of the Opéra 57*; poster for the *Deuxième Salon du Cycle 136*
Fournaise, Restaurant 86, 89, 90, 93
Fournaise, Alphonse 89–90, *91*, 92
Fournier, M. *1*
Franc-Lamy, Pierre *31*
Fuller, Loïe 49

Gad, Mette Sophie 158, 165
Gallo, M. *1*
Gamage's 119
Ganne, François 59
Gare Saint-Lazare 8, *10*, 85, 128, 138 *138*, *139*, *140*, *143*, 154, 169
Garnier, Charles *52*, 53, 169
gas lighting 10, 18, 41, *41*, 43, 49
Gauguin, Paul 23, 25, 134, *156*, 158, 165, 168, 169; *Near the Farm 158*

Gautier, Theophile 117
Geffroy, Gustave 27, 152
Gervex, Henri 31
Giffard, Pierre: *Les grands bazars* 120
Gisors *107*, 125, 161
Giverny 128, 157, *157*, 169
Gleyre, Charles 60, 164, 166, 167, 168
Gluck, Christoph Willibald von 53
Goeneutte, Norbert *15*, *31*, 165; *The Boulevard de Clichy under Snow 11*
'Goulue', la *46–7*, 47, 168
Goncourt, Edmond de 35
Gounoud, Charles 53
Grand Café 18, 169
Grande Jatte *74–5*, *79*
Grenouillère, La 8, *84*, 85ff., *85*, 102, *151*, 169
Guerbois, Auguste 18; *see also* Café Guerbois
Guilbert, Yvette 47
Guillaumin, Armand *156*, 168
Guimard, Hector 127

Halévy, Geneviève 93
Halévy, Ludovic 53, 55, 103, 151, 161, 165
Hare, Augustus 65
Hassam, Frederick Childe 39–40, 64, 67, 74, 105, 107, 108, 114, 165, *165*, 169; works by: *April Showers, Champs-Élysées, Paris 130*; *At the Florist 122*; *la Bouquetière et la Laitière 107*, *107*; *Carriage Parade 126*; *Descending the Steps, Central Park 67*; *At the Grand Prix in Paris 34*; *Grand Prix Day 39*, *132–3*; *La Fruitière 107*; *The White Dory, Gloucester 80*
Hassam, Maud (née Kathleen Maud Doane) 105, 107, 165
Haussmann, Baron Georges Eugène 10, 65, 128, 165–6, 169
Havemeyer, Louisine 119, 121
Hecht, Albert 55
Henschling, Andrée (Dédée) 156
Hiffernan, Joanna 98
Hirsch, Alphonse 138
holidays 13, 82, 93, 128, 136, 137, 144–5, 160
Homer, Winslow: *Croquet Scene 73*
Honfleur 100, 127, 169
horses and riding *10*, *36*, *129*, 154
Hoschedé, Alice 49, 128, 144, *144*, 166, 169
Hoschedé, Blanche *162*, 166
Hoschedé, Ernst 79, 166
Hoschedé, Germaine *163*
Hoschedé, Jean-Pierre *163*
Hoschedé, Suzanne *163*
hotels 7, 89; *see also* names of individual hotels
Hôtel Baudy 169
Hôtel de Roches-Noires *98*, *99*
Hôtel Tivoli *97*, *98*
Howe, William Henry 107
hunting 154–5, *154*
Huysmans, Joris-Karl *151*, 166: *Parisian Sketches 41*

ice-skating *4*, 66, 70, *70*
Impressionist exhibitions 165; first 164; third 167; fourth 86; seventh 43, 144; eighth 69, *75*, 134, 167, 168
industrialization 8

James, Henry 100–101, 166: *Parisian Sketches 18*, 107; *The Ambassadors 65*
Jardin de Paris, Le *47*, 164
Jas de Bouffan 159, 164, 169
Jeannoit, Georges 55, 161
jewelry 53
Journal des modes d'hommes 117

Kahn, Gustave 134
Koëlla, Léon 17

Lamb, Rose *133*
Latin Quarter, Paris 134
Latouche, Gaston *40*, 41
Laurent, Méry 166
Lavery, Sir John: *The Bridge at Grez 86*
Le Coeur, Jules *60*, 166
Le Divan Japonais 47, 164
Le Havre 82, *105*, 166
leisure 8, 11, 12
Lejosne, Madame *62–3*, 64
Lemaitre, Jules 44, 47
Lemonnier, Isabelle *102*
Lerolle, Henri 44
Leroux, Gaston *52*
Leroy, Louis 122
Leroy-Beaulieu, Paul 120
Les Collettes 137, 167, 169
Les Halles 125
L'Estaque 81, *156*, 165
Lestringuez, Eugène *31*
Lhote, Paul *31*, *113*, 166
Liberty's 119
'limelight' 49
Loir, Luigi: *The Night Café 18*
Longchamp (racetrack) 35, *35*, *36*, 69, 169
Lord and Taylor's 119
Loubens, Madame *62–3*, 64
Louveciennes 18, *138*, 160, 168, 169
Luxembourg Gardens *64*, 65, *65*, *67*, 114, 169

Mabille brothers 47
'Macarona', La *46–7*, 47
Macy's 119
Madrid 137
Magasin du Louvre 119
Maggiolo *91*
Maison Aubrey 148
Maison Doré 18, 169
Mallarmé, Stéphane 116, 128, 152, 162, 166, 168
Manet, Edouard 8, 17, 18, 36, 64, 65, 93, *116*, 138, 144, 166, *166*; and Baudelaire 8, 108; character of 116; works by: *The Absinthe Drinker 22*; *At the Beach 100*; *At the Café 17*; *The Bar at the Folies-Bergère 40–41*, *40*; *Chez le Père Lathuille 22*, *28*, 29; *Les Courses 39*; *Race Course at Longchamp 35*; *Déjeuner sur l'herbe 12*, 61, 166, 168; *The Game of Croquet 72–3*; *George Moore (Au Café) 24*; *The Grand Canal, Venice 144*; *Isabelle plongeant 102*; *Monet Working on his Boat in Argenteuil 8*; *Music in the Tuileries 62–3*, 116; *La Prune (The Plum Brandy) 26*, 28; *The Railroad 142*, *142*; *Skating 4*;

Summer at Boulogne, sketches of a game of croquet 73, *The Waitress 16*, 28
Manet, Eugène *100*, 151, 155, 162, 166, 167
Manet, Julie 49, 129, 136, 166: *Growing up with the Impressionists 137*
Mante, Suzanne 55
Marlotte 60, 169
Marly-le-Roi 160, 168, 169
Marshall Field 119
Maugendre, Adolphe: *Trouville, View of the Beach and the Roches-Noires 98*
Maupassant, Guy de 22, 89, 160; *La Femme de Paul 92*
Mauri, Rosita 55
Medrano 43
Melun 60, 61
Menil Hubert 36, 168
Menzel, Adolph Friedrich Erdmann von: *Breakfast at the Café 32*; *In the Luxembourg Gardens 64*
Mesnil-Théribus 161
Metcalf, Willard: *In the Café (Au Café) 18*
Metro (Paris) 127
Meurent, Victorine 142, *142*, 166
Meyerbeer, Giacomo 53
Michelet, Jules 20
Michelin, Edouard *136*
middle classes 10, 49, 65, *75*; *see also* bourgeoisie
Millet, Jean-François 59, 154, 167
milliners 10
Mirbeau, Octave 49
Miss La-La (Olga Kaira) *42*, 43, 166
modernity 8, 28, 29, 35, 64, 93, 108, *110*, 153
Monet, Claude 24, *59*, 60, *60*, 74, 81, 97, 137, 144, *144*, *151*, 162, 166, *166*; and family 79, 147–8, *163*; friendship with Bazille 8, 59, 60, 127, 166; influenced by Boudin 164; financial problems 7, 60; depictions of *3*, 8; works by: *Arrival of the Normandy Train, Saint-Lazare Station 138*; *The Bark at Giverny 154*; *Beach at Trouville 96*; *Déjeuner sur l'herbe (study) 1*, *60–61*, 61; *Le Déjeuner (The Luncheon) 76*; *The Bank on the Seine, Bennecourt 7*; *Bathers at La Grenouillère 85*; *The Gare Saint-Lazare, Arrival of a Train 139*; *Hôtel des Roches-Noires, Trouville 99*; *Interior of the Gare Saint-Lazare 10*; *Meadow at Bezons 162*; *On the Boardwalk at Trouville 98*; *Parisians enjoying the Parc Monceau 58*; *People in the Open Air 74*; *Poppies, near Argenteuil 147*, 148; *La Promenade (Woman with a Parasol) 148*; *The Shoot 154*; *The Stroll at Giverny 163*
Monet, Jean *59*, *76*, 79, 82, 97, 147, *162*, 166
Monet, Michel 79, 166
Montagne, Prosper 29
Montgeron 161
Montmartre 28, 47, 49, 107, *113*, 134, *142*, 165, 167, 169; the 'Butte' 28, 31
Mont-Saint-Michel 55
Mont-Sainte-Victoire 159, *159*, 164
Moore, George 20–25, 117, *24*, 166; *Confessions of a Young Man 20*
Moreau, Gustave 47
Moret 152, 168

Morisot, Berthe 8, 12, 20, 49, 64, 70, 74, 81, 85, *101*, 103, 128, 151, 152, 154, 162, 166–7, *166*, 169; *The Butterfly Hunt 153*; *Hide and Seek 146*; *Summer's Day 88–9*
Morisot, Edma 162, 167
Moulin de la Galette 29, *30*, 31, *31*, 169
Moulin Rouge 8, 29, *46–7*, 164, 169
Murer, Eugène 167
Musset, Alfred de 22

Napoléon III 166
Nice 137, 162
Nini 12, 49, *49*, *124*
Nittis, Giuseppe de 167
Normandy 82, *105*, 157, 164, 168
Notre Dame (cathedral, Paris) 108
Notre-Dame de Lorette 17
Nouvelle-Athènes 20–27, *21*, *25*, 165, 166, 169

Offenbach, Jacques 49, 53, 116, 165
Olmstead, Frederick Law 66
omnibuses 127, 128, *130*, 131, *131*, 134, *134*
opera 12, 44, 49
Opéra (in Paris) 49, *49*, 53, *57*, 165, 169
Opéra-Comique 49
orchestras 41, 47, *50*, 52

Pacy-sur-Eure 128
parasols 36, *36–7*, 39, *97*, 129, *148*
Parc Monceau 13, *58*, 70, 74, 79, 169
Paris 8, 108, 169; growth in population of 10
Paris Brillant 110
parks 8, 10, *64–79*
Pasdeloup, Jules Étienne 52
Pavlova, Anna 49
Père Lathuille, Le *28*, 29
Petit Gennevilliers *1*, 164
Peugeot, Armand 134
Philippe d'Orléans 74
Picasso, Pablo 43
picnics *9*, 13, 60, *156*
Pissarro, Camille 8, 24, 60, 107, 122, 134, 156, *156*, 167, *167*; character 18, *25*, *125*; works by: *Apple Picking at Éragny-sur-Epte 157*; *Cour du Havre (Gare Saint-Lazare) 143*; *Place Saint-Lazare 135*; *Place du Théâtre Français 109*; *The Pork Butcher, Market Scene 124*; *The Poultry Market, Gisors 106*
Pissarro, George Manzana *156*
Pissarro, Julie *see* Vellay, Julie
Pissarro, Lucien *108*, 134
Place des Arts-et-Métiers 134
Place de la Bastille *122*
Place Clichy 17, *134*
Place Pigalle 20, *21*, 25
Place Saint-Augustin *117*
Place Saint-Lazare *135*
plein-air painting 82, 154, 161, 164, 169
Poe, Edgar Allen 22
Pont de l'Europe *140–41*, 169
Pont Neuf *114*, *115*, 169
Pontoise 122, 157, 158, 165, 169
Pornic 103, 169

Prendergast, Maurice Brazil: *Sketches in Paris* 69
Printemps 119, 169
Prospect Park 66
prostitution 10, 20, 22, *26*, 41, 65
Proust, Antonin 64
Puvis de Chavannes, Pierre 107, 162, 167

races 8, 12, 35ff., 65, *132–3*
Raffaëlli, Jean-François 53, 167; *The Absinthe Drinkers 23*; *Boulevard Haussmann, Paris 108*; *Young Woman in a Café 27*
railway *see* trains
Régamey, Frédéric *24, 136*
Renard, Gabrielle 156, 167
Renaudin, Etienne 167
Renault, Louis 134
Renoir, Claude ('Coco') 156, 164
Renoir, Edmond 49, 167
Renoir, Jean 49, 156, 164; *Renoir, mon Père 114*
Renoir, Pierre 156
Renoir, Pierre-Auguste 14, 17, 24, 60, 81, 103 107, 128, 136, 148–51, *151*, 162, 167, *167*; character 18, 25; financial problems 7; models 12, 122; love of music 49; move to south 156; works by: *Acrobats at the Cirque Fernando 43, 43*; *The Ball at the Moulin de la Galette 30*, 31–2; *The Beach at Pornic 13*; *Le Cabaret de la mère Antony 60*; *Rower at Argenteuil 89*; *Dance at Bougival 2*; *At the Theatre (La Première Sortie) 6*; *The Fishermen 155*; *La Grenouillère 84*; *La Loge 48*, 49, *The Luncheon of the Boating Party 8*, 89, *91*, 93, 164, 165, 169; *Picnic 9*; *The Morning Ride 69*; *Oarsmen at Chatou 81*; *The Pont Neuf 115*; *Return of the Boating Party 82, 82*; *Road rising into Deep Grass 149*; *Lunch at the Restaurant Fournaise (The Rower's Lunch) 90*; *Boating on the Seine 82*; *Skaters in the Bois de Boulogne 70*; *The Swing 15*; *The Umbrellas 112*
restaurants 10, 28; *see also names of individual restaurants*
Revue Blanche 64
Revue Illustré, La 47
Reyer, Ernest 53–5
Richmond, Sir William Blake 22
Rivière, Edmond 31
Rivière, Georges 25, 31, *31*, 167
Robbins, Mary Caroline 66
Robinson, Theodore 105, 167

Rodin, Auguste 137
Roger, Laferiere and Pignant, Mmes 122
Rouart, Henri 69, 167
Rouen 81–2, 90, 100
Rousseau, Théodore 59
rowing 12, *81*, 86, *86, 87*, 90, 138
rue Cortot 31, 169
rue de Douai 17
rue d'Edimbourg *59*, 79
rue Giraudon 169
rue de Laval 169
rue Lepic *113*
rue de la Paix (rue de la Condamine) 17, 122
rue Paradis-Poissonnière 134
rue de Peletier 53, 169
rue Rembrandt 74
rue de Richelieu 122
rue Richer *41*, 169
rue de St Petersbourg 17, 142
rue Victor Masse 169

Sacré-Coeur 29
Saint-Cloud 35
Saint-Michel 82, 85
Saint Tropez 169
Salon 8, 18, 60, 61, 69, 142; (1859) 22 (1864) 97, 167 (1872) 164 (1876) 165
Salon des Refusés 60, 168
Samaritaine 119
Samary, Jeanne 93, 167
Sargent, John Singer 66, 167, *167*; works by: *Claude Monet Painting by the Edge of a Wood 3*; *In the Luxembourg Gardens 68*; *Rehearsal of the Pasdeloup Orchestra at the Cirque d'Hiver 52*
Sari, Léon 40
Schneider, Louis 47
seaside 8, 94–105
Second Empire 35
Seine 8, 18, *75*, 81–2, *83*, 85, 89–92, 100
Seurat, Georges 8, 25, 107, 154, 167, 168; *Bathers at Asnières 92*; *The Circus 43, 43*; *Le Pont de Courbevoise 150–51*; *A Sunday Afternoon on the Island of the Grande Jatte 74–5*, 93, 167
Sheldon, George William 67
shopping 12, 107ff.
Sickert, Walter 103, 105, *123*, 167–8, *168*; *Green and Pearl – La Plage, Dieppe 105*
Signac, Paul 25, 107, 144–5, 161, 168; *Grand Canal, Venice 145*

Silvestre, Armand: *Au pays des souvenirs* 116
Simmel, George 133
singers 44; *see also names of individual singers*
Sisley, Alfred 7, 8, 17, 60, *60*, 81, 151, 152, 166, 168, 169; character 18; works by: *A Meadow in Springtime at By 152*; *Promenade des Marronniers 12*
Sisley, Henry 81
skating *see* ice-skating
smoking 23, 47, 101; cigarettes 24; cigars 18, *41*; pipe 22, 28, 49
Solares y Cardenas, Pedro Vidal de *31*
spectacle 35, 41, 43
sports 36, 93, 136
Starley, J. K. 136
Steinlen, Theophile-Alexandre: *Aux Folies-Bergère 44*; *Paris Traffic Jam 137*
Stephens, Alice Barber: *A Spring Morning in the Park 78*
Stewart's 119
Stillmann, James 74
Strasbourg 55
Straus, Madame Emile 119
studios 17, 35, 107, 142, 159, 164
Suisse, M. *1*

'Tamagno' 23
Tavernier, Adolphe 148, 151, 153
Thaxter, Celia 105
Théâtre Française 49
theatres *6*, 12, 13, 35, 47; *see also names of individual theatres*
Tonks, Henry: *The Hat Shop 121*
top hats 12, 25, 32, 41, *41*, 62, 86, *87*, 116–17, *116, 117, 129*
Tortoni's 18, 117, 169
Toulouse-Lautrec 8, 31, 36, 43, *105*, 107, 136, 161, 164, 168, *168*; alcholism 22, 47, *105*; works by: *At the Moulin Rouge 46–7*; *Café-concert in Montmartre 32*; *Country Outing 131*; *The Passenger from Cabin 54 104*
tourism 108
trains 7, 18, *82*, 127–8, 133, 138–43, *138, 139, 142, 143*, 156
trams 127, 133
Trehot, Lise 168
Trouville 8, 12, 13, 85, 96, *96, 97, 98, 99*
Tuileries Gardens 59, *62–3*, 64, 69, *79*, 114, 165, 169
Twachtman, John 105, 167, 169

Uzanne, Octave 117

Valadon, Suzanne 168
Valenciennes 120
Valpinçon, Paul 36, 168
Valvins 152
van Dongen, Kees 43
van Gogh, Theo 23, *125*
van Gogh, Vincent 22, 107, 168, *168*, 169; *The Bakery in de Geest 125*; *Café Terrace on the Place du Forum 29*; *The Night Café 23*
Vaugirard 134
Vaux, Calvert 66
Vauxcelles, Louis 145
Vellay, Julie 125, 165, 167
Venice 93, 144–5, *144, 145*, 160, 165, 168
Verlaine, Paul 22
Versailles 35
Veuillot, Louis 128
Vexin 157
Viaud, Paul 105
Vincennes 35
Virot, Rebout and Braudes, Mmes 122
Voissins-Louveciennes 82
Vollard, Ambroise 89, *119*, 137, 168

Wagner, Richard 49, *52*, 53
waiters and waitresses *16, 17, 28*, 29
walking 90, 108, 157, 160
Weber, Louise *see* 'Goulue', La
Weir, J. Alden 59, 66, 105, 153, 154, 167, 168, 169
Whistler, James McNeill 66, 68, 103, 105, 117, 168; works by: *Symphony in White, No. 1: The White Girl 96*; *Variations in Violet and Grey – Market Place, Dieppe 123*
wine 10, 70
women 8, 35, 49, *50*, *89*, 93, 113–14; working-class 10, *26*; middle-class 121; Impressionsts 20
working classes 18, *31*, 44, 53, 79, 93
Worth, Charles-Frederic 122

Zola, Emile 17, 18, 25, 81, 136, 154, 158–9, 165, 168; *L'Assommoir 23, 25*; *Au Bonheur des Dames 119, 120*; *L'Oeuvre 159, 168*

ACKNOWLEDGMENTS

Many people have helped me in the preparation and writing of this book. I am pleased to acknowledge with thanks the facilities afforded me by the British Library, the University of London libraries, the Ashmolean, the National Gallery and the Courtauld Institute. The London Library has once again yielded great treasure and provided a serene space in which to reflect and write. I thank all the librarians who have guided and aided me and the custodians of those artists' houses and studio open to the public. I have been particularly fortunate in my teachers and should like to thank Professor Lynda Nead, Tag Gronberg and Professors Will Vaughan and Francis Ames-Lewis for their initial faith in me. I am, as ever, grateful to the staff of Thames & Hudson. I owe a particular debt of gratitude to my editor Christopher Dell who has steered the book safely and expertly through the editorial process and shared with me his entertaining views on life and leisure even when the demands of this book meant that neither of us had a chance to enjoy any. I am grateful to Katie Morgan for truffling out some wonderful pictures and to David Fordham for arranging them in such a pleasing design. It is only fitting that a book about how such a lively group of individuals spent their leisure time should have had its own pleasurable interludes. Work tipped into holiday often in France and I am grateful to Hilary and Russell Hanslip, Rebecca, Peter, Zillah and Raphaela Rauter and Sarah Lesage for their excellent hospitality and for accompanying me around some of the sites and homes I have included here. Finally, as ever, I thank my family, and particularly my children, Chloe, Freddie and Florence – the spur to work but also great enjoyers and my leisure companions of choice.